THE ROSSETTIS IN

WONDERLAND

THE ROSSETTIS IN WONDERLAND

A Victorian Family History

Dinah Roe

Haus Publishing
London

First published in Great Britain in 2011 by
Haus Publishing Ltd
70 Cadogan Place
London SW1X 9AH
www.hauspublishing.com

Copyright © Dinah Roe, 2011

The moral right of the author has been asserted

A CIP catalogue record for this book is available from the British Library

ISBN 978-1-907822-01-8

Typeset in Caslon by MacGuru Ltd
Printed in India

CONTENTS

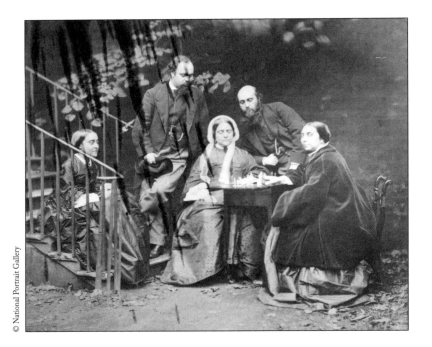

Lewis Carroll, *The Rossetti Family*, 1863

Left to right: Christina, Gabriel, Frances, William and Maria. Christina
Rossetti never forgot the day that 'the author of "Wonderland" photographed
us in the garden.'

PREFACE

'Celebrities seem to come like misfortunes, "it never rains but it pours."'[1] Most Victorian photographers would have greeted the opportunity to create the Rossetti family portrait with more enthusiasm, but history will have to forgive the Reverend Charles Lutwidge Dodgson for his gloomy forecast. He was complaining about Dante Gabriel Rossetti's casual announcement that Robert Browning wanted to be a last-minute addition to the photo-shoot he was working so hard to organise. Presumably, the great English poet would be expecting a portrait of his own.

Even for a tireless social butterfly like the good Reverend Dodgson, better known to us as Lewis Carroll, London in the first week of October, 1863, was a dizzying prospect. Carroll had yet to write the book that would make him famous, *Alice's Adventures In Wonderland*, but at thirty-one, he had begun his campaign to be accepted by Victorian artistic society. He had left his quiet Oxford digs that autumn to photograph a veritable Who's Who of the capital city's artistic scene. The Anglo-Italian Rossetti family, who boasted a respected 'poetess' as well as a commercially successful painter, were high on his list. In the days preceding his appointment with the Rossettis, he was introduced to London publisher Alexander Macmillan, dined with a different set of Victorian intelligentsia every night, attended services at Kensington Church, visited St. Stephen's Church in Westminster, took portraits of the Alexander Munros as well as dramatist Tom Taylor and family, and played croquet with another Pre-Raphaelite artist, Holman Hunt.

By the time Lewis Carroll lugged his camera to 16 Cheyne Walk to take the Rossettis' portraits on 7th October 1863, he was badly in need of a rest from the demands of his famous clientele. Like almost

everyone else who came into their orbit, he was about to experience the Rossetti effect. His encounter with the self-appointed First Family of nineteenth century arts and letters would change his life forever. He was utterly taken with Christina Rossetti's volume of poems, *Goblin Market*, which he would describe in later years as 'a work of real *genius*.'[2] Its titular work featured two young sisters enchanted by magic fruits sold by goblins in the guise of talking animals. One of its most famous lines, 'Eat me, drink me, love me' would resurface in his own *Alice's Adventures in Wonderland*.

As for Gabriel, Carroll 'had never seen such exquisite drawing before', and looked forward to photographing the best drawings, which the artist (and his photographer) could use to woo prospective clients.[3] He stood in awe before the unfinished paintings in Gabriel's studio, such as the stunning *Fazio's Mistress*, done in the Venetian style with a nod to Titian. Gabriel's real-life mistress and model for the painting, Fanny Cornforth, had made herself scarce for the day; the voluptuous ex-prostitute was not the sort of woman likely to amuse Gabriel's deeply religious female relatives. Although Fanny did participate in some of Gabriel's own experiments with photography, it was unthinkable that she would appear in a family portrait.

A fashionable street with artistic credentials, Cheyne Walk collected famous Victorians as avidly as Gabriel pursued blue and white china. Elizabeth Barrett Browning had been born at number 93, while JMW Turner had died at number 119. Other famous residents included George Eliot, Whistler, Brunel, Bram Stoker and Hilaire Belloc. Henry James would die at number 21. Leigh Hunt had lived in nearby Cheyne Row, the same street where Gabriel's neighbour Thomas Carlyle built his double-walled 'Attic Study' in an attempt to muffle the incessant noise of the waterfront. Work on the Victoria Embankment would commence in the New Year, but it would take the better part of decade before the concrete wall stretched past Gabriel's house.[4] In the summer evenings, over-laden fragrant hayboats came down the Thames, their red sails 'shining like dull bronze' at sunset. In winter great 'boulders of ice' caused havoc as they crashed and ground against ships, piers and bridges. One year, an unlucky vagrant had been found frozen solid on a slab of river ice.[5]

As he crossed the threshold of Gabriel Rossetti's riverside home,

Carroll's flagging energies were revived. The decor of Tudor House was eye-catching, to say the least. Looking around the drawing-room, which ran the length of the first floor, Carroll was confronted with his own image everywhere he turned. The sea-green walls were lined with mirrors and looking-glasses of all shapes and sizes. The few remaining spaces were filled with framed paintings whose female subjects surveyed the elegant clutter of the room with dark, languid eyes.

Three large bay-windows framed the Thames. Daylight played on the blue-veined Delft tiles of the fireplace and the mandolins, lutes and dulcimers scattered on oriental rugs. There was an English china cupboard in the corner filled with Spode ware. Belgian brass sconces, gold ornaments, and earthenware pots decorated with birds were on display, as well as carved oak furniture foraged from an antique dealer on the Strand. Japanese prints, woodcuts and cabinets reflected the new 'Japanese mania' that was overtaking Gabriel's circle. A revolt against the staid Victorian 'best parlour', Tudor House's eclectic interior alternatively startled and delighted guests. Gabriel had been tickled at Robert Browning's awe-struck first impression. The English poet walked 'many times round the rooms', then finally stood gaping, 'with his hands in his pockets and his eyes wide open.'[6]

Gabriel's drawing-room was a like a dream, a great core sample mined from the Victorian subconscious and manifested as interior design. Indeed, the room *was* a dream of sorts: a Pre-Raphaelite painter's vision of bohemian paradise. Carroll's host had paid for the house, its ten bedrooms, cellar, drawing-room, parlour and one acre garden, with the proceeds from his art. The fantasy-women he regularly magicked from his imagination had been transformed into a domestic fantasy of nineteenth century England: a room decorated from all over the world, but with a view of the Thames.

Tudor House's mirrors would frame many of the period's most famous faces: Henry James, John Ruskin, James McNeill Whistler, George Meredith, Edward Burne-Jones, Holman Hunt, Henry Wadsworth Longfellow, Ivan Turgenev, Algernon Charles Swinburne all saw themselves reflected on Gabriel's walls. As Carroll was well-aware, the Rossettis' pre-eminence was as dependent on social networking as it was on artistic ingenuity.

Carroll made his way to the acre-long back garden where the

Rossetti family were gathering for the photograph itself. As usual, they were not alone. Sculptor Alexander Munro and family, who posed for their own portrait the day before, had come along to watch the proceedings. Browning, to Carroll's relief, had not come after all. Photography in those days required long, patient work, by photographer and subjects alike. There were no shortcuts, but a great deal of equipment. Carroll would first set up his tripod, followed by the sliding-box folding camera itself. Inside his large monogrammed black case were his photographer's slides and bottles of chemicals, and the sensitizing tank full of silver nitrate into which he dipped the plate before loading it in his camera. Assembled beside this, perhaps on a small cart, would have been the dark-tent, where Carroll would begin a race against time to develop his wet-plates. He had about ten minutes before they dried, and the image they captured was lost forever. The collodion process, as it was known, required a sensitive hand. It was a method much better suited to indoor photography, but like so many eminent Victorians, Carroll enjoyed a challenge.

He arranged the Rossettis, like an image from *Alice Through the Looking Glass*, around a chessboard laid out on a small wooden table. The autumn leaves scattered on the ground, and those still clinging to the trees, provided the photographer with the perfect back-drop. Other photographers of the day relied on costumes and props, but Carroll was ahead of his time. He preferred to let composition and subject tell the story. The Rossetti siblings and their mother would not be weighed down by easels, brushes, books, quill pens, inkwells, or the medieval attire so popular in the period. There was just that chess-board, a symbol of their status as England's leading artistic family, and a representation of the one thing they had in common: an ambition to win. The Rossetti family loved games; Christina's latest poem, 'The Queen of Hearts' featured in that month's issue of *Macmillan's Magazine*, described a loser's frustration with a superior player:

> I cheated once; I made a private notch
> In Heart-Queen's back, and kept a lynx-eyed watch;
> Yet such another back
> Deceived me in the pack:

The Rossettis' competitive streak had its dark side; they were driven as much by the dread of losing as the promise of winning. '*Frangas non flectas*' [Break not bend'] was the family motto. When the family patriarch, Gabriele, fled Italy almost forty years before, the motto came with him, printed on 'a largeish seal'.[7] He was the one Rossetti absent from Carroll's family portrait: he died nearly a decade earlier in 1854. Parental expectations for the first-generation English Rossettis were always intense, and they dreaded disappointing the family. Gabriel, who in 1863 began stamping his notepaper with this unbending motto, defined ambition as 'the feeling of pure rage and self-hatred when any one else does better than you do.'[8]

Carroll's finished photograph shows the family in the relaxed pose of winners. In the centre sits Frances, the mother flanked by her four adult children. She studies the chessboard on the table before her with an authoritative eye, the white lappets of her mourning cap trailing down her shoulders. It was important to Frances to signal that she was a widow as well as a mother. Ostentatious mourning had been encouraged by Queen Victoria, whose recent widowhood had become one of her defining features. Like her monarch, Frances would never marry again.

Thirty-three year-old Christina is slightly apart from the group, sitting on steps that descend from the top left of the picture, hands folded in her lap, the ghost of a smile on her lips. Her dashing elder brother Gabriel supports himself on the railing behind his sister, legs crossed, one hand clutching his dandyish hat as he feigns interest in the chess game. The balding, bearded William Michael leans in behind Frances, his right thumb hooking his waistcoat. He eyes the chessboard critically, as if he is planning to whisper the next move in his mother's ear. His familial role was as onlooker, admirer, critic and advisor. Very rarely would the youngest brother interfere directly in the Rossetti family game. Interestingly, he was the only family member less than impressed by Carroll, a lone voice in finding him 'conventional': 'I do not think he said in my presence anything "funny" or quaint', William noted stiffly.[9]

Seated on the far right is Maria, the eldest sibling at thirty-six. Her generous figure is concealed by a velvet cloak whose voluminous pagoda sleeve swallows her left hand. She is the only person looking

directly at the camera, her faint smile a stronger echo of Christina's watery one. Maria was the only Rossetti ever to smile in photographs. The least famous of the four siblings, she was arguably the most content. An Italian tutor and dedicated parish visitor, she found fulfilment in community social work and by quietly dedicating her life to the God in whom her brothers did not quite believe. An inky stain which mars the family portrait spreads its thin fingers between the seated Christina and her standing brother Gabriel, occupying a space which might otherwise have been filled by the plump form of their father Gabriele.

Carroll had probably hoped that the curtains of his makeshift dark-tent would protect his wet-plate from the afternoon drizzle. Unfortunately, the few raindrops that spattered the plate blighted the negative. Christina later lamented that 'we appear as if splashed by ink', yet she ordered a print, unable to resist the only picture to show 'the full family group of five'.[10] Did the inky stain also remind her of a different time in her life, when, as a fourteen year-old she cared for her father at home during one of his many mental breakdowns? One of her main duties, as she recorded in a poem called 'Lines / given with a Penwiper', had been to spare the Brussels rug from the ink which leaked from Gabriele's careless pen. 'Behold, I come the carpet to preserve / And save your spine from a continual curve', she wrote. Could this splash of ink have seemed like a final call for attention from her father's ghost?

All that survives of that autumn day in Chelsea are glancing mentions of the episode in diaries and letters, and a ruined portrait. Yet ruins can tell us as many stories as flawless things; for example, the dark stain on the photograph reveals what the weather was like when it was taken, and that Christina Rossetti was the kind of person too sentimental to discard a flawed photograph. Nevertheless, she disposed of Carroll quickly enough. When he wrote in November, asking the Rossetti women to pay him a visit at Oxford, Christina declined: 'It is characteristic of us to miss opportunities.'[11]

This was only a half-truth. The Rossettis selected their opportunities with the same care that Gabriel took when finding the ideal prop for his own models, or that Christina displayed when choosing the perfect rhyme. Perhaps it was Carroll's association with pretty

young actresses that discouraged the strait-laced Rossetti women. Possibly they did not want to stray too far from London and their beloved Christ Church, Albany Street as Christmas approached. The Rossettis were urban to their bones, and the prospect of an extended rural retreat in Oxford probably held less appeal than might be supposed. When an acquaintance advanced the argument that the countryside provided 'the best inspiration' for artists, Christina responded with the pride of a true Londoner: 'my knowledge of what is called nature is that of the town sparrow, or, at most, that of the pigeon which makes an excursion occasionally from its home in Regent's Park or Kensington Gardens. And, what is more, I am fairly sure that I am in the place that suits me best.[12] Maria felt the same: 'I must still greatly prefer London to any part of the country I have ever yet seen.'[13]

Other artists and writers bemoaned the city's grinding poverty, industrial bleakness and social degeneration; the Rossettis inhabited another city entirely. For them, London was a place of transformation, excitement and infinite possibility. This wide-eyed perspective was a legacy from their father, an Italian exile who had forged a new identity and a new life in the capital. The Rossettis' colourful, cosmopolitan city was far removed from the bleak urban sprawl evoked by Dickens and his fellow realists. Frances maintained that 'true happiness' was being 'a citizen of the world', and what better place was there than London to enjoy the benefits of citizenship? Frances never tired of extolling urban virtues, and made sure that her children developed an appreciation for 'the stream of pure enjoyment flowing to the mind from such institutions as public libraries, exhibitions of pictures, zoological and botanical societies, museums, and national monuments.'[14] Born and raised close to Regent's Park Zoo, which they considered their 'garden', the Rossettis thought of their city as a home to craning giraffes and trumpeting elephants as well as bustling cab-stands and Rookeries teeming with thieves.

Despite the famously relentless monochromes of the cityscape, the Rossettis composed and dreamed in colour. Christina had a dream that, while she was walking through Regent's Park at dawn, she saw a wave of yellow light sweeping the trees. She realised that all of London's canaries were returning to their cages after one magical

night of escape. When she told Gabriel of her vision, he made plans to paint it, and said he would dress his sister in yellow to match the birds and the carpet of primroses at her feet.[15] Colour was the first thing he taught his art students at the Working Men's College, though this was 'heresy' at the time. 'Rossetti gave his students colour, and full colour, to begin with', one pupil reported. 'Draw or not, he gave them colour'.[16]

The Rossettis were not interested in disregarding urban reality, but in transforming it. They took their cue from English poet and visionary William Blake, whose biography the Rossetti brothers had just helped complete: 'You have only to work up imagination to the state of vision, and the thing is done,' Blake had written.[17] The intense passion and colour of the Pre-Raphaelite aesthetic, the music and visually stunning rituals of the Rossetti women's church, the gothic revival and the neo-medieval fashions inspired by Gabriel's artwork, presented a counterpoint and a challenge to the dreary functionality of the modern metropolis. The Rossettis and Lewis Carroll shared a similar imagination, which combated the dullness of Victorian life with the mystical, the whimsical and the unexpected.

Whatever the reason, the Rossetti women did not visit Carroll that winter. By then it hardly mattered. The alchemical reaction that happens between like-minded artists had already turned the encounter into gold. The family portraits were a great success: 'Everyone concerned has reached such a pitch of excitement about them,' Gabriel wrote.'[18] Carroll's photographs of Gabriel's drawings helped to inspire the painter's own interest in photography. In 1865, Frances, Christina and Maria declared themselves enchanted with their autographed copy of *Alice's Adventures in Wonderland*.

Though they would never become intimate, the Rossettis and Carroll would continue to cross paths. He was an occasional houseguest of Gabriel's throughout the 1860s, and he visited Christina until the end of her life. The two corresponded and sent each other newly published works with affectionate inscriptions. By the 1870s, Christina was writing short stories 'in the *Alice* style with an eye to the market.'[19] A Rossetti cousin, Teodorico Pietrocola-Rossetti, translated *Alice* for Italian readers in 1872: *Le Avventure D'Alice Nel Paese Della Meraviglie*.

At the age of fifty-eight, Christina looked back on that day, when her family was at the height of its powers, with a distinct wistfulness: 'Tudor House and its grounds became a sort of wonderland,' she explained.[20] So much had happened since that magical afternoon; so many members of the family and their circle were broken, often because they refused to bend. The remaining photograph, saved from oblivion despite its inky stain, was treasured by Christina because it captured all four siblings and their mother. It is more than just an artefact; it is a rabbit-hole that transports us to a Victorian Wonderland.

ABBREVIATIONS

Names

ABH	Amelia Bernard Heimann
ACS	Algernon Charles Swinburne
CP	Charlotte Polidori
CGR	Christina Georgina Rossetti
DGR	Dante Gabriel Rossetti
EES	Eleanor Elizabeth Siddal
EP	Eliza Polidori
FC	Fanny Cornforth
FGS	Frederic George Stephens
FMB	Ford Madox Brown
FMLR	Frances Mary Lavinia Rossetti
GR	Gabriele Rossetti
JEM	John Everett Millais
KT	Katharine Tynan
LMR	Lucy Madox Rossetti (neé Brown)
MFR	Maria Francesca Rossetti
TW	Thomas Woolner
WA	William Allingham
WBS	William Bell Scott
WHH	William Holman Hunt
WM	William Morris
WMR	William Michael Rossetti

Sources

ADC	Angeli-Dennis Collection, University of British Columbia Library Special Collections

AN	William Bell Scott, *Autobiographical Notes of the Life of William Bell Scott*. 2 Vols (London: Osgood, McIlvaine, 1892).
Bell	Mackenzie Bell, *Christina Rossetti: A Biographical and Critical Study* (Boston: Roberts Brothers, 1898).
Bornand	*The Diary of William Michael Rossetti 1870–1873*, ed. Odette Bornand (Oxford: Clarendon, 1977).
FMBD	*Diary of Ford Madox Brown*, ed. Virgina Surtees (New Haven: Yale University Press, 1981).
FLCGR	*The Family Letters of Christina Georgina Rossetti*, ed. William Michael Rossetti (London: Brown, Langham, 1908).
FLM	*Dante Gabriel Rossetti: His Family Letters, With a Memoir by William MichaelRossetti*, ed. William Michael Rossetti 2 Vols (London: Ellis and Elvey, 1895).
Fredeman	*The Correspondence of Dante Gabriel Rossetti*, ed. William E. Fredeman. 9 Vols (Cambridge: D.S. Brewer, 2004–2010).
Harrison	*The Letters of Christina Rossetti*, ed. Antony H Harrison. 4 Vols (Charlottesville: The University Press of Virginia, 1997–2004).
LPI	'The Letters of Pictor Ignotus,' by William E. Fredeman, *Bulletin of the John Rylands Library* 58 (1976): 306–352.
PRDL	*Praeraphaelite Diaries and Letters*, ed. William Michael Rossetti (London: Hurst And Blackett Limited, 1900).
Peattie	*Selected Letters of William Michael Rossetti*, ed. Roger W. Peattie (University Park: The Pennsylvania State University Press, 1990).
Pre-Raphaelitism	William Holman Hunt, *Pre-Raphaelitism and the Pre-Raphaelite Brotherhood* (London: Macmillan, 1905).

PWCGR	*The Poetical Works of Christina Georgina Rossetti*, ed William Michael Rossetti (London: Macmillan, 1904).
RP	*Rossetti Papers*, ed William Michael Rossetti (London: Sands, 1903).
RRP	*Ruskin: Rossetti: Pre-Raphaelitism*, ed. William Michael Rossetti (London: George Allen, 1899).
RFP	Rossetti Family Correspondence and Papers (Bodleian Library Special Collections)
SR	*Some Reminiscences*, ed. William Michael Rossetti. 2 Vols.(London: Brown, Langham), 1906.
TF	Christina Rossetti, *Time Flies: A Reading Diary* (London: SPCK, 1885).
FD	Christina Rossetti, *The Face of the Deep*, (London: SPCK: 1892).
Waller	R.D. Waller, *The Rossetti Family 1824 – 1854*. (Manchester: Manchester University Press, 1932).
VA	Gabriele Rossetti, *Gabriele Rossetti: A Versified Autobiography*, Gabriele Rossetti, ed. William Michael Rossetti (London: Sands and Co., 1901).

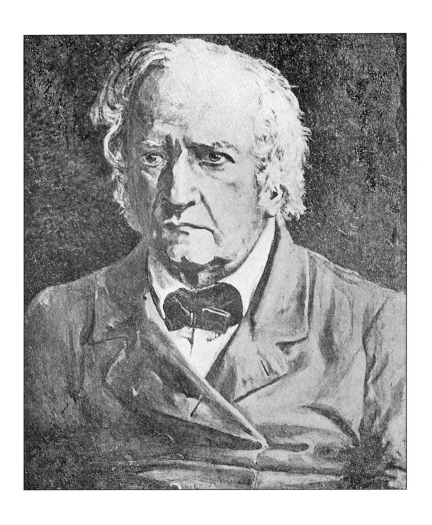

Dante Gabriel Rossetti, a portrait of *Gabriele Rossetti*, 1848

Commissioned by his good friend and patron Charles Lyell, this portrait
captures the anxiety which clouded Gabriele's sunny temperament in his old
age.

1

GABRIELE ROSSETTI

Gabriele Rossetti was the kind of man who attracted pickpockets. With a Mediterranean disposition as sunny as 1820s London was grey, the exiled Italian poet explored the streets of his new city on foot, oblivious to the dangers lurking in their shadowy corners. There were the thimble-riggers and buttoners whose quick hands and quicker tongues regularly convinced passers-by to take their chances in the rigged 'shell game'. Newspapers reported cardsharps and conmen who masqueraded as respectable citizens; robbers and murderers disguised themselves as clergymen. 'The blackguard population of the place is the most consummately blackguard of anything I ever saw', wrote one chronicler of London life.[1]

Most denizens of the capital city cultivated a continual wariness, but reserve was not in Gabriele's nature. Whenever he chanced upon a fellow Italian, whether an organ grinder in the notorious thieves' quarter of Saffron Hill or a plaster-cast seller hawking his wares in Soho, his greeting was always the same: '*Di che paese siete?*' ('What part of Italy are you from). His English friend and patron, Edward Davenport, worried 'that a certain Parson-Adams-like simplicity, of which the pickpockets have already twice availed themselves, will prevent his keeping his money'.[2]

Gabriele's inability to spot enemies was always offset by his talent for making friends. The extroverted personality that had made him one of Italy's most successful poetic *improvisatores* served him equally well in London. As he had once plucked rhymes from thin air to charm crowds back in Naples, Gabriele now conjured friends from the most tenuous of connections. Short in stature and inclined to

plumpness, he nevertheless cut a dashing figure as he strode about the city. His substantial upper body meant that he didn't have to pad his clothing to achieve the ultra-fashionable silhouette of the day, which combined a wasp-waist with a barrel-chest, a figure that society wit Henry Luttrell sent up in verse: 'In vain your buckram-wadded shoulders / And chest astonish all beholders.'[3] Gabriele wore his curly black hair short, and sported rich side-whiskers. His brown eyes and youthful face were open and round, his nature expansive and affectionate. He possessed a generous laugh, an engaging smile, and his rich tenor voice was a welcome addition to drawing-room entertainments. His habit of gesticulating vigorously while talking endeared him to the English, who expected no less from an Italian. Had they looked more closely at Gabriele's fast-moving hands, some might have spotted clues to the anxiety he otherwise hid so well: he was an incurable nail-biter.

Gabriele Rossetti arrived in London from Malta on 7 April, 1824. He had a few letters of introduction, little money and less English. By the end of the following year, however, he would have invitations to summer at the country houses of wealthy patrons, a career as a teacher of Italian, his first book heading for publication, and a pretty English fiancée. No wonder he held the capital in high regard: 'London, or rather England, is an object of the greatest wonder to me. What seemliness and order, what wealth, what … but what is there not! The very bells play tunes,' he wrote ecstatically.[4] Optimism was not simply one of Gabriele's leading personality traits, it was the product of his recent history. London may have looked forbidding to many of its inhabitants, but for Gabriele, it was an improvement over his homeland, which had subjected him to poverty, violence, chaos, and the whims of despotic rulers. Working out his literary destiny from a tiny bedsit in Soho's Gerrard Street was preferable by far to hiding in an attic from the Neapolitan secret police, where he had watched helplessly as friends and colleagues were rounded up, jailed, and murdered for crimes against the state.

Soho may have been new to Gabriele, but the Italian poet did not particularly stand out in his first London neighbourhood. Today, we can recognise Gerrard Street by the pagoda-style arches at either end which mark the heart of London's Chinatown. When Gabriele

arrived in the area, it was welcoming its first wave of Italian immigrants, many of them, like Gabriele, fleeing a divided Italy. Soho was a formerly illustrious neighbourhood gone to seed after the rich deserted it for fashionable Mayfair in the mid 1700s. Successfully repelling various attempts at gentrification, it attracted a wide range of immigrants. Greek Orthodox Christians and French Huguenots jostled newer Italian arrivals on Soho's snaking streets, their diverse languages, foods and religions making the area a veritable Babel, and also a hotbed of creativity and cultural exchange. Remembering those heady days in his autobiography, Gabriele versified: 'Mid grand activity which knows no pause / I found my own increasing day by day'. The poet thrived in the 'freer air' of this environment.[5]

Other Soho residents of 1824 would have hesitated to describe their surroundings in such glowing terms. The overstuffed capital was about to surpass Beijing as the world's most populous city, and its poorer inhabitants were already feeling the squeeze. Overcrowding, and the consequent crime and disease, was commonplace. Immigrants lived in particularly poor conditions, and their troubles were compounded by difficulties with English language and culture. Italians were caricatured as irritating street performers accompanied by unhygienic monkeys and white mice, or stereotyped as members of the thieving classes. In *Oliver Twist*, Fagin's child-pickpockets lived in the grim Italian Quarter of Saffron Hill, which Charles Dickens immortalised as 'the emporium of petty larceny'.[6]

Gabriele made certain that no one would ever mistake him for a Clerkenwell thief, street performer or trinket-seller; he belonged to the Italian educated elite, and thus had a direct line to important people in British society. From his little garret at number 37 Gerrard Street, Gabriele wrote to Lady Moore, wife of Admiral Graham Moore, whose ship had spirited him to safety in England: 'if in Italy my verses were thought to be something, I hope that in England they will not be without worth for those who love our poetry'.[7] This was a canny appeal to the current London fashion for all things Italian. English poets like Byron and Shelley had popularised Italy by going abroad to defend foreign causes; Italian exiles returned the favour, arriving in droves upon English shores, hoping to build new lives and careers. Many educated immigrants lived in reduced circumstances;

men who had held high positions in their homeland now worked as waiters or sold silk flowers on street corners. The lucky ones caught the attention of London's elite. Men like Gabriele were smart enough to market themselves as Romantic exiles in the Byronic vein, and found themselves welcome adornments to both town apartments and country houses.

Soho was well-known for harbouring artists and writers. Gerrard Street was especially famous. The former Poet Laureate John Dryden lived at number 43. In 1764, the Turks Head tavern played host to Dr. Johnson and Sir Joshua Reynolds' famous literary dining club. Gabriele saw himself as part of this artistic tradition, and he made sure his patrons saw him that way too. He slipped easily between two worlds: English drawing-rooms and Italian coffee houses alike eagerly flung open their doors to greet him.

At his window most mornings, Gabriele watched as 'the radiant torch of day turned into a ball of glass glowing red hot from the furnace, even that soon to be hidden behind black clouds of thickening fog'.[8] This Romantic enthusiasm for London was not dampened by its dreary rain, its fog, or its habit of picking his pocket. Gabriele felt in his bones that he would be a success in his adopted land; he was a son of Vasto, whose legendary founding father was reputed to have been Diomedes himself. One of Odysseus's men, who sprang from the belly of the giant wooden horse to sack Troy, he was among antiquity's greatest warriors. Gabriele employed a similar strategy, although he intended to conquer his foreign city with words rather than blows. He had been spirited out of a divided Italy, in the wooden belly not of a horse but a ship. Now he was ready to spring into action, albeit in a more civilised manner than Diomedes: 'I also will enter the ball and we shall see who has the best legs,' he vowed.[9]

As is the case for most asylum-seekers, Gabriele's route to London was anything but straightforward. His story was as convoluted as the Neapolitan politics that eventually drove him from his native land. Even Gabriele was confused by the ever-changing alliances which characterised Italy's domestic affairs: 'I understand these matters not at all,' he confessed. 'Truly it is a strange thing that I who don't at all understand what politics are, should for politics be persecuted and exiled'.[10] This failure to understand was not the result of intellectual

laziness, but a mark of his character. Gabriele was a librettist as well as an *improvisatore*, and it is in the nature of both arts to simplify, to communicate essence rather than detail.

He had perfected his craft during his youth in Naples, where he had been mentored by THE *improvisatore* Luigi Quattromani. Quattromani taught him all the skills a good improvising poet would require, including the semblance of composing poems on the spot, many of which had actually been prepared beforehand. A fearless self-promoter, the young Gabriele tested his new work on Naples' streets, where he tutored himself in the art of manipulating the emotions of a crowd, flattering both audience and location by incorporating them into the performance. In truth he was better in person than on paper.

Reading Gabriele's poems years later, his youngest son William would find 'some of them poor, and not any exactly good'.[11] His father's poems were of their moment, in more ways than one. Live poetry made the best of Gabriele's personal magnetism, his oratorial skills adding drama to sentiments which, on the page, could seem plodding or commonplace. This was not the only danger of the written word, as Gabriele discovered to his cost when he was exiled by King Ferdinand in April 1821. Imagining Ferdinand's defeat at the hands of the Constitutionalists in July 1820 was permanent, Gabriele had written pamphlets and poems praising the new constitutional monarchy. When Ferdinand was restored to power, with the aid of the Austrian army, Parliament was dismissed, and an era of vicious persecution followed. The literary merit of Gabriele's popular verses may have been questionable, but their republican sentiments and gloating tone were never in doubt.[12]

Gabriele's habit of expressing himself without considering long-term consequences would eventually land him in trouble in England. Literary London in the 1820s, however, was in thrall to the Romantic poets, who prized free expression as the highest form of art. Coleridge himself gave Gabriele the seal of approval when they met in 1824, declaring him 'a gentleman, a scholar, and a man of talents'. The English poet was riveted by the life story of a man 'driven into exile for the high morale of his writings.'[13]

Coleridge would have been filled with Republican indignation at the story of Gabriele's father Niccolo, a humble blacksmith who

in 1798 was beaten nearly to death by invading French Republican troops after he refused to shoe their horses. He died only two years later. Newly politicised by these events, Gabriele turned his hand to writing patriotic poetry, and started living a double life. On the one hand, he was a respected librettist for the Theatre of San Carlo, a curator at the Royal Museum and a secretary for the Public Instruction of Fine Arts in Rome. On the other, he was a member of the Freemasons, a group who in that era were closely associated with European revolution and dissent. There were cells of Freemason 'Illuminati,' (republican freethinkers who desired unification) scattered all over Italy, making her ruling classes uneasy. Gabriele also joined another insurgent movement, the Carbonari, in 1812.

The story of Gabriele's exile and escape had the requisite amount of adventure and romance to stir Coleridge's imagination. After Gabriele went into hiding, Dora Moore, an English admirer of his poetry, came to his aid. She persuaded her husband, an admiral of the British Fleet, to offer Gabriele safe passage to Malta in his man-of-war, *The Rochfort*. They concocted a plan which might have been ripped from the pages of the Ann Radcliffe's popular gothic romances. One evening, two English naval officers, dressed in their distinctive red uniforms, entered Gabriele's safe house in the Concordia quarter of Naples. Moments later, three scarlet-clad officers emerged, one rather more plump and less English than his fellows. The trio entered a coach which rattled off at break-neck speed towards the beach. A police inspector, observing the full-faced figure wedged between his two strapping colleagues, commented, 'By God! The man in the middle looks to me like Rossetti!' But he did not question them, and the disguised, exiled poet made it to the *Rochfort* unimpeded. Years later, when describing his great escape, a grateful Gabriele would tell of his relief when, still wearing his borrowed naval officer's uniform, he knelt on the deck and 'kissed that wooden Albion'.[14]

Later, gratitude mixed with sorrow, as the poet stood on the prow, 'communing with my land betrayed,' and remembering 'a few happy days and many dire'.[15] The dire days were not only caused by his deteriorating relationship with the Neapolitan ruling class. There was Donna Peppina, a girlfriend who had given birth to a son that survived only six hours. Peppina was not in good health herself, but would later

sail to join Gabriele in his exile. Leaving his son in a graveyard to which he was unlikely to return must have caused Gabriele untold grief. The same could be said for his family, friends and position, not to mention his hard-won connections. But as the shoreline slipped from his view, Gabriele couldn't have known that he would never return to his homeland again. Then aged thirty-eight, nor did he realise how difficult it would be to start a new life. His unflappable optimism and sociability, which could be his downfall and saving grace alike, came to his rescue that spring night as *The Rochfort* sailed from the Italian coast. As distressed as he was to be leaving his homeland that night, he did not forget to seek out the two subalterns who had helped him escape. Beaming, he compared them to the sea-gods Thetis and Neptune, thanking them effusively for their assistance.

His sojourn in Malta was peaceful, if short-lived. The Treaty of Paris had made Malta officially part of the British Empire in 1814, which ensured that Gabriele was safe for the time being. He enjoyed his new freedom in the city Walter Scott described as 'built by gentlemen, for gentlemen'. He took walks along the flat terraces and rocky slopes of the island, resting against the drystone walls which criss-crossed its fields and composing new poems in his head. Here Gabriele met important patron John Hookham Frere, a retired diplomat and a fellow Mason. Frere not only found Gabriele work as a teacher of Italian, but also provided companionship. Gabriele frequently visited his friend's country villa, where the two men strolled among the loggias and pergolas of Frere's famously beautiful garden, enjoying the scent from its citrus blossoms and roses. A compassionate man who had himself lost a wife to sickness, Frere might have considered Donna Peppina's plight a further reason for support. Although she had joined Gabriele in exile, he had not promised her marriage. It is possible that the island's curative atmosphere attracted her. Very little is known of her, and the record of her life ends in Malta in 1823.

Gabriele knew that King Ferdinand still wanted to settle old scores, so he was studying English in preparation to make '"*un salta vitale ad uno scoglio più grande*' [a jump for his life on to a greater rock]: England.'[16] In the end, he did not jump; he was pushed. On the twenty-eighth of September, 1822, Naples declared an amnesty for all exiles, save thirteen men: unlucky for some, Gabriele was

number thirteen on the list. The British foreign secretary Castlereagh ordered the expulsion of the remaining 'fugitives' from Malta, and Gabriele witnessed in horror the persecution and imprisonment of fellow-exiles; one close friend, Pier de Luca, drowned himself in the sea rather than be evacuated. Suffering from a mental breakdown, Castlereagh would slit his own throat with a letter opener later that year. It came too late for Gabriele: 'thy best service was thy suicide' he remarks in his autobiography, 'But why no suicide a year before?'[17]

Admiral Moore came to his rescue once again, offering him passage to London. Donna Peppina did not accompany him. Whether she died in Malta or was abandoned by Gabriele, either way their parting cannot have been happy. As a London newspaper joked, Italian immigrants separated from their sweethearts 'do not throw themselves into the Thames but marry English girls'.[18] Gabriele was no exception; he would marry an English girl and reinvent himself as the ultimate family man.

The journey to England was long, but Gabriele enjoyed himself nonetheless. He wrote to Frere from Gibraltar, 'I have been eating like a wolf, digesting like an ostrich, and sleeping like a dormouse'.[19] An attack of gout belied his claims to ostrich digestion, and ruined his arrival in London, where he remained bedridden for ten days. Any other foreigner arriving ill and alone in March 1824 might have felt intimidated, if not actually depressed. As always, Gabriele was not really alone: he already had important friends. Between the English acquaintances he met through Admiral and Lady Moore, and the Italian expatriate community already resident in London, Gabriele's social calendar was full from the moment his feet touched land at Chatham dockyard.

His written English was good, but Gabriele rarely spoke the language. 'He *understands* English,' Coleridge noted, 'and, he speaking Italian and I our language, we had no difficulty keeping up an animated conversation.'[20] In any case, Gabriele was surrounded by his fellow countrymen. He reunited with old friends: his beloved General Pepe, who had led a failed charge against Ferdinand and the Austrians at Rieti in 1821; Alessandro Poerio, a poet who had fought at the General's side; the lawyer Guglielmo Paladini; and Filippo Pistrucci, an engraver and *improvisatore*.

These educated Italian expatriates were feted by the English, and they passed on the benefits to other newcomers. Gabriele's friends were not the target of articles in the *Times* whose authors were 'exceedingly annoyed by the appearance of a number of Italian boys with monkeys and mice wandering about the streets', nor were they forced to sleep two men to a bed and fifteen to a room.[21] English 'Italophiles', whose opinions had been formed by their 'grand tour' of Italy and their love of Byron and Shelley, did everything in their power to help the exiles find their footing. Unlike their uneducated countrymen, these well-connected Italians did not choke down the working man's diet of bread, potatoes and cag-meat (offal) in the city's infamous 'dead meat shops.' Instead they dined at the finest addresses in London, or enjoyed native dishes with each other, cooked from the olive oil, pasta and specialty cheeses which were becoming readily available in Italian-run grocers in Soho.

Nor was Gabriele lacking in new English friends, courtesy of the letters of recommendation that had accompanied him from Malta. Within two months of his arrival, renowned translators of Dante Alighieri like William Stewart Rose and Henry Cary were recommending him as a teacher of Italian, as was the poet Thomas Campbell. In those days, word of mouth could make or break a teacher's career; although learning Italian was considered an essential part of a respectable education, the influx of educated Italian exiles meant stiff competition for pupils. Gabriele was especially concerned about the 'swarm of unfortunates who have undertaken teaching'.[22]

He needn't have worried. The same improvising charm that transfixed strangers on the street worked its magic on students as well. Gabriele's energy and obvious passion made him a good teacher, the kind who inspires as well as instructs, as later students like Dante translator Charles Cayley would attest. He regarded lessons as part of his own personal mission 'to spread a taste for our Italian literature.'[23] While Gabriele could inspire the poetic and scholarly spirit in others, his own literary efforts were never more than modest. He would never become a famous poet, like his beloved Dante and Petrarch. Gabriele's tragedy was not an absence of talent, but a lack of self-knowledge.

In England, Gabriele gave up his improvisational poetry because he thought it 'would lower his position as a serious professional man

in the teaching and literary vocation'.[24] He may well have been right; the British appreciation of the art was limited. When Jane Welsh Carlyle wrote of an 1842 anniversary celebration at Mazzini's school for boys, she described the after-dinner improvisations of Rossetti and Pistrucci as a 'horrible *recitative*' given by 'two old fools' who, with 'all sorts of coyish grimacing' had given vent to their 'melodramatic propensities'.[25]

Gabriele viewed the poetry of the page as superior to the poetry of the street, disregarding the fact that he was more successful with the latter. A man with a talent for making friends does not belong imprisoned behind a scholar's desk, as Gabriele's future struggles in academia would prove. Jovial, passionate and garrulous, he thrived in company where he withered in solitude. Even Jane Carlyle had been an admirer before disillusion set in: 'Rossetti is a charming old man – and the words came from him "like the notes of a nightingale touching and strong"'.[26] But he convinced himself that to be taken seriously, he needed not only to *write* poetry, but to become a scholar as well. Thus Gabriele allowed his native talent to be crushed under the weight of financial considerations, an act of self-denial that would return to haunt him, and his family, for years to come.

Gabriele's first year in London, however, was an exciting round of introductions and sight-seeing. It was an ideal time for a man to make his way in a capital city undergoing its greatest and most rapid transformation since the 1660s.[27] There was the elegant curve of Regent Street, which divided 'aristocratic London in the west and plebeian London in the east', the demolition of London Bridge and the construction of a new version upriver and the building of St. Katharine's Dock, which was 'closer to the centre of London than any before'.[28] The Metropolitan Police would replace the inefficient (and unpaid) constables and nightwatchmen. By the end of the 1820s, the first horse-drawn omnibus would take to the streets. Urban development took place at the expense of the city's poor, who were simply pushed into different ghettos that were still tantalizingly close to the better neighbourhoods. John Fisher Murray would observe, 'The conscious bitterness of poverty is of tenfold bitterness in a place like London, where men do not only starve, but starve in the midst of plenty: there is but an eighth of an inch between the perishing wretch and abundance'.[29]

Gabriele Rossetti was determined to stay on the safe side of that eighth of an inch. He thrived under the constant pressure to acquire more pupils, peddle more poetry and carve a niche for himself in an overcrowded capital city. He met with Signor Benelli of the *Teatro Italiano* to discuss the possibility of writing some libretti, and offered his services to Rossini. These opera connections yielded no fruit, but he soon managed to get £40 out of Cipriani Potter, the principal of the Royal Academy of Music, for a libretto, which led to more commissions. He befriended the great composer Nicolo Paganini, who offered money to accompany him on a tour of the provinces. During his first English summer, Gabriele escorted Giuditta Pasta, one of the most famous sopranos of the day, to an engagement in Cambridge. Astounded by her £200 fee, Gabriele was even more impressed by the crowd which came to see her; so tight was the throng, he couldn't fit in the door, and had to force his way through the window to see his friend sing. Rossini, the Italian composer of *The Barber of Seville*, was the conductor. Although Gabriele failed to command the fees of Pasta or Paganini, his friendships with Charles Lyell, Davenport and the Moores kept him financially afloat through his first year in London.

Now aged forty-two, Gabriele was tiring of his nomadic existence. He longed for the comforts of home, hearth and a steady career. Perhaps most pressing of all, he was still to produce the great work he felt destined to write. More and more, his attention turned to the study of Dante, which was congruent with his obsession with Freemasonry. A Mason even before he ever joined the Carbonari, his loyalty to that organization was one of the motivating factors of his life, tied as it was to patriotism and exile. Despite being raised as a Roman Catholic, Gabriele was neither a church-goer nor religious; like most significant Italian exiles, he was firmly anti-papal, another characteristic that endeared him to the English.

Freemasonry was the closest he came to a belief system, and it dominated his work, thoughts and deeds. Secret societies and brotherhoods, with their promise of belonging, often exert a strong appeal to strangers in a strange land. A project began to form itself in the poet's mind, and he became convinced that Dante Alighieri and the Freemasons shared a connection beyond his love for them both. In order to prove this hypothesis, he needed stability and time. Squiring Signora Pasta

and Paganini around England was a project notably at odds with this serious ambition. He may also have worried that his lack of forthcoming publications might exhaust the patience (and purses) of his patrons. Wary of looking too much the dilettante, Gabriele determined that the best course of action was to settle down and get married.

He found his father-in-law before he found his bride. Gaetano Polidori was a straight-talking, burly Tuscan on the lookout for a son. Formerly secretary to the dramatist Vittorio Alfieri in his native land, Gaetano now tutored pupils in Italian in rented rooms on Wells Street (decidedly on the wrong side of Regent Street), commuting as often as he could to his family house at Holmer Green in Buckinghamshire. Having emigrated to England 25 years before, he spoke perfect English, and had assimilated well. He had even taken an English bride, an ex-governess known for her beauty, named Anna Maria Pierce. Their daughters, though unmarried, were all clever, self-sufficient and had independent careers. Polidori's sons, by contrast, had been a terrible disappointment. Where their father was strapping and confident, the boys were thin-skinned and not terribly bright. Philip was too 'weak-minded' and 'odd' to move out of his parents' home, while Henry Francis was a failed solicitor.

John had initially pleased him by following in the footsteps of his Italian grandfather Agostino and becoming a doctor. But his eldest son had no real aptitude for medicine, much to the infamous annoyance of Lord Byron, who took him on briefly as his personal physician. John felt himself an artist at heart, something he proved, however fleetingly, by writing the first vampire story in English, *The Vampyre*. Featuring an undead hero based on Byron himself, the novella was written during the same horror-story competition in Geneva that generated *Frankenstein*. But John Polidori was no Byron or Mary Shelley. As William Rossetti put it rather harshly, 'it may be at once admitted that his poetry was not good'.[30] *The Vampyre* had exhausted John's literary potential. After a few unsuccessful volumes of poetry, he fell into heavy gambling debts, and in 1821, committed suicide by poison.

His mother, Anna Marie, reacted by taking to her bed for the next thirty years of her life. Grief-stricken yet too angry to unburden himself by a display of grief, Gaetano derived what enjoyment

he could from his surviving children, his teaching career and his carpentry hobby. Clever and well-read, he began to long for intelligent male companionship. Gabriele Rossetti came along at just the right moment. In the summer of 1825, a shared love of Dante Alighieri made the two men fast friends. As was his custom with new acquaintances, Gabriele soon became a regular at the Polidori house in Holmer Green.

Gabriele's frequent visits soon acquired a second motive: Gaetano's bright, attractive second daughter, Frances. He would later claim that it was something approaching love at first sight when he met Frances: 'A single moment regulates a life: / My heart became the lodestone, she the pole'.[31] Frances possessed her English mother's good looks, calm demeanour, and independence of mind. With lustrous dark hair, clear skin and sympathetic blue-grey eyes, she remained a handsome woman all her life. Trained as a governess, she spoke and wrote French and Italian, though English was her first language, and she had a passion for literature. Seventeen years Gabriele's junior, Frances was not young by the standards of the day. At twenty-five, her marriage prospects were dwindling, and she was in no position to be particular about her bridegroom.

An admirer of Romantic poetry, she was impressed with the story of Gabriele's exile, though presumably Donna Peppina was silently omitted in the re-telling. Frances would have consulted her Atlas to find Gabriele's birthplace, Vasto, a coastal town east of Rome located right above the 'ankle' on the boot-shaped Italian peninsula. She warmed to the story of his Italian childhood spent playing with his siblings and scrabbling along the rocky shoreline in search of treasures washed up from the Adriatic sea. Gabriele had exhibited an early talent for drawing and painting, cutting open the bellies of local *calamarello* (cuttlefish) to obtain free sepia 'ink.' His mother, Francesca (neé Pietrocola), the illiterate daughter of a shoemaker, had given birth to him on the top floor of their crumbling five-storey house which overlooked the Adriatic Sea. His father, Nicola, was a blacksmith and locksmith with a reputation as a respectable, if strict patriarch. He considered himself descended from a noble line, the Della Guardias, noted for their 'great men of letters' and their red hair. According to family legend, this latter feature earned the Della

Guardias the nickname 'Rossettis' or 'little reds,' which evolved into a real family surname.[32] Frances must have noticed that, despite having dark-hair, her suitor possessed the stereotypically passionate, stubborn nature frequently attributed to redheads and Della Guardias alike. It was from the Della Guardias that Rossetti inherited his own family motto, a paean to stubbornness: 'Break Not Bend' (*Frangas Non Flectas*).

In December 1825, Gabriele wrote Gaetano a letter, asking him 'to the gracious name of friend … to add the loving name of son'. He enclosed a love letter to Frances as well, but added that if her father disapproved of his matrimonial intentions, he should feel free to throw the letters into the fire. This proved unnecessary. The rudderless Gabriele might not have been every father's ideal son-in-law, but Gaetano already loved him as a friend, and probably realised that his daughter could not count on many more marriage offers. Upon their engagement, Gabriele wrote to his patron, Charles Lyell, in terms notably less passionate than his letter to Gaetano. 'I am going to marry Signor Polidori's daughter,' he announced. 'It was necessary for me to engage in a more regular system of life in order to give proper attention to my studies'.[33]

This uncharacteristic pragmatism may seem unromantic, but it led to the best decision Gabriele ever made. His marriage to this eminently sensible, family-oriented, intellectually ambitious woman completed his transformation from callow immigrant to venerable expatriate. Within the next five years, the once rootless exile would become a father, publish his first works in England, and win a prestigious appointment as Professor of Italian at King's College London. There would be no more lodgings in Soho or acting as Signora Pasta's anonymous escort. The English would soon be addressing the formerly penniless poet as Professor Rossetti. The Italian expatriates, who came to the Rossetti family home to pay court, would honour him with the title, 'Don Gabriele'.

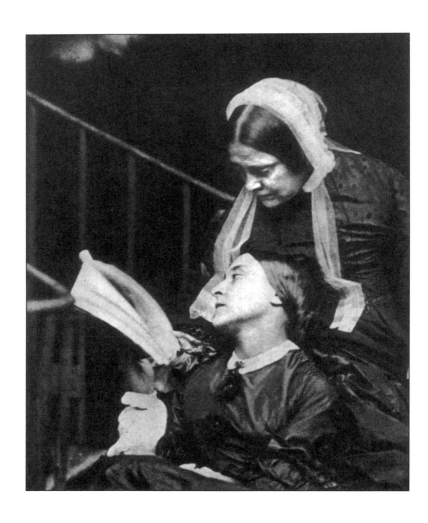

Lewis Carroll, *Christina and Frances Rossetti*, 1863

A native Londoner, Frances taught her children to regard their city as 'a stream of pure enjoyment flowing to the mind'.

2

SIGNORA FRANCESCA'S COMMON SENSE

Seen through the eyes of her children and family friends, Frances Rossetti comes across as a Victorian household angel, worshipped for her domestic skills and silent, long-suffering nobility. She is often portrayed as a woman whose 'motherly life had absorbed her existence'.[1] This view, perpetuated by the men in her life, obscures a key aspect of Frances's character. She may have been celebrated for her practicality, but her best-kept secret was her own romantic nature. While evident enough in her decision to marry Gabriele Rossetti, it had its first expression much earlier, in the young Frances's abiding hero-worship of her brother John, a tearaway who was as unbalanced as their father was steady. As Gaetano Polidori's eldest son, John had received the material and educational advantages withheld from Frances and her three sisters, Eliza, Charlotte and Margaret. But neither medical, legal, religious nor literary training was sufficient to save Frances's brother from himself. In 1821, at the age of twenty six, he ended his own life by taking cyanide.

A failed poet, mediocre physician, hopeless gambling addict and finally a suicide, John Polidori had always been the black sheep of his family. The darker aspects of his character, including a quick temper and a tendency toward melancholy, were offset by his good looks, charm, and ability to make others feel they were the exclusive focus of his attention. His physical appearance certainly inspired adolescent

passion in thirteen-year-old Harriet Martineau and her sisters: 'We younger ones romanced amazingly about him – drew his remarkable profile on the back of all our letters, dreamed of him, listened to all his marvellous stories…'[2]

John was also the pet and pride of his own sisters, in particular Frances, with whom he kept up a close correspondence. Whereas his letters to his father are formal and angry, his letters to Frances are intimate and earnest, revealing both his ambition and his anxieties. John taught his younger sister Latin by correspondence, and, as a middle child of eight, she relished the special attention. Her brother left her another, more valuable legacy: an abiding love of Romantic poetry which she would pass on to her own children. That young Frances, already a devout Christian, was drawn to Romantic figures, might seem at first surprising. After all, these writers often advocated atheism and free love. But the young Romantics provided imaginative respite from an otherwise stern upbringing.

Her father was a patriarch of the old school, who believed in the benefits of a traditional education as firmly as he was convinced of the dangers of singing and dancing, neither of which was permitted in his household. Even after old age had mellowed him, he was described by his grandson as 'solid, unbending, somewhat dogged.'[3] The same qualities which made Gaetano a great translator were his downfall as a father. Despite the greater social and educational opportunities that were the privilege of the male children, all of Gaetano's sons would fall far short of his inflexible standards. Philip was so 'weak-minded' that he was never able to leave the family home or hold down a job, while Henry ended up a solicitor's clerk after failing as a lawyer. His desperation to succeed was betrayed by a decision to Anglicise his name as 'Polydore.'[4] Paternal favouritism towards the boys turned out to be an advantage for their sisters; it allowed the Polidori daughters to evade the over-critical eye of their father. The girls still had to observe Gaetano's strict codes of conduct, but their upbringing was largely left to their mother Anna Marie.

While their father obsessed about John's difficulties at school, the girls quietly went about their education. They were remarkably well-read, and were confident in French, Spanish, Italian and German, Greek and Latin. As the Polidori boys were receiving theoretical training in

law and medicine, the girls entered the practical world of governessing work. In a profession which depended on word-of-mouth, a good reputation could not be underestimated, and the young Polidori sisters found that their excellent education, along with their natural ability as teachers, kept them in demand. John wasn't the only Polidori sibling to go abroad; the energetic and lively Charlotte travelled Europe in her capacity as governess, and Margaret became a resident governess in Gloucestershire. Eliza, the youngest sister, suppressed her naturally independent spirit in order to stay and look after their mother. Frances too found work close to home when she accepted her first appointment as a governess in Leatherhead, Surrey at age sixteen.

It was in her pupil's home that she encountered a family friend, the handsome teenage John Shelley, brother of the poet Percy Bysshe. No one was allowed to even whisper the name of that 'world-abandoned rebel' and 'versifying atheist', which must have added an extra frisson to these encounters. In this same year, Frances was receiving letters from her brother who was touring Europe with Byron as his private physician, and socializing with Shelley. 'I am very pleased with Lord Byron,' John reported. 'I am with him on the footing of an equal, everything alike'.[5] But John's infamous temper and insecurity quickly upset this equilibrium. In the summer of 1816, while Frances exchanged shy glances with John Shelley in Leatherhead, her own brother was threatening to shoot Percy Bysshe after losing a sailing match to the poet. Other stunts included fights with locals and an arrest for assault after breaking an apothecary's glasses and knocking off his hat. Thoroughly fed up with John's aggressive outbursts and his graceless attempts at literary networking among his friends, Byron fired the young doctor. Even a year later, Byron's irritation with Polidori had not abated, as he revealed in a poem to publisher John Murray regarding Polidori's latest literary attempt:

Dear Doctor, I have read your play,
Which is a good one in its way,
Purges the eyes, and moves the bowels,
And drenches handkerchiefs like towels…[6]

Byron may have sneered, but, along with exasperating his employer,

John secured his place in literary history that summer by writing *The Vampyre.*

'Don't you wish to be with me?', John wrote to his 'dear Fanny' from Belgium (somewhat insensitively).[7] Although this was an impossibility for the young, unmarried Frances, she managed to 'be with' her brother and his glamorous companions in the only way she knew how: through poetry and imagination. Missives from John could be tucked away in her commonplace book to be opened like portals when she needed to transport herself from the workaday world of Surrey to the hills of Tuscany or the warm hearth of the Villa Diodati.

Critics of the day tended to dismiss any woman's interest in Byron as a schoolgirl crush, but the attraction of Romantic poetry for a woman like Frances lay as much in its accessibility as it did in the dashing personalities of its writers. With their liberal attitudes, youthful, rebellious energy, scepticism about marriage, and willingness to write in the vernacular, the Romantics had a lot to offer the young female reader. Instead of patronising her or protecting her from 'scandalous' content and ideas, Romanticism treated the woman reader, if not as an equal, than at least as an adult. More women than ever were reading contemporary poetry (and writing it as well), challenging Wordsworth's declaration that 'a poet is a man speaking to men'.[8]

Frances Polidori's hero-worship of Romantic poets and poetry developed alongside her burgeoning Christian faith. Where the two came into conflict, Frances, a born educator, saw the opportunity to learn. Poetry taught her the delicate art of suspending, sustaining, and even relishing contradiction. She happily copied out Byron's poetry alongside the earnest devotional sermons in her commonplace book. Her son William would write that 'though religious, she was in no way fanatical, nor even prejudiced', and recalled her asserting, "I will never believe that Socrates is condemned to eternal torment."'[9] There was a personal motive behind her generosity to Socrates, who committed suicide, like her brother John. Her brother's death prompted the first real crisis of Frances's twenty one years, testing not only family loyalty but religious faith.

Sisterly grief was compounded by Gaetano's refusal to entertain even the mention of his favourite son's name, much less any discussion

of what had befallen him. And, though family strings were pulled to solicit an offical verdict of death from natural causes, the Polidori family knew the truth. Despite a respectable burial in St. Pancras Churchyard, John Polidori was damned. For all his carousing with versifying atheists, John died a Roman Catholic.

Frances and her sisters had been raised in their mother's Anglican faith, which left marginally more room for manouevre. Frances painstakingly copied a sermon on suicide from *A Practical Discourse Concerning Death* by English clergyman William Sherlock into her commonplace book. Sherlock concludes that the suicide damned himself because he was unable to repent. The good reverend did admit a slim possibility of forgiveness: 'We know not what allowances God may make for some men's opinions of the lawfulness of it…'[10] The Polidori daughters could not shut their hearts to their beloved brother. Unlike so many men of his time, John Polidori had never considered his clever sisters' gender a bar to their capacity for learning. This irredeemable sinner demonstrated his faith in their intelligence to the last; he willed his books to his sisters. Tellingly, Frances received his collection of English poetry.

Nearly ten years after their brother's death, Frances and her sisters were still unmarried. At a time when marriage was essentially mandatory for women, the reasons are unclear. All four Polidori girls had a model for unmarried success in their mother's sister, Harriet Pierce who had been a governess to the Earl of Yarborough and was spending her retirement living by herself in an elegant London apartment. Though unmarried, she insisted on being called 'Mrs. Pierce', and it was rumoured that she was the Earl's mistress.

If they did not secretly hanker after female independence, perhaps the Polidori sisters' zealous religious beliefs and practices, which saw them attending church at least twice a day, acted as a deterrent to suitors. Possibly their Italian heritage restricted their pool of potential prospects to Italians or Anglo-Italians. Eliza's caretaking duties for her mother, who was essentially an invalid, absorbed most of her energy. Charlotte, whose income and reputation as a first-class governess were on the rise, was becoming an independent career woman, away as often as she was at home. As for Margaret, her eccentricities might have discouraged any would-be suitors. Her nephew William

remembers her 'touchy temper', 'nervous tremor' and habit of falling into 'peals of long-continued quasi-laughter, which rang over the house…like the vocal gymnastics of a laughing hyena'. If this was her competition, is no wonder that Frances's more discreet charms attracted the attentions of her father's new friend, Gabriele Rossetti. Frances was also the prettiest sister, with a fresh complexion, glossy brown hair, and large gray eyes whose 'shapely, Madonna-like eyelids' shrouded their mysteries.[11]

Frances never lacked for male attention. She told her children (probably within earshot of her husband) that a highly respected Colonel in the Macdonald family for whom she worked had been pursuing her when she met Gabriele. William would later characterise his parents' relationship as polite and respectful, with Gabriele's 'absolute esteem and confidence' reciprocated by Frances's 'cordial admiration'.[12] But this upstanding Victorian language conceals the marriage's passionate beginnings. Gabriele, whose dark good looks and political passion encouraged comparisons with Byron, may have reminded Frances of her favourite Romantic poet, whose erotically-charged lines crackle across the pages of her commonplace book:

And still we near and nearer prest,
And still our glowing lips would meet,
As if in kisses to expire.[13]

Like her brother John, Frances had great respect for poetry and poets, and romanticised them out of all proportion. Money and social position were less important to her than intellectual and artistic accomplishment. The appeal of a handsome expatriate Italian poet with deep brown eyes, dashing side-whiskers, broad shoulders and connections to literary London is not hard to imagine. As their marriage date approached, Gabriele published the first volume of his scholarly work, *La Divina Commedia di Dante Alighieri con Comento Analitico*. The publication was paid for by subscribers, some of whose names (Disraeli, Samuel Rogers, Lord John Russell, Walter Scott), would have impressed the young governess.

Despite the seventeen year age gap, Frances and Gabriele's marriage was a love-match. Frances at least had 'expectations' of a modest

inheritance, but Gabriele brought almost nothing to their union; his freelance teaching and writing did not promise any kind of regular income. Marrying a foreigner would hardly have been considered a coup. Frances's maternal grandfather William Pierce had been disappointed enough when his daughter married the Italian Gaetano Polidori, and he let Frances know that he considered her choice of an Italian husband 'very odd.' To the English-Tory side of her family, marrying Gabriele was not only 'flying in the face of…Chatham, Wolfe, Nelson, and George III,' but also 'truckling to the far from blessed shades of a Voltaire, a Mirabeau, and a Bonaparte…".[14] Of course for Frances, this insurgent spirit was precisely Gabriele's appeal, and the Pierce family's disapproval only stoked the dormant fires of her rebellion. Her penniless, foreign poet offered Frances what the obedient, self-contained governess craved: a revolution. She was an aging, single woman of limited means who wanted the impossible: to devote herself to intellectual pursuits. Marrying Gabriele Rossetti gave Frances the opportunity to live a life of the mind. 'I always had a passion for intellect,' she admitted, 'and my wish was that my husband should be distinguished for intellect, and my children too.'[15] In this way, Frances Rossetti gave Victorian striving a bohemian twist; she aspired for her children to become, not captains of industry, innovators in science, or leading political lights, but true Artists.

The couple wasted no time in starting a family. Gabriele and Frances married in April 1826, and by February 1827 they were welcoming their first child, Maria Francesca. Her thick curly hair and dark complexion reminded Gabriele of his mother, while her exaggerated, round face earned her the nickname 'Moon' or 'Moony.' If Gabriele was disappointed that the baby was not male, he didn't show it. In any case, a son Gabriel Charles Dante had arrived by the following May (1828). A testament to the Rossettis' passionate marriage, the next two Rossetti babies followed swiftly, William Michael in September 1829 and Christina Georgina in December 1830. Although paternal favouritism was predictably shown to the eldest boy, Gabriele's affections were not restricted to his sons, as his 1834 poem reveals:

Christina and Maria,
My dear daughters,

Are fresh violets
Opened at dawn –
They are roses nurtured
By the earliest breezes ;
They are lovely turtle-doves
In the nest of Love.[16]

Her father's tender image of sisterly love imprinted itself on Christina. It reappeared frequently in her adult poems such as 'Goblin Market', where two sisters lie together 'Like two pigeons in one nest / Folded in each other's wings…/Cheek to cheek and breast to breast / Lock'd together in one nest'. In fact, the Rossetti family nest was so comforting and nurturing, all four children would have considerable trouble leaving it. Even Gabriel, who flew earliest and farthest, would transport his childhood bed to his adult home, continuing to sleep in it until his death.

A typical Rossetti day began at seven in the morning. Frances, always an early riser, began the household chores. According to William, Frances never kept more than one servant, a rarity in the days when everything from cooking to washing to childcare was laborious and time-consuming. In a time when servants' wages were criminally low, it was possible and customary for a woman of her station to employ, at minimum, a Nurse and a Cook. Frances understood that the wife of a great poet needed to be more frugal than the wife of a headmaster or a factory foreman. The family lived hand-to-mouth, but within their means, with Frances ensuring that, 'not butcher nor baker nor candlestick-maker ever had a claim on us for sixpence unpaid.'[17]

But times were hard. When his youngest daughter Christina was baptised in 1831, her father was only giving eight Italian lessons a week, where once he had been giving over forty. Although Gabriele was subsidised by English friends like Charles Lyell and the Moores, and was giving private lessons in Italian, he required more stable employment. Although Gabriele galvanised his supporters, Henry Cary, W.S. Rose, and Edward Davenport, a desirable position as Professor of Italian at UCL went to another self-made Italian exile, Liverpool-based teacher Antonio Panizzi. Gabriele raved publicly

that Panizzi was a 'sorcerer of sorcerers' who had won the position unfairly.[18] In 1828, Panizzi had his revenge, albeit anonymously, giving Gabriele's *Comento Analitico* a bad review in the *Foreign Review*. In a sense, Gabriele was right about Panizzi's sorcery; socially, he had the magic touch. The truth was that Panizzi was better connected, most crucially in this case with Henry Brougham, one of the University's founders. Panizzi also was more willing to assimilate to his new culture. He spoke English willingly and well, and in 1832 became a naturalised British subject, a step that Gabriele never took.

Gabriele's prospects brightened when he gained a prestigious appointment as Professor of Italian at King's College in 1831. King's had been set up as an Anglican alternative to the secular University College London. All professors were supposed to be members of the Church of England, but this requirement was overlooked in Gabriele's case. Although he did not renounce his Roman Catholic faith, the anti-papal tenor of his writings made it clear that he wouldn't be seeking to inspire Romanist passion in his pupils. His own children were baptised as members of the Church of England; their religious education was undertaken entirely by their mother. One look at the manuscript version of his *Sullo Spirito Antipapale che produsse la Riforma* [*Disquisition on the Anti-Papal Spirit Which Produced the Reformation*] was enough to convince College founder Charles Blomfield, Bishop of London, that Gabriele was not harbouring secret Roman sympathies. When the book came out the following year, *The Monthly Review* observed that its sentiments were typical of 'foreigners who have been expelled from their own countries', adding that 'M. Rossette [*sic*] is a professor of Italian at King's College; we suppose he thought it incumbent upon him to court the favour of the heads of that establishment'.[19]

The post paid a salary of only £10 a year, but the title of Professor would attract more private students and higher fees. A family the Rossettis' size needed a minimum of £250–£300 a year to survive, leaving a considerable gap in the family finances. In those days, it would have been an embarrassment for a teacher's wife to go out to work to support the family, so Frances did the next best thing; she borrowed against her inheritance to keep the wolf from the door. What Gaetano Polidori thought about his daughter supporting

her husband is unrecorded, but one wonders whether he regretted Frances's refusal of Colonal Macdonald.

As a mother, Frances was progressive, ahead of her time in her believing that children should not be raised by nannies. This choice also enabled Frances to realise her ambitions for her children. As a multi-lingual professional governess, she was the teacher most likely to inspire them to intellectual achievement and artistic greatness. Although Frances employed a temporary nursemaid to help during the childrens' early infancy, the hired help had disappeared by the time they were toddlers. There was no nursery in the Rossetti household, no segregation of children from adults as was common practice in the Victorian age. The family would breakfast together, and Gabriele would leave for work on foot, often walking several miles each day across London to attend appointments with his students. Whereas other wives and mothers received morning calls, Frances rolled up her sleeves and got to work.

Accounts written by her sons and their male friends tell us that Frances was not outgoing, and preferred domestic work to social intercourse. William comments that he never saw his mother attend an ordinary evening party, and that his parents rarely if ever went to social entertainments together. While it seems likely that this portrait of Frances is accurate – her daughters would inherit her aversion to 'going out' – her lack of social interaction must have been isolating. Her professional work as a governess had not only put her in control of her own finances, but also regularly exposed the independent, intellectually curious Frances to daily interactions with a wide variety of people. But now her world had contracted to fit the small house on Charlotte Street with four young children for company.

What kind of companionship did Frances have? There was her husband, but he was out at work all day, and it was his custom to return late in the evening, after the children's supper, to work on his own academic research or receive social calls from other expatriate Italians his own age. It was unlikely that a woman of Frances's background and education would have become close to the rotating servant girls of the household.

The poet William Allingham once remarked on her social awkwardness: 'She says nothing clever but it's always a pleasure to be

near her.'[20] This comments tells us as much about her visitor as it does about Frances. Allingham, a sociable Irish poet who thrived on the very male, dining club atmosphere of the Pre-Raphaelite Brotherhood, might have valued a different brand of 'cleverness' than that displayed by the modest Rossetti matriarch. Frances's exposure to poetry in her youth had taught her to trust her interior life. She developed a Romantic faith in the power of the individual imagination which was complemented by her religion, which told her: "The less we live for things outward, the stronger burns our inward life.'[21] Such ideas about the primacy of the unseen made sense to women like Frances, who inhabited a domestic sphere which was invisible, in so many ways, to the masculine world.

One primary resource Frances drew upon was her sisters Charlotte and Margaret, who helped educate her children, but surely must have done much more in terms of emotional and social sustenance. The Polidori sisters were close their whole lives, seldom living apart, and frequently inhabiting the same household. But in the early years of Frances's marriage, they were less available. In the early 1830s, the sisters were working as governesses themselves. Unmarried and childless, they would in any case have been unable to provide first-hand advice on maternal or wifely dilemmas. Frances's mother, a chronic invalid who seldom left her bed, would not have been much help either.

Despite the domestic trials of managing four small children and a servant, Frances's spirits would revive with Gabriele's return in the evening. He brought with him the dynamism and general bonhomie which remained the hallmarks of his character, despite his professional struggles. He may have been absent during the day and worked on his own papers late into the evening, but Gabriele's parenting style was far from remote. In middle age, his muscular bulk was turning decidely to plumpness and his dark hair was thinning. Yet he still had the energy of a young man. He would enter the house in booming good voice, taking the children on his lap for games of 'Pat-a-Cake' and regaling them with Italian poems and songs, the adult content of which occasionally met with his wife's disapproval. Like any mother hoping to settle the children down for the evening, she also frowned upon the sugary lollipops he would distribute among the children,

which she tartly referred to as 'trash'. Gabriele did not retreat to his study in the evening, but was happy to 'allow his four children to litter and rollick about the room while he plodded through some laborious matter of literary composition'. He was careful, however, not to step over any child on the ground, in deference to a superstitious Italian belief that this action would arrest their growth.

As an adult, Gabriel would remember his childhood home as more Italian than English. Gabriele's Italian friends continued to drop in and out of his house as if he were still a bachelor, though they were happy to accept Signora Francesca's bread and butter when she could spare it. This circle was like a second family to the Rossettis, coming to dinner on Christmas day laden with sweetmeats for Frances and wooden toys for the children. The four young Rossettis played at their feet as these venerable expatriates discussed the latest political developments and reminisced about the old country. The Rossetti household was a place where the exiles could lose their foreigners' self-consciousness and be themselves once again. The visitors ranged from the obscure (the gossipy bookseller Pietro Rolandi and a plaster-cast vendor named Sardi) to the famous, such as the composer Paganini and violincello virtuoso Domenico Dragonetti. Regular visitors also included the sculptor Benedetto Sangiovanni, Count Carlo Pepoli and Filippo Pistrucci, who would later work at Mazzini's Italian School for Boys. The children, who spoke Italian with their father and English with their mother, were aware of Gabriele's elevated status within the Anglo-Italian community. They may have lacked material wealth, but the Rossettis were rich in the things that mattered in their expatriate circle: respect, literary reputation and community feeling.

Their house, at 38 Charlotte Street (now Hallam Street) near Port-land Place, was located in a neighbourhood considered 'the extreme reverse of respectable', which resisted all attempts at gentrification. During daily excursions to nearby Regent's Park, Frances took care to hurry her children past the indecent colour prints displayed in the windows of a lecherous local barber William jokingly referred to as 'Figaro'. It was typical of a Rossetti to remagine the everyday in this way, transforming an ordinary London barber into a colourful opera character. Exposure in early childhood to Rossini, the com-poser of *The Barber of Seville*, had apparently had the desired effect.

Imagination breached the gap between shabby lived experience and rich interior life. Instead of feeling deprived in their cramped, urban environment, they took advantage of it, loftily referring to Regent's Park as 'the garden'.

The house itself had a misleading frontage which made it look bigger from the outside than it was on the inside. The chronic short-age of space became increasingly difficult as the four siblings grew bigger and more boisterous. Although their life was 'threadbare' and sometimes 'dingy' during this period, the Rossettis were sustained by family pride, developing a scorn for bourgeois trappings that would last a lifetime. William remembers that 'The British religion of "keeping up appearances" was unknown – thank Heaven – in my paternal home; my father disregarded it from temperament and foreign way of thinking and living, and my mother contemned it with modest or noble superiority.'[22] This idealism was easy to maintain within the tight-knit circle of friends and family, but the Rossetti 'superiority' would soon be challenged by the outside world's empha-sis on material success, particularly as the children grew old enough to notice the differences between themselves and their peers.

At the end of a typical Rossetti family day, Frances would prepare a Mediterranean supper for Gabriele who never warmed to the English fare his children preferred. Gabriele's exertions would finally catch up with him. He would lie down on the hearth rug and doze along with the family tabby, whose habit of warming herself by hanging, spread-eagled from the fender-wires in front of the fireplace, never ceased to amuse him. When the cat had kittens, Maria made her Papa proud, showing off her burgeoning knowledge of Greek by naming the first of the litter 'Zoe' ('life').

As this suggests, both Rossetti sisters benefitted from a first-class education. The Rossettis had free access to three professional educa-tors, in the formidable shape of the Polidori sisters who were familiar with many European languages, as well as Greek and Latin. They were also well-acquainted with maths and science, not to mention literature and theology. The greatest advantage was their training in early education, garnered from years of governessing. Charlotte and Margaret may not have had any offspring of their own, but they had arguably raised more children than the average Victorian mother. It is

doubtful that the Rossetti famly would have been able to afford their professional services.

The Polidori sisters had been governesses since the early part of the century. They would have been expected to supervise their charges night and day, not just as teachers, but as guides through all the crises and triumphs of childhood. The relationships that inevitably formed between governess and children often blurred the boundaries between mother and teacher, family and hired help. There was a great fear among employers that these single, young women would induce the family patriarch to stray, or seduce other male relatives.[23] This attitude was not so paranoid as it seems. Frances's aunt Harriet Pierce was hotly rumored to have been secretly married to her employer Lord Yarborough after the death of his wife. The Polidori sisters, however, tended to form permanent attachments with the women, rather than the men of the household. Charlotte Polidori, who became governess to Lady Bath's children, would stay on long after the children were grown, as companion to the aristocratic matriarch until her retirement in 1885.

Charlotte and Margaret approached the prospect of educating their own young relations with enthusiasm. When Frances had difficulty teaching William to read, Margaret Polidori took over, transforming her frustrated pupil into a voracious reader. William remarks dryly that Margaret's approach (in contrast to his mother's 'loving tuition') was 'not wanting in rigour'.[24] The Polidori sisters' formidable teaching was to instill a respect for female intelligence in the Rossetti boys. Unlike so many men of their era, Gabriel and William were raised to consider women their intellectual equals. Such training would manifest itself in the adult William's vocal support of female suffrage and sexual equality, and in Gabriel's blithe (and sometimes damaging) refusal to consider the social consequences of treating female friends like male ones.

This rigorous tuition was not reserved for the boys. Frances had no interest in sewing or planning dresses and little patience with cookery, nor did she insist that her daughters display enthusiasm for these chores. She did, however, demand that they were done, and uncomplainingly. We can get a glimpse of Frances's pedagogical methods in her grown-up daughter's short stories, *Speaking Likenesses*, which Christina dedicated to her mother 'in grateful remembrance of the

stories with which she used to entertain her children.' These tales are narrated by a dead-ringer for a Polidori aunt, who keeps interrupting her tale to draw the attention of her small listeners back to their sewing: 'Jane and Laura, don't *quite* forget the pocket-handkerchiefs you sat down to hem...Yes, Maude, that darn will do: now your task is ended, but if I were you I would help Clara with hers.' But piecework is not the only lesson being taught these fictional nieces. When one little girl interrupts the story to ask, 'what are acoustics?', the aunty replies, 'The science of sounds'.[25]

Needle-work was not promoted as self-expression in the Rossetti household. William remembers that his sisters and the Polidori aunts showed a lifelong disregard for fashion, often wearing out-of-style dresses into the ground rather than going through the bother of obtaining new ones. Margaret and Eliza Polidori, who wore coal-scuttle bonnets well into the 1860s (they had gone out of fashion twenty years before), were role models in this respect. William argued that his female relatives did not consider themselves superior to those who modeled the latest styles, but it is difficult not to see the Rossetti women's resistance as a social critique. In fact, Frances deliberately instilled in her girls a scepticism of fashion.

Frances felt that sharpening her daughters' minds was every bit as important as honing their domestic skills. By the age of five Maria was reading both Italian and English. Gabriel gave Christina a mahogany writing desk with lockable drawers when she was only six years old. Of his four grandchildren, Gaetano Polidori predicted Christina would be the brightest: '"*Avrà più spirito di tutti*" [She will have more wit (or cleverness) than any of the others]'.[26] Although Gabriele bragged that his eldest boy read English better than he did, he was equally happy to identify Maria as his *figlia poetessa* (poet-daughter). Maria was the most natural scholar of the siblings, regularly outstripping her brothers in her ability to absorb academic knowledge. She decided to teach herself Greek when her brothers began to learn it at school, ostensibly so that she could help them with their lessons. That William and Michael, who received professional tuition, struggled with Greek more than their home-educated sister pays homage to the Polidori sisters' pedagogical talents and Maria's native intelligence. By the age of thirteen she was reading *The Iliad* in the original, and

making headway in the Greek New Testament. Gabriel was inspired by his sister's love of Homer; some of his earliest drawings (at age 11) are pen and ink illustrations for Homer's epic poem. Maria was also the keenest listener to the political talk of visiting exiles.

The Rossetti siblings played and learned together. Following their parents' example, they had no love of outdoor sports, preferring indoor games such as blindman's buff, spinning-top, ninepins, and puss-in-the-corner. The gambler's shadow of their Uncle John Polidori fell across the children's card games, as Frances forbade them ever to play for stakes. The children identified themselves with favourite suits: Maria was clubs, Gabriel hearts, William spades and Christina diamonds. These childhood preferences reflected the Rossetti siblings' strong suits in adulthood. Gabriel and Christina, whose fiery tempers and passionate natures earned them the nickname 'the storms', were as glittering and romantic as the diamonds and hearts they favoured. Maria and William, their father's reliable 'calms', were more attracted to the workaday utility suggested by the prosaic spades and clubs. In her forties, Christina would compose a nursery rhyme which remembers these childish card games.

A house of cards
Is neat and small
Shake the table
It must fall.

As an image of imminent collapse, the poem also recalls the end of the Rossettis' childhood.

The omens were present as early as 1832. Gabriele, the family breadwinner, began to complain of problems with his vision. There were periodic recurrences of Gabriele's gout as well as an episode of bronchitis. Something of a hypochondriac, he was not a stoic patient. He compared the walk from his study to his bedroom to Christ's journey on the road to Calvary. Anna Maria Polidori took a turn for the worse and Frances had to spend much of the summer of 1835 nursing her mother at Holmer Green. William was laid up by a severe gastric illness, and there was a problem with Gabriel's legs, for which he was forced to wear splints and be carried up and down stairs.

But these were not the only growing pains the family endured; as the childrens' personalities developed, conflict inevitably followed. Gabriel was a picky eater until he was eight years old, while Maria, neither as pretty as her sister nor as doted upon as her brothers, acquired a jealous streak. Christina worried her mother by exhibiting her Uncle John Polidori's lethal combination of oversensitivity, quick temper and rebellious nature. Her father wrote about Christina's epic resistance 'when you force her teeth, medicine-glass in hand: but what is the end of the performance? Christina gulps the medicine…'[27]

William, though a passive follower by nature, was closest to Gabriel, who instigated pranks such as feeding beer to the pet hedgehog and pretending to be a hunchback to startle strangers on the street. William describes his older brother as a leopard cub and himself as the baby goat with whom Gabriel chose to lie down. It is a curious metaphor for fraternal relations; a biblical image of violence restrained only by supernatural power. Like all siblings, the Rossetti boys and girls ganged up on each other, switching allegiances with the breath-taking fickleness of childhood.

Although the Rossetti parents tried not to play favourites, it was evident that Gabriel was his father's preferred companion, while Frances had a soft spot for William. These preferences were dictated by similarities in character and temperament. Gabriel was a 'rum customer' like his father, accustomed to exploiting his good looks and charm to extract himself from tight corners. Like his mother, William was almost pathologically modest and self-effacing, a peacemaker with a natural inclination for order and harmony; while Gabriel showed an early aptitude for reading, William was better at maths.

Character flaws were tolerated in the male children, but were corrected in the sisters. Although short-tempered and domineering, Gabriel was seldom rebuked. His father affectionately declared Gabriel a 'born rapscallion', but there is an argument that rapscallions are made as well as born. 'In most matters, he had his own way,' William concedes.[28] While individuality was cultivated in all the siblings, some were encouraged to be more individual than others. Maria's jealousy and Christina's temper were supposedly 'early conquered', but future years would demonstrate that these characteristics had merely moved underground.[29]

As in most families, roles were cast early, and remained stubbornly in place. It was decided that Gabriel would be the artistic genius of the family, notwithstanding the fact that his brother and sisters all showed early promise in this direction. Family legends formed quite quickly around Gabriel, and all are breathlessly recounted by his brother William in his old age. There was the time the milkman was surprised to find a boy as young as Gabriel drawing a picture of a rocking horse. Or there were the pictures from *Henry VI* Gabriel drew to entertain his bed-ridden brother during an illness. Encouraged as much by rapturous approval as natural ability, Gabriel drew illustrations to Shakespeare's plays, which Frances lovingly labeled and preserved. Ever the baby goat to his older brother's leopard, William placidly insists that his brother was not spoiled. But Gabriel was undoubtedly indulged, by both the approbation of his parents and the admiration of his siblings, who were eager to imitate his literary and artistic efforts.

Even though Maria was technically the eldest child, it seems that Gabriel, as the first-born son, was granted the privileges she might have expected. Her response to this disruption of the sibling hierarchy was to dominate Christina, the youngest, smallest and prettiest. Gabriele's stocky build, unfashionable dusky skin and round face were the unfortunate Maria's paternal inheritance; the pale, delicate Christina took after her handsome mother. When Gabriele's friend Count Pepoli first met Maria, the sharp nine year-old recognised that Pepoli had been over-compensating with his extravagant praise of her beauty. 'Papa, I don't believe what that gentleman said,' she told her father. 'Christina is much prettier than I, everybody says so.'[30] Her father assured with a brutal neutrality that while Pepoli was not wrong, at the same time Maria was right.

Maria and Gabriel frequently ganged up on their younger siblings, targeting Christina in particular. Nevertheless, the baby of the family continued to look up to her older sister, regarding her as 'an inspiriting Muse in a pinafore.'[31] Others would observe that Christina's admiration for her sister remained 'extreme' throughout her life. Deference to the old sibling hierarchy in still detectable in Christina's adult remembrances: 'my dear sister used to say that *she* had the good sense, William the good-nature, Gabriel the good heart, and I the bad

temper…'[32] Anger may may have been Christina's defense mechanism, and a way to attract the attention of parents who rewarded such wrothful displays in her brother Gabriel. When childish bullying got out of hand, it was William who intervened on his little sister's behalf, describing her as 'my chief "chum" in point of standing.'[33]

The children were not above playing favourites with the adults; although they competed avidly for the attention of both parents, Gabriel, William and Christina were unanimous in their preference for their mother. As the deposed eldest sibling, Maria was more circumspect, openly less in thrall to Frances than the other three. A favourite with neither her abstracted father nor her harassed mother, Christina found an admirer in her grandfather Polidori, who was the earliest advocate of her poetic talents. Gaetano Polidori seemed more immune than the rest of the family to Gabriel's charms, schooled perhaps by his own painful experience of indulging a handsome, temperamental eldest son. Christina preferred her grandfather's company to that of her own father. This was partly the result of happy summer holidays spent playing at Holmer Green. Polidori had mellowed with age, keeping himself busy in retirement by pursuing carpentry. Planing a board to perfection or sawing a table-leg to measure was an antidote to years of teaching Italian and parenting difficult boys. Wood had no will of its own, and could always be made to conform to Polidori's exacting standards. Polidori tried to entice Gabriel with the gift of a mini file and saw, but the boy was more interested in the edition of Aesop's fables that his uncle Philip gave him. More tolerant of young people in his own old age, Polidori entertained the grandchildren by taking pot-shots at wood pigeons who had the temerity to fly past his workshop window. When he hit his mark, the birds would turn up on the supper table in the evening, delighting the children all over again.

For the urban Rossettis, who were growing up across the street from a pub and a cab-stand, Polidori's country retreat provided access to a world that must have bordered on the magical. There the glue and gun-powder scent of their grandfather's workshop, the smell of freshly mown grass, and clear country air which (unlike the atmosphere in London) could be gulped in great lungfuls. Here, exotic creatures did not peer morosely out from between the bars of cages

at Regent's Park Zoo; they were touchable, chase-able, and native. There were lessons to be learned from observing animals in their natural environment. Some of these were very dark indeed. Christina discovered, to her horror, that a burrowing insect could make a home in the decaying carcass of a mouse. Maria forbade her sister to taste a strawberry until it was fully ripened, and the girls learned disappointment when a snail gobbled it before they got the chance. Gabriel observed that if he deprived frogs of water for long enough, their throats would split, but if he released them back into the pond, they would live again. Looking on, William learned that his brother had a capacity for self-deception and cruelty; Gabriel's frog-resurrection fantasy was not destroyed by the reality of the amphibians' floating corpses.

These visits to Buckinghamshire would prove that childhood impressions could be lasting ones. These primal, primitive encounters with nature would haunt the Rossettis' imaginations. Gabriel and Christina would make their lives in the city, but their poetic imaginations dwelled in the hedgerows and streams of Holmer Green. While Wordsworth and Coleridge inhabited the countryside which inspired their poetry, the Rossettis were content to conjure a vivid natural landscape from their memory, an artistic choice they would defend vigorously. When an acquaintance later posited that the countryside provided 'the best inspiration' for artists, an adult Christina responded with the pride of a true Londoner: 'There are more Lambs and Wordsworths among us townfolk ...'[34]

The Rossetti family's countryside holidays improved Frances's relationship with her own parents. While her children were only permitted to enter the hushed atmosphere of their grandmother's bedroom 'at sparse intervals with a certain awe', Frances spent a great deal of time tending to her invalid mother.[35] Frances's sacrifice was reciprocated by Polidori, who welcomed his daughter and grandchildren into his home when she fell ill in 1836. Her alarmingly rapid loss of weight worried her relatives, and she spent much of the year recuperating at Holmer Green. The exact cause of Frances's illness remains uncertain, but balancing the books while looking after four boisterous children aged six to nine was not an effective remedy. Her husband's lofty dictum, *Age quod agis*, ['Do what you do'] uttered

with a quill in his hand while she did the grunt work of running the household, may have been less of an incentive than he imagined. Having given birth four times in as many years, the clearly fertile Frances would give birth to no more, which suggests at least the use of birth control, if not a cooling ardour. Methods available to Frances are recognisable to the twenty-first century woman: primitive versions of the condom, diaphragm and sponge were all available to the middle-class mother.

Her domestic stresses were not alleviated when the Rossettis were forced to move house towards the end of 1835, decamping to number 50 Charlotte Street in order to accommodate the rapidly growing children. Initially, Frances took 'the storms', Christina and Gabriel with her from January through March 1836, leaving 'the calms', William and Maria in the care of their father, with aunt Margaret acting as a surrogate mother. The childcare arrangements were far from ideal. Their aunt was still tutoring her own students and always on the lookout for more pupils. She reported proudly that she was teaching William his sums, and he was making good progress. Maths rewarded William's workmanlike, diligent learning style. He found that numbers, like his Aunt Margaret, behaved with a comforting consistency. The children were models of good behaviour, and were rewarded with days out at the houses of their father's friends and patrons. Maria was impressed by the wealthy financier Isaac Goldsmid's extensive collection of stuffed birds and butterflies, while William shyly accepted the gift of a red stick discovered in the garden by one of Sir Isaac's daughters. The meal of cold fowl beef, potatoes, sweetmeats and fish they received was only surpassed by the plumcake they enjoyed on another day at the home of Rossi, an Italian friend who allowed them to read his bound copy of their favourite Shakespeare plays.

By contrast, Gaetano Polidori reported with some amusement that Gabriel and Christina often fought, cried and yelled at each other. Without the diplomatic influence of their siblings, with Aunt Eliza busy looking after their invalid grandmother, and with their mother unable to discipline them as normal, the two 'storms' raged unchecked. During the year it took for Frances to recuperate, all of the children came and went from their grandfather's home in shifts,

dutifully writing to their mother from London, and looking forward to receiving her letters in return. Christina, a child so prone to tears that her father joked she could fill bottles with them, had an especially hard time with any separation, and was the most eager of the children for Frances's permanent return to London.

When Gabriele informed his patrons that his wife was ill, they sprang into action: Frere sent money and Lyell sent Frances a gift of three dozen bottles of port and sherry, accompanied by a jokey note about enjoying their medicinal benefits. Frances's absence yielded another unexpected gift: it gave her husband the chance to miss her. A man inclined to chaos needed a calming influence. To his surprise Gabriele found himself lonely and at odds without his wife. He confessed that he never knew how much he loved her until she was ill and far away, and wished that his arms stretched from London to Holmer Green, so that he could carry her back home. Having to take over Frances's household duties may also have contributed to this impulse. Managing 'the storms', 'the calms', or sometimes all four children proved to be a challenge, as did various dramas with the domestics. Gabriele fired the maid Betsy for letting a married boyfriend visit her at Charlotte Street, and upbraided another maid for breaking a window.

When the family were finally reunited in November 1836, life seemed at first to improve. 50 Charlotte Street was roomier and more comfortable than 38, and the family settled in well. Even a grim basement kitchen and a yard too small to be considered a garden could not take the shine off having a ten-room house. Gabriel quickly commandeered his father's dressing room on the third floor as his own private space, to which he sometimes granted William admission. Friends and family rallied round to keep Frances's spirits up. Her English aunt, Harriet Pierce ('Granny' to the children), gave her favourite niece a picture of the newly-crowned Queen Victoria in her opera box to brighten the place up, along with books for the children and various serviceable domestic items. Frances was also given two small paintings of the city of Vasto and the Blue Cavern at Capri by a Vastese painter who was a guest of Gabriele. Another Italian friend gave the couple an oil painting called *The Marriage Feast of Tobias*, whose biblical subject pleased Frances.

Gabriele's pupils were increasing, and both his sons enrolled at Kings' College School, which was attached to King's College London; their father's Professorship meant their fees were reduced. Frances continued their extra-curricular education, taking all the children to see the National Gallery in its new location on Trafalgar Square. When Gabriel expressed admiration for a large, flashy Benjamin West painting of Christ healing the sick, she corrected her ten year-old son, confidently dismissing the work of the former President of the Royal Academy of Arts as 'commonplace and expressionless.' Something of Frances's attitude towards West would endure in her son's rebellion against conventional English Academic painting in general, and the Royal Academy in particular. But Frances's firm convictions would not always be so easily accepted, particularly by her 'storms', Gabriel and Christina, who were beginning to strain against their mother's sensibilities. Their frustration was enhanced by the challenge of rebelling against a regime of liberal parenting. While Frances supplied them with morality tales about 'good little boys and girls', she also allowed her children to express their dislike for them, which, William remembers, 'we generally did.'[36]

Frances produced in-house magazines for her children to write in, and kept an album for them to copy their favorite poems and add ones of their own. Standards for inclusion in this album were rigorous, for Frances held good writing sacred. She abhorred cliché and commonplace, and cautioned her children never 'to say what has been said before.' Other family albums did not have the genius of the Rossettis', as she maintains in one contribution:

Albums are books of great annoy,
Receptacles of base alloy,
Of dead-born wit, of pointless pun,
Abortive hits at sportive fun.

Into her family album were copied the poems of Maturin, or Byron, and, in a forgivable display of nepotism, John Polidori. The fragments which remain of Frances's own writing display, if not a great literary talent, than a pedagogue's discriminating eye, and a twinkling sense of humour. She set her daughters a very modern example of

womanhood, exhorting them to study and achieve rather than set their caps at marriage. She sees bad poems as worse than tiresome:

Thoughts they suggest of brainless head,
Of praise-slick maids by flatt'ry fed
Intruding on a studious hour
With friendship's plea, or love's mute pow'r;
Compelling you lame rhymes to write.[37]

Frances kept up her vigilance against bad poetry and brainless girls, and Christina and Gabriel's verses are a testament to her success. 'I assure you that your first inculcations on many points', writes Gabriel at forty-eight, 'are still the standard of criticism with me.'[38]

In cultivating intellectual independence in her children, Frances had in some ways fashioned a rod for her own back, something she would acknowledge in later years: 'I now wish that there was a little less intellect in the family, so as to allow for a little more common sense.'[38] In marrying a headstrong, penniless poet, she found that she had underestimated the dangers of her own Romantic nature. Ever the teacher, she made sure that her children would benefit from her experience. Virtues such as practicality, simplicity and humility would be martialled against the chaos (generated by her proud, impractical husband) about to engulf her family. As the Rossettis' material fortunes worsened and crisis approached, the children would find themselves drafted into their mother's never-ending battle between Romanticism and common sense.

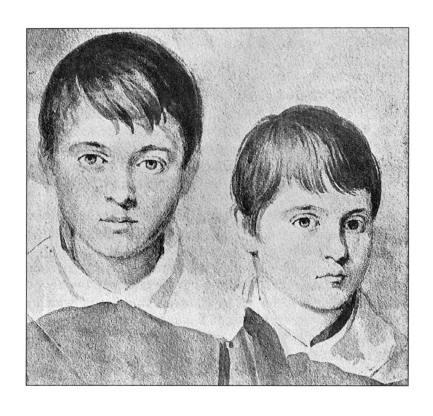

From a watercolour sketch by Filippo Pistrucci, 1838

A childhood portrait of Dante Gabriel and William Rossetti, an early indication of the close brotherhood that would endure until their later years.

3

CHILDHOOD: THE CALMS AND THE STORMS

Among its other problems, the Rossetti's new house at number 50 Charlotte Street was haunted. More precisely, the ghost of Dante Alighieri, which had followed Gabriele from Naples to London, was beginning to manifest, both within the household and in the outside world. The medieval Florentine poet and exile was a spirit fit to torment the aspirational Anglo-Italian family, and he was not exactly uninvited. After all, Gabriele's specialist knowledge of Dante had opened many doors on his arrival in England. The ghost was also a spiritual godfather, after Gabriele's oldest son was christened 'Gabriel Charles *Dante* Rossetti' in his honour. Even the unassumingly Anglicised 'Charles' possessed Dantesque echoes, being a prudent tribute to Dante enthusiast Charles Lyell, the boy's more corporeal and deep-pocketed English godfather. That Gabriele clearly preferred his Italian counterpart was revealed in the nickname he gave his son: 'Dantuccio' rather than 'Charley'.

Dante Alighieri's supernatural presence in the Rossettis' lives recalls Emily Dickinson's definition of art as 'a house that tries to be haunted.' William reports that the domestic atmosphere thickened with 'wafts and rumours of the mighty Alighieri'. Little Gabriel was convinced that his father's copy of *Vita Nuova* glowed malevolently in the dark. He also avoided the second landing at night for fear of coming face to face with the ghost of 'Mr. Dante.' For all of the

children, the medieval poet hovered somewhere between household saint and poltergeist. He was 'a sort of banshee in the Charlotte Street houses, his shriek audible almost to familiarity.'[1]

Dante was also starting to scare off Gabriele's patrons; those who had initially been receptive to Gabriele's ideas about his works as anti-papal allegories were now finding his arguments bizarre and alienating. Like many scholars, Gabriele had fallen into the trap of identifying too closely with his subject; Dante Alighieri's politics were becoming indistinguishable from Gabriele's own. In October 1838, staunch defender Charles Lyell refused the dedication to Gabriele's latest five volume work on Dante, *Mistero dell'amor platonico*. He withdrew his financial support for the publication, and asked Gabriele not to allude to his assistance in any way. Lyell was not the first to sound a note of caution. After reading the first chapter of the *Mistero* in 1836, fellow-Mason Frere had warned Gabriele that neither Masonic nor Church of England readers would appreciate the suggestion that 'Religion's a politic trick / Devised to keep blockheads in awe.'[2] Lyell agreed. Between 1838 and 1841, he wrote a frantic series of letters to his old friend warning that because of increasing revolutionary activity in Europe, England was not a friendly climate in which to launch what would be perceived as an attack on Christianity: 'You are not *fully* sensible of English feelings on the subject, even among liberals.'[3]

Gabriele's first books on Dante had been well-received. Readers were finding the sequels more and more unorthodox. Gabriele's theory that the poet's allegories were political rather than religious had morphed into the conviction that Dante's poems contained secret codes. When these were cracked, it would reveal that he was writing in the Masonic tradition, and was in fact linked to the Knights Templar. The inescapable historical fact that Freemasonry did not yet exist in Dante's time did not dampen Gabriele's enthusiasm. He was convinced that the poet's symbolism was a veil that concealed his covert political beliefs and conspiracy theories from the prying eyes of Church and State. Gabriele's scholarly work on the Florentine poet was criticised for ignoring any facts which ran counter to his theories, and for inflating evidence which supported his perspective. In the twentieth century, Umberto Eco would hold Gabriele's work

up as an example of dubious scholarship in an essay tellingly entitled 'Overinterpreting Texts'.

While authorial practices such as fudging footnotes undermine Gabriele's credibility as a scholar, his passionate, even desperate desire to perceive connections where few existed speaks to his vocation as a poet, and his experience as an exile. Gabriele felt a poet's scorn for the confinements of historical fact, linear time and authorial intention, and a patriot's disgust for State abuse of religious authority. The spirit of Dante granted access to parts of himself long denied: the *improvisatore* and insurgent he had suppressed in order to carve out a respectable academic career in England. There is a creative, almost post-modern force at work in Gabriele's desire to follow his favourite poet where Dante could not possibly have trod. He delighted in pursuing the most tenuous clues to their logical, or more frequently their illogical conclusions. As he grew older, Gabriel's *improvisatore* re-emerged, shaking the dust from the *Professore's* academic prose with a force that alarmed friends and patrons alike. 'The pot can only be kept boiling by giving lessons,' Lyell gently warned him, and the 'horrid consequences' of alienating pupils' parents with heretical opinions and subversive politics would leave 'Maria Francesca and Co. hungry and calling out for their macaroni …'⁴ Gabriele himself longed for the freedom of interpretation that spontaneous composition allowed, and that his duties as a scholar and father alike prohibited. His works were not just haunted by the spirit of Dante Alighieri, but by the ghost of Gabriele's former self.

His working methods were becoming studies in obsession. 'My own shadow terrifies me,' he wrote. 'I have become like one of those people of exaggerated piety who think that in their most insignificant action they have committed a mortal sin.'⁵ Folios of information on freemasonry, alchemy, the Cabbala and *libri mistici* rose like fortifications around Gabriele as he filled 'page after page of prose…full of underscorings, interlineations and cancellings.'⁶ Half amused and half frightened by the intensity of their father's devotion, the Rossetti children avoided reading Dante altogether, preferring Shakespeare's robust English dramas to medieval Italian metaphysics.

The Rossettis had real-world troubles as well as supernatural and literary ones. Dwindling student numbers and nervous patrons were

not the only problems afflicting Gabriele's livelihood. Two schools went bankrupt before they could pay his outstanding fees. A disadvantage of the larger Charlotte Street house was exposed when a carpenter hired to repair some bedsteads stole cash and valuables from the upper rooms, unheard and unobserved. Frances went to court to testify, but the Rossettis never recovered their goods. Exhibiting his typical sympathy for the common man and his distrust of the State, Gabriele wrote a letter to the magistrate pleading for clemency, but in the end the carpenter was declared guilty and transported. In 1838, while others were celebrating Queen Victoria's coronation, the Rossettis found themselves £150 pounds down. By 1840, the appetite for tuition in the newly fashionable German language of Albert, the Prince consort, would pose a serious threat to the demand for Italian lessons. The Rossettis themselves would fall prey to the *zeitgeist*; in 1842, the children were tutored in German by Dr. Adolf Heimann, who accepted Italian lessons from Gabriele in lieu of payment.

Gaetano Polidori, who must have realised how much the Rossettis were struggling, gave up Holmer Green in the autumn of 1839 and settled his family in a smart, detached villa near the Regent's Park canal. It was part of the Park Village East development, a series of Italianate villas designed by Nash as a haven for the middle classes. These detached houses with their private gardens resisted London's push toward industrialism and urban development. A fifteen minute walk from Charlotte Street and a stone's throw from the beloved Zoological Gardens, Polidori's villa had been chosen for its proximity to Frances and the grandchildren. If they looked out the front window, they could see trains running by, preceded by great puffs of sooty smoke and a shrieking whistle. If they went out into the sloping back garden, they could watch boats peacefully sailing back and forth on the canal. Perfectly poised between the urban and the rural, 15 Park Village East was an ideal playground for the Rossetti children, and a satisfying substitute for the delights of Holmer Green.

Polidori liked it because, depending on which window he looked out of, he could imagine himself either in the town or the country. Frances's bed-ridden mother watched vigilantly at her window for soldiers being drilled in the nearby military barracks, a habit which caused Gabriele to joke about the old matriarch's 'warlike spirit'. He

was certain that, had Anna Maria Polidori been a man, 'history would already have consecrated some page to her deeds.'[7] Eliza continued to look after her mother and brother Philip. Margaret gave up her governessing jobs outside London to become a permanent member of her parents' house. Their brother Henry would temporarily join the household in the early 1840s, after a failed bid for independence as a solicitor in Chalfont St. Giles.

The house contained a well-stocked library, whose contents were regularly raided by the Rossetti children, on the run from their father's arcane Dantesque investigations. There they also found respite from the morality tales their mother was still vainly trying to press upon them, such as the despised *The Fairchild Family*, a didactic childrens' story about a religious family striving to find redemption. At Park Village East, they lost themselves in their grandfather's illustrated edition of another Italian poet, Ariosto, enraptured by his tales of magic, adventure and romance. They did not generally warm to love stories. Literary displays of passion like Coleridge's 'Genevieve', whose 'breast' was prone to 'heave', only made them giggle with embarrassment. Among their uncle Philip's store of books they discovered more contemporary fare: thrilling Newgate novels about the criminal underworld and *Hone's Every Day Book*, a periodical collection of poetry, stories and miscellanea. It was here Christina first discovered the poetry of Keats.

For the moment, their great favourite was *Legends of Terror*, a collection of lavishly illustrated horror stories which contained such ghoulish delights as 'The Legend of the Bloody Hand', 'A Night in the Grave' and 'The Maniac's Fate'. Entertaining and frightening in equal measure, this volume provided a template for the Rossettis' gothic imagination. Gabriel and William's enthusiasm for American writing probably has its roots in the book's selection of 'Rip Van Winkle'. Other story collections featuring brave knights in armour, such as *The Seven Champions of Christendom* and *Tales of Chivalry*, were also great favourites. Polidori's library was not the only literary enticement. A shed in the garden housed their grandfather's private printing press. Operated with the help of Sicilian compositor Privitera, the small iron press was purchased to turn out Polidori's translations, as well as his own poems and prose. As a retirement project, it kept Polidori

occupied and his name in the public arena. His books, proudly press-marked with a greyhound and priced in *scellini* (Italian shillings), could be bought from local Italian bookshops, such as Rossetti family friend Pietro Rolandi's, or direct from the author himself. Gabriele marvelled at the energy of his father-in-law, now in his late seventies, and contrasted it mournfully with his own decline.

Polidori's new home provided Frances with respite from the chaos of her husband's studies and increasing ill-health. He complained of diabetes and exhaustion, as well as general lassitude aggravated by financial worries. Increasing his anxiety was the fate of his five-volume *Amor Platonico*, which had been printed in 1840 but withheld from distribution. That Frere wanted the entire run burned gives some idea of how dangerous this publication was, but *Amor Platonico* was ultimately spared the flames and put in storage. Such a setback might have caused other men to think twice before pursuing similar subject-matter, but in 1842 Gabriele published *La Beatrice di Dante*, whose argument that Beatrice was an entirely symbolic figure connected to a Masonic lodge (rather than a real woman) inspired predictable howls of protest.

Even Gabriele's status as London's most venerable expatriate was challenged during this period by the arrival of Giuseppe Mazzini. Nicknamed the 'Soul of Italy', Mazzini was a democratic nationalist who imported his *Giovine Italia* movement to the English capital. An activist and powerful organiser, he galvanised support for Italian unification, winning important English friends like Thomas and Jane Carlyle, and establishing a free school for Italian boys in Hatton Garden.

At first, Rossetti and Mazzini cautiously supported each other; Rossetti even performed his improvisations at Mazzini school fund-raisers. But Gabriele was a constitutional monarchist who believed in violence as a last resort, whereas Mazzini wanted to abolish monarchy and establish Italian unity by any means necessary, including guer-rilla activity. Combined with their professional rivalry, these political differences were enough to keep the pair at a distance. Mazzini, a romantic figure who dressed always in black because he was in mourning for Italy, captured the English imagination to an extent that threatened Gabriele. Turning out unpublishable treatises on a

medieval poet's rebellion against Rome seemed increasingly obsolete when contrasted with Mazzini's muscular activism. To his distress, old friends started to desert Gabriele's fireside to sit at the feet of the new arrival. The strain began to tell on Gabriele. He contracted a case of bronchitis which he couldn't shake, lost weight, coughed incessantly and started losing teeth.

What Frances thought of her husband's writings is not recorded. Based on her own fervent Christianity, it seems unlikely she would have agreed that political allegory trumped religious revelation in the *Commedia*. That her husband pursued this line of thought against the advice of the patrons who had supported the Rossetti family for years must have caused considerable anxiety. For all their progressive thinking when it came to the education of their daughters, the Rossetti family structure remained traditional, and it is doubtful whether anyone was permitted to question Papa's methods directly. Nevertheless, Frances was concerned enough to perform a small act of disloyalty; she added a secret postscript to one of her husband's letters to Lyell. She tells Lyell that she is very seriously worried by her husband's changeable health. Some days Gabriele awakes 'feeling and inspiring the brightest hopes'; on others his state of mind brings back 'all my fears'. Whether Frances is more afraid for his physical or his mental health remains delicately unspecified, but the language she uses, as well as her insistence that Frere keep Gabriele in the dark about her concerns, points to the latter.[8]

How much the children were told about their father's health is also uncertain, but in a family as close as the Rossettis, and with a father as voluble as Gabriele, it is unlikely that they were unaware of his troubles. Gabriel and William had problems of their own. Both were unhappy at King's College school, where rote methods of learning were a dull contrast to their vibrant studies at home. Although there was no flogging at King's, discipline was enforced in ways which would raise eyebrows among today's educators. Teachers were allowed to cuff students, hit them in the head with books, or force them to stand in the middle of the room to be mocked by their peers. Even milder punishments like being forced to stay in at playtime or to copy out lines of poetry fifty times over came as a shock to Gabriel and William. There were social challenges also. Like many

home-loving boys who are artistic and bad at sport, the Rossettis were not welcomed into any clique. About this time, Gabriel produced a drawing of schoolyard fisticuffs, called *Bantam battering Lower Division – Upper Division*, 1838. The work is not proof positive that its creator was bullied, but it does reveal at the very least the alarming contrast between the Rossettis' nurturing domestic environment and the realities of institutional education. For the first time, Gabriel and William were wrenched from the company of their sisters. One purpose of sending boys to school was to introduce them to the exclusively masculine sphere in which they would now be expected to conduct their social and working lives. Manliness was very much part of the school curriculum, and a continuing attachment to mother and sisters was regarded as an obstacle to progress.

The Rossetti brothers' Italian heritage and status as scholarship students might also have exacerbated any mistreatment. But their failure to integrate cannot be entirely blamed on the prejudices of English public schoolboys. Gabriel and William had been raised to think of themselves as exceptional and unique, particularly Gabriel, who was encouraged to regard himself as a child genius. It is likely that the brothers' sense of their own superiority kept them apart as effectively as their lack of enthusiasm for cricket and fighting. Raised to believe they had been born to a higher destiny, they resisted becoming a part of a school renowned for 'converting a tradesman's son into a gentleman.'[9] This attitude survives in William's priggish recollection that at home the boys were exposed to 'nothing that was not pure right, high-minded, and looking to loftier things', while at school they were forced to confront the 'common and unclean.' These phrases, which could have been plucked from Frances's Commonplace Book, reveal William's loyalty to his mother's teaching. Frances's Evangelical upbringing stressed that the spiritual and moral development of the male children was a maternal responsibility; it was a mother's sacred duty to keep her boys on the straight and narrow path. The dark corollary to this concept was that she could be held accountable for her son's misdemeanours as well as their triumphs.

The Rossetti brothers' encounters with the 'common and unclean' seems to have contaminated Gabriel the most. Although his brother's conduct was challenging at the best of times, William tows the

family line when assuring us that Gabriel's schoolboy naughtiness was anyone's fault but his own. Rather, it could be attributed to 'some nasty-thinking boy' ready 'to egg-on his juniors upon a path of unsavouriness.'[10] At home, by contrast, Gabriel was no stranger to egging-on his juniors. He once convinced Christina to play Desdemona to his outraged Othello. It was only as he was about to stab her with a chisel that Maria intervened, protesting that her little sister might be hurt. Gabriel compromised, sustaining a minor injury by stabbing himself in the chest while reciting Othello's lines, 'I took by the throat the circumcised dog / And smote him thus!' This was not an isolated incident. When the boys' school-master called at Charlotte Street one day, he surprised the Rossetti children rolling on the floor in mock agony during a particularly vigorous re-enactment of Sir Walter Scott's 'Battle of Clan Alpine' from *The Lady of the Lake*. Gabriel's experiments could be inspirational as well as hazardous. A born leader, he tried to get the others to join him in starting family magazines and artistic collaborations. He instructed each sibling to write a story, for which he would provide illustrations. Gabriel was the only one to finish his tale, 'Roderick and Rosalba', a Gothic romance animated by lively allusions to Coleridge and Byron, with its first line shamelessly pilfered from Bulwer-Lytton's *Paul Clifford*: "It was a dark and stormy night." Lassitude at school was countered by great energy at home, as Gabriel began illustrating his favourite stories, such as Bulwer-Lytton's *Rienzi*. The tale of an Italian uprising against the tyranny of medieval nobles must have struck a chord, and may have been produced with an eye towards his father's approval.

The company of other boys at King's College School entirely failed to lure Gabriel and William away from their sisters. Neither would retain any friends from school after their departure. Despite their separation during the day, Maria and Gabriel evidently remained close: 'In my boyhood I loved Maria better than any one in the world,' he would confess in middle age.[11] His early experiments in drawing are obvious attempts to cater to his older sister's tastes. After she rhapsodised about Pope's translation of the *Iliad*, Gabriel produced twenty seven illustrations in February 1840. Like many island children, Maria was drawn to tales of the sea. Her little brother illustrated an episode from her favourite book of naval stories, which depicted

a gentleman refusing to help a begging sailor because 'you are not of my parish.' The sailor replies, 'I lost my leg fighting for all parishes.'

This drawing is a reminder that the legacy of the Napoleonic wars was still being felt in Britain, and also points to the emergence of an important aspect of Maria's character: her social conscience. Around 1840, she was confirmed into the Anglican Church at St. Katherine's in Regent's Park. From then on her sense of social responsibility and her religious beliefs developed together. St. Katherine's was the last church the Rossetti boys ever attended regularly, but it proved a formative influence on the spirituality of the Rossetti girls, particularly Maria. While William and Gabriel were wrestling with the boisterous mysteries of Kings, their sisters were encountering a different, female world about which their brothers knew even less.

The original chapel had been demolished during the construction of St. Katherine's Docks in the late 1820s. Although it retained its original six-sided pulpit and a grand monument to John Holland Duke of Exeter (d.1447), the Gothic-style church the Rossettis attended was a new build, designed by Ambrose Poynter, who had trained under John Nash. Located on the Northeast corner of the park, between Cumberland Terrace and Macclesfield Gate, the new chapel was close to the Polidoris' house; the military barracks the Rossettis' grandmother so enjoyed could be seen through the chapel's east window. A *Picturesque Guide to the Regent's Park* published in 1829 admires St. Katherine's beautiful stalls, Gothic alterpiece, and its windows with their 561 feet of glass, but hastens to assure readers that the interior is of a suitably chaste, English devotional character.[12]

The chapel was only one of a compound of buildings belonging to the Foundation of St. Katherine, which included offices, housing for the Brothers and Sisters, a coach house and a Master's residence set on two acres. Comprising a hospital, residential almshouse and school as well as a religious order, the Foundation had been running uninterrupted since 1147. In the mid to late 1820s it had been forced to relocate to Regent's Park in order make way for the development of the St. Katherine's docks area. The Foundation enjoyed a special status as a Royal Peculiar, which meant that this functioning religious community belonged to the monarch, rather than any individual diocese. It had been permitted to retain its three Brothers and three

Sisters even after the Reformation, and was the oldest Ecclesiastical community still extant in England. Although they held no recognised Ecclesiastical position in the English Church, the Sisters were given their own residences, which they were allowed to let, and had equal voting rights with the Brothers in running the Foundation. Aside from the business and administration aspects, the Sisters also participated directly in the religious life and charity work of the Foundation.[13]

William dates Maria's confirmation at St. Katherine's in 1840 as the start of her lifelong commitment to religion, when her 'uncommonly enthusiastic temper...settled down into religious devotion.'[14] The phrase 'settled down' does not do justice to what in fact was an awakening, both social and spiritual. While William enjoyed looking at the beautiful stained glass and listening to the singing at St. Katherine's, his eldest sister was experiencing something much more profound: a revelation about community and of her place in the world. It was understood that her brothers would attend school and pursue masculine career paths, but Maria's future was less clear. At twelve, she would have been old enough to be aware of her family's financial straits, and her father's declining health. The family's protection of Gabriel's artistic genius meant that, as oldest sister, she would be first in line if it came to helping support the family. Notoriously plain in an era which was every bit as unforgiving about women's looks as our own, Maria must have been aware of the difficulties she would face in the overcrowded marriage market; her unfashionable intelligence and erudition would only have compounded her lack of physical attractions.

Unlike her brothers, who had recourse to various male institutions and social networks to support their ambitions, the only career path open to middle class women like Maria was the stressful, unremunerative and insecure job of governessing. Like all the Rossetti children, Maria had been raised to believe that she was special and unique. She might not, like her pretty mother, find a poet-husband unthreatened by her intelligence, but St. Katherine's offered an alternative not generally open to single Anglican women: a life of religious devotion.

The three Sisters whom St. Katherine's supported were role models of unmarried feminine independence. Their religious community

gave them rights and privileges about which the average English woman could barely dream. At a time when universal suffrage was decades away, the Sisters' votes carried the same weight as the Brothers' in their community. No Foundation business could be transacted without them. They participated in the election of Hospital officers and exercised their right to let their own property at will. Although the Sisters were paid about half what the Brothers received, the income they generated from letting their property was considerable. In 1837, two sisters were each making £90 a year in rent. The young Maria Rossetti was in all probability unaware of these particulars, but she could not have failed to notice the religious community's support of female agency. St. Katherine herself was the patron saint of virgins and female students, which must have chimed with the scholarly Maria. Famous both for her intelligence and her refusal to marry, St. Katherine successfully converted to Christianity the wife and court philosophers of the Roman Emperor Maximus. Unable to defeat her intellectually, Maximus sentenced her to death on the wheel, but the instrument miraculously broke at her touch and she was finally beheaded. This grisly tale possessed all the adventure, cunning, romance and violence of Maria's favourite war-time Homerian epics, but with an important difference: its brave hero was a woman. Women tended to play active, central roles in Christian narratives, or at least enterprising clergy keen on targeting the young female demographic made it seem so. Women were encouraged to apply lessons of feminine power not only to their spiritual practices, but to their charity work with the poor and the infirm.

This narrative of female martyrdom has its darker implications, of course, not least that women's ultimate spiritual fulfilment is achieved through their suffering and death. Whereas Maria greeted this concept with scholarly equanimity, Christina was troubled by the link between female suffering and salvation, simultaneously drawn to and repelled by the sadomasochism inherent in her religion.

Maria herself was soon at work on her own narrative of contemporary female martyrdom, a blank verse translation of a Giampietro Campana poem about the Princess Borghese, a English Catholic who had married an Italian Prince and was known for her work with the poor and the sick in Rome. When she died of fever in October

1840 at the age of twenty-two, the Princess's burial was attended by thousands, and there was talk of beatification.

Gaetano Polidori, undoubtedly pleased that his grand-daughter took after him in her enthusiasm for translation, rewarded her efforts by printing her Princess Borghese poem, 'On the Death of Lady Gwendoline Talbot', on his private press. At 13 foolscap pages in *piccolo octavo*, it came out badly. Nevertheless, Maria's translation is notable for being the first publication by a Rossetti sibling. The thirteen year-old eldest Rossetti must have been proud to beat her 'genius' brother to the punch, in this respect at least. Feelings of competitiveness were still evident years later when the 55 year-old Christina alleged rather peevishly that their mother wrote most of it. Competition from this 'inspiriting muse in a pinafore' caused Gabriel to pick up the pace of his literary efforts. Illustrations of other peoples' tales gave way to original (if derivative) compositions. When he was thirteen, he wrote a ballad called 'William and Marie' and sent it, along with an illustration, to *Smallwood's Magazine*. Rejection did not stop him; he was soon composing a long poem, 'Sir Hugh the Heron', based on one of the stories in the treasured *Legends of Terror*, although it was slow going. Procrastination and perfectionism would remain stumbling blocks throughout Gabriel's career.

In an effort to motivate his grandson, Polidori offered to print Gabriel's poem when it was finished. Polidori also tried to involve him in the mechanical operation of the press, but Gabriel was no more attracted to the nuts and bolts of book production than he had been to his grandfather's carpentry; he was more interested in writing stories than printing them.

As Maria's publication had motivated Gabriel, so Gabriel in turn spurred on Maria. She produced an original poem, 'Daughter of Jairus', for Lady Isabella Howard, a sickly pupil of Charlotte Polidori and a Rossetti family friend. Like *Gwendoline Talbot*, the poem focuses on female suffering, and on the special relationship between Christ and women. It retells a biblical episode where Christ, on his way to heal Jairus's sick daughter, pauses to heal an old woman. During this delay, Jairus's daughter dies, but is restored to life by Christ (Luke 8:41–56). Maria's two poems are markedly different from her brother's, both in subject and tone. While Gabriel relates a chivalric adventure,

Maria concentrates on heroism of a quieter, specifically feminine kind, which derives its strength from qualities of endurance, faith, community and service. These literary divergences also anticipate the different worlds the two siblings would be expected to inhabit as they grew older. The urgent need to separate the boys from the girls had been one of Gabriele's justifications for the family's move to a bigger house. This segregation would only be reinforced by the children's experiences in the male and female spheres.

Gabriel and William's bond was strengthened by their experience at King's, while their absence from the house resulted in growing intimacy between Maria and Christina. The sisters modelled their new relationship along religious lines: Gabriel remarks that Maria was a 'born leader,' while Christina was a 'born apostle'. He explains that 'No one was ever afraid of Christina', implying by contrast that Maria could be fearsome.[15] Intimidation in the face of Maria's accomplishments may explain the tentative, conventional mood of Christina's first poetic offering, 'To My Mother on Her Birthday'. The elder sister signalled her approval by beginning to copy Christina's poems into notebooks along with their composition dates.

Fraternal relations were governed by a similar power dynamic; the younger William continued to play the baby goat to his big brother's leopard cub, blaming the darker side of Gabriel's domineering tendencies on 'the moral atmosphere' at King's, which taught him 'unveracity, slipperiness and shirking.'[16] William himself appears to have been immune to these highly infectious traits. Perhaps the Rossetti parents also blamed King's for bringing out the flaws in Gabriel's character; in 1841 he withdrew from the school with his father and mother's blessing, in order to focus his efforts on the study of art.

His father's connections were more literary than based in the world of visual arts, but a tug on the line reeled in the well-known Dante translator Henry Cary, whose son Francis had recently taken over running the respected Sass's Academy. Gabriel enrolled in July 1842. Essentially a feeder school for the prestigious Royal Academy Schools, Sass's was serious, disciplined and academic. A stern bust of Minerva (goddess of wisdom) presided over the threshold of the elegant building in Bloomsbury. Inside, students were taught the rudiments of anatomy, perspective, proportion, light and shadow, character, expression,

composition and colour through rigorous exercises. For instance, they had to perfect drawing a plaster ball before they could progress to grapes, and then on to begin drawing portions of a hand. Under Sass, a frustrated student had been expelled for sketching a hanged figure in a gallows in the middle of the dreaded ball. Mottoes more likely to foster rebellion than conformity in young boys decorated the walls: 'Those models which have passed through the approbation of ages are intended for your imitation, and not your criticism'; 'Blessed is he that expecteth nothing, for he shall not be disappointed'. A third, '*Laborare est orare*,' ('to work is to pray'), must have reminded young Gabriel of his father's tiresome fondness for Latin dictums.[17]

There was plenty to engage Gabriel's imagination at Sass's, such as a well-stocked library which included drawings, plaster casts and folios of prints of works by the Old Masters. A circular gallery was filled with life-size copies of famous statues such as Apollo and the Venus de Medici, all dramatically lit in a scheme which imitated that of the Pantheon in Rome. Although he was hardly a star pupil, Gabriel did learn the rudiments of anatomy and perspective, even if he did not master them completely. He also learned another valuable lesson, which was that girls could be painters too, for Sass's (unlike the Royal Academy) had been admitting female students since 1832. While the Royal Academy Schools' refusal to admit women kept numbers at Sass's to a minimum, a few aspiring girls took up the challenge. Shared interests in art, as well a gender-inclusive admissions policy, meant that he made more friends at Sass's than at King's. Here he first met Anna Mary Howitt and Eliza Fox, who would go on to establish her own drawing classes for women in her father's library. He also met Walter Howell Deverell, who would remain a close friend. Cary was a more understanding master than his predecessor, and Gabriel did not chafe under his instruction as might have been anticipated.

For William, this must have been a very lonely time, who remained behind at King's. Formerly a conscientious student, William sorely missed Gabriel's companionship, and he drifted on in a desultory fashion, doing only so much work as was necessary to scrape through. Remarkably, his mother, who prized academic achievement and repeatedly extolled the virtues of hard work, did not intervene. William's solitary studies at King's failed to drive a wedge between him

and Christina. She remained his 'chief chum'. Sixty two years later, he would fondly remember his twelve year-old sister joining in on his homework, writing a poem called 'The Chinaman' in response to an assignment on the First Opium War.

Frances's uncharacteristic carelessness with William's schoolwork reflects her growing distraction at home. The cause was Gabriel's deteriorating health, which by the summer of 1843 was so poor that he and Frances travelled to Hastings and then Paris in the hopes that a change of climate would improve him. Evidence of Frances's disorientation can be found in the weekly family magazine, *Hodge-Podge*. Written in Frances's own hand, the surviving copies contain many articles and poems which, although unsigned, echo her pedagogical voice. The first issue has a 'Letter to My Dearest Daughter' on the subject of Joan of Arc and a school-marmish essay 'On Conceit' which begins with an Alexander Pope couplet on vice: 'a monster of so frightful mien, that to be hated needs but to be seen'. The religious topics, instructional essays and mottoes reflect parental concerns and adult anxieties, far from the tales of medieval chivalry and romance that were shaping the Rossetti children's imagination at the time. In fact, Margaret Polidori had written to Frances to report that Gabriel was reading 'indecent books' in her absence.[18]

Intended as a family collaboration, *Hodge-Podge* became something of a diary for Frances, as her commonplace book had in the past. It became the means for her to communicate the unsayable, to reveal her maternal anxieties to her children without raising an alarm or requiring a solution. The lauding of female sacrifice and endurance are self-soothing as much as they are educational. Her description of life in 'London's smoky, smithy streets' tells us as much about Frances's state of mind as it does about her city: in London, 'all that was once white puts on a dingy hue, where no harmonious sound salutes your ear, but all is crash and dash, squeak and creak', 'where the din and hurry of life imprints each face you meet with a look of anxiety and exhaustion'. The extremes of this urban environment reflect her worries about her young children and ageing husband; she finds that in London 'childhood has an aspect of supernatural intelligence and sedateness' while 'old age is doubly old and parched.'[19]

Once again, Frances's common sense refuses to give way to despair.

Her remedy can be boiled down to the very English recommendation to take a nice, brisk walk out-of-doors. Born and raised in the St. James's area of Piccadilly, Frances knew how to get the most out of an urban environment. 'Instead of sitting grumbling at home and ruining our health by sedentary habits', Frances recommends that everyone 'sally forth' to Regent's Park and climb Primrose Hill to get a different perspective on the city. As always for Frances, there are the salutary pleasures of the intellect: 'a stream of pure enjoyment flowing to the mind' through public libraries, exhibitions, zoological and botanical societies, museums and national monuments. London also offers that *sine qua non* for the Rossetti family: 'many more friends than you would scrape together in the country'.[20]

Frances wrote this passage while she, Gabriele and Charlotte were at Hastings, where it was hoped the sea air would aid her husband's recovery. Read in this light, the article in *Hodge-Podge* is an exhortation to cheerfulness meant for children feeling left out their parents' holiday, and a reflection of her own homesickness. Most at home in an urban environment, Frances taught her children to treat London as an exciting, magical labyrinth of infinite diversity and wonder, urging them to look beyond its grim, industrial sprawl. Once she and Gabriele repaired to Paris, her spirits improved significantly, and she records their visits to *Le Jardin des Plantes*, and the *Panthéon* in enthusiastic detail in the pages of *Hodge-Podge*. There is also a sobering visit to *Père La Chaise*, where Frances is struck by a monument to a husband and wife: 'two arms seem to force their way out of the grave beneath…their hands are clasped, and underneath is inscribed, "*Nous serons réunis*"'. This image of reunion touched the mother who was separated from her children, but it must also have been a reminder to the wife of her husband's serious illness, and the very real possibility that he was dying.[21]

The children responded to the maternal cues for cheerfulness and resilience. Left in the care of their aunt Margaret, they directed their energies into writing stories and poems intended for the *Hodge-Podge* and for a collaboration called the *Illustrated Scrapbook* (of which no known copies survive). Gabriel even managed to finish *Sir Hugh the Heron*, which had been three years in the making. His grandfather privately printed it as promised.

Maria, probably the 'dearest daughter' to which her mother's essay on Joan of Arc is addressed, was responding strongly to her mother's intense religious feeling. The Rossetti women had recently switched their allegiance from St. Katherine's Chapel to Christ Church, Albany Street, a London centre for Tractarian worship. Also known as High Anglicanism or Anglo-Catholisicm, Tractarianism had grown out of the Oxford Movement in the early 1830s, where clergymen scholars like John Keble, John Henry Newman and Isaac Williams felt that the authority of the Church was dwindling in the face of the increasing powers of the State. Tractarians wanted to restore a sense of mystery, wonder and influence to Christian worship, and called for a return to the medieval traditions of the Church in a controversial series of sermons and published tracts (hence the name 'Tractarian'). They reintroduced ritual practices such as regular Confession and the wearing of traditional vestments, and established Anglican religious orders for both men and women.

Many Evangelicals like Frances were attracted to its patterns of worship. William Dodsworth, Christ Church, Albany Street's first incumbent, had even begun his career as an Evangelical. Looking back on the period, the *Edinburgh Review* remembered watching the 'old wine of evangelicalism settling itself into new high church bottles.'[22] This is not to suggest that the two modes of faith saw eye to eye. Evangelicals, who believed strongly in a personal, private relationship with God, were suspicious of the Tractarian reliance on clergy and ritual, and its stronger emphasis on Church authority in general. But Tractarians did share the core principles of Evangelicalism, such as the belief in biblical supremacy and individual accountability, as well as the urgent need to convert non-believers. Both schools were highly critical of modern, secular laws which they felt were taking less notice of Christian principles.[23]

Tractarians also recognised and validated the importance of female work. While school enabled William and Gabriel to escape the dreary atmosphere of the sickroom, Frances, her daughters and often the Polidori aunts would have been acting as child-care, on-call nurses and unpaid secretaries for the desperately ill patriarch. Reality was coming down harder on the women, who had the responsibility of managing the household, a sick patient, and the dwindling family

budget. In a culture that expected men to take a leading role, there were few templates for women assuming so much responsibility, and correspondingly little recognition or help from the wider society. The Tractarians capitalised on this neglected demographic, mobilising this undervalued workforce by sending women out into the community to teach, nurse and spread the Word of God. Although women could not become official clergy, they were given roles of responsibility within the parish, and were rewarded with praise and esteem from clergymen and female colleagues, and made to feel a valuable part of the community. Eliza Polidori had been yearning for a life beyond caring for her invalid mother, and found that parish visiting provided a justification for leaving the house which was beyond reproach. She was sometimes joined by her nieces in this work.

Tractarianism's other likely attraction for the Rossetti women was that it was both a literary and a religious movement. It was defined by a particularly Victorian blend of romance and realism, where the mystery of the Eucharist and the power of literature were as central to worship as parish visiting and setting up soup kitchens. Poetry was of particular importance to the Tractarians, who regarded its oblique, indirect operations as a parallel for God's relationship to the world and mankind. Like poets, God spoke to the world through metaphor, communicating His lessons in parables. A poem put into practice all the virtues preached by Tractarianism: the contemplative, the meditative, the symbolic, the indirect and mysterious. In this way, poetry combated the secular ethic of an increasingly utilitarian age. Keble was the Oxford Professor of Poetry, whose volume of devotional poems, *The Christian Year* was a runaway popular and critical success, even outside of Christian circles. Gabriel was taken aback when the Rossettis' Jewish German tutor, Adolf Heimann, openly admired Maria's copy of *The Christian Year*. Isaac Williams was another important poet of the Oxford Movement, and John Henry Newman was famous for his persuasive, elegant prose. In the summer of 1843, Maria was reading the third volume of Newman's *Tracts for the Times* and Keble's *Psalter or Psalms of David*. These became her new literary role models, and she wrote a religious allegory, *Vision of Human Life*, which her grandfather would privately print under the title *The Rivulets* in 1846.

The Rossettis' newfound brand of High Church Anglicanism skirted dangerously close to Roman Catholicism, making even its own supporters uncomfortable. Many important Anglo-Catholics, including Newman himself, eventually did convert to the Roman Catholic Church. Anxiety is the key-note in Tractarian writings of the period, which attempted to distinguish High Church practices from Roman ones by re-casting the Roman Catholic Church as the aggressor. In the *Tract* that Maria Rossetti was reading that summer, Newman wrote: 'we are assailed, and we defend ourselves and our flocks.'[24] Frances' anti-Roman Catholic poem of this period, 'A True Story', suggests that she and Maria were on the same page.

Gabriel had no patience at all with religious controversies. In the summer his parents were away, he was cheerily dashing off chapters of a Faustian story called *Sorrentino*. Gabriel's version of the Devil tries many devious strategies to break up two young lovers, such as impersonating the paramour in order to trick the lady love. Later he seduces a phantom double of the woman in front of her lover. Although no known copies survive, William remembers it as the best of his brother's junior productions. Maria by contrast pronounced it 'horrible' and refused to read forthcoming instalments. Luckily Frances was away, for she would surely have worried that her son had 'entered fully into the spirit of a story of diablerie.'[25] Gabriel was not experiencing any dark Satanic urge; he was simply bored by the obligations and duties of Christianity. Staying with his Catholic Uncle Henry Polydore in Chalfont-St-Giles, he had weaselled out of attending mass with the flimsy excuses that he wouldn't know where to sit, and that he was anxious about being stared at by the locals. Gabriel also informed his mother that he had forgotten to bring his Prayer Book, offering the deeply dubious assurance that he would read his uncle's copy on Sunday.

Christina's poems during this period are torn between the influence of Maria's evangelism and Gabriel's Romanticism. For the moment, Gabriel had the upper hand. While Christina's 'Hymn' dutifully rattles off religious platitudes, the love-lorn 'Corydon's Lament' and 'Rosalind' are written with a drama and narrative drive which are arresting, if not wholly original. Certainly 'Rosalind', in which a pirate violently hurls a Lady's husband into the sea, echoes the evil

knight of Gabriel's *William and Marie*, who throws his rival's lady love into a moat. William, worshipful of his older brother as always, was hard at work on his own chivalric tale, *Ulfred the Saxon*. It made little noise in a family which had already decided that Gabriel would be its representative writer. Polidori did not privately print William's contribution. William was a painfully shy boy. Where Gabriel leapt at the chance to recite poetry for guests or family, his younger brother hung back in dread. A combination of reserved temperament and lack of parental encouragement allowed William to maintain his place in the background, where he would remain a diffident but canny observer of the family story. His natural reticence might also have held him back from participating in the Anglican fervour that was overtaking the Rossetti women. Around the time his sisters started attending Christ Church, Albany Street, William determined that he was not a believer. While Maria was reading Keble's religious poems and Gabriel was writing about the Devil, William was in raptures over his discovery of the atheistic Shelley, the very poet whose name had been forbidden in the home of Frances's first employer. The mysteries of the Church were not for him; he felt that 'the constituent parts of the universe' were simply 'a series of effects arising from causes', and were not governed by heavenly forces.

William's newfound realism may also have been related to the decline in the Rossetti family's fortunes. Frances and Gabriele had returned refreshed from their holiday in Paris, but soon afterwards, Gabriele's health turned for the worse once again. With his ability to work severely impaired, the Rossettis' financial situation was becoming critical. William vividly remembers being invited to the home of a wealthy friend, and trying to disguise the faded elbows on his only good jacket with blue water-colour paint. His father wished out loud that he had the money to ensure William was *"vestito come un principino"* (dressed like a Prince). Even as an adult, William chafes at this episode: 'I felt grateful to him for the fatherly remark, though my jacket grew none the handsomer for it.'

William never forget how close his family came to real poverty: 'I know what it is to be "hard up," and to see all those around me hard up – pinched and pinching.' [26] Frances was forced to take tutoring work outside the home, a humiliating circumstance for a

middle-class married mother. Charlotte Polidori set Maria up with a job as governess to Lady Bath's five year-old niece, Gertrude Thynne. The major drawback was that the position was residential, meaning that the sixteen year-old girl could no longer live at home with her family. Women's employment was still too poorly paid to compensate for the loss of Rossettis' earnings. 'All of them put together cannot make the half of what I used to make myself', Gabriele observed with a hint of misplaced pride.[27]

Arguably, the task of supporting the family ought to have fallen to Gabriel, who was the eldest son. Already earmarked for a life of genius, rather than labour, he continued his education at Sass's, at no little expense. 'Therefore', William observes drily, 'he cost something and earned nothing.'[28] Gabriel was also causing trouble at home, where conflicts were brewing between father and son. Always a dilatory scholar, he was not demonstrating the devotion to his studies that his father understandably wanted to see. The irony of being lectured on responsibility by a semi-employed patriarch was not lost on Gabriel, who responded with characteristic storminess, given a boost by his adolescent moods. His father scoffed at his son's pleasure-reading, which consisted of gothic fiction and adventure stories, and strayed far from the preferred scholarly path. He berated Gabriel for getting his history from the novels of Scott, Hugo and Dumas: 'When you have read a novel of Walter Scott, what do you know?' he would boom rhetorically. 'The fancies of Walter Scott.'[29]

William's pliability doomed him to work just as surely as Gabriel's stubbornness excused him from it. In the end, it was the shy, bookish William who was made to give up his ambitions to be a doctor, in order to step into the breach. Gabriele touched a former employer, the wealthy financier Sir Isaac Goldsmid, for a suitable position. Aged fifteen, William became a clerk at the Excise Office on Old Broad Street, starting at £80 per year. In later life, he was circumspect about this development, but full-time employment at a tender age must have been as profound a shock to William as it had been to Maria. At the same time, work introduced brother and sister to a world outside of home, school and church, exposing them to a wider variety of people and experience. In learning to get along with his Excise Office colleagues, whom he was shocked to discover were not at all

interested in art and literature, William developed social and business skills which shaped an identity outside the family circle. His talents, more administrative than artistic, were applauded and rewarded at work where they were ignored in the home. Maria too was exposed to family lives very different from her own. As a governess, she learned the art of diplomacy from living in households in which she both an insider and an outsider.

Not yet old enough to be called upon to work, Christina had the most severe reaction to the traumatic conjunction of ill fortune, ill health, and the loneliness of being left at home with her sickly, broken father. The causes remain ambiguous, but in 1845 at the age of fifteen, Christina suffered a breakdown. William's account would at least recognise the psychological component of her illness, describing it as 'angina pectoris (actual or supposed)'. The heart-pain that lead doctors to the diagnosis of angina might just as easily have been symptomatic of panic attacks. As her biographer Jan Marsh discovered, Christina's medical notes from the period suggest 'she was then more or less out of her mind...suffering, in fact, from a form of insanity, I believe, a kind of religious mania.'[30]

Teetering on the brink of womanhood, this temperamental, sensitive girl was more prone to dramatics than her older sister. Christina was drawn to the masochistic undercurrents of a religion which emphasised the importance pain and suffering, often in sexualised language: 'The deeper the iron enters, the deeper he knows is the sore which God would lay open and heal,' Pusey sermonised. He called for his parishioners to beg God to mutilate their human hearts: 'Circumcise, yea, cut them, Lord, round and round, until none of the vanities or love of this world cling unto them; break and bruise them in pieces...'[31]

1845 was also the year that Christina lost one of her rare friends, the eighteen year-old Isabella Howard, daughter of the Earl of Wicklow and a pupil of Christina's Aunt Charlotte. Christina would later compose a sonnet ('A Portrait') and two eulogistic poems entitled 'Lady Isabella', one of which her brother Gabriel illustrated. The poet's idealised portrait of her friend, which commemorates her 'glorious' midnight eyes, and 'perfect' body and face, is as much a revelation of a younger girl's hero-worship as it is her grief. In the

sonnet, the dead Lady Isabella is laid out in her bed like a saint and depicted as 'a lily flower', 'gem of priceless worth' and a 'dove with patient voice and patient eyes.' This sacramental imagery is linked to the Tractarian emphasis on female sainthood, which already had a strong hold on the Rossetti sisters' imaginations.

Christina would mainly have met women her own age at Christ Church, Albany Street, an institution that arguably specialised in encouraging female martyrdom as much as female independence. There was an emphasis on self-mortification which High Church opponents found unsettling; indeed in 1850, one of the Park Village Sisters would die from over-zealous fasting. There is a hint of this devout death-wish in Christina's first 'Lady Isabella' poem, which eagerly prays for the time when 'We too may pass away.'

It is impossible to diagnose Christina's condition from the opaque explanations and conflicting evidence of doctors and family. Biographers disagree on the exact cause of Christina's breakdown, but most agree that the convergence of adolescence, money worries, family illness and her separation from worshipped older siblings all played a part in aggravating any physical symptoms. The role of religion, however, has too often been accepted at its sensationalised face value ('religious mania'). In fact, Christina's spirituality is much more complex than this phrase suggests. If anything, the diagnosis reveals the helplessness of the male medical establishment to cope with the problems of adolescence in general and female adolescents in particular. Adolescence as we understand it now was not really recognised as a developmental stage in Christina's day, and no medical or social support was available to see her through this transition. Schooled at home, she had no peers to whom she could compare her experiences, or with whom she could bond and sympathise.

The diagnosis of 'religious mania' also reflects the widely-held suspicion of the Anglo-Catholic revival, which was often blamed for contributing to the deterioration of the traditional family structure. The practice of Confession (where women spoke privately to male authority figures outside the family), the establishment of Anglican Sisterhoods, and the emphasis on God as the ultimate father figure were seen by mainstream society as a serious challenge to domestic patriarchal authority. In this context, it may have seemed safer to

blame the interference of Church fathers rather than the failings of Christina's actual father.

In the absence of adequate social or medical support, the Anglo-Catholic approach to heartbreak and anguish provided an outlet and a theology for Christina's complex and socially transgressive feelings. These must have included anger toward her parents, whose protection was proving inadequate, and whose promises of paternal fame, artistic fulfilment and success for their children were not coming true. Just as Gabriel prickled when being corrected by his father, Christina resented lessons in resignation and self-control from a mother whose deferral to her husband had singularly failed to safe-guard the family. As an older woman, Christina would famously tell her niece about the time she 'seized upon a pair of scissors and ripped up my arm to vent my wrath' at a rebuke from Frances. Nowadays, self-harm is understood as a reaction to stress, as an attempt by the helpless to establish a semblance of emotional control. In middle age Christina would admit this: 'I have since learnt to control my feelings…'[32] In light of William's adult criticisms of her 'overscrupulous' Anglo-Catholicism, it is tempting to regard Christina's religious submission as the taming of a free spirit. Or, as William puts it: 'Her temperament and character, naturally warm and free, became 'a fountain sealed'.[33] William is quoting from the Song of Solomon, 4:12, a particular favourite of Christina's. Read in context from an Anglo-Catholic perspective, it proposes another side to the story: 'A garden inclosed is my sister, my spouse; a spring shut up, a fountain sealed.' This Old Testament verse would have been interpreted as Christ speaking to his 'bride' (the Church), promising to defend her by his care, reserving her delights for his exclusive use. Such vigilant protection of an interior life suggests that Christina thought she had something worth guarding.

Religion gave Christina permission to have a private life, an important privilege in a family that prioritised the communal over the individual, at least when it came to the girls. The Church provided Christina with a template for self-control and self-esteem was beyond the purview of her family or the medical profession. It supplied a dependable structure missing in her chaotic home life, an alternative sense of 'family' at a time when her own was becoming unstable. As her father's full-time carer, Christina witnessed

Gabriele's disturbing deterioration firsthand; it is not difficult to see the appeal of a religion which acknowledged the frailty of human fathers and offered an alternative, all-powerful Father. The Church provided other substitute fathers in the form of authoritative literary figures such as the much-admired Keble and Newman, as well as firebrand preachers like Edmund Pusey and his acolyte William Dodsworth, the perpetual curate of Christ Church, Albany Street. That these fathers could themselves prove unreliable may have been an additional source of anxiety; the Rossetti sisters' beloved Newman became a Roman Catholic about a month before Dr. Hare diagnosed Christina's religious mania. Dodsworth would also 'go over' in 1851.

Different cures were attempted, including visits to Maria, a family holiday in Herne Bay and a new friendship with Amelia Bernard Heimann, her German teacher's young wife. Frances believed that Christina was improving; she wrote brightly to her husband that she had gathered 500 acorns during a walk in Herne Park. But this seems an unlikely sign of recovery in the passionate, cerebral Christina.

As would so often prove the case, it was the return of the poetic impulse that marked the real turning point in Christina's life. In May 1845, her 'Lines to my Grandfather' complained of feeling listless and uninspired, and she all but stopped writing. 'My muse of late was not prolific', the poem begins, and goes on to find making 'a verse a task terrific / Rather of woe than weal'. The poem hints at stasis that is creative, social and spiritual in nature; the poet intends to write 'plain things' because she has 'met with no adventure.' 'Lines to my Grandfather' is a youngest sibling's lament about being stuck at home while everyone else enjoys themselves in the outside world.

Christina's crises are thrown into sharp relief by Gabriel, who was extremely productive during this period thanks to daily contact with other young aspiring artists at Sass's. This was augmented by trips abroad to Boulogne to visit Signor Maenza, an exotic refugee friend of his father's who had married an Englishwoman. Gabriel was dimly aware of his relative advantages, particularly in regards to Maria. He joked that the Gothic interior of the local church at Boulogne, with its picturesque fisherwomen at prayer beneath the watchful gaze of saints, was so impressive that it would have converted Maria to Catholicism. It is doubtful that Maria, whose church

was haemorrhaging converts in this period, would have found this notion particularly amusing.

If European holidays and formal education were to be denied Christina, she determined to seek inspiration, quite literally, closer to home. Like its young writer, 'Lines to my Grandfather' contents itself with the delights of native apple and pear trees, cowslips, primroses and daisies: 'Give me uncultured bowers / Before the bright parterre!' she writes unconvincingly. This poem contains the germ of Christina's genius: the uncovering of universal beauty in the local and the particular, the unexpected delights of the 'garden inclosed'.

Gaetano Polidori was alert enough to read the creative desperation between Christina's 'Lines to my Grandfather.' Perhaps his son's suicide had taught him to recognise the symptoms of mental and artistic distress in anyone with Polidori blood. Or perhaps he simply remembered his prophecy that Christina would be the cleverest among his grandchildren. He collected her best juvenile poems and privately printed them in a volume called *Verses* (1847), complete with a caveat whose restraint is not enough to conceal that he is bursting with pride: he was 'confident that the lovers of poetry will not wholly attribute my judgment to partiality.' Polidori's preface reassures readers that Christina's feminine resistance to publication has been overcome with some difficulty.

This extreme modesty was perhaps a reaction to her father, whose energetic self-confidence had turned out to be bluster. More than any other Rossetti, Christina would have seen the family patriarch at his weakest, and probably his most self-pitying. Her eldest brother's arguments with Gabriele were based on a filial assumption that his father was still a powerful figure worth struggling against. For Christina, her father's decline marked a tragic end to her childhood. He was to be pitied. Christina's 'Lines given with a Penwiper' provides us with a domestic portrait of her time caring for her father:

I have compassion on the carpeting,
And on your back I have compassion too.
The splendid Brussels web is suffering
 In the dimmed lustre of each glowing hue;
And you the everlasting altering

Of your position with strange aches must rue.
Behold, I come the carpet to preserve,
And save your spine from a continual curve.

In Christina's hands, giving her father a penwiper to soak up stray ink becomes an act of 'compassion', a small way to alleviate 'suffering', disguised as concern for a stained rug in order to preserve the father's dignity. Gabriele was no longer the pleasure-seeking provider, returning home from work with pockets full of lollipops, but a sickly old man who needed to be reminded not to spill ink on the carpet. Maria, miserable and homesick as governess to the Thynnes, concurred with her sister's view: 'I thank God for having given me talents which enable me to assist my dear father by removing the burden of my maintenance', she writes, 'Might I only remove as easily all the anxieties which weigh upon his heart, and all the vexations that oppress his mind.'[34] The daughters had both begun to parent their father.

Gabriele loved his daughters dearly, but retained his highest hopes for his son, despite the boy's defiance. His *Autobiography* makes his expectations clear: 'You will be doing what I could not do.'[35] He harboured no such artistic ambitions for William: 'But such a mind as yours exerts its power / Among the thinkers, not on Helicon.'[36] In Greek mythology, the Muses live on Mount Helicon, guarding the streams from which artistic and poetic inspiration flow. It must have been painful to William to realise that his poet-father recognised no artistic potential in him, although it may not have occurred to him that Gabriele's view was self-protective; having taken his younger son out of school and doomed him to a career as a civil servant, the father may have been eager to reassure himself on this score. Hurt feelings are still detectable in William's adult memoir, where he protests, 'if I had persevered with verse, I should have produced some very passable work, rivalling that of various accepted versifiers.' In the end, the dutiful Rossetti son is reluctant to disagree with his father's judgment: 'I felt that in the long run I should prefer to stay outside the arena of verse altogether.'[37]

For the girls, Gabriele penned a few lines vaguely extolling their 'virgin modesty', 'intellect and ethics' and 'prose and verse', without anticipating any particular accomplishments from them. He exhorts

all four to 'grow, grow up to patriot love' because 'In you the blood and name of me is stored.' All the children took Gabriele's parental directives to heart, although each interpreted 'patriot love' in different ways (as clever children tend to do). Frances, though deeply respectful of her own Italian heritage, had different, more English expectations concerning patriotism. Her convictions were only strengthened by the tragic events of the next phase of the Rossetti family story, which were driven by the continuing interference of an Italian even more stubborn and difficult than her husband: Dante Alighieri.

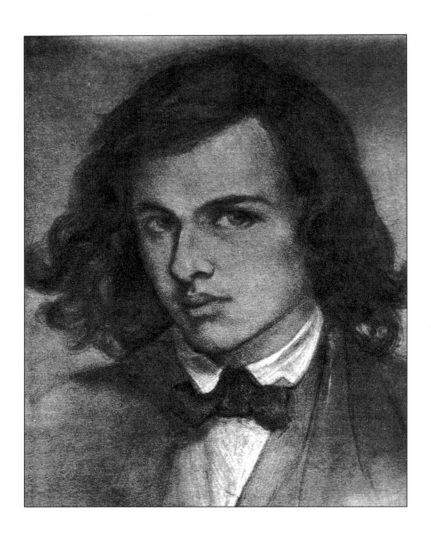

Gabriel Charles Dante Rossetti, *Self-Portrait*, 1847

This self-portrait captures what a fellow art-student characterised as Gabriel's 'insouciant air which savoured of defiance, mental pride and thorough self-reliance.' Aware of the commercial importance of image, by 1850, the artist would drop 'Charles' from his signature, using the professional name 'Dante Gabriel Rossetti.'

4

THE PRE-RAPHAELITE BROTHERHOOD

Negative repercussions on finances and reputation had not per-suaded Gabriele to abandon his Masonic investigations into Dante Alighieri's work. In 1846 he published a long autobiographical poem anticipating Italy's unification, entitled *Il Veggente In Solitudine* (*The Seer in Solitude*). He dramatises his own sea voyage from Malta to England as a mystical encounter with the spirit of Dante, in a section entitled '*L'ombra di Dante*' ('The Shadow of Dante'). The Florentine poet, ringed by a circle of fire, appears out of a cloud to assure Gabriele that one day Italy will be free. Dante proceeds to liken his own banishment from Florence to Gabriele's exile from Naples, and encourages him to go on seeking the hidden meaning in Dantean texts.[1] While the poem enjoyed modest success in Italy, where it was circulated secretly, it did little to restore English faith in Gabriele's scholarship.

The family's money-worries were exacerbated by the death of long-term patron Frere in the summer of 1846. Already emotionally fragile, Gabriele was devastated; he saw in the deaths of friends intimations of his own mortality. In April 1847 he resigned his Professorship at King's College, losing not only his small annuity, but the institutional affiliation which attracted prospective new students. As Mazzini began to take over as the leader of Anglo-Italian political activity in London, Gabriele was left with the dregs of the Italian

expatriate community. Shady new friends soon flocked around him, among them a group of defrocked priests and evangelicals who convinced him to vent his anti-papal spleen in a magazine called *L'Eco di Savonarola*, and to speechify against Rome at their gatherings. He wrote to Lyell that he was now white-haired, thin as a skeleton and toothless, but it was evident that Gabriele's prose still had bite. The old *Professore* was treating his reduced teaching load as a sabbatical rather than a retirement, entering a productive period in old age. Fuelled by the contents of an unfeasibly large snuff box, a peaked cap shading his weak eyes, he spent his days composing poems for *Arpa Evangelica* and his evenings pontificating on Italian politics.

His eldest son had just entered the Royal Academy Antique School, audaciously claiming not to have met its deadline for the completion of required probationary drawings. The presence of his son's art school friends inspired him anew; the young men orbiting his son reminded him of the pleasures of male camaraderie, although perhaps his input wasn't always wanted. A friend of Gabriel's remembers that the old man's voice 'had a slightly rigorous ring speaking to his sons and their visitors' as he sat sermonizing 'like an old and somewhat imperative prophet.'[2]

Open hostilities between father and son seem, at this period, to have resolved themselves into a kind of uneasy détente. Partially, this was because the son's activities were increasingly unmonitored as he began the transition from home-life to adult independence. Although the family circle widened to accept his new friends, Gabriel in turn was welcomed into other social circles from which his father, mother and sisters were excluded. He and William frequently took tea with the American Doughty family near Gloucester Gate, Regents Park. The young art student Thomas Doughty introduced them to another American, Charley Ware, who lived with a mistress in Leicester Square and painted a picture of Gabriel playing whist with the Devil. We can be fairly certain this man was never introduced to Frances and her daughters.

This busy social life meant Gabriel's attendance at the Academy School was sporadic, but in this he was not particularly unusual; many art students were also engaged in painting pictures for sale, which interfered with regular attendance. He had inherited his

father's self-confidence and personal magnetism, which allowed him to critique Academy convention and pursue his own path. Fellow students remember that Gabriel was always greeted with enthusiasm by the other artists in training who gathered round to watch him draw illustrations of Romantic poems, and sketch medieval knights and ladies. He bestowed the finished products on his most ardent admirers in a princely manner. Gabriel had learned from his father that patronage was just as important as attracting a following, and he set about making influential friends. At first, these were literary rather than visual artists. Competition has always acted as a spur to Gabriel; the fuss that greeted grandfather Polidori's publication of Christina's *Verses* had helped reignite his poetic impulse. He started enclosing his poems along with fan letters to the poets Robert Browning and William Bell Scott, and the Romantic critic and poet Leigh Hunt, who had known Keats and Shelley personally. Gabriel's gushing, unguarded style inspired positive responses. To Hunt, for example, he wrote: 'You have delighted me – strengthened me – instructed me: you do so still. How then could I consider you otherwise than as a personal friend, or address you otherwise?' Hunt praised the young writer's poems, but pointed out that painting would be a more lucrative career: 'If you paint as well as you write, you may be a rich man.'[3] Hunt's advice chimed with Gabriel's experience. He had learned from watching his own father's failure to keep the pot boiling with verse, and ultimately he decided it was more practical to pursue painting than poetry.

This was not as commercially naive a decision as it may seem to us now. Painting, in those days, was a viable means for young men of meagre resources to achieve a higher standard of living, both economically and socially. By the 1840s, the rise of the merchant and manufacturing classes meant that painters were less dependent on the old system of aristocratic patronage. Important collectors were now industrialists and businessmen who no longer relied on direct consultation with galleries, but on the advice of newly professionalised picture-dealers. Doing away with the polite relationship between aristocrat, artist and gallery meant tougher negotiation as these picture-dealing middle-men (whose origins were often in printselling rather than fine art) hashed out deals with a view towards

high commissions. As a consequence, prices rose. Collecting fine art became a visible signifier of the merchant classes' social ascension. Two of the most important collectors of Turner, for example, were an oil merchant and a carriage maker.

The new social mobility extended to the artistic classes, as success began to depend as much on cultivating a good commercial reputation as on patrimony or connections to the upper classes. A Liverpool ship-builder looking to make a return on an artistic investment always had his eye on the bottom line. Picture-buying also served the important social function of announcing that the purchaser was a man of taste and discrimination, who knew an up-and-coming artist when he saw one. Artists of humbler origins could give themselves a better chance by learning that in the new art market, the artist was becoming as much of a product as his paintings.

Gabriel was very commercially astute, and he worked out fairly early on how to market himself. The most beautiful of the Rossetti children had grown into a good-looking young man, slim and 'saturnine' with 'very full, not to say sensuous lips', a 'square-cut, masculine chin' and deliberately tousled, shoulder-length brown hair. The star of his family knew how to make an entrance: 'Rossetti came forward among his fellows with a jerky step, tossed the falling hair back from his face, and, having both hands in his pockets, faced the student world with an insouciant air which savoured of defiance, mental pride and thorough self-reliance.' He understood the importance of image, and while he was becoming an artist, made sure he looked the part, as a fellow-student remembers:

> A bare throat, a falling ill-kept collar, boots not over familiar with brushes, black and well-worn habiliments including, not the ordinary frock or jacket of the period but a very loose dress-coat which had once been new – these were the outward and visible signs of a mood which cared even less for appearances than the art-student of those days was accustomed to care...[4]

Gabriel had learned from his sisters and aunts, with their outdated bonnets and dark, sombre skirts, that anti-fashion can make as big a statement as dressing in style. William remarked that his

brother was never interested in the latest clothing for men. Gabriel's anti-materialist critique diverged from that of his female relatives, however. Whereas their plain clothing suggested that Christian worship fully occupied their attentions, Gabriel's threadbare dress-coat signified that his energies were feverishly devoted to Art.

Gabriel was self-aware enough to know that his image was nothing if not backed up by talent. His attendance at the School was patchy and lax, and he had no great fondness for what he perceived as its dull, out-dated methodology. His networking letters started to reap rewards, and new visitors to the Rossetti house on Charlotte Street were now more likely to be seeking the son than his father, a reality that must have pained the old man as much as it made him proud. William Bell Scott, a Scottish painter and poet Gabriel admired, recalls turning up at the house in January of 1848, hoping to meet the 'wonderfully gifted boy', although he was worried that Gabriel's poems displayed 'the Oxford Tractarianism just then distracting weak intellects.' Gabriel was out that afternoon, but Scott did meet the family patriarch and Christina, both of whom he found hard at work: 'By the window was a high narrow reading-desk, at which stood writing a slight girl with a serious regular profile, dark against the pallid wintry light without. This most interesting to me of the two inmates turned on my entrance, made the most formal and graceful curtsey, and resumed her writing.'[5] He did not realise that it was this shy seventeen year-old girl, and not Gabriel, who harboured radical Tractarian sympathies.

The frosty Tractarianism of Christina's *Verses* 1847 blows through Gabriel's early poems about lovers and families separated by death and anticipating heavenly reunion, such as 'My Sister's Sleep' and 'The Blessed Damozel'. Gabriel even borrows some of Christina's rhymes. The opening of his 'Blessed Damozel': 'The blessed Damozel leaned out / From the gold bar of Heaven: / Her blue grave eyes were deeper much / Than a deep water, even', echoes a slanted rhyme from Christina's lines: 'In the silent hour of even / When the stars are in the heaven' ('The Water Spirit's Song').

While Scott is not entirely wrong to identify an Anglo-Catholic mood in Gabriel's poetry, Christina's influence on her brother was more stylistic than ideological. For a start, Gabriel's poems were

(unsurprisingly) inspired by visual art rather than Christian worship. Gabriel was far more interested in paintings of religious subjects than he was in the subjects of religious painting. The intense symbolism, emblematic use of colour and codified meaning appealed to him as a poet and a painter, but he was not at all attracted to the idea of renouncing the world, the flesh and the devil. Gabriel's agenda at this time was far from the self-denying pieties of the Oxford Movement. His fascination with Faust and the devil was still going strong; he produced the poem 'Jan Van Hunks', based on a Dutch story about a man who loses a smoking contest with Satan and is taken to Hell, where his corpse is used as the devil's pipe. During this period, he wrote an early draft of a poem about contemporary prostitution called 'Jenny.' These of course were not the poems Gabriel was using to lure new mentors. Those he sent out for critique were intended for a larger collection to be called 'Songs of the Art Catholic', an obviously religious title which Scott found mildly alarming.

Gabriel's fan letter to Ford Madox Brown was so fulsome in its praise that Brown, a struggling, slightly older painter self-conscious about his lack of success, thought the letter was a cruel joke. He stormed round to Charlotte Street aggressively wielding a stick to teach the prankster a lesson. Gabriel charmed him too, and before he knew what was happening, Brown had agreed to tutor him in painting for free. As was often the case with Gabriel, he chafed under the discipline, complaining when Brown set him to drawing still life studies, bottles and pickle jars.

Gabriel soon realised he would need some allies his own age alongside more established mentors. He actively began courting the golden-bearded RA student William Holman Hunt. The son of a Cheapside warehouse manager, Hunt shared with Gabriel a need to turn a profit from his art, and a burning ambition to prove himself. Pugnacious and determined, Hunt would never forget his two initial rejections for admission to the RA Schools; he was the kind of man who held a grudge. Hunt first encountered Gabriel when he came upon the artist conveniently draped over some steps in his path, sketching a female figure from the bronze Gates of Ghiberti. Hunt had also been working on figures from Ghiberti, and, whether or not Gabriel was aware of this in advance of their conversation, the

subject proved a good talking point. Gabriel next approached Hunt at the RA exhibition, loudly declaring Hunt's painting of Keats's poem, *The Eve of St. Agnes*, to be the best in the collection. He boldly asked Hunt if he would accept him as a pupil. Hunt turned him down, but he was flattered, which was the primary purpose of the request. He was also impressed by Gabriel's knowledge of the then little known and under-appreciated Keats, whose works had gone out of print; Hunt had found his first edition in a book bin labelled 'this lot 4d.'

Keats's passion, youth, and lack of pedigree appealed to two young painters whose own limited finances meant they had to struggle just that little bit harder than some of their fellows. Hunt's other close student friend, for example, was the wealthy James Everett Millais, who had introduced himself while sporting a belted velvet tunic. Millais had been the youngest student ever admitted to the Schools at age 11, and was widely regarded as a prodigy. Gabriel, with his immigrant surname, distressed clothing and naked ambition provided a welcome contrast. Millais, perhaps resentful of Hunt's affection for the newcomer, thought Gabriel was pretentious. Years later, he remarked, 'If you affect a mysterious air, and are clever enough to conceal your ignorance, you stand a fair chance of being taken for a wiser man than you are.'[6] Hunt was soon welcoming Gabriel to his studio, and over the summer of 1848, the two became fast friends.

There could be no firmer indication of Gabriel's friendship than an introduction to his family. He had learned the benefits of inclusion from his father, and was not interested in drawing firm boundaries between family and friends, home and work-life. Hunt remembers dining at Charlotte Street with the Rossettis and a number of Italian expatriate guests. Where Christina was quiet, Maria was sociable, asking questions of the guests and bustling around making sure they were comfortable. She had the confidence of an elder sister, and was aware of her duties as hostess. Yet it was Christina, with her pretty face and air of melancholy, whom Gabriel's friends would ask to model for their paintings. Christina shared this reserve with her mother, who is described only as saint-like and maternal as she prepared the family meal and watched her husband hold court. She must

have been grateful that his friends, mindful of the Rossettis' financial situation, either left before dinner or claimed to have eaten already.

Another RA student Gabriel befriended, Frederic Stephens, recalls listening to the Rossetti patriarch in full flow. In the flickering firelight, he thought the old Professor looked like a Rembrandt come to life. Although it wasn't always easy for Gabriel's English guests to follow the ex-pats as they each took turns standing in the middle of the floor to rage in French and Italian against political injustice, the younger men were impressed by their passion. The Rossetti boys, however, appeared unmoved by these performances, shrugging their shoulders as if to suggest they'd seen it all before. Neither the Rossetti girls nor their mother participated in these heated discussions of current events.

The Rossetti boys had good reason to be interested in politics, but they were more interested in revolutions in art. The publication of *The Communist Manifesto* that year in London was far less inspirational to them than the release of Monkton Milnes's *Life, Letters and Literary Remains of John Keats*, which Gabriel and Hunt pored over as if it were a sacred scroll. They thrilled to Keats's axioms on art and literature, which the poet had written when he was, like them, in his early twenties: 'the excellence of every art is its intensity'; 'with a great poet the sense of Beauty overcomes every other consideration'; 'if Poetry comes not as naturally as the Leaves to a tree it had better not come at all…'.[7]

It was a timely publication in a political sense, as it detailed Keats's fight to overcome class prejudice and be recognised as a great poet, despite his lack of an independent income or a gentleman's education. In 1848, Europe was experiencing an unprecedented surge of revolutions and political upheavals, as the working classes began to organise and demand rights and representation. Although England has escaped previous waves of revolutionary activity, many worried that this time she would succumb. Would the mass demonstrations, marches and insurrections taking place in France, Germany and Italy spread to England? The closest it came was the Chartist demonstration on the tenth of April, 1848, when thousands of working men met on Kennington Common to demonstrate their support for voting reform. They intended to march through London to deliver a petition

in support of the People's Charter to Parliament. Revolutionary activity in Europe had made officials more than usually jumpy about this working class labour movement, and thousands of special constables were deputised to keep order on the day. One of these constables was William Rossetti, whose job at the Inland Revenue placed him in the government's camp, although his true sympathies were with the Chartists. He was sworn in and given a truncheon, but was not put on street detail, much to his mother's relief. He did, however, have to spend the night guarding the office, wondering whether he would be forced to break Chartist heads, or risk having his own broken.

Gabriel, for his part, commemorated the event with a parodic poem entitled 'The English Revolution of 1848', with the tongue-in-cheek subtitle, 'No connection with over the way.' While neither police nor protestors emerge with dignity, it is obvious that Gabriel feels no great affinity with the Chartists: 'Ho ye that nothing have to lose! ho rouse ye, one and all! / Come from the sinks of the New Cut, the purlieus of Vauxhall!' William excused his brother's snobbery on the grounds of his 'disdain for noise and bluster,' though he admits that Gabriel 'did not always appreciate correctly the distinction between the noise and the ideals.'[8] Even if he had not been suffering from a painful outbreak of boils on the day of the Chartist march, it is unlikely that Gabriel would have attended. Hunt and Millais went along, but they were more spectators than revolutionaries; they were treating themselves to a day out after painting through the night. They watched the Chartist speakers from the sidelines rather than joining the crowd on the green, and beat a hasty retreat when they thought violence might break out.

Although the performances of Gabriel's father and his expatriate friends never roused the young artists to political activism, they did help inspire the rebellious mood which transformed them from a disparate group of students into a force to be reckoned with. Taking their cue from other contemporary youth groups such Mazzini's *Giovine Italia* (Young Italy) and Disraeli's Young England, Gabriel Rossetti and his RA friends organised themselves as the 'Pre-Raphaelite Brotherhood.' They knew they wanted to reject the 'sloshy' painting subjects and techniques instilled by the hated 'Sir Sloshua' (Joshua Reynolds, first President of the RA), and to reject classicism in favour

of medieval painting. Beyond a general rebelliousness, their strategies for accomplishing their goals remained informal and vague. Only years after the movement ended would William attempt to outline their methodology: '1, to have genuine ideas to express; 2, to study Nature attentively, so as to know how to express them; 3, to sympathise with what is direct and serious and heartfelt in previous art, to the exclusion of what is conventional and self-parading and learned by rote; and 4, to produce thoroughly good pictures and statues.'[9]

Gabriel, Hunt and Millais were the original founders. Other members included painters James Collinson and Frederic George Stephens, sculptor Thomas Woolner, and group secretary William Rossetti. Gabriel asked Ford Madox Brown to join, but the individualistic painter refused, citing his distrust of coteries. He may also have been self-conscious about his age; at twenty-eight, he was nearly a decade older than his prospective Brothers, though not much more successful. The founding of the Pre-Raphaelite Brotherhood was not as programmatic or formal as its name suggests, but rather evolved out of a series of pub discussions, informal get-togethers, and a defunct sketching club rather pompously called the Cyclographic Society. No one could ever be sure who exactly came up with the name 'Pre-Raphaelite Brotherhood', or even its precise meaning. Among themselves they joked that the initials stood for 'Please Ring Bell' or 'Penis Rather Better.'[10] Hunt would later claim 'Pre-Raphaelite' was originally a derogatory term invented by their critics. William Rossetti felt it had signalled the group's admiration of painters earlier than Raphael. Stephens said that the name was invented 'more in fun than otherwise.'[11] Everyone agreed that it was Gabriel who added the word 'Brotherhood.' It is unsurprising that a man so defined by family should choose this familial designation for his peer group. To emphasise the point, he put his actual brother up for membership, even though William was not an artist but a civil servant. Gabriel even tried to smuggle in a sister; he asked Christina to contribute her poems to a proposed literary society attached to the Brotherhood. She wouldn't allow him to read her contributions to the group in her absence, let alone attend any meetings herself, even the ones that took place upstairs in her own home. She was worried her inclusion would 'seem like display.'[12]

As her brother was becoming more visible, Christina started going into hiding. Although gender expectations had a role to play in her withdrawal, socially prescribed female modesty was not the whole story. Given the Rossetti family's reverence for art and literature, it seems unlikely that they would have been moved by conservative worries that writing was an unladylike activity. After all, grandfather Polidori had already privately published both of his grand-daughters' poems. Women were publishing in greater numbers than ever before; respectable female writers were hardly unprecedented in the period which saw the rise of the Brontë sisters and Elizabeth Gaskell. Even poetry was no longer considered outside women's purview; Elizabeth Barrett Browning had become one of the most beloved poets in the country with the publication of her 1844 *Poems*. The difference between Christina and these female contemporaries was religion.

Anglo-Catholic theology viewed vanity and self-regard as spiritually dangerous. Pusey warned his followers that 'self-display, self-applause, deadens our inward life', while 'obedience, renunciation of ourselves and of self-will, deadness to the world's applause…is an increase of our hidden life.'[13] This religious injunction, coupled with her mother Frances's natural tendency towards self-effacement, caused Christina to worry excessively about her own motivations, both as a Christian and as an aspiring writer. This self-doubt was reinforced by Frances's frequent warnings against vanity, and her watchful regime in general. Where Gabriel and William's sex gave them the option of spiritual independence, eventually leading both to reject Frances's religion, Christina's duty was to obey. Maria accepted this absolute maternal authority, but Christina struggled with conflicted feelings which her mother's homespun homilies could not always remedy. Self-harming with scissors in response to a 'rebuke' from her mother was a gesture of inarticulate anger towards Frances as well as herself. She wrote a poem about 'St Andrews Church' in Wells Street, which she sometimes attended for its superior choir services. Even this brand of enjoyment was spiritually suspect:

Vanity enters with thee, and thy love
Soars not to Heaven but grovelleth below

Vanity keepeth guard, lest good should reach
Thy hardness...

She was writing depressing poems called things like 'Death' and 'A Hopeless Case', and it seemed as if a repeat of her breakdown might be about to occur. Her father was also undergoing another period of melancholy following over-optimistic forecasts that Italian liberation would arrive along with the spring. General Pepe had gotten his hopes up by writing that things were going so well in Italy that Gabriele would soon be able to return home, where a post would surely be created for him by the new Neapolitan government. When this did not come to pass, Gabriele was once again in despair. Recognizing that it did no good to expose an emotionally fragile Christina to his dark moods, Frances took her on a summer holiday to Brighton. Almost as soon as Frances left, her husband and son started squabbling again.

As Gabriel grew, so too did his father's difficulties in managing him. Consequently, he relied on Frances. 'Gabriel seems to think as much about doing my portrait for Mr. Lyell as I do about making a journey to the moon', he complained to his wife. Aside from a few tense sittings, after which Gabriel usually tore up his efforts and stormed out to see his friends, little progress was being made in his painting of his father. The painting had been commissioned by Gabriel's godfather, who was beginning to wonder when the promised work would be delivered. In a sleight of hand well-practiced by parents everywhere, the Rossetti patriarch held his spouse responsible for their son's bad behaviour: 'You did not do well to let him get those £10 from you; the money should not have been given to him until the work was finished,' he remonstrated. However, he was reluctant to be so stern with his son himself, and asked Frances to mediate: 'I say nothing to him for fear of some insulting reply.'[14]

Acting as intermediary between her critically ill husband and stubborn young son added to Frances's worries, which at the time the letter was written included Christina's first attack of neuralgia. 'Neuralgia' was a catch-all diagnosis for extreme, recurring nerve pain, normally presenting on one side of the face or in the head, but also occurring all over the body. Attacks could be set off by eating,

talking or even the touch of the breeze. Because this pain had no corresponding physical signs, such as lesions or swelling, neuralgia was difficult to diagnose and open to various interpretations. Often occurring in women, it was associated with hysteria, heightened emotions, melancholia, a sedentary lifestyle and over-exertion. Treatments for neuralgia included surgery and opium, but in Christina's case, it is likely that the less dramatic alternatives of blood-letting, diet modification, exercise and distraction would have been prescribed. Sea-bathing was also thought to help prevent attacks. To Frances, Christina's symptoms would have looked worryingly like a repeat of her breakdown two years before.

In the end, it wasn't the sea air that improved Christina's spirits, but her brothers. In Gabriel's opinion, his sister needed neither full-body immersion in the ocean nor affusions of sea-water poured on her head, but the two home remedies he found most effective: poetry and romantic love. When William arrived at Brighton to help cheer her sister, they passed the time by writing sonnets in a Rossetti family parlour game they called *bouts-rimes*, in which Gabriel participated by correspondence. His letters were saltier and more refreshing than the sea breezes. Strict time-limits and rhyme schemes were imposed, and each sibling set out to best the other. Her poems were always superior to William's, and the real contest took place between Christina and Gabriel. He hoped that the poetry contests would help enliven 'dreary snobbish Brighton'. Temperamentally similar, Gabriel and Christina were both prone to bouts of melancholy, brooding and procrastination. Gabriel had developed a capacity for self-mockery which helped guard against depression. He joked, for instance, that he and Hunt were going to start a Mutual Suicide Society, in which melancholy members would agree to cut each other's throats upon request. 'It is all of course to be done very quietly without weeping or gnashing of teeth,' he hastened to add. 'I, for instance, am to go in and say, "I say, Hunt, just stop painting that head a minute, & cut my throat"; to which he will respond by telling the model to keep the position as he shall only be a moment, and having done his duty, will proceed with the painting.'[15]

Newly inspired by family competition, the siblings rushed to beat one another into print. Although Maria had beaten them before in

the arena of private printing, she appears not to have taken part in the sonnet contests, or in poetry writing in general. It was becoming evident that the scholarly Maria did not have her siblings' creative impulse. Like her mother, she would remain admirer of poetry, but not an active practitioner. William too lacked the talent so obvious in Gabriel and Christina, though it would take him longer than Maria to admit it. Although his summer *bouts rimes* sonnets failed to impress, during the Rossetti race to publication, William turned out to be the dark horse. His 'In the Hill Shadow', a dramatic monologue spoken by a grieving father burying his dead daughter, appeared in the September issue of the prestigious *Athenaeum*. The poem's melancholy tone and grim mood are reminiscent of Christina's mournful verses, while its speaker's death-wish tips its hat to the Mutual Suicide Society: 'I am athirst / To follow her the way she went'.[16] The subject matter is also Christina's; her 1847 *Verses* contained several poems about young girls dead and dying, such as 'Lady Isabella', 'The Ruined Cross', 'The Martyr' and 'The Dead Bride'. Parental grief is addressed in Christina's 'Life Out of Death', where a dying girl begs her mother not to mourn because they will be reunited in heaven. William's description of the daughter in her grave as 'a young bird within the nest' also darkly echoes (perhaps unconsciously) his own father's poem about Christina and Maria as '...lovely turtle doves / In the nest of love'.

Gabriel was the next officially published poet, with 'My Sister's Sleep' appearing in the *Monthly Belle Assembleé*, after persistent lobbying on his part. He showed the poem to almost everyone in his circle, until Calder Campbell, a retired Major in the Indian Army, took the hint and passed it on to the editor of the *Belle Assembleé* who published it with a commentary. Like William's poem, 'My Sister's Sleep' also looks on death as a family matter. Set on Christmas Eve, the poem depicts a mother keeping a death-bed vigil at her daughter's side while the son looks on helplessly. Although it is credited as one of the first distinctly Pre-Raphaelite poems, its melancholy, sparse, plain language and air of resignation are the hallmarks of Christina's work, and show her strong influence on her brother's writing during this period, as does its pervasive religious imagery.

The Tractarian leanings Scott detected in Gabriel's work can be seen in the religious iconography and symbolism of 'My Sister's Sleep': the clouds which are hollow as an 'altar cup', the evergreen on the dying girl's windowsill which symbolises Christian faith, the figure of the praying mother which suggests a *pietá*. It is Gabriel's use of realistic detail that makes the poem feel authentic. He describes the mother's anxiously clicking knitting needles, the rustle of her silk dress as she stands, and the expression on her grief-stricken face: 'Lightly she stooped, and smiling turned; / But suddenly turned back again; / And all her features seemed in pain / With woe, and her eyes gazed and yearned.' Having watched Frances cope with Christina's extended illnesses, he knew what it was to observe a mother's agony over a sick daughter, which he described as: 'A moment that the *mind* may touch, / But the *heart* only understands.' This is no ancient alabaster Virgin Mary, but a recognizable woman in a modern setting. The poem shows that Gabriel was combining his life classes at art school with real-life studies of his domestic environment. The sound of knitting needles and the whisper of skirts were as much a part of his experience as the bronze doors of Ghiberti or Dante's *Inferno*. Growing up as part of the Rossetti family had taught him that women's domestic lives were as worthy a subject for art as religion or history.

Women in general were suddenly taking up more space in Gabriel's consciousness. As children, the Rossettis had snickered at the sappy romanticism of Coleridge's, 'Genevieve', but as a twenty year-old experiencing romantic stirrings of his own, Gabriel proclaimed the poem's perfection and drew an illustration for the Cyclographic Society. Grand passion was no longer something to mock; it was something to emulate. As a boy, he had avoided his father's copy of Dante's *Vita Nuova* because he fancied it glowed in the dark, but as a young man, newly enthralled by Dante's poems of courtly love for Beatrice, he began to find that glow rather enticing. Perhaps drawing from the naked female form was also helping to change his mind about romance. Having given up the tiresome still-life studies with Brown, he was sharing a studio in Cleveland Street with Hunt and attending life classes (drawing from nude male and female models) at the Maddox Street Academy, taught by Brown's friend Charles Lucy.

His Aunt Charlotte paid the tuition fees. She was under strict orders never to hand over any fee monies to Gabriel, but to forward the cash to Frances only. It was well-known among the family that money given directly to Gabriel tended to vanish. Fashionably dressed, confident and lively (she taught Maria to play billiards at Longleat), Aunt Charlotte had more money than any one else in the family. Her sophistication certainly made her a more appropriate source of fees than her sisters Margaret and Eliza, who might have been squeamish about financing nude drawing classes. Charlotte's social ease, sense of style and talent for making herself indispensable were among the many skills that made her a valued paid companion to Lady Bath. Gabriel was well aware of his Aunt's connections to the aristocracy, and he hoped Lady Bath might be persuaded to become a patroness of the arts. Gabriel always turned on the charm for Charlotte, sending her his poetry along with regular updates on his artistic progress, and thanking her profusely for financial support while at the same time suggesting that more money would not be unwelcome. He even went so far as to praise Charlotte's own dubious poetic efforts.

His interest in Charlotte's work was not purely mercenary, however. It was characteristic of Gabriel to encourage others, and as soon as 'My Sister's Sleep' was published he began nagging his younger sister to submit her poems. Ever with one eye on the market, Gabriel suggested the compelling titles which transformed her first published poems into companion pieces. Christina's 'Death's Chill Between' and 'Heart's Chill Between' appeared in the 1848 October issue of the *Athenaeum*. Grief, the death of love, and emotional pain were the subjects of all the Rossetti siblings' poems, which were so depressing that they might have been commissioned by Gabriel's Mutual Suicide Society. Yet it was the queasy anxiety of Christina's 'Heart's Chill Between' that had the ring of authenticity:

What time I am where others be
My heart seems very calm,
Stone calm; but if all go from me
There comes a vague alarm,
A shrinking in the memory
From some forgotten harm.

At this stage, the 'harm' was remembered in tranquillity rather than re-experienced, as publication was reviving Christina both personally and creatively. Like grandfather Polidori, her brothers recognised that writing was the best salve for her melancholy. William's success with the *Athenaeum* had encouraged her to submit her work. Although she never would have said so, she must have realised that if a mediocre talent like William could gain a foothold, surely she had a chance. Even the *Athenaeum*'s subsequent rejection of more poems because of Christina's 'Tennysonian mannerisms' could not dampen her mood.

Gabriel had yet another trick up his sleeve to help improve his sister's state of mind. He selected RA student James Collinson to be Christina's love-interest. He had come to Gabriel's attention when his painting, 'The Charity Boy's Debut' received favourable criticism at the 1848 RA Exhibition. The Rossetti women and Polidori aunts had already approvingly noticed the twenty three year-old at his devotions during services at Christ Church, Albany Street, even before Gabriel invited him to join the PRB. Like most of the other Brothers, Collinson was from a relatively humble background. His father was a bookseller in Nottinghamshire, and though he was given a decent allowance, it only stretched far enough for him to occasionally hire a model to paint from, and to maintain solitary lodgings in Somers Town. Bounded by the Hampstead, Pancras and Euston roads, this immigrant neighbourhood was considered rather seedy. Its population was comprised of political refugees primarily from France, but also Spain and Italy, and its low rents also made it popular with struggling artists. In Dickens's *Bleak House*, Somers Town is distinguished by 'a number of poor Spanish refugees walking about in cloaks, smoking little paper cigars.' Like *Bleak House*'s down-at-heel Mr. Skimpole, Collinson was a tenant of rooms in the Polygon, a fifteen-sided housing complex of thirty two homes, located in the centre of Clarendon Square.

While poverty and crime plagued his neighbourhood, it was also animated by a spirit of energetic Roman Catholic activism. There was an order of Carmelite nuns in Clarendon Square, and the St. Aloysius Catholic Chapel, with charity schools attached, was a two minute walk from the Collinson's rooms. St. Aloysius also organised soup kitchens and donation drives for money and goods for the local

poor. Motivated by an evangelizing drive, it promoted the Roman Catholic Church by encouraging conversions, mission work, and supporting the foundation of religious communities. Cardinal Wiseman, in England, was associated with St. Aloysius, and with community activity in Somers Town. A persuasive and dynamic activist, he would become the first Archbishop of Westminster in 1850 when the Catholic hierarchy was re-established. He organised Catholic retreats and missions, revived religious orders, and founded ten religious communities in England within a two-year period. Wiseman had also been responsible for confirming the Roman Church's most prized convert in 1845, the Rossetti sisters' beloved John Henry Newman.

Cardinal Wiseman fanned the flames of Collinson's own fervent Roman sympathies and, shortly before joining the PRB in 1848, Collinson converted to Roman Catholicism. Gabriel, a famous optimist, had imagined that Collinson's religion would be no bar to a potential union with Christina. Given his father's anti-papal hostility, glowing white hot during this period, it is surprising that Gabriel thought this match desirable. There is no record of the Rossetti father's response to this proposal, but it is hard to imagine it would be an entirely happy one, although it should be remembered that his own marriage was an example of successful interfaith union. Christina quickly turned down Collinson's proposal of marriage, which, encouraged and possibly initiated by Gabriel, may not have been the most persuasive of offers to begin with. The reason she gave was Collinson's Roman Catholicism, but the proposal had also taken her by surprise, and she had not at that stage developed particular feelings for her brother's friend.

To everyone's astonishment, Collinson said he was willing to re-convert to Christina's religion. William worried that his sister felt herself honour-bound to accept Collinson's proposal on this condition. We do not have Christina's words about her change of heart, but other factors certainly would have contributed to her decision. The attentions of the young painter must have been as flattering as they were surprising. The Rossetti children had been taught to admire the artistic impulse in others, particularly where it expressed itself in the appreciation of the Rossettis. When Collinson painted a portrait of his pretty eighteen year-old fiancé, and proudly showed it

off to relatives in Mansfield along with a copy of her *Verses*, it seemed that the longed for love-object of Christina's melancholy poems had at last appeared. Pressure from her beloved eldest brother may also have been a factor in Christina's change of heart. Gabriel actively campaigned for this union between his Pre-Raphaelite 'Brother' and his sister, lobbying Christina on Collinson's behalf. Smart, charming and clearly headed for success, Gabriel was a brother worth listening to. From his father, Gabriel had learned the benefits of blurring the boundaries between friends and family, and here was a chance to erase that boundary together. Romance may also have been seen by the family as an antidote to Christina's depression, while the prospect of a married future meant one less economic dependent at home.

As William suspected, Collinson's Roman Catholicism was not the only obstacle to a happy union with Christina. His re-conversion to the Anglo-Catholic faith did not eliminate other problems with his character, not the least of which was the indecisiveness which led to the conversions in the first place. Shy, reticent and by all accounts a little dull, Collinson was hardly the type to send a young woman's heart fluttering. William described him as thick-necked and small. Holman Hunt referred to him as the 'forlorn-hoper', and others were frustrated by his introversion, lack of enthusiasm and ineptness at reading outloud. The reluctance of this 'meek little chap' to join in PRB midnight rambles and hijinks tested the groups' collective patience, but Gabriel would not abandon the man he insisted was a 'born stunner'. Every group needs a scapegoat, and the tiny, timid Collinson, with his pious prevarications about everything from romance to religion was perhaps the best candidate. The Brotherhood's scorn for Collinson may also have been related to his religion. Perceived as an off-shoot of the Roman Catholicism to which Collinson had formerly subscribed, Anglo-Catholicism was frequently critiqued by the mainstream on the grounds that it was effeminate. Its womanly promotion of celibacy and virginity, fussiness about the details of religious costume and ritual, celebration of transcendent music and reliance on the emasculating practice of Confession offended Victorian standards of independent manliness. The language of the Brotherhood's critique of Collinson is very much in this mode. Hunt described him as 'meek', 'little', 'tame', 'bashful', 'lachrymose', while William Rossetti found him

'small', 'timid', 'not strong enough', 'modest and retiring'. Bell Scott criticised his painting technique as 'feeble in the extreme' and 'flaccid and weak'.[17] Anecdotes about Collinson paint him in contrast to the prevailing mode of PRB blustery, self-conscious manliness. While the others enjoyed rousing the ire of a passing policeman with their night-time jollity, Collinson begged to be allowed to remain in bed. Where his Brothers competed with each other in dramatic renderings of Browning and Dante, Collinson was not at all adept at reading out loud. While the rest of the painters bragged that they frequently stayed up all night talking or working, Collinson's preference for sleep was so marked that he regularly dozed off in company.

If these young men were at all anxious about spending all day painting and reading poetry, the meek and mild Collinson would have brought out their worst insecurities about their own masculinity. Collinson's apparent lack of virility may also explain why Gabriel selected him as a good potential husband for Christina; this timid man was unlikely to cause his sister any trouble, nor would he ever pose a challenge to Gabriel's position as the dominant head of the Rossetti family.

His little sister was obviously on his mind that summer and autumn. The new poem he showed to Brown, Bell Scott, Aunt Charlotte and anyone else who would look was 'My Sister's Sleep.'

His family, at this period, were Gabriel's greatest inspiration. The first full oil painting he completed was a head of the eighteen year-old Christina. She looks out at the viewer, her prettiness made interesting by the earnest, direct gaze of her gray-blue eyes. A domestic study of mother and daughter was also the subject of his first major oil painting, *The Girlhood of Mary Virgin*. Christina and Frances modelled for the Virgin and her mother, St Anne, making the family connection even more explicit than it had been in 'My Sister's Sleep.' Interestingly, he did not use his own father as the model for the Virgin's father St. Joaquim, but instead drew Williams, a Welsh ex-policeman who worked as odd-job man for the Rossettis. After the Lyell portrait fiasco, his father may have been fed up with posing for his son, or perhaps Gabriel couldn't resist the temptation to paint his interfering father out of the family picture altogether.

As in his poem, 'My Sister's Sleep', Gabriel's painting combines

the realistic with the symbolic. His goal was 'to attempt something more probable and at the same time less commonplace', and so he chose to portray the Virgin Mary and her mother engaged in an every-day domestic activity.[18] In the foreground, the seated Virgin is embroidering a white lily on a red cloth as her mother keeps a watchful eye on her progress. The Virgin is copying the lily from life, and the flower is being tended by a child-sized angel. The lily is growing from a pot which rests on top of a pile of books labelled in Latin with the Christian virtues. Through a window-like aperture in the background, St. Joaquim is seen standing in profile, trimming a vine. The picture is so loaded with religious imagery and symbolism, from the lily, rose, ivy and palms to the haloed dove sitting on the lattice, that viewers would have been forgiven for linking Gabriel with the Anglo-Catholic revival.

Betraying his reluctance to give up poetry, Gabriel wrote two explanatory sonnets to accompany the painting. One was written on gold paper and affixed to the frame while the other was printed in the exhibition catalogue. His poetic impulse breaks out all over the picture: Latin inscriptions appear on the books, the bench and the scroll wrapped around the palms, while the saints' names hover in gold over their haloes. The young painter was not as immune to the religion of his mother and sisters as has often been suggested, although his Christianity was more aesthetic than spiritual. According to his brother, by this period he was already a religious skeptic. When Gabriel (infrequently) attended High Church services with his family, he was in effect conducting market research. As the commercially savvy artist explained to his godfather, he intended his first painting to belong to a certain 'religious class' which would 'interest the members of a Christian community.'[19] Women made up the majority of the 'Christian community' he knew best, and this was a painting calculated to appeal to this audience. It enshrines a mother-daughter relationship and sanctifies the ordinary activities of the female sphere. Traditional female values of cooperation, teaching and nurture are lauded; the father is not central, but is relegated to the outdoors. The picture even hints at female artistic accomplishment as the Virgin embroiders a lily from life, much as a Pre-Raphaelite Brother might paint a flower from nature.

Although there was some talk of submitting *The Girlhood of Mary Virgin* to the RA exhibition of 1849, in the end Gabriel showed it at the Free Exhibition at Hyde Park Corner in March, which preceded the RA exhibition by over a month. He claimed that he wanted to bypass the RA selection process, but Hunt and Millais were dubious, pointing out that this effectively meant Gabriel was stealing their Pre-Raphaelite thunder because of the enigmatic 'PRB' initials which appeared alongside the artist's signature on the painting. Their pictures also displayed the PRB monogram, but would not be seen until May. It was a moot point in any case, as the critics failed to notice the initials on any of the group's contributions.

Gabriel's painting was reasonably, if not rapturously received. He got a good write-up in the *Athenaeum*, and no one raised Scott's fears about Gabriel's Tractarian sympathies. The purchaser, however, would almost certainly have confirmed them. Gabriel's market research paid off when Aunt Charlotte's employer, the Marchioness of Bath, gave him £80 for the picture. While it is entirely unsurprising that Gabriel's first sale was a family concern, it should not be overlooked that it was a religious matter as well. Lady Bath was a prominent and devout Anglo-Catholic, and she had warmed to the painting's reverent subject. She valued the supportive femininity the painting celebrates; not only did she make her daughters' ex-governess a permanent fixture in her household, she also frequently invited Christina and Maria to spend time at Longleat. If Christina spotted any incongruity between her reservations about 'self-display' and modeling for a painting which hung in a public gallery and then a private home, she kept quite about it.

The Rossetti family's appeal clearly was not limited to blood relatives during this period; it inspired all of the Pre-Raphaelite Brothers. Like Gabriel, Hunt and Millais used the Rossetti family as models for their RA submissions, which were hung side by side. Both men chose Italian stories for their subject matter. Hunt's *Rienzi* was inspired by a Bulwer-Lytton novel about mistreatment of the common people at the hands of fourteenth century Italian nobles. After his brother is killed in a feud between nobles, the plebian Rienzi cradles his corpse and vows to the heavens that he will have justice. Hunt chose the Rossetti brothers to illustrate this dramatic moment, though

naturally Gabriel posed for Rienzi, the focus of the picture. William was Adrian di Costello, the knight on the far left who tries to comfort Rienzi. Hunt used the brothers because he felt their features were racially correct, but also because of their perceived closeness to the cause of Italian freedom, a subject brought to his attention by the Rossetti family. 'Like most young men, I was stirred by the spirit of freedom of the passing revolutionary time,' he explained.[20]

Although Millais's setting was also Italian, he chose William as the focus of his picture. Based on Keats's poetic interpretation of Boccacio, his *Lorenzo and Isabella* shows the titular ill-fated lovers sitting at a crowded table with Isabella's brothers, who later will murder Lorenzo. William is the vulnerable, doomed Lorenzo, who gazes at Isabella with unguarded admiration. Far down the table, the guest draining the dregs of a glass of wine was modelled on Gabriel.

The Italian connection is also evident in James Collinson's contribution, *Image-Boys at a Roadside Alehouse*. It shows a group of Italian plaster-cast vendors grouped around a table on which are displayed small casts of Pio Nono, Napoleon and Joan of Arc, among others. These Italian street-sellers are a far cry from the refined Rossettis, and are more representative of the down-at-heel immigrant population of Collinson's Somers Town neighbourhood. Collinson's inclusion of Pio Nono (Pope Pius IX) is interesting here, as he was the subject of passionate denunciations in the Rossetti house after his support for Italian unification crumbled under the pressure of the 1848 revolutions. The presence of Pio Nono probably reflects the painter's involvement with Nicholas Wiseman, a trusted friend of the Pope who would make Wiseman Cardinal one day. Pio Nono's presence also points to Collinson's lingering Roman Catholic loyalties, despite his recent re-conversion to the Anglican Church for Christina's sake.

In all the excitement of 1848, it was easy to overlook William's accomplishments, and almost everyone did. His own reserved nature, learned at his mother's knee, was partially at fault. While Gabriel sent out poems, charmed editors, asked for money, and bullied his way into shared studio arrangements, William was content to operate from behind the scenes. Despite Gabriel's encouragement of his artistic abilities, none of the other PRBs believed William would ever become a good painter. He took a few drawing classes, but as Holman Hunt

observed cruelly, he was already too old to make a start in painting. Balanced, meticulous and cautious, he shared neither his older brother's unshakeable self-belief nor his talent for self-promotion, and in fact had grave doubts about his own ability. In an era that enshrined Romantic 'genius', and expected its artists to have a touch of Byronic glamour, the prematurely balding, quiet William never had a chance, and he knew it. 'I obviously was, and I remained, an outsider,' he admitted.[21]

William also felt alienated from his work at the Excise Office, whose routine, mechanical duties depressed him. He tried hard to be amused by the habits and eccentricities of his work colleagues, which in truth were either generic or ghoulish, such as the old man in knee-breeches who was always late to work because of his penchant for watching 'gallows-birds' swing at public hangings. Some men had short tempers, some were inefficient workers, some had pimples, some were drinkers and some had too many children. William never developed friendships with these stereotypically dull account men. In fact, they acted as cautionary tales and his boring day job motivated him to work hard at his career in the arts. Procrastination was anathema to William, who had to make the most of every available scrap of time to keep up with the other PRBs. In many ways, he took Pre-Raphaelitism more seriously than the others. He used his holiday on the Isle of Wight to begin a long poem about the titular 'Mrs. Holmes Grey', a married woman who dies after being rejected by an old lover. Her story is told first through the narration of her distraught and vengeful husband, and then through a blank verse rendering of a coroner's inquest into Mrs. Grey's death in a newspaper. William intended his poem to reflect the principles of Pre-Raphaelitism, but he took 'truth to nature' and close observation of detail in a more modern direction than his Brothers. Flashes of the creative imagination which kept William apart from his office colleagues are visible in the creepy, scandalous subject-matter and surreal imagery such as, 'An Englishman's a centaur of his sort, / Man cross-bred with an umbrella'. Although it is unknown whether 'Mrs. Holmes Grey' is based on a true story, in recognizing the poetic potential of a contemporary newspaper report, William's poem anticipates Tennyson's 'Charge of the Light Brigade.' The interaction among witnesses, coroner and jury also looks forward to the court-room drama.

The figure of the dead woman on display is a common trope of Gabriel and Christina's poems of this period, but William's description of Mrs. Grey's corpse, with its 'hair, which caught the light within its strings' and mouth 'that kept its anguish, and the lips, / Closed after death, seemed half in act to speak' is more immediate and less idealised that the beautiful, saintly dead women of his siblings' poems. There is also a notable lack of judgment or moralising in the tale which is unusual for the period. Everyone in the tale has transgressed in some way, whether it is Mrs. Holmes Grey in her adulterous feelings, her reluctant lover in his rejection of her, or her husband in his vengeful obsession with ruining the lover. William's epigraph, from Edgar Allen Poe, tells us that this moral ambiguity is deliberate: 'Perverseness is one of the primitive impulses of the human heart; one of the indivisible primary faculties or sentiments which give direction to the character of man.' Despite his high-minded ambitions for his characters, William's inexperience in such adult affairs meant that his story came across to others as melodramatic and two-dimensional; one friend even mistook the poem for a comic one. 'Mrs. Holmes Grey' did not earn the others' respect, and never appeared in the PRB journal; even the encouraging Gabriel joked to Stephens about William's 'poetical perpetrations, which he intends on inflicting on…the brotherhood'[22]

William readily confessed to Bell Scott that he lacked the 'extended experience of real life' needed to create convincing characters.[23] Why then, did these unknowable adult themes interest William? Perhaps the answer lies in the arena of William's experience that his Pre-Raphaelite Brothers knew little or nothing about: work. At the time, he was mulling over the predicament of a work colleague who had been accused of poisoning his mother. A lack of evidence meant that the man was acquitted, but the Excise Office used revelations about the man's unseemly personal life that had come out during the trial as an excuse to fire him. Newspaper coverage meant that some of these were public knowledge. Although William disliked his colleague personally, he felt that this dismissal was unfair in principle because the man had been found innocent. The combination of trial, newspaper publicity and his own conflicted feelings about his colleague's fate may have found expression in 'Mrs. Holmes Grey', which is notable

for its lack of heroes or heroics, and its uneasy inability to locate any clear distinction between victim and perpetrator.

During his tenure as PRB secretary, William worked hard at his own drawings, composed poems, wrote letters to promote the group, maintained a diary of its activities, kept the minutes of its meetings, and recorded its plans and aspirations. While Gabriel inspired the other PRB members creatively, William's skills as a time and man-manager got them organised, and he was almost solely responsible for getting their literary project, a magazine on art and culture called *The Germ*, off the ground. William, whose adolescence had been cut short by the demands of full-time employment, was finally enjoying himself. Whether taking moonlight walks by the Thames, being introduced to Tennyson at the house of the poet Coventry Patmore or enjoying a pipe and a glass of beer with his Brothers, William felt that he was a part of something wonderful and exciting, even if he felt he was not destined to be a great artist himself. 'Those were the days of youth,' he would later remember, 'and each man, even if he did not project great things of his own, revelled in poetry or sunned himself in art.'[24]

Despite continuing financial difficulties, in many ways things were looking up for the Rossettis. Gabriel had sold a painting and had started another on the subject of the annunciation, with Christina once again posing as the Virgin Mary. When William modelled for the angel Gabriel, it was clear that this new painting would also be a family project. As for William, he was gainfully employed at the Excise Office and intellectually satisfied by his association with the Brothers. Maria had been able to find enough governessing work in London to allow her to live permanently at Charlotte Street, far from the dreaded Thynne children, who Gabriel joked had been 'beastly brats' who needed to be kept in line with a bamboo. Having come round to Collinson as a suitor, Christina was not only happily engaged but was also writing and publishing good poems, though they still borrowed from the darker side of human experience. This was the period during which she wrote one of her most famous poems, 'Song', which begins:

When I am dead, my dearest
Sing no sad songs for me;

Plant thou no roses at my head,
Nor shady cypress tree:

The Rossetti father, while not exactly in the pink, had not significantly deteriorated, and Frances was relieved to have all her family together again in London. This fragile peace was not to last. Towards the beginning of 1849, Gabriele had worried that 'poverty…is knocking at my door and threatening to make a violent entry, and I see no means of driving it away.'[25] Gabriele and Frances had achieved their parental goal of producing four accomplished, intelligent and cultivated children, but with the exception of William, they had not taught them how to keep the pot boiling. Sustained by a network of informal connections and part-time employment, the Rossetti family belonged, to borrow Zuzanna Shonfield's phrase, to the category of the 'precariously privileged'. While they were socially cultivated and well-educated, they had no significant savings or financial security to see them through difficult times, and they lived largely through a combination of patronage and hope. As Lyell had predicted, the next few years would see all the Rossettis 'hungry and calling out for their macaroni.'

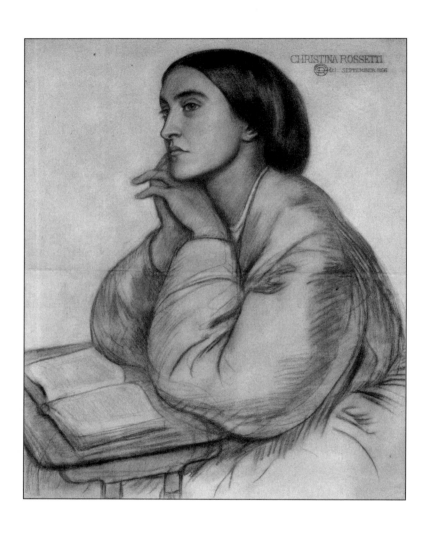

Dante Gabriel Rossetti, portrait of *Christina Rossetti*, 1866

Though Christina was the more beautiful and talented Rossetti sister, she was also the least confident.

5

DANTE DRAWING AN ANGEL: THE ROSSETTIS IN LOVE

As the decade turned, death returned to plague the Polidori side of the family. The glamorous Harriet Pierce, who had always helped the Rossetti family out with frequent luxury treats and gifts, died in 1849, leaving her favourite niece Frances a sizeable bequest and making her residuary legatee. But a technical problem invalidated the will, and in the end Frances received only a fraction of her expectations. Harriet's death also meant that Frances lost a valuable source of emotional and social support. Although she was prone to insensitive, queenly pronouncements about the size of Maria's nose and Gabriele's teeth, Harriet had provided a much-needed sense of lightness and fun, earning her the nickname 'granny' from the children. She had been more of a grandmother to the Rossetti children than the bed-ridden Anna Maria Polidori, into whose hushed chambers they were infrequently ushered to pay their dutiful respects. Harriet had adopted a motherly role with Frances, complete with interfering criticism as well as sage advice, and she would be sorely missed for more than her money.

To add to Frances's worries, Christina was showing symptoms of her customary melancholy, and her old tetchiness. Her famous childhood temper was reasserting itself, this time in the guise of frosty sarcasm rather than outright hostility. Perhaps the long engagement to Collinson was beginning to play on her nerves; her young fiancé

relied on his brother for his allowance, and would not have the means to support a wife for some time. After the death of Harriet Pierce, Christina was quietly packed off to stay with a friend of her mother's in Clapham, ostensibly to better her health, but probably also to give the grieving Frances a small holiday from her daughter's moodiness. Never one to stray far from home, Christina characterised her time away as a banishment. She wrote grumpily to William about the weather and the round of tedious morning-calls and local outings her mother's friend forced her to endure. She joked that she was considering stealing a donkey from Clapham Common and making a break for freedom. This unsuccessful springtime visit was followed by an even more unsatisfying summer stay with Collinson's family at Pleasley Hill in Mansfield, Nottinghamshire. Bizarrely, Collinson himself was painting in the Isle of Wight during his fiancées visit, so Christina had to content herself with the company of her prospective mother and sister-in-law. While the other women gossiped about boring subjects such as local affairs and *beaus*, she let her mind wander. 'In my desperation I knit lace with a perseverance completely foreign to my nature,' she confessed. She begged William for news of the PRB. 'Ah Will!' she wrote, 'if you were here we would write *bouts-rimés* sonnets, and be subdued together.'[1] Even these feeble attempts at humour soon soured. Neglected by Collinson and stranded far from the Pre-Raphaelite excitement in London, Christina allowed her wit to turn cruel. 'She is reckoned to have been very pretty in her youth, but of this fact, I have my doubts,' she wrote of Collinsons's widowed mother. His sister Mary, whom she had at first liked, was described thus: 'it is impossible to pronounce whether she would have been good looking, as her face is much disfigured by an eruption. She plays and sings a little, but has no pretensions to being a musician. To complete her portrait, she is past 30.' The last remark was a particularly catty swipe at Mary's spinsterhood.

These displays of insensitivity and sharpness, although probably aggravated by social anxiety, were not isolated incidents. At eighteen, Christina was widely regarded as a 'marked personality.' She was becoming increasingly self-conscious about her own behaviour, berating herself for displaying 'unlivable-with politeness' when she passed Holman Hunt on the stairs at Charlotte Street and felt too awkward

to say hello.[2] Painter and fellow church-goer John Clayton noticed that sometimes a startling passion would break through Christina's habitual reserve and she would speak with a 'great vigour and energy.'[3] Around this period, Thomas Woolner observed that Christina could be combative, while several of her friends made negative remarks about her pride and hauteur. Her competitive spirit came out during her visit to the home of Collinson's brother Charles, where she did not disguise her delight whenever she beat him at chess. Letting her host win to spare his blushes at being beaten by a girl never occurred to her. She was hurt when one friend accused her of responding to others with 'self-respect' rather than 'fellow-feeling', and wrote a poem in rebuttal. The final stanza of 'Is and Was' describes a misunderstood 'noble lady' with a 'calm voice' whose reserve is mistaken for a pride:

> Yet you think her proud;
> Much too haughty to affect;
> Too indifferent to direct,
> Or be angry, or suspect;
> Doing all from self-respect.

This lady's observer is fooled by her haughty façade, which conceals turbulent feelings of sensitivity, anger and suspicion. Strong passions bubbling under an impenetrable surface is a variation on one of Christina's favourite themes; the 'fountain sealed' and the 'well shut up.' Probably for fear of being further accused of displaying 'self-respect', she never published it in her lifetime. William, however, had no reservations about publicly defending his sister's 'self-respect'. He published this poem after Christina's death, along with the anecdote about her friend's comment, and assured readers Christina had been hurt by the critique. Having been asked to give up further education and his dreams of becoming a doctor for the sake of supporting his elder brother's artistic career, William knew all too well the effort it took to suppress true emotions.

Unfortunately for the talented Christina, pride, self-expression and self-respect were regarded as exclusively male privileges. When they did bubble over, Christina's passions and eccentricities were not afforded the benevolent indulgence granted to Gabriel, or to the

rest of the Brotherhood, who could be no less opinionated, sarcastic or difficult. Holman Hunt for example, was laughingly nicknamed 'Maniac', and all of the Brothers frequently sent each other up in rude poems, sketches and letters. They bitched behind each other's backs and picked on the weaker, less conventionally masculine members like James Collinson.

As in childhood, Christina was reprimanded for behaviours that were indulged in her eldest brother. She struggled under the double-standard that meant Gabriel could hawk his productions, air his opinions and travel alone with impunity, while she was socially policed for any signs of dangerous independence, vanity or 'display.' There were cultural as well as familial reasons for this state of affairs. In 1849, there was no template for the female poet as there was for the male artist. Elizabeth Barrett Browning had articulated this problem four years before when she lamented a lack of 'literary grandmothers' for women writers. There were many reasons why so few female role models had emerged in the world of poetry. Women had little access to formal education, let alone to artistic schools and the coteries they bred. It would have been unthinkable for financially depend- ent middle-class women to take working holidays together in the countryside, go on bracing midnight walks by the Thames, or lounge in each other's drawing rooms, sharing ideas and glasses of beer while the sun came up. She had never seen the sun rise in real life, but one night she dreamed that she and Gabriel were walking through Regent's Park at dawn. Just as the sun rose, brother and sister saw 'a wave of yellow light sweep the trees', and realised it was made up on 'a multitude of canaries'. In her dream she understood 'that all the canaries in London had met, and were now returning to their cages!' Like Christina, these domestic London birds could only experience freedom and release in dreams.[4] When she told Gabriel about her dream, he promised to immortalise it in a painting. Christina would be wearing yellow to match the canaries in the sky and the primroses under her feet. Like many of Gabriel's promises, he never followed through with it, but his enthusiasm shows that he was a supporter of his sister's dreams.

Christina was permitted to participate vicariously in PRB activities through Gabriel and William, who either did not see or refused to see

her gender as a bar to her inclusion. Pre-Raphaelite associate John Clayton observed that both of her brothers, and Gabriel in particular, were 'adorers' of their sister.[5] Her status as Brother's fiancée and a Rossetti sister allowed her freedom of movement within this very male group, effectively forestalling any accusations of impropriety. Gabriel tried very hard to talk her into closer formal association with the PRB. He was encouraging about her poetry and he used her as a model, though this activity was not considered respectable at the time. William sent her updates on the group's activities, asked her advice and involved her in the production of the PRB literary magazine, *The Germ*, to which she would be the only woman to contribute. On Gabriel's suggestion, she published under a name he'd seen in an old ballad, 'Ellen Alleyn', which suggests that her fear of display, or of openly associating with a Brotherhood, was still active. Even so, what Christina called her 'double sisterhood' was a considerable source of pride and excitement. In consequence, it was very painful for her to be confined at Pleasley Hill while all of interest to her was happening in London. While her 'Brothers' were travelling, painting and writing, Christina told William that she was listlessly planting currant slips in mud pies, an activity she was certain would bear no fruit. She didn't realise it at the time, but this unproductive activity was an apt metaphor for her visit to Pleasley Hill.

Perhaps Christina had overestimated her talent at concealing her distaste for Collinson's female relatives. Shortly after her return to London, she received a letter from Mary Collinson requesting that their correspondence cease because she felt her 'brother's affairs' were 'so unpromising as to render our continuing to write to each other not pleasant.'[6] Whether Mary was motivated by personal dislike, genuine worry about Collinson's finances, or by foreknowledge of her brother's intentions toward Christina, the letter did not bode well for the couple's future union. Although Christina tried to downplay her response as 'surprised' at Mary's 'extraordinary' wishes, she must have been truly alarmed at this development, or at the very least embarrassed to contemplate the possibility that her company had been no more enjoyed by the Collinsons than she had enjoyed theirs. Christina was learning that the Rossetti family values of competition, culture and accomplishment were not universally shared, and must

have had the sneaking suspicion that finding a mate was going to be more difficult than anticipated.

Gabriel was also having trouble with his love-life, although, unlike Christina's, his difficulties centered around his absence of a love-object rather than the presence of a reluctant one. Fortunately, he had his tour of Continental art galleries with Holman Hunt to distract him. In Paris, the two young men shouted exuberantly from the top of the cathedral towers of *Notre Dame*, praised the early Christian art at the Louvre, and admired the Luxembourg's Delaroche, Robert-Fleury, Ingres, Hesse, Scheffer and Granet paintings while dismissing the rest as 'trash'. As was to be expected with two young men in their very early twenties, their tour included low as well as high culture. They fell in briefly with some disreputable, bearded art students who vanished in response to a police inquiry. Paranoid that this association would draw the authorities' attention to themselves, Gabriel and Hunt feared the worst when they were halted in the street by a strange man. Their panic turned to delight when the close-shaven stranger revealed his true identity as one of the art-student fugitives.

As well as attending the theatre, they also were spectators at a can-can. The sonnet Gabriel sent to William describing the performance expresses the young man's ambivalence about such frank sexual display. The poem compares the French dancers to a horse, a dog, a cat, a beast and a cow, commenting on their 'nasty backsides', 'bitch-squeaks' and 'heated quims'. Gabriel complained that French girls were ugly, and that William would be amazed at 'the females, the whores, the bitches – my God!!' Realizing that such 'emphatic' material would hardly meet with Frances's approval, he warns William to conceal his letter from the family.[7] Gabriel's casual misogyny reflects not only a conformist Victorian aversion to displays of female sexuality, but also a young man's self-consciousness about his own uncomfortable sexual response to such provocation. His strong language and sentiments belie his claim of imperviousness to the eroticism of this spectacle. His purported disgust for the can-can dancers co-exists with the need to record their antics in close, somewhat breathless detail, and to share those details with his brother. Gabriel's aversion to the dancers was also a question of erotic taste; his literary heroes like Dante and Keats exhorted idealised, ethereal women, rather than the more earthy,

carnal variety. This attitude to women was reinforced by his religious training. During their Paris trip, Hunt commented on Gabriel's 'greater respect for [Christian] dogma', which also informed his stated preference for reserved, virginal womanhood over obvious sexuality.[8]

More surprising in some ways is his xenophobia, reflected in his characterisation of Parisian women as domestic animals, whores and bitches, and in his claim that London girls were vastly superior in beauty. This jingoism continues throughout his European tour, where Gabriel finds 'The English are victimized to a beastly extent everywhere'. In Brussels he is disgusted by the natives' 'most servile aping of the French'.[9] This English chauvinism is curious in a young man who revered European art, and whose own heritage was three-quarters Italian.

It is debatable whether Gabriel was conscious of his good fortune in being able to holiday in Europe while his family struggled financially at home. As the eldest Rossetti boy, privilege was his due, and he seems simply to have accepted it, without a sense of debt. His father, for example, had given him various letters to deliver to some old Continental friends, but Gabriel failed to shepherd even one missive to its destination. He was living off a combination of 'loans' from Frances and the Polidori aunts, and was not above touching up his friends and William for ready cash, which he called 'tin.' Although William was doing well at the Excise Office and would be making £100 pounds a year by 1850, it was still not quite sufficient to support the whole family, let alone his brother's expenses. At one point, the Rossetti brothers had only one good pair of evening trousers between them.

William, who would grow to enjoy Continental travel far more than anyone in the Rossetti family, must have felt a stab of envy when reading about his brother's European adventures. He was in the unenviable position that his own mother had experienced in relation to her more glamorous and favoured brother John. Just as the young governess had lived vicariously through John's anecdotes about gathering around the fire with the Shelleys, William's only experience of Europe came second-hand through Gabriel's letters. Walking the native sands of the Isle of Wight with the tame James Collinson was a far cry from admiring the Van Eycks and Titians at the Louvre, or rating the female populace with Holman 'Maniac' Hunt. Organizing

the first issue of the PRB journal, writing poetry and being on holiday from the onerous duties of the Excise Office was fulfilling enough for William, for the time being, although he did sometimes chafe under these responsibilities, particularly where the unappreciative PRB were concerned. William's status as a PRB who was not an artist obliged him to handle less glamorous, more administrative matters, and sometimes made him feel like an outsider. He wrote pointedly to Stephens, 'I speak solely from an outward point of view, as an observer. Again.'[10]

When Hunt and Gabriel returned from abroad, they contemplated sharing a studio again, but Hunt had lost patience with Gabriel's lackadaisical working methods and frequent, unscheduled visits from friends. Gabriel took a studio in Newman Street, close to Oxford Street and Fitzroy Square, while Hunt chose the less entertaining, but more responsible Collinson as a studio mate, and moved his things into his Brompton lodgings. Hunt's time with Collinson was no more successful. Hunt felt Collinson's subjects were thin and lacking in imagination. He particularly disliked his painting of the medieval martyr St. Elizabeth of Hungary because Collinson had violated the Pre-Raphaelite principle of truth to nature by depicting the interior of a modern church rather than a medieval one. Hunt's dislike of the subject may also have been related to its Roman Catholicism, towards which Collinson was inclining again during this period. His new neighbourhood, whose low rents attracted actors, singers and artists, was as Catholic as Somers Town; the London Oratory of St. Philip Neri, a religious community of Catholic priests and lay brothers, had just settled in this Kensington parish, and its presence would give rise to the famous Brompton Oratory, the second largest Roman Catholic Church in England (after Westminster Cathedral). In the same year that Collinson's old Catholic mentor Nicholas Wiseman was promoted to Vicar Apostolic of the London District, Collinson found himself once again struggling with his religious faith. Hunt observed that Collinson's sleeping-patterns were becoming more erratic. He complained every morning of insomnia and regularly fell asleep while painting during the day. 'In his personal life the painter seemed less awake than ever,' Hunt noted prophetically.[11] Mary Collinson might have had some notion of her brother's inclinations toward Rome in

this period, which may have been behind her decision to stop communicating with Christina.

By the turn of the year, Christina sensed that something was wrong with her fiancé. While staying with her Aunt Charlotte at Lady Bath's grand estate at Longleat, she anxiously probed William for information, but received no direct communications from Collinson, who was almost as cold as the January weather. Her letters to her friend Amelia Barnard Heimann were full of forced cheer. She mentioned a servants' ball which she might attend, and the kindness of everyone in the household. The picture she presented to William was much bleaker. She spent her days shivering in a blanket shawl, wandering the cold, echoing halls and galleries of the great house, once in a while venturing a stroll around the grounds or a visit to the hot-houses. Longleat was famous for its beautiful park and stunning scenery, but these failed to impress Christina who, like Gabriel, derived more comfort and inspiration from city life. While she realised that the countryside was apt to make others 'gush poetry', it 'seems to influence me but little.' She wryly admitted that the cold weather 'can never fail to interest a well brought-up Englishwoman', and felt some sympathy with a glum, black-spotted yellow frog who was 'leading a calm and secluded life' in the garden. She begged William to tell her news of 'the one thing that *does* interest me', an oblique way of asking after Collinson, whose silence was becoming deafening.[12] William and Gabriel were evidently in contact with Collinson during that winter. They were in touch with him regarding magazine matters, and he was still attending and hosting PRB meetings. Both brothers admired his poem for *The Germ*, and William was convinced that Collinson's close personal ties to influential Catholics could be used to boost the magazine's circulation figures. If Collinson was hedging his bets with the Rossettis while he contemplated religious conversion, his own family were uncomfortable with the situation. That winter, his brother Charles followed his sister Mary's example in ceasing communication with the Rossetti family, a fact of which Christina was aware.

Aunt Charlotte did her best to raise Christina's spirits. As she had done with Maria, Charlotte distracted her niece by teaching her to play billiards, and trying to involve her with the social life of the household, for example inviting her to a ball. Although Christina

wanted to return to London, Charlotte encouraged her to see out the month of January at Longleat. Gabriel tried to take the edge off his sister's homesickness by sending her a jokey sonnet entitled, 'St. Wagnes Eve' (a pun on Keats's 'St. Agnes Eve'), which described a PRB meeting at his studio during which Collinson, predictably, fell asleep early. Normally, poetry could coax Christina out of her moods, but this time the strategy failed. Christina was not enjoying her stay. She fell ill again, and developed a persistent cough which meant she stayed indoors most of the time. Collinson's neglect took the shine off the poems she published in *The Germ*'s January issue. Christina did muster the energy to lobby Lady Bath about becoming a patroness of the magazine, but was politely turned down. Regardless, there was ample evidence of her support of the Rossetti family; Gabriel's *Girlhood of Mary Virgin* was hanging on the wall of her sitting-room, and Christina was sometimes to be found sulking beneath it.

The Germ could have used a patron. Despite William's heroic organizational efforts in getting it off the ground, the magazine's January and February editions had not sold well, to the point where each contributor owed over £1 to cover production expenses. Christina had predicted poor sales when she saw the first issue, suggesting that the 'heavy' contents be leavened with 'an amusing tale' in future.[13] She was absolutely right. One of the PRB's greatest flaws was its public high earnestness, which left it vulnerable to mockery and parody. The bloke-ish humour the Brothers exhibited in private nourished the group's spirit of youthful rebellion, but they suppressed it in public productions. It was different for Christina, whose humour was of the wry, sardonic variety that was easy to miss. In any case, an 'amusing' tale would certainly not come from her pen. The next poem she submitted, 'A Testimony', began, 'I said of laughter: it is vain. / Of mirth I said: what profits it?' All the poems she contributed were in a melancholic vein that was becoming her signature style. For instance, there was 'An End,' which began: 'Love, strong as death, is dead.' Gabriel, though he could be very amusing, had also contributed 'heavy' material. 'My Sister's Sleep' was complemented by a long autobiographical short story called 'Hand and Soul', about a Renaissance artist who paints his own soul when it appears to him in the form of a beautiful woman. William had written an earnest sonnet on PRB

principles which was so bewildering that Scott joked that 'it would need a Browning Society's united intellects' to decipher it.[14]

A few good reviews appeared, including one which Frances clipped out of *The Guardian* (and which William suspected was written by Patmore), but these came too late to save *The Germ*, whose last issue appeared in May 1850. Millais would claim years later that the magazine's focus on literature over fine arts meant that the painter-members had not benefitted from the publication. In some ways he was right, as the only person to benefit directly was William Rossetti, whose skills as a reviewer were noticed by the editor of *The Critic*, who asked him to contribute art and literary reviews to this American periodical. The position was unpaid, but William was canny enough to understand that building up his reputation as a critic might lead to more profitable assignments. By November, he would be in post as a salaried art critic for the *Spectator*.

Even if the release of the final issue of the *Germ* had been greeted with enthusiasm, it would have been dwarfed by the attention the press gave the PRB in the spring of May 1850. Once again, Gabriel stole a march on Hunt and Millais, exhibiting his oil painting *Ecce Ancilla Domini* and watercolour *Rossovestita* at the National Institution, Portland Gallery in April, a month before the RA Exhibition. This time, he received mixed reviews. According to the *Athenaeum*, *Ecce Ancilla Domini* was 'an example of the perversion of talent which has recently been making too much way in our school of Art and wasting the energies of some our most promising aspirants.'[15] The *Times* said the painting's 'hard Paganism' and 'flat Catholicism' made it look like 'a leaf torn out of a missal', but that the painter's passion just about counterbalanced its 'frozen fervour.' Deverell, whose *Twelfth Night* hung in the same room as Gabriel's painting, did not fare so well. 'His mannerism is more conspicuous than his genius,' the *Times* reviewer noted, taking him to task for painting 'common' faces. [16]

This snide remark paled in comparison to the critical drubbing Hunt and Millais received for their RA exhibition pictures. This was partly because by May, the PRB initials had been rumbled by the press, who took a decidedly hostile position towards the idea of secret brotherhoods. Gabriel was behind the 'leak', having told his Scottish sculptor friend Alexander Munro, who promptly took

the information to his journalist friend Angus Reach. He broke the story in an *Illustrated London News* gossip column which sent up the Brotherhood as 'small-beer daubers' and 'practitioners of Early Christian Art' who depicted saints 'squeezed out perfectly flat – as though the poor gentlemen had been martyred by being passed under a Baker's Patent ironing machine'.[17]

Like his father, whose membership in secret societies had never prevented him writing about them quite openly, Gabriel was constitutionally incapable of discretion. He was also a self-publicist who had been disappointed when the PRB initials had failed to make a splash during their 1849 debut. He must also have realised that never showing at the RA might position him as too much of an establishment outsider. Revealing the PRB initials just as the London exhibition season kicked off gave him the best of both worlds. They suggested that his outsider status was part of an intentional, organised protest against the conventionality of Academy art, while simultaneously associating him with his 'Brothers' who did exhibit at the RA. His chances of getting his picture reviewed again were thus dramatically increased by his well-timed 'reveal.'

While Gabriel had been prepared for the hostility of the old guard to the new, he had not factored in religion to its response. Unfortunately for the PRB, all of whom had submitted Christian pictures, 1850 was the year in which religious controversy threatened to tear apart the English Church. The trouble had started with the resolution of the Gorham Controversy in March, two months before the RA exhibition. The case centered around George Cornelius Gorham, an Evangelical clergyman whose appointment to the vicarage of Brampford-Speke was blocked by the Bishop of Exeter because he objected to Gorham's views on the doctrine of baptismal regeneration. Gorham felt that baptism did not automatically result in salvation, but was conditional upon behaviour in life. The Bishop felt this was a Calvinist view which challenged the Anglican belief that baptism was necessary for the salvation of the soul. Gorham took legal action, and although the Bishop initially won the case, the decision was reversed in March 1850, and the vicarage was told it had to accept Gorham. It was a controversial decision on two counts: one; a secular, state-appointed tribunal had been permitted to interfere in a Church affair, and two; Tractarians viewed

the decision in favour of the Evangelical Gorham as expressing tacit Anglican approval of Gorham's position on baptismal regeneration.

The decision resulted in a flood of new conversions to Roman Catholicism, which worried not only Tractarians, but also English Protestants of all stripes. Since the Reformation, Roman Catholicism had been regarded with suspicion and it had not escaped anyone's notice that it was experiencing a resurgence in England. The influx of immigrants fleeing revolutions in France, Spain and Italy had swelled Catholic congregations, as had the Irish Catholics escaping the ravages of the 1849 potato famine. When High Church Anglicans started defecting in droves after the Gorham decision, it became clear that Roman Catholicism was also appealing to England's native population. 'Popery' and 'papal aggression' were condemned from the pulpits and in angry newspaper editorials, as many in England feared a return to the dominance of Rome. Because of their reinstatement of rituals, vestments, incense and Confession, the Tractarians were already suspected as being Roman Catholic in all but name, and their subsequent conversions after Gorham were seen as conclusive proof of their dangerous 'Romish' loyalties. Furthermore, the fear inspired by the European revolutions of 1848 was still alive in the English memory, and was rekindled by anxieties about 'papal aggression.' Secret 'Brotherhoods', with their connotations of state overthrow and revolutionary movements, were not likely to be looked upon kindly.

It was into this highly-charged atmosphere that Gabriel, Millais and Hunt released their new paintings, which suddenly looked less like a revolution in aesthetics, and more like a religious revolt. As art critic Alfred Boime notes, both Millais and Hunt's paintings boasted clay bowls of water and the figure of John the Baptist, into which critics of the day would have immediately read a commentary on baptismal regeneration. Hunt's painting, *A Converted British Family Sheltering a Christian Missionary from the Persecution of the Druids*, showed a missionary hiding from an angry pagan mob in the overcrowded hut of a family he has converted to Christianity. Hunt inscribed biblical verses on the picture frame. Millais's *Christ in the House of His Parents* portrayed Christ as a red-headed child holding up his palm to reveal an injury from a nail on Joseph's workbench. Mary, her mother St. Anne and Joseph comfort him, while a nervous-looking John the

Baptist hovers to right, carrying a bowl of water to wash the wound. A flock of sheep watch the proceedings through the open doorway. The religious paintings offended critics on several points. They were annoyed generally by the PRB's hubris in attempting a new art whose nebulous goals included truth to nature and sincerity. 'Affectation' rather than sincerity characterised the 'mountebank proceedings' of artists 'stimulated by their own conceit.' Their hard-edged realism was offensive, both socially and aesthetically. Gabriel's thin, red-headed Virgin Mary, cornered on her bed by the Angel in *Ecce Ancilla Domini!* looked frightened rather than beatific at receiving the news that she would bear the saviour of mankind. Red hair, with its Victorian connotations of Jewishness and unbridled sexual passion, would have been shocking on the Virgin Mary. In Millais's painting, the physiognomies of Christ's family, as well as their thinness and dirtiness, conform to Victorian stereotypes of the working class. Portraying a red-headed Christ as a member of the labouring poor was considered blasphemous, which was only to be expected from PRB painters who 'delight in ugliness'. Such ugliness is not true to nature. Rather, the PRB 'select bad models, and then exaggerate their badness till it is out of all nature.'[18]

The Art Journal shuddered at the Pre-Raphaelite desire to return to a time 'when Art was employed in the mortification of the flesh', while *The Times* thought that Millais's portrayal of the Holy Family was 'disgusting' and 'revolting'. The minuteness of detail in both Hunt and Millais was associated with a Roman Catholic fussiness and over-reliance on symbolism and ritual, and expressed 'intolerable pedantry' rather than truth to nature.[19] Charles Dickens agreed, finding in Millais 'the lowest depths of what is mean, odious, repulsive, and revolting.' He disapproved of portraying Christ as 'a hideous, wry-necked, blubbering, red-headed boy, in a bed-gown', and felt that Millais's Mary 'would stand out from the rest of the company as a Monster, in the vilest cabaret in France, or the lowest gin-shop in England.'[20] The working class foreigners swelling the ranks of Roman Catholics in England were stigmatised for both their religion and their poverty, and an art movement which took them seriously or suggested they were holy was dangerous. The artist Frank Stone, a close friend and neighbour of Dickens, condemned the Brotherhood

in similar terms in the *Athenaeum*. He singled out Gabriel as their leader: 'In point of religious sentiment Mr. Rossetti stands the chief of this little band.' He found all the painters' realistic portrayal of the human body offensive, and declared Millais's painting 'pictorial blasphemy.'[21]

The strong language of these critiques arose not only from an aversion to the portrayal of the Holy Family as working class, but also from very serious worries that the Pre-Raphaelites were promoting a Tractarian or Roman Catholic revival. In a letter about his Millais review, Dickens justified his condemnation on the grounds that 'without some vigorous protest, three fourths of this nation would be under the feet of Priests in ten years.'[22] Ralph Wornum of *The Art Journal* also worried that the Pre-Raphaelite painters, in reviving 'the miserable asceticism of the darkest monastic ages', were forwarding a Romanist agenda.[23] An influential and respected art critic, Wornum was also a committed member of the New Church of Emanuel Swedenborg, a branch of Christianity which taught that salvation was not exclusive to confirmed Christians, but was available to anyone who lived a virtuous life. In the Gorham controversy of that year, Wornum's beliefs would have put him firmly on the side of the Evangelicals and against the Tractarians and Roman Catholics. Although critics reserved their severest criticism for Millais, it was Gabriel who was explicitly identified as 'one of the high priests of this retrograde school.'[24] Holman Hunt's father held Gabriel solely responsible for the critical censure being heaped on the Brotherhood. He ranted that Gabriel's work 'provokes the common sense of the world' with its 'gilt aureoles and the conventionalisms of early priesthood, which we did away with at the Reformation.' According to Hunt, Millais's parents chiefly blamed Gabriel for the bad reception of their son's painting, citing Gabriel's indiscretion at revealing the meaning of the PRB initials, and his underhanded tactic of exhibiting before his Brothers. Millais's mother reportedly called Rossetti a 'sly Italian' whose actions were 'quite un-English and unpardonable.'[25]

There is also an unpleasant whiff of xenophobia in the focus of the media critique on the Brothers with foreign-sounding names (Rossetti and Millais), rather than recognizably English ones (Hunt and Collinson). It is ironic that James Collinson, the only member of the

Brotherhood who was seriously in danger of going over to Rome, was largely ignored by critics for his tame *Answering the Emigrant's Letter*. The critics of the *Times, Athenaeum* and *Art Journal* might have been surprised to learn that Collinson left the PRB because they weren't Catholic *enough*.

Shortly after the RA exhibition in May, Collinson resigned from the Brotherhood because he could no longer 'as a Catholic, assist in spreading the artistic opinions of those who are not.' No Brother was particularly devastated by this loss, and it appears that none tried to violate his final injunction: 'Please do not attempt to change my mind.'[26] Gabriel immediately suggested Deverell as Collinson's replacement, although he was voted down by the other members.

Collinson's resignation did manage to devastate Christina Rossetti. Although Christina was the one who called off the engagement, Collinson had effectively ended their relationship with his re-conversion to Roman Catholicism. Christina's heart-wrenching decision was, as William noted, consistent with the Rossetti family motto, *Frangas non flectas*. She had suffered through months of suspense as her fiancé wavered between religious affiliations, and now the crushing disappointment took its toll. Several months after their break-up, she saw him in Regent's Park and fainted away in the street. Art and literature had prepared the nineteen year-old for high romances in which lovers were separated by death, feudal conflicts, dark magic and even infidelity, but nothing had prepared her for a lover who would choose God over her. As a devout Christian whose religion would have obliged her to support his decision, she was even denied the cathartic fury or righteous rage that would have attended a more mundane cause for Collinson's exit. William writes that Collinson's decision 'struck a staggering blow at Christina Rossetti's peace of mind on the very threshold of womanly life, and a blow from which she did not fully recover for years.'[27] A shy, sensitive person who presented herself to others as 'a spring shut up' and 'a fountain sealed', Christina had taken a risk in revealing herself to Collinson. It was an error of judgment she would not repeat with anyone outside of her family circle.

William wasn't the only Pre-Raphaelite Brother to be distinctly unimpressed with Collinson's actions. No one in the Movement had a positive thing to say about Collinson after his broken engagement

with Christina. Holman Hunt's memoirs paint a picture of a nerdy, tedious man sleepwalking through his own life, while Scott remembers him as a feckless dilettante. In his own memoirs, the usually balanced William writes that his prospective brother-in-law was small, dumpy and thick-necked, as timid socially as he was in his painting, and not the sort of man who inspired friendship. These harsh criticisms of Collinson are belied by his previously warm reception by the PRB, the Rossettis and their circle. William repeatedly went on holiday with the man he purported to find so objectionable, and, a year after his sister's broken engagement to Collinson, even gave his *St Elizabeth of Hungary* painting a largely positive review in *The Spectator*. Though he later sought to disassociate himself from Collinson and his religion, Hunt had spent many hours at Collinson's studio and even briefly shared work space with him. The retrospective Pre-Raphaelite scorn for Collinson is both a demonstration of loyalty to Christina, and a self-protective gesture.

By August, the engagement had officially ended, and Frances tried to cheer her daughter up with a holiday to Brighton. Maria, on vacation from her pupils, had fallen ill, and Frances hoped the sanative seaside atmosphere would also do her eldest daughter some good. Considered a 'gawky piece of London', the thriving coastal resort had been made even more accessible to inhabitants of the capital when the railway line connecting London and Brighton opened in 1841.[28] The curative properties of its sea and air earned Brighton its reputation as 'the lungs of the great capital.'[29] The bracing, restorative qualities of the air, as well as the baths of fresh, sea, medicated water or vapour, were heartily recommended to patients suffering all kinds of maladies from rheumatism to broken bones. Wealthy families tended to visit between October and March. Not so well-to-do, the Rossettis arrived for Brighton's less fashionable 'second season', which occurred between June and October. The family's lodgings were so close to the health-giving sea front that one doctor breathlessly described the effect of 'emerging' from West Street as entering 'another world – brilliant, clear and sparkling.'[30] This location ministered to the spirit as well as the body; Brighton was one of the largest early centres of Tractarianism outside of Oxford and London, and West Street boasted the newly-consecrated St. Paul's Church. Built in the gothic

revival style, with a soaring spire and gleaming with stained glass, this Anglo-Catholic church would become so notorious for its Ritualist practices that its services were mocked as 'the Sunday Opera at St. Paul's.' The curate, Arthur Wagner, counted Pusey and Newman among his acquaintances, and would found an Anglo-Catholic Sisterhood in 1853.

Fresh from her broken engagement, Christina needed her faith more than ever, but she was struggling with the sacrifice she felt it demanded of her. Maria's health was improving while Christina's was getting worse. The neuralgic migraines were back, and no amount of exercise, church attendance or socializing could make them go away. She was not diverted by visits to her mother's dreary old Evangelical acquaintances, the Sortains. Mrs. Sortain, whom Christina criticised for not providing enough food at tea-time, was a member of the MacGregor family for whom Frances had been a governess in her teens. The Rossetti sisters' visit with her father's old Italian friend, the sculptor Sangiovanni, was more successful. Sangiovanni's blustery self-confidence reminded Gabriel of the sixteenth-century Florentine sculptor Benvenuto Cellini, but Sangiovanni showed Christina his softer side, giving her a small clay dog he had made. The sculptor's gesture of kindness meant a lot to the heart-broken girl; she never kept much in the way of material things, but William would find the little dog among his sister's effects at her death.

Maria bathed while Christina worried at her worsted work, ignored the beach vendors, and trailed listlessly along the dreary pier trying not to think about Collinson. She was fighting a losing battle, as she was ashamed to admit to William when she wrote him to ask for news of Collinson. She anxiously flattered her brother, writing that she had chosen to write to him over Gabriel because he was 'far more agreeable.' Despite Christina's casual tone, her queries about Collinson's delicate health and his new picture, *St. Elizabeth of Hungary* were hardly disinterested; she asked William to conceal the letter from their mother. Sharp-eyed Frances, who was not easily fooled, eventually discovered it and made her displeasure known to Christina, who felt a deep sense of shame. It was a difficult time for both mother and daughter. In her fifties now, fully occupied with governessing and nursing her sickly husband, Frances's concerns

were far removed from the girlish territory of broken hearts. Yet her youngest daughter's suffering must have reminded her of herself as a teenage girl, when she had worshipfully copied Byron poems into her commonplace book and dreamed of romance. Life with a chaotic poet for a husband had taught Frances that survival lay in ruthless practicality. She evidently had drawn a line under the Collinson romance and insisted that Christina do the same. Such a pragmatic approach might have been effective with Maria or William, who were temperamentally similar to their mother. With Christina, however, this method drove her feelings underground, and she simply brooded and agonised in secret.

The sense of a mother and daughter at odds appears in Christina's poem 'Three Moments', which is a kind of fable about grief and growing up. It was written in March, shortly after the Gorham decision, which Christina knew would be likely to drive Collinson back to Catholicism. The poem features an ongoing conversation between a mother and daughter, where the mother's repeated warnings that life will soon provide a genuine reason to weep is a variation on a timeless parental response to childish tears. In the first part, a mother tells her child not to cry when her bird flies away: 'keep / Tears for future pain more deep.' In the second part, the child becomes a girl who weeps at the death of a rose. The mother advises her to 'keep thy tears… / For something heavier'. In the third part, the girl becomes a woman who is at last experiencing a painful, adult loss. Although we are not told the exact nature of it, heartbreak seems a likely cause. Having wasted all her tears on childish trifles, the woman can no longer relieve her pain by weeping. Her mother, a sort of spokeswoman for cold comfort, says she should be grateful to suffer such profound pain, because a heart can only be broken once: 'Once more thy heart shall throb with pain, / But then shall never throb again / Oh happy thou who canst not weep'. Christina never published this intensely personal poem.

Christina was not the only child giving Frances cause for concern. A month after Christina returned to mope at Charlotte Street rather than in Brighton, Gabriel was evicted from his Newman Street studio. The dancing-master who ran what Gabriel called the 'hop-shop' upstairs had absconded without paying his rent, for which

Gabriel was jointly liable. There followed a kerfluffle which involved William smuggling books out of the flat, Gabriel fleeing the scene, and his landlord seizing his furniture. He went into hiding until his aunt Margaret paid his debt, which must have been embarrassing for Frances. The unembarrassable Gabriel dashed off a quick thank-you note to his aunt for helping to get him out of this latest 'unlucky pickle.' Her sisters always assisted Frances's children financially,' which served to highlight her eldest son's careless spending habits and her husband's inadequacy as a provider. Notorious for sponging off his friends, Gabriel was again in trouble again with money by October, but he was not worried: 'I shall attempt to extort it from the wretched William.'[31]

During this period, the sickly Gabriele turned his attentions to entertaining Italian exiles of dubious importance, his first-rate acquaintances having defected to Mazzini. The events of late 1850 and early 1851, however, made the anti-papal ravings of Frances's husband and his friends seem more prophetic than paranoid. At the end of September, the Pope restored the Roman Catholic hierarchy in England, appointing Collinson's mentor Nicholas Wiseman Archbishop of Westminster, elevating him to the rank of the first English cardinal since the Reformation. Predictably, there was an anti-Catholic outcry and the Anglo-Catholic community was tested once more as converts to Roman Catholicism defected in droves. Wiseman, who sermonised in full vestments and mitre, enjoyed a reputation as a powerful and moving speaker, attracting people of all denominations to hear him preach. Millais's brother reported that Wiseman's Sunday service was so crowded he couldn't get near enough to hear the sermon. Millais himself attended one of Wiseman's services with fellow-painter Charles Collins (brother on the novelist Wilkie Collins), and joked to that he was thinking of 'going over' to the Roman Catholic Church 'as all the metropolitan High Church clergymen are sending in their resignations.'[32]

For the Rossetti women, the most traumatic of these desertions was that of William Dodsworth, the perpetual curate of their beloved Christ Church, Albany Street. Edward Stuart, Dodsworth's curate, took over temporarily. An Oxford Movement man of the old school, he had studied at Balliol College Oxford and worshipped at Albany

Street during vacations. Having supported the Anglican choral revival, Stuart was well-connected with other Anglo-Catholic churches famous for music such as St. Andrew's Church, Wells Street and St. Margaret's Chapel. Christ Church, Albany Street was one of the first Anglican churches in London to boast a surpliced choir, and the congregation chanted psalms in the Gregorian style. Maria Rossetti was particularly taken with Stuart in this period. She felt he 'stemmed the tide' of Roman Catholic conversions from Christ Church, 'and with undaunted courage rallied the fainting hearts of the congregation, and patiently stood firm at his post.'[33] She was also impressed by his service to the local community. The independently wealthy Stuart was heavily involved in social work in the area, donating much of his fortune to charity, living among the neighbourhood's poor and inviting neglected children to share meals and attend a school he set up in his house. He also preached against the system of pew rents, prohibitive fees paid to reserve pews for individual families which all too often simply excluded the poor from attending services.[34]

Around the same time that Dodsworth went over to Rome, the Rossetti family endured the further upheaval of having to move house again, as their funds were not stretching far enough to cover their Charlotte Street rent. They moved to 38 Arlington Street, near Camden Town in early 1851. Neither the neighbourhood nor the house itself were as nice as Charlotte Street, although there was a small back garden where Gabriele could take exercise on the rare occasions he went outdoors. Frances and Christina opened a local day school in their home, with the hope of attracting respectable children of the professional classes. They were disappointed when their new neighbourhood could only offer pupils who were daughters of tradesmen, hairdressers and butchers. Maria, meanwhile, persevered with her governessing day-job, while William continued to live at home and contribute the whole of his Excise Office salary to the family. Gabriel was still notionally living at home, but he was preparing to fly the nest. He was sharing a studio at 17 Red Lion Square with Deverell and going on painting holidays with friends, often staying the night at others' homes and studios. The family's financial distress must have been considerable at this point, as it was at last registering with Gabriel. In a letter accepting more money from his aunt Charlotte,

he writes that he has 'determined I would be no further drag on my parents.'[35] He even considered becoming a telegraph operator for the railway, and went so far as to visit a suburban station to get a feel for the job. Nothing came of this plan, much to the relief of William, who worried that rail passengers would not be safe in his careless brother's hands.

Money was becoming a big worry for Gabriel. He was supposed to have become successful by now, but since Lady Bath's purchase of *The Girlhood of Mary Virgin*, he had made no major sale. Irritated by his incessant requests for 'loans', friends began to avoid him, including his own brother. He was making designs for paintings and had a minor commission along with Hunt to illustrate Longfellow's poems, but was hardly painting at all during this period, which Ford Madox Brown put down to idleness. 'I am growing seedy in all things,' Gabriel observed, 'even my friendships begin to *look* out of elbows.' His imagination and good humour stood him in good stead to survive this rather lean period, as we can see from his self-parodic meditation on his own poverty in a letter to Tupper. His 'waistcoat of Poetry is quite threadbare' while 'the breeches of Art have fared traditionally through a "misplaced confidence" in PRB doctrines' and 'the hat of Cheerfulness has shrunk with the rain.' The 'Shirt of Self-respect has long needed the wash-tub', and if he were to go out, he would need to 'mount the dickey of Pretension.' Gabriel concluded that he was getting 'figurative', not because he was feeling distressed or poetical, but because he was writing the note 'between painting and dinner.'[36]

Hunt and Millais's paintings for the RA were ready to 'kill everything in the exhibition for brilliancy', but Gabriel had completed nothing. He did appear on the walls of the RA after a fashion: Gabriel and William had posed for Brown's well-reviewed *Geoffrey Chaucer Reading to Edward III and his Court*.[37] It was a crucial exhibition to miss, as this was the year that the PRB began to be taken seriously. When *The Times* predictably came down hard on the Brotherhood for its 'monkish follies', the respected art critic, wealthy patron and author of *Modern Painters* John Ruskin came to the group's defence. In letters to the *Times*, he wrote that they had been unfairly critiqued, and that they were 'at a turning point, from which they may either sink into nothingness or rise to very real greatness.' He liked their

boldness and originality, and supported their 'fidelity to a certain order of truth', particularly in their close representation of the natural world, as in Charles Collins's water lily in his picture of a nun in a garden, *Convent Thoughts*. He made it very clear that he did not support 'their Romanist and Tractarian tendencies,' which probably were the true objections of the *Times*, a paper which was anti-Roman Catholic and none too pleased with Anglo-Catholicism. Ruskin made it clear that he had 'no respect' for Collins's nun or the 'painted window' and 'idolatrous toilet-table' of Millais's *Mariana*, and he disliked the 'common features' of some of the models.[38] Followed by his pamphlet, *Pre-Raphaelitism*, Ruskin's criticism was positive on the whole, and marked a reversal of fortune for the PRB. Gabriel was in a panic; even un-official PRB members Collins and Brown had been acknowledged by Ruskin, but his name was notably absent.

It was difficult for Gabriel to watch his close friends receive the plaudits and success he craved. In the autumn of 1851, the wealthy Anglo-Catholic Thomas Combe offered to sponsor Hunt and Millais on a painting trip to the Holy Land, proving that the Tractarian tendencies Ruskin had identified remained a powerful part of the PRB's appeal. Gabriel, who had not been asked, immediately tried to cadge an invitation, but was discouraged. Although he continued occasionally to attend both St. Andrew's Wells Street and Christ Church, Albany Street with his female relatives and read the whole of the New Testament that year, his tastes were too eclectic for him to be mistaken for a genuine High Church devotee. During this period, he was developing an interest in séance and the occult. His mother and sisters would have frowned upon his attendance of an 'Electro-biology' (hypnotism) demonstration, and probably would not have enjoyed 'Deuced Odd, or, The Devil's In It', Gabriel's abortive short story about the devil playing himself on stage.

Anxiety about his career was making Gabriel grouchy and restless. 'I am not doing anything and probably shall cut Art as it is too much trouble', he grumbled to William. His writing career was faring no better. He'd been sending around his translation of Dante's *Vita Nuova* to literary acquaintances, but no one was interested in publishing it. He was spending less time in the studio and more time with the hard-drinking journalist James Hannay and his circle. If Gabriel

were planning a foray into the world of Grub Street, nothing came of it. Journalism was not a sensible career option for a poor time-manager with little self-discipline, as Gabriel's unsuccessful episode of covering for his vacationing brother at *The Spectator* proved. He did not keep his promises to his little brother to write all his reviews while William was visiting Scott in Newcastle. Various excuses such as illness, tiredness and the loss of William's carefully written instructions were offered, but it was apparent that Gabriel's attention was elsewhere. Even meeting his hero Robert Browning and his wife, the poet Elizabeth Barrett Browning, did not seem to improve his spirits. With unusual sharpness, he observed that the very ill Elizabeth was 'as unattractive a person as can well be imagined.'[39] In August, he turned down Lady Bath's suggestion that he send the unsold *Ecce Ancilla Domini* to be exhibited in Liverpool, for fear of drawing attention to the fact that it had failed to sell the first time. He also made an uncharacteristically fussy excuse about his fear that the frame would be damaged in transit. His new best friend Hannay's engagement to a beautiful 'sugarplum of the universe' however, brought about a burst of enthusiasm: 'Hannay is writing and boozing as usual – but, wondrous to relate! – about to get married!'[40]

This new enthusiasm for sugarplums and marriage was a major clue that there was more to Gabriel's moodiness than career anxiety: closer observers than the boisterous PRB might have noticed that he was exhibiting the classic symptoms of being in love. Unsurprisingly, the object of his affections was a young red-headed model frequently used by the PRB. Deverell had 'found' Eleanor Elizabeth Siddal working in a milliner's shop in Cranbourne Alley, near Leicester Square; legend had it that he'd seen the lissome seventeen year-old girl reaching to take down a band-box, and been taken with her beauty. On his behalf, his mother approached Siddal to ask if she would sit for him. Her reedy androgynous build made her Deverell's perfect Viola, Shakespeare's heroine from *Twelfth Night* who masquerades as a man. The handsome Deverell painted himself as Count Orsino, her love-interest, and used Gabriel as Feste the clown. The rest of the Brotherhood soon discovered her, and raved about her beauty and poise. She was not beautiful according to the conventions of the day, which exalted petite women with voluptuous figures. Willowy, tall and red-headed, Siddal

was the perfect model for a Brotherhood bent on challenging convention. That she had her own artistic ambitions was an added bonus.

Born to a Sheffield cutler, she lived south of the Thames in Newington Butts, near the Elephant and Castle, in a mixed neighbourhood that was home to tradesmen, clerks and artisans as well as the working poor who inhabited its 'back-slums.'[41] Her father's obsession with being done out of an inheritance dominated the family psyche. Like the Rossetti children, the Siddals (and Lizzie in particular) had been encouraged by a rather grandiose father to think something of themselves, and to regard their family as unrecognised members of a more privileged class. Unfortunately, these feelings did not translate into material reality. Siddal was no Anna Mary Howitt, who had the advantage of liberal, wealthy parents willing and able to pay school fees as Sass's Art Academy. Nor did she have, like the Rossetti sisters, clever brothers eager to involve her in home-made artistic and literary collaborations. When she was plucked from obscurity by the PRB, who (unlike most of their contemporaries) did not regard class as a barrier to true beauty and grace, it validated Siddal family-feelings of specialness and uniqueness, which may be why her parents allowed her a relationship with the painters which was highly unconventional. The respectable Christina Rossetti, for instance, was accompanied by her mother when sitting for Hunt's *The Light of the World*. William found that Siddal exhibited 'an air between dignity and sweetness' yet this was 'mixed with something which exceeded modest self-respect, and partook of disdainful reserve.' Like Christina, she was aloof, but because she was no-one's sister, her sexuality was not off-limits to the Brotherhood. Where Christina's standoffishness was considered problematic and somewhat cranky, Siddal's was interpreted as erotic and mysterious. Apparently a woman of few words, she came across as both compliant and intriguingly unknowable, and they all competed for her attention. Even William, the man most sceptical about Siddal, admired this 'beautiful creature' with her 'greenish-blue unsparkling eyes, large perfect eyelids, brilliant complexion, and a lavish heavy wealth of coppery-golden hair', although he did add snobbishly that 'she had received an ordinary education, and committed no faults of speech.'[42] In terms of her intellect and character, this is damning with faint praise indeed.

Scott first met her when he visited Gabriel's romantic, ivy-covered outdoor studio in Hampstead, lent to him by the kindly Howitts. His recollection of meeting Siddal is startlingly similar to his first encounter with Christina Rossetti at Charlotte Street three years before. Again, it was dusk, again he was unannounced and startled a seated young woman whose features he could barely make out in the encroaching darkness, and again the woman did not speak a word. Where Christina made a formal curtsey and returned to her writing, Siddal did not acknowledge Scott's polite bow, but rushed silently from the studio, unintroduced.

This episode highlights the social differences between Christina and Siddal. Where Scott met Christina under the supervision and implied protection of her father, he met Siddal in highly improper circumstances, when she was alone at night in a male artist's studio. That Gabriel did not introduce her, and that she wordlessly fled the room, indicates not just reserve, but also embarrassment. Wealthy or aristocratic envelope-pushers like Barbara Lee Smith (later Bodichon) and her friend Anna Mary Howitt could carry off unsupervised friendships with male painters, as could the decidedly working-class girls who modeled for the PRB, but a cutler's daughter lived too close for comfort to the line between respectability and its opposite. There was a sexual anxiousness around the desirable Siddal's presence in this very male circle, which is evident in an early prank, where Stephens and Hunt tried to pass her off as Hunt's wife to Tupper and Brown. Gabriel made 'Maniac' Hunt write an apology (to Tupper, not to Siddal), but Hunt's tongue-in-cheek letter merely prolonged the joke. He wrote that he had been prompted by 'the archangel Gabriel' to '[clear] his conscience of such an atrocious life' hastening to add that he would not have tried the trick with 'any but a modest agreeable girl...and not a common model.'[43] No one would have dreamed of using Christina for such a joke, nor would it have been necessary to clarify that she was 'not a common model' afterwards.

Gabriel and Siddal's romance appears to have blossomed slowly, but was very intense. According to William, Siddal was Gabriel's first love, and his behaviour toward her bears this out. 'My brother was a lover of boundless enthusiasm and fondness', William remembers, 'He made no secret of his condition in the close circle of his nearer

intimates.'[44] He gushed about her to a degree which others found embarrassing, insisting that she was not only a great beauty, but also a poetic and artistic genius. He idealised her and was possessive and jealous, refusing to let her sit for anyone else. Siddal was quite simply swept off her feet by Gabriel, who at this stage was at his most dashing. He had inherited Frances's striking bluish-grey eyes, and his romantically unkempt dark hair retained a tell-tale touch of auburn, a legacy from his father's side. She also liked the way he saw her. Originally, her surname had been spelled 'Siddall', but Gabriel convinced her to drop one 'l' to make her name more suitable to her romantic, neo-medieval beauty. Well-loved and socially in demand, he also possessed impressive leadership qualities that allowed him to dominate his own circle. He was not a snob, and like his father, exhibited a kind of democratic sociability that took no particular notice of class. He was interested in people; throughout his life, he would talk to anyone, and was as popular with servants, boot-blacks and organ-grinders as he was with society matrons. Gabriel was known for his willingness to go to any lengths to promote others, and, though capable of professional jealousy, he never begrudged his friends' successes. While he had a devilish sense of humour and was a confirmed night-owl, he did not drink, smoke or gamble, and although he could be careless, he was serious about his art. Like his sister Christina, he was also very serious about love. Gabriel told Brown that when he first saw Siddal, 'his destiny was defined.'[45]

Like many self-fulfilling prophecies, this one turned out to be a little dangerous. This talk of 'destiny' was a sign that Dante Alighieri was back in Gabriel's life, and up to no good. Despite their fractious relationship, in adulthood Gabriel was beginning to understand his father's fatal fascination with the medieval Florentine poet; the painter was no longer frightened by the family ghost, but inspired. After the death of his English godfather Charles Lyell towards the beginning of 1850, Gabriel had dropped the 'Charles' from his signature, and began signing his name, 'Dante Gabriel Rossetti.' When the Rossetti family left Charlotte Street, Dante's ghost had come with them, folded in with the household linens, secured along with the furniture, packed among the crates of books.

Following in his father's footsteps, Gabriel was starting to

over-identify with Dante Alighieri, but the son was more success-
ful than the father in convincing others to play along. Ruskin, for
example, would remember him as 'really not an Englishman, but a
great Italian tormented in the Inferno of London.'[46]

During this period Siddal modelled for Gabriel's watercolours
*Dante Drawing an Angel, Beatrice Meeting Dante at a Marriage Feast,
Denies him her Salutation, Giotto Painting the Portrait of Dante,* and
The First Anniversary of the Death of Beatrice. She would die trying to
assume the shape of Beatrice, Dante's impossibly idealised, unrequited
love. Knowing (or at least telling themselves) that it was useless to
interfere in Gabriel's affairs, the Rossetti family would stand aside
and let it happen.

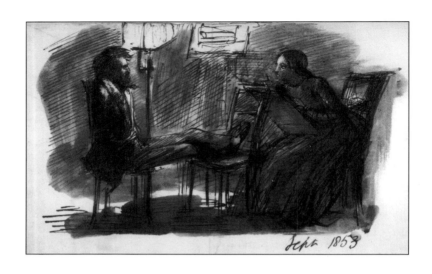

D.G. Rossetti Sitting to Elizabeth Siddal, 1853

Gabriel's collaborations with his sisters taught him respect for female artistic accomplishment; Lizzie Siddal was Gabriel's pupil as well as his model and lover.

6

BREAK NOT BEND

No one had ever imagined that Frances Rossetti would be the one to burn all the remaining copies of her husband's *Amor Platonico* after his death. Gabriele had willed them to her, perhaps hoping unrealistically that one day they would rescue his reputation, but at least trusting that his wife would care for them. William was horrified at the burning, remembering the act as 'the only one ever performed by my mother having some colouring of bigotry.'[1] The reasons she gave were religious; the book, with its Masonic prejudices and anti-Christian leanings, was deeply offensive to her, and when it came within her power to destroy it, she felt it was her spiritual duty to do so. Yet William's explanation does not take into account the emotional content of Frances's destructive act, whose violence reflects something more than the fulfillment of a pious obligation.

It is surprising that a family who professed such a love of literary history boasted a significant number of people quite prepared to commit it to the flames. Christina and Gabriel would carry on this tradition, burning significant amounts of their correspondence. After transcribing selected passages, Charlotte Polidori had destroyed the original of her brother John's diary. Such censorship of personal items is not unusual; it was a common Victorian practice to protect privacy and to sanitise family history. The Rossettis always knew they would be important enough for future generations' scrutiny, and prepared for this as self-consciously as they polished their writing for publication. They were similarly aware of the dramatic nature of these holocausts; a burning is not an emotionally neutral event, as the conclusion to Christina's 1850 novella *Maude* acknowledges. When a friend fulfils

the young poet Maude's dying request to have her poems burned, she is 'astonished at the variety of Maude's compositions. Piece after piece she committed to the flames, fearful lest any should be preserved which were not intended for general perusal : but it cost her a pang to do so'.[2] Christina's protagonist also requests that her locked writing book, which is a combination of common-place book, album and diary, be buried with her, its secrets committed to the grave.

The other siblings' reactions to Frances's burning of *Amor Platonico* are not recorded, nor is it clear who, if anyone, was present. Might her daughters, equally religious and wholly devoted to their mother by this time, have supported her? William's shock, when he found out (evidently he was not told until long after the event), was powerful enough to jar his placid family narrative decades later with the word 'bigotry.' Words were very important to all the Rossettis, and were selected more carefully than clothes, houses, or lovers. William's choice of this term in relation to his mother is considered and deliberate, and belies his claims elsewhere that his mother's religion never really came between them. Given Frances's common sense in most matters, (including her religious attitude which William describes as non-fanatical and far from prejudiced), the destruction of her husband's books was distinctly out of character. The pious integrity of her act was compromised by the dramatic manner in which it was performed, which involved fire, betrayal and secrecy; Frances's Romantic nature briefly eclipsed her role as the good wife. The act reduced her anger to ashes. By the summer of the following year, she was back to her old stoic self, reading a work on Freemasonry as a way of remembering her husband, 'uncongenial to my taste as is that craft.'[3]

Although it felt like a bolt from the blue for her youngest son, Frances's destruction of her husband's work was in fact a long time coming, as a perusal of the events leading up to it shows. In the early 1850s, Gabriele's health problems had grown more severe, but worse than that was his depression, an understandably common side-effect of chronic illness. Never one to disguise his emotions, Gabriele was as voluble in suffering as he had been in joy. The dramatic change in the Rossetti father's attitude was sobering for everyone. The buoyant spirit who was never too tired after a day's teaching to play pat-a-cake with his children had been replaced by a querulous, prematurely old

man who spent his days rehashing old quarrels with enemies and bemoaning his fate. His appearance too was alarming. Teodorico Pietrocola, a cousin visiting from Italy, was shocked to find the formerly plump Gabriele toothless and skeletally thin, having lost much of his hair. He had suffered a small stroke in 1851, which, along with leading to false rumours of his death in Italy, robbed him of his sense of taste. Severe gout meant the sixty eight year-old was forbidden to drink beer, while he complained that all food now tasted of hay. He was unable to bear direct sunlight, and preferred to sit in his study in semi-darkness with the curtains drawn. He was more subdued in company, cryptic where formerly he had been garrulous, to the extent that Gabriel punned that his guests mistook him for the *Rosetta* stone. The only thing which cheered him was correspond-ence from old friends Filippo Pistrucci, Thomas Keightley and his father-in-law, who praised Gabriele's newly published poems, *L'Arpa Evangelica* (1852). The only person the formerly sociable patriarch visited anymore was Gaetano Polidori, still in maddeningly better shape than his son-in-law. Barely able to walk without assistance, Gabriele required enormous amounts of care, and, with Maria off governessing, that duty was split between Frances and Christina. The Rossetti sons' gender excused them from attending to their father, and Gabriel was unavailable in any case, having by that time moved into his own rooms at Chatham Place, Blackfriars. Feeling abandoned and distressed, the Rossetti patriarch was very pessimistic, often discussing his impending death with something approaching morbid excitement. He upset the solicitous Teodorico by speaking of his desire to die and reciting the following verses:

> Into the sea the drop
> Falleth and disappears.
> Life is a little drop,
> Lost in the sea of years.[4]

To add to the Rossetti family's worries, by 1853 it could no longer be denied that their domestic day school had failed to attract enough pupils. William and Maria's salaries were not enough to keep the family afloat, and Gabriel was still costing something and contributing

nothing. It was Charlotte Polidori who found a solution through her employer, Lady Bath, who had an aristocratic fondness for the Rossettis. Like Charlotte, Lady Bath was a formidable character who did not mince words. Although she had purchased Gabriel's *Girlhood of Mary Virgin*, she had not, for reasons unrecorded, shown interest in *Ecce Ancilla Domini*. She had declined to patronise *The Germ*, and had been critical of Christina's 1850 novella, *Maude*, whose poems she liked, but whose dialogue she faulted for being too commonplace. Christina's realistic dialogue was no more appealing to her than Gabriel's unidealised teenage Virgin Mary, whose failure to attract any buyers spoke to a contemporary distaste for realism in religious art.

Lady Bath wanted to help and support the Rossetti family, but she had learned from her financier father to invest with prudence. By the same token, she was more generous than many other employers in allowing her governess's nieces their frequent visits to Longleat, and she didn't quibble about releasing Charlotte when she needed to attend to family matters in London. She was also a good role model of female strength to Charlotte's fragile niece, impressing her by allowing Christina to take the carriage home from church while the aristocrat herself walked in the rain.

Her own unconventional background had prepared her to be sympathetic to a family like the Rossettis. Born Harriet Baring, she was the daughter of Alexander Baring, an immensely wealthy international merchant banker who had served under Robert Peel as president of the Board of Trade and master of the Royal Mint. Harriet was considered an arriviste by the aristocratic circle into which she married. Her American mother Louisa was the daughter of a US senator whom Alexander Baring had met in the United States while negotiating between the French and the Americans over the Louisiana Purchase. Although her father had been elevated to the peerage in 1835, becoming Baron Ashburton, doubts remained as to Harriet's social status. In the end, her marriage to Henry Thynne, Marquess of Bath, was approved because 'the Barings want connection, and he wants money', financial necessity overriding Henry's mother's fears about 'what she heard of Miss Baring that was not the line.' Harriet's serious, down-to-earth attitude was not considered attractive by her

contemporaries, but it had stood her in good stead when her husband's death in 1837 left her a widow and a mother of four at the age of thirty three. Charlotte's governessing expertise had been invaluable during this difficult time, as had her no-nonsense personality and her easy adaptability to the rhythms and requirements of aristocratic life, toward which her own Aunt Harriet had pretensions. Unlike some of Lady's Bath's social acquaintances, Charlotte Polidori, then also in her early thirties, had not expected her newly widowed employer to be 'amusing.'[5] Re-styled the Dowager Marchioness of Bath, Harriet turned out to be an excellent manager of the Thynne family finances, and of its estates in Longleat, Shropshire and Ireland. When her eldest son John Alexander came of age, she purchased Muntham Court in Findon, Sussex in 1850, which became her primary residence.

A personal friend of Keble and Pusey, Lady Bath was active in High Church circles and donated her resources to charity work and the restoration of churches. When controversial ritualist W J E Bennett was forced to quit his London parish of St. Barnabas Pimlico by the anti-papal rioting that took place during his sermons, Lady Bath appointed him Vicar of Frome-Selwood (now Frome) in Somerset. A local petition was got up against Bennett, but Frome, like Brighton, was a growing High Church centre, and in the end only 56 signatures could be coaxed from the population of 12,000. Lady Bath gained admirers when she accompanied Bennett to his induction, amid a shower of stones, eggs and curses from protestors.

Reasoning that devoted Puseyites like Frances and Christina Rossetti were not likely to be put off by Bennett's ritualist quirks, Lady Bath turned to the Rossetti women to run a church day school for him at Frome. It was decided that Frances, Gabriele and Christina would move to Somerset in April 1853, while William, Maria and Gabriel would remain in London. This was far from an ideal solution. The separation, William remembers, 'was grievous to all of us. To divide the family party between two such remote localities was the very last thing that my mother, in especial, could have tolerated, save at the clear call of duty and the bidding of hard necessity.'[6] Aside from economic opportunity, Frome had other attractions. A pretty market town with easy access to the countryside, it boasted a restorative, temperate climate and famously cloudy weather which would be

easy on Gabriele's sensitive eyes. The relocation did not begin well. When Frances and Christina went down ahead of Gabriele, they were dismayed to find the house with the painting and wall-papering unfinished. A broken washstand completed the dismal picture. Though Frances wrote that the subsequent arrival of the piano forte and the family cat helped it feel more like home, her husband would not be comforted, predicting that his bones would be buried at Frome. Nor did Christina, urban to her core, thrive in this quiet community, where the lack of even a local library meant the family were forced to join a slow-moving postal book club. William, still in London with Maria and his father, accurately imagined Christina acting 'rather dreary and particularly objectless, in a state of extreme politeness.'[7] Being separated from her siblings, her beloved grandfather Polidori and London plunged the twenty three year-old into a state of melancholy boredom. A few days before the move she had been sitting to Hunt for the face of Christ in *The Light of the World*, and now the only thing she had to look forward to was attending school children's tea parties organised by the well-meaning Reverend Bennett. Christina had a poet's knack for projecting her own emotions onto the surrounding landscape, writing gloomy dispatches to London about the sparse and disappointing blossoms on her garden's lone, struggling apple tree, and the baby thrush she rescued but was forced to abandon in a field when it refused to feed. Christina dreamed of the day when she would be a literary lion, writing to William that when the short story she'd sent to Hannay became a runaway success, she would give half the proceeds to Frances, and the other half to Maria for her dowry.

Matters did not improve when Aunt Charlotte wrote to inform Frances that their mother's health had taken a decided turn for the worse. She was feverish, and so weak that Eliza had to wash her face and hands for her. Though she could sometimes be persuaded to take broth and calves foot jelly, Anna Maria Polidori's appetite had nearly gone, and she was acting foggy and confused. Although Charlotte and Eliza were exhausting themselves taking turns attending to her, struggling particularly with lifting their mother in and out of bed, it was plain that they would get no help from their brothers. Henry had gone to Cheltenham on business despite his mother's grave illness,

and no assistance could be expected from weak-minded Philip. Charlotte was all too aware that the burden of family management often lay heavy on women's shoulders. 'You never say how you yourself are, my dear Fan,' Charlotte remonstrated gently, hoping to coax her displaced sister into unburdening herself.[8] Eliza told Frances to look after her cough, and to remember that no news was good news, so she shouldn't worry herself if no updates on their mother's health were forthcoming. Maria was also worried about the pressure her mother was under, sending her rueful birthday wishes to commemorate what was 'a happy day for [your] children at any rate.' Although Maria reassured Frances that Anna Maria was not 'in any violent pain,' she confessed that her grandmother was 'dreadfully weak.' As was the custom among the Rossetti women, Maria offered her mother a comforting quotation from a sermon at Christ Church: 'When you do anything towards the promotion of moral goodness, you co-operate in the production of what is far more excellent than the loveliest of the planets or the most powerful of the elements.'[9]

Everyone was concerned for Frances. Even Gabriele, who was temporarily in London, was making an effort not to be any trouble, placidly switching from chocolate to tea in the morning in deference to William and Maria's habits. As one of Christina's first orders of business in Frome had been to buy a chocolate pot, we can guess who his morning chocolate companion must have been. William observed wryly that his father was acting 'somewhat less "tormentato" than usual.'[10]

In frank yet sensitive terms, Maria made it clear to her mother that Anna Maria's end was near, and shortly after receiving the letter from London, Frances rushed to Park Village East. She was just in time to say goodbye to her mother; Anna Maria Polidori died a few days later. Her one-line obituary in *The Gentlemen's Magazine* gave her age as 83, a remarkable age for an invalid to reach. Christina had been left in charge of the new school, but asked to come up to London to see her grandmother's body, ghoulishly adding 'unless the lapse of so many days renders it inadvisable.'[11] The grieving Frances and Christina were back in Somerset by the ninth of May, having brought Gabriele with them. Much to everyone's surprise, he seemed less morose, going about his reading and writing with something like

his old enthusiasm. But for Christina, having to be separated from her London family again weighed heavily.

William and Christina, the younger and more sensitive of the four siblings, were finding the separation the most difficult to bear, and attacked the problem in typical Rossettian fashion: they made portraits of each other. Two days after leaving her brothers behind in London, Christina wrote them a wistful goodnight poem, 'Portraits'. She pictured the two young men 'Unlike and yet how much the same,' sitting up late while William, with his 'Dark eyes and features from the south' smoked a 'meditative pipe' and Gabriel dozed beside him. Her homesick poem also remembered their shared PRB 'friends':

Friends of the selfsame treasured friends
And of one home the dear delight,
Beloved of many a loving heart
And cherished both in mine, good night.

Christina also sent William two pencil portraits of their mother, at his request. Although she had been taking classes at the North London School of Drawing and Modelling in Camden Town and sketching in Frome, the portraits were a disappointment. Half-jokingly, she excused herself by claiming that Frances's handsome features were too regular for her amateurish drawing style, which tended towards caricature. Yet Frances encouraged Christina's new-found interest in drawing, hoping the practice would aid in 'carrying her out of herself.'

Gabriel's offering of his father's portrait was, predictably, more successful, and Frances proudly displayed it over the mantelpiece in the family drawing room at Frome. She also considered his letters a species of self-portrait: 'I see and hear you in your letters, they are your truest portrait,' she wrote.[12] He also provided Christina with a pencil portrait of Aunt Charlotte, and began work on an oil portrait of Charlotte for his grandfather. Tellingly, Gabriel's portrait experiments were not confined to his family. He was missing Woolner, who had gone to try his luck in the gold fields of Australia, and so he gathered PRB members together for a sketching party, where they made portraits of each other to send to Woolner.

As for William, he attempted portraits of Christina. Yet he was no more skilled a visual artist than his sister, and frustrated, he threw both his efforts into the fire. Not only were his family separated, but his Pre-Raphaelite Brothers were also drifting away. Meetings, if they were even scheduled, were sparsely attended. Gabriel was busy playing house with Siddal, Hunt was planning a glamorous sojourn to the Middle East and Millais's work seemed on the verge of departing from the Pre-Raphaelite style altogether. With the Brotherhood threatening to dissolve, William worried he was doomed to a dull fate as a civil servant. Certainly, his full-time job meant that becoming an artist was out of reach. 'William Rossetti has now no chance of taking to painting,' Millais observed, and William was coming to terms with this brutal truth.[13] He was not just losing Christina and his mother, but his brother as well, who was spending more and more time with Elizabeth Siddal. There were fewer nights of brotherly togetherness than Christina's poem imagined. For the first time in their relationship, Gabriel had found someone whose company he preferred to that of his brother. Forced to fend for himself in this arena, William's shyness at first made him awkward with women. His friendship with Mrs. Eliza Orme, Coventry Patmore's glamorous sister-in-law, came to his rescue. Barely thirty years old when the Rossettis met her, she was known for her 'rich physique' 'luminous dark eyes' and 'refined taste.' She was the wife of a wealthy brewer who, though he was not interested in art himself, gave her licence to patronise artists and hold salons. While her sister Emily was the inspiration for Patmore's famous paean to female domestic subjugation, 'The Angel in the House', Eliza was a feminist who held progressive political views. She would sign the Suffrage Petition in 1866, and her daughters would both become feminist activists. Like his shy sister Christina, William had a hard time finding a middle ground between self-assertion and self-effacement, and he could come across as combative in conversation. Eliza taught William his first important lesson about socializing as an adult, discreetly taking him for a stroll in the garden to tell him he ought to be less 'sarcastic' in mixed company.[14] The boyish banter acceptable at late-night PRB meetings was not suitable for the civilised drawing room. Though William was mortified at being rebuked, he took her advice and began to consider the difference

between plain speaking and insensitivity. He began quietly to court Henrietta Rintoul, the daughter of his editor at *The Spectator*.

At exactly this time, Maria Rossetti was getting to know the girl who would grow up to be William's wife, Ford Madox Brown's daughter Lucy. She was the only daughter of Brown's first wife Elizabeth, who had died in 1846 at the age of twenty-seven. After her mother's death, Lucy had been sent to live with her Aunt Helen in Kent while Brown co-habited with his model Emma Hill, a young bricklayer's daughter with whom he had fathered an illegitimate daughter in 1850. The couple had married earlier in the month, with Gabriel as a witness, and Lucy's day out with Maria may have been something of a consolation treat from a guilty father. Lucy worshipped her father, although he was remote and distant towards her. At Brown's request, Maria took the ten year-old to the Zoological Gardens, showing her all the favourite Rossetti haunts from her own childhood. Afterwards, Brown (or 'Bruno' as the Rossetti sisters called him), joined the pair for tea, and Maria showed him Christina's abortive portraits of Frances, presumably to much amusement. Having lost her favourite companion when Christina moved to Frome, Maria tried to fill her time with social visits, some of which she enjoyed more than others. Christina envied Maria her time spent with Amelia Heimann and her small children, but was relieved to have avoided the eccentric friends of the Scotts, John and Ellen Epps, who lived in a spacious house near the British Museum. Balding and hard-of-hearing, John was a quack homoeopathist with a habit of greeting female guests with an over-zealous kiss. His wife Ellen, though warm and good-natured, was prone to airing her passionate dissenting religious views which were contrary to the beliefs of the Rossetti sisters. Scrupulously polite throughout the evening with the Eppses, Maria nevertheless agreed with William that they were 'cracked.'[15] Following her Aunt Charlotte's example, Maria was building a reputation as a very successful teacher, and was much in demand. She was actively courted by well-heeled clients such as Lady Dynevor, with whom she was invited to dine on a supper of stewed rhubarb and macaroni pudding, her hostess's nod to Maria's Italian heritage.

Letters from London stoked Christina's curiosity and homesickness, and she found it particularly painful to miss that year's RA

exhibition. Millais had received unprecedented attention for his *Order of Release*, which attracted crowds so large that constables were called in to keep people moving. Its subject was a defiant Jacobite soldier's wife, handing her husband's jailor an order of release. The husband is collapsed in gratitude and relief on his wife's shoulder while their baby sleeps in her arms. The family dog wags its tail approvingly. The picture, with its muted palatte, chiaroscuro and 'sloshy' subject matter, marked Millais's conscious departure from the Pre-Raphaelite style. Gabriel recognised this, preferring Hunt contributions *Claudio and Isabella* and *Our English Coasts*, whose bright colours, intensely realised natural detail and profusion of symbolism were more in the PRB line.

Christina also preferred Hunt's work, but for different reasons. Not only was she closer to Hunt than Millais, having recently modelled for him, but also the religious subject matter of his paintings appealed to her High Church sensibilities. Millais had obeyed Ruskin's warning about depicting 'Tractarian heresies', but Hunt continued to explore controversial religious subject matter. *Claudio and Isabella* illustrates a scene from Shakespeare's *Measure for Measure*, where Claudio, sentenced to death, begs his sister, a virtuous novice nun, to give her virginity up to the lecherous Duke of Vienna in exchange for his life. *Our English Coasts* is a Christian allegory which depicts shepherd-less sheep struggling to keep their foothold along a rocky coastline. England, it seemed to say, was in danger of losing its way in the modern world.

Gabriel, by contrast, had taken Ruskin's advice to heart. He abandoned his idea for a companion piece to his unsold *Ecce Ancilla Domini*, entitled *The Death of the Virgin*, because 'such themes were "not for the market"'[16] When he'd finally managed to unload *Ecce Ancilla Domini*! on new patron Francis MacCracken earlier in the year, he had excised the Latin mottoes from the frame and retitled it 'The Annunciation' in order 'to guard against the imputation of popery.'[17] Having purchased a painting from Holman Hunt, Mac-Cracken was the first of a new breed of buyer for the Pre-Raphaelites. A Belfast merchant variously described as a cotton-spinner and ship-broker, he represented the aspirational merchant class who were looking not only to make an investment, but to become the new

tastemakers in British art. Gabriel had convinced his new would-be patron to commission an ambitious work called *Found*, which would depict the moment a country drover discovers that his lady love has fallen into prostitution in London. The woman would be slumped in shame before a brick wall while the drover, with his symbolic calf tied up in a cart behind him, attempts to help her to her feet.

When half of his family moved to Frome that spring, Gabriel, riding high on the sale of the 'blessed white eyesore,' was so preoccupied that he barely noticed. Despite his love for Siddal, which was in full flower, it was a time of restlessness for him. He was plagued with recurrent boils and thrush, a sign of a stressed immune system and poor hygiene. Cohabitation with Siddal, who was now semi-permanently installed at Blackfriars, was proving more of a strain than he'd imagined. Ignoring his mother's repeated requests for him to visit Frome, he borrowed 12 pounds and a carpet bag from Aunt Charlotte, and went off to visit Scott at Newcastle, afterwards embarking on a walking tour of Coventry, Warwick, Kenilworth and Stratford. In a letter headed PRIVATE, he left instructions to William to keep an eye on Siddal, who would be staying at Chatham Place on her own. Perhaps he hoped that the drawings by Millais, Hunt, Deverell, Woolner, Scott and Brown that decorated the walls would keep her company in his absence. In a sonnet about fickleness that boded ill for his relationship with Siddal, he wrote about a tempting honeysuckle blossom, which, once plucked, loses its allure. The speaker then spies another, richer honeysuckle bush with blossoms so lush and thick that 'from my hand that first I threw, / Yet plucked not any more of them.' That summer he was also eagerly tearing through the Italian sculptor Benvenuto Cellini's autobiography, a self-justifying primer in narcissistic behaviour in the male artist, including graphic seductions, affairs with models and murder.

As if to make up for her son's conspicuous absence, all of Frances's sisters made themselves available at one time or another throughout the summer. Charlotte in particular was a great help, regularly turning up in her fashionably ostentatious bonnet to shepherd her sister and niece on day trips to Bath, and sending gifts such as a matching water-proof cloaks for Christina and Maria. Although Frances tried to remain cheerful, even she could not deny that the Rossettis' school

was failing once again. Any successful small business enterprise should begin by identifying its target market, but (as was the case with their London day-school), the Rossetti women had failed to do their market research. It had certainly never occurred to Lady Bath that the daughters of Frome's farmers and local tradesmen had very different needs than the children of the well-to-do to whom the Frances and Christina were best suited. Their usual curriculum was unsuitable for their pupils, whose needs ran more to basic literacy and numeracy skills rather than the cultivation of French and Italian, or the appreciation of Dr. Johnson's epigrams. As a result, both students and teachers were bored and frustrated. Having done her figures, Frances estimated that her failing church school needed three times the amount of pupils it had attracted so far in order to survive.

As always, immersion in art and literature provided a temporary escape-hatch from the tedium of the classroom. Frances wrote to Gabriel about her day out with Aunt Margaret to Longleat, whose collection of paintings Frances enjoyed, particularly portraits of 'the chief worthies of dear old England', like Shakespeare, Ben Johnson and the Earl of Essex. Her English patriotism is a reminder that Frances was descended from old Tory stock on her mother's side. Although married to an Italian and ½ Italian, she thought of herself as an Englishwoman, and was as proud of that heritage as she was of her Italian ancestry. The family connection to Lady Bath and Longleat was a source of pride, although Frances retained a reflex Evangelical suspicion of the material splendour of 'show palaces.' Being a grateful guest brought its own stresses. As Frances remarked to Gabriel, 'I should like to have been left alone with the pictures and the books, but…one's attention is continually called off from what is most to one's own taste, to be fixed on something really indifferent.' Frances was no kill-joy. She was particularly tickled by portraits of diametrical opposites Thomas Ken and Jane Shore. Ken was a seventeenth century High Church bishop who had lived at Longleat after William and Mary deprived him of his see, while Shore had been a famous courtesan and mistress of King Edward the Fourth, despite her low-born status. 'Jane Shore's beauty must have been of no common caste,' Frances punned with a twinkle. She knew how to cater to her eldest son's taste, even deploying a PRB watchword to

qualify her enjoyment of a Rubens painting, 'In despite of his being so sloshy.'[18]

As the summer drew to a close, Gabriel found himself too busy at what he called 'work (and shirk)' to visit Frome. His guilt about this began to manifest itself in the defensive tone of his letters. He accused Frances of hinting that he found writing her a bore. 'Is this really quite fair,' he went on testily, 'when I sent a letter by Maria, and even before that...I had been the last to write. At any rate, I know I am a better correspondent to you than to almost anyone, as my friends could testify.'[19] Frances was having none of it: 'Read my letter again and you will see that I never said that you thought it a bore to write to me, but that my letters are so barren that they may well prove a bore to you to read.' Frances had much greater worries than toting up Gabriel's correspondence. She did not dwell on recriminations, and told Gabriel that she and Christina had discovered, as he requested, a country wall which he could sketch for *Found*. Hoping artistic reasons might entice Gabriel to Frome, Frances urged him to hurry before the autumn cold set in and made it difficult to work outdoors. Starved for culture in her tiny market town, she begged for news of Hunt, Brown, Woolner and Stephens. Trying, rather transparently, to appeal to Gabriel's sense of filial duty, she reminded him of 'one of the dearest remembrances of my heart' when 'quite little, you came forward in my defence if I was attacked, and tried to console me if I seemed unhappy.'[20]

Gabriel's father was not so conciliatory. The school at Frome was failing, and he was worried for the family's fiscal future: 'Remember, my much-loved son, that you have only your own ability upon which to thrive. Remember, that you were born with a decided aptitude; and that, even in your earliest years, you made us conceive the highest hopes that you would prove a great painter.'[21] Neatly projecting the responsibility for fatherly expectations onto the son ('you *made us* conceive the highest hopes'), this letter was the closest anyone would come to reminding the eldest son how much support he had received. He also suggested that Gabriel seek a commission for a portrait from Lady Bath. Gabriel patiently explained that it would be a bad career move to neglect his burgeoning artistic career for commercial portrait painting. Written in respectful Italian, Gabriel's letter sought to pacify the old man with praise for the *L'Arpa Evangelica* poems. If Gabriel

was gentler with his father than his mother, it was because they were more remote. As father and son aged, the old days of stand up rows gave way to a distant, wary politeness.

Despite the Rossetti parents' unshakeable faith that their eldest's painterly talents would pay off, it was William who came through in the end to rescue his family from dreary Frome. In the autumn, his latest promotion at the Inland Revenue meant that he could afford to support the family's move back to London. The promotion had been in the works for awhile, but the family had concealed the possibility from Gabriele, because his inability to cope with uncertainty would be a further burden on the already strained family: 'he would be restless, constantly expecting the matter to be immediately settled, and unable to reconcile himself to any possible diminution of the advantage when it does come.'[22] William wasn't wrong about his father's out-sized reactions to fortune and misfortune alike. When Gabriele did find out, he enthused, somewhat irrelevantly, that he was so pleased that if William 'wishes to get married to carry on his race and perpetuate the name of Rossetti in England, I shall give my consent with pleasure.'[23]

Gaetano Polidori's death of a stroke that December cast a pall over William's announcement, though the legacy Frances received from her parents meant that she and her girls would not be wholly financially dependent on William's job. Although Polidori had reached his nineties and his death was not entirely unexpected, he was nonetheless sorely missed in the Rossetti family. Tougher, more dependable and less flighty than his son-in-law, Polidori has been a surrogate father to Frances's children. 'He was one of the people in the world for whom I had a real affection,' Gabriel wrote, 'Our family may wait long now for so stout a branch.'[24] Polidori's death was a double-tragedy for Christina, because she had lost not only her grandfather, but also the only person who truly believed in her potential. Maria, William and Gabriel were given credit by their parents for carving out independent careers, but Frances and Gabriele tended to regard Christina as a troubled youngest sibling. Where Gabriel's artistic ambitions were wholeheartedly encouraged, Christina's were often treated as therapeutic solutions to her malaise. Polidori, by contrast, had taken the baby of the family seriously from the start.

That December, in order to save money, William and Maria moved into rooms above a chemist's shop at 14 Albany Street, Regent's Park. They were befriended by the chemist, a friendly amateur water-colourist thrilled by William's connections with the art world. He introduced them to the up and coming Dr. William Jenner. In a time where an unregulated medical community was rife with quacks and pretenders, it was particularly important to locate a good doctor, and William made sure to strike up an acquaintance. It was a wise deci-sion; Jenner, who became Christina's doctor, would rise to become physician to the Queen.

By March 1854, the Rossetti family were reunited in a new house at 45 Upper Albany Street, Regent's Park (re-numbered 166 in 1864). Although hardly palatial in size, and overlooking the back of a ter-raced row rather than having a desirable view Regent's Park, it was the nicest house the Rossettis had lived in so far. Located close to the Rossetti women's beloved Christ Church, it was also near to the homes of the Polidori aunts and uncle Philip, all of whom lived sepa-rately after their parents' death. This was primarily Eliza's decision. Having been liberated from being a permanent carer, she acquired a taste for freedom. Gabriel was taken aback, for instance, by his aunt's enthusiastic request to view the Lord Mayor's Show from his Blackfriars studio. Airy and light, with windows on all sides, it was the perfect location to view the annual parade. Like Frances, Eliza was a patriot and a fan of London, and she enjoyed the pageantry which accompanied the newest Lord Mayor on his inaugural journey from the city to Westminster. Dating from the sixteenth century, the Show was a yearly gigantic procession comprised of the city's soldiers and livery companies, headed by effigies of the city's pagan protec-tors, 'gogg and magogg', reminders of London's Pre-Roman past. It probably occurred to Eliza how much her mother would have enjoyed watching the marching regiments of the city of London pass by. They were accompanied that year by elaborate displays symbolizing Eng-land's expanding empire. Scenic artists from Sadler's Wells Theatre had created an enormous six horse chariot which boasted a throne atop a giant globe, on which two pretty circus girls from Astley's Ampitheatre perched, dressed as Peace and Prosperity. There were tattooed natives from South America and an oxen-drawn Australian

car containing a gold-digger panning for gold. Standard-bearers of many nations marched by, and Dickens recorded in *Household Words* that the Turks received rapturous applause while the Russians predictably were booed. The Crimean War had just broken out, and the Russian Empire were the enemy of the alliance between Great Britain, France and the Ottoman Empire. This war was about to become unexpectedly significant for the Rossetti family in general, and Eliza in particular. Pent up for years caring for her mother, Eliza Polidori was developing a thirst for adventure that was about to go global.

Back in Frome, there was talk of Gabriel re-joining his family once they reunited in London, but Gabriel would never return now that he had tasted freedom. Also, there would have been the awkward business of Siddal. While the family had been away, it was easy enough to conceal his liaison, but upon their return in the spring of 1854, it was clear that introductions would have to be made. He decided to start with Christina, hoping that the two women's interest in painting and poetry would spark a friendship. Gabriel's infatuation blinded him to the insensitivity of his approach, which included instructions to his sister 'not to rival the Sid' in her artistic aspirations, but to 'keep within respectful limits.' Nor could he see that 'a lock of hair shorn from the beloved head of that dear, and radiant as the tresses of Aurora,' might fail to 'dazzle' his sister when she was given the great privilege of beholding the object.[25] Gabriel's timing was insensitive as well; not five days after Christina's return to London, he was insisting that his sister make it a priority to meet his girlfriend. His sickly sweet pet names for Siddal, including 'Gug', and 'Guggum' and 'Guggums' did not help to endear her to his straight-talking younger sister, nor, probably did Siddal's dubious class origins. The Rossettis were not snobs about money, but they were snobbish about culture and education, and it is likely that Christina would have been less than impressed at the mawkish (and possibly apocryphal) tale of Siddal discovering Tennyson's poems in the paper which wrapped the family butter.

Incidents of brotherly tactlessness may have helped sabotage Christina's friendships with other women in his circle, such as Barbara Lee Smith (later Bodichon), whom Gabriel introduced

with a now-familiar lack of delicacy: 'Ah! If only you were like Miss Barbara Smith…blessed with large rations of tin, fat, enthusiasm and golden hair, who thinks nothing of climbing up a mountain in breeches or wading through a stream in none…'[26] Smith invited her to join the 'Portfolio Society', whose members submitted artistic and literary works based on prescribed themes and then met to discuss them. Christina kept her distance, agreeing only to be a corresponding member, and did not attend meetings. Christina's natural reserve and shyess was reinforced in the case of Smith by a suspicion of, or at least a discomfort around, bohemian feminism. Barbara Smith was the illigitimate, independently wealthy daughter of the radical MP Benjamin Smith. A staunch feminist activist and close friend of George Eliot, she would go on to found Girton, the first Cambridge College for women, as well as the Langham Place Group, a feminist publishing collective. Although Christina's aunts had accustomed her to models of strong, independent womanhood, she was always quite circumspect about left-leaning feminism, primarily for religious reasons. While in practice the Anglo-Catholic revival encouraged women to take greater leadership roles in church and community, doctrinally women were still considered 'helpmeets' to men. In addition, the Tractarian belief in reserve and humility was in direct conflict with the vocal activism of Smith and her feminist associates, an activism which was after all, bought and paid for by paternal wealth. On this score, Gabriel's friend Anna Mary Howitt should have been slightly easier to take. Not only did she have Frances's seal of approval, but like Christina, she had grown up in a culturally rich but materially poor household after her Quaker parents went bankrupt. A great friend of Smith, Howitt had gone to Germany to finish her art school training as the RA schools refused to accept women, participated in the Langham Place Group, and painted controversial subjects such as a prostitute in *The Castaway*. During the fifties, Howitt published Christina's poems in a collection she edited, *The Dusseldorf Artists' Album,* and recruited her as a contributing author for Waller's *Imperial Dictorinary of Universal Biography*. This friendship also never really took root, not only because of Howitt's leftist feminism, but also because of a ferocious sociability that may have intimated the much quieter Christina. Howitt also fell in with the

nineteenth century Spiritualist craze, which involved table-rapping, seances and other occult parlour games. She eventually poured all of her creativity into producing 'spirit drawings', a practice Christina would have found offensive both spiritually and aesthetically. Unlike her brother William, Christina was socially independent of Gabriel, and she did better when she chose her own friends.

By contrast, Siddal was a huge hit with Smith and Howitt's crowd. Although her views on women's rights are not recorded, she was clearly living a fairly unconventional lifestyle with Gabriel, as well as making strides in her own artistic career. Under Gabriel's supervision that spring, she was making designs inspired by Tennyson's *The Eve of St. Agnes* and *The Lady of Shalott*. She was a genius, Smith and Gabriel declared, although Howitt privately thought Siddal's productions lacked originality. Smith invited her to Scalands, her Sussex estate, where she, Gabriel and Howitt all sketched Siddal with an iris in her hair.

Siddal had replaced Christina as the female sitter for both religious and literary subjects, reflecting the widening of the Gabriel's experience with women. This was more than simply a sexual awakening for the young painter. He had drawn the female figure from the nude, and poems such as 'Jenny' (about a prostitute) and his plans for *Found* show that he was hardly naïve about the details of sexual commerce. Many middle-class men of the era were initiated into the sexual world by prostitutes, and it is not beyond the realms of possibility that they were part of Gabriel's experience, although there is no way of knowing for sure.

Relationships with his sisters, mother and Polidori aunts had taught him that women could be intellectual, creative and capable, but their God, rooted in the self-censoring Evangelical tradition, was never going to be the object of Gabriel's continuing worship. Nor was God likely to yield a profit in the current market; there was no longer capital to be made in being the 'high priest' of Pre-Raphaelite religious realism. It was in this period that Scott observed a sea-change in Gabriel's art: 'His curious materialistic piety disappeared, burst like a soap-bubble, and the superficial prismatic colours vanished into air.'[27] The young painter had also disappeared from the PRB social scene. "Rossetti is a myth and seldom visible to the naked eye," an

THE ROSSETTIS IN WONDERLAND

old acquaintance observed. Gabriel was busy cultivating friendships instead with Barbara Lee Smith, Bessie Rayner Parkes (the future mother of Hillaire Belloc) and the Howitts, who were as serious about women's artistic capabilities as the Brotherhood had been about the creative potential of young men. Pre-Raphaelite associate Arthur Hughes noticed that 'ourselves excepted the women of this generation are surpassing the men.'[28] They also admired and took Lizzie seriously.

For a time, Gabriel replaced the Brotherhood with a kind of artistic Sisterhood. His exposure to different types of women started to be reflected in his work. During the fifties, the virginal femininity and suppressed sexuality celebrated in Gabriel's earliest works was overlaid with a ripening eroticism, illustrated in the watercolour *Annunciation* (1855), for which Siddal was the model. Unlike *Ecce Ancilla Domini*'s Virgin (drawn from Christina), Mary is no longer confined to a bleached, spartan bedroom but is roaming free by the side of a stream in a lush, overgrown landscape. One can't help thinking of Gabriel's admiration for the capable Barbara Lee Smith, lustily wading breech-less through a stream. In this latest annunciation, the Virgin is blissful and serene, rather than doubtful and distressed at the Angel's message. Gone are the predominating shades of white, replaced with verdant greens and golden yellows. Here Mary is mystical and sensual, the blooming landscape around her acting as a trenchant metaphor for her own fertility. This effect is repeated in *Mary Nazarene* (1857) where Siddal models for a Virgin Mary dressed unusually in green, planting a lily and rose with a watering can by her side. Siddal's own artistic creativity partook of this same magic, according to Gabriel, who praised 'her fecundity of invention.'[29]

Gabriel wasn't the only one to appreciate Siddal's 'fecundity.' John Ruskin was so taken with Gabriel's girlfriend that he gave her both a £150 annuity and a pet name, 'Ida' (from Tennyson's poem, 'The Princess'). He hosted her at his parents' house, where his father, a man not easily impressed, said that she looked as noble as a countess. Ruskin also financed and facilitated recuperative trips to Florence and Oxford. Ruskin, who had always paid much closer attention to the rest of the Pre-Raphaelite Brothers, was now ready to give Gabriel his full attention, an irony Gabriel appreciated but did not resent. He

claimed to Brown that Ruskin said Siddal's drawings bested his own, which he regarded as a compliment because he was her teacher. He had predicted that Ruskin would worship his 'pupil', and had prepared the ground so that Ruskin had been yearning to meet her for some time. Though Gabriel was irresponsible and emotionally immature in many ways, jealousy was never one of his faults, and most people who knew him remarked on his generosity in promoting others' works.

Perhaps it was because envy was not in his makeup that he failed to spot its potential in his siblings. Christina, William and Maria had accepted the favouritism lavished on Gabriel by their parents, but it was when he began to favour Siddal over them that the dam broke, or rather began to crumble in a quiet, reserved way. Christina did not respond as enthusiastically as Gabriel expected to the news that she had been superceded, both as his closest female companion and muse. It became obvious that Christina would not be as much help in softening Frances up for meeting Siddal as he'd hoped. Mystified, he complained to William that Christina's 'appreciation of Lizzie was not up to the mark.' William's sympathies were with his sister. He was also underwhelmed by Siddal. 'All her talk was of a "chaffy" kind – its tone sarcastic, its substance lightsome,' he complained. 'It was like the speech of a person who wanted to turn off the conversation, and leave matters substantially where they stood before.' Gabriel's affair with her had been ill-timed, from his younger brother's perspective; it had begun while half of his family had been forced to desert London for Frome, just when William was in extra need of company. Like Christina, he felt replaced by Lizzie in his brother's affections. Never one to make a scene, William beat a dignified retreat. Coinciding with his realization that he would have to give up any lingering dreams of becoming an artist, the couple's reciprocal infatuation made him feel even more like an outsider than usual. William even partially blamed Siddal for the dissolution of the PRB, claiming that Gabriel 'was so constantly in the company of Lizzie Siddal that this may even have conduced towards the break-up of the P.R.B. as a society of comrades.'[30] The usually sanguine William's unfairness in blaming Siddal for the PRB break-up was a measure of his hurt feelings. In truth, the PRB had been in decline for some time, and Hunt's long absence in the Holy Land and Millais's 1853 election as an associate of the RA

did more to bring the groups' halcyon days to a close than the fact that Gabriel had a girlfriend. Many of them in fact found her unusual beauty as captivating as Gabriel did, and were intrigued rather than repelled by her personality. Most reported that she was a quiet and enigmatic figure, rather than one who sought to cut conversation brutally short. The 'chaffy' talk William objected to could as easily have been a mark of Siddal's nervousness at meeting an intellectually intimidating Rossetti brother, of whose approval she may have been less sure than Gabriel. Unlike the Rossetti sisters, she may have been at times out of her depth in conversation with members of Gabriel's bi-lingual, extremely articulate circle, and taken refuge in sarcasm or silence.

Even if the introduction of Siddal and Christina had gone smoothy, it would have been an inauspicious time for her to meet Frances in any case. Frances was two days back in town when her brother Henry wrote in a panic, requesting help in locating his daughter Henrietta. His wife (also named Henrietta) who had left him earlier that year, had abducted their eight year-old girl from her Catholic boarding school in Lincolnshire and was looking to flee the country for the United States. While emigration seems at first an extreme way to leave a marriage, it should be remembered that divorce in those days was virtually impossible for women to initiate, and not only because of religious restriction and social taboo. While a husband could divorce a wife and retain custody of the children simply on suspicion of adultery, a woman had to prove irrefutably that the husband had committed adultery, *along with* bigamy, incest or gross cruelty. There was no real provision for ordinary civil divorce for irreconcilable differences; a prohibitively expensive private act of Parliament was required. Furthermore, a wife's resources, money, land and children all were considered her husband's property if she abandoned the marriage illegally. Henrietta Polydore would have had an additional problem; Henry was a strict Roman Catholic, and only an endorsement from the Pope could end his marriage.

The Rossettis are silent as to why their uncle's marriage failed so spectacularly. William writes discreetly that their 'tempers and habits disagreed, but there is no imputation of Mrs. Polydore's character.' Henry was not as well-liked as his sisters in the Rossetti family.

He was known for his ham-fisted attempt to convert the girls to the Roman Catholic faith, the utter hopelessness of which amused William. Most mentions of him concern his persistent requests for out-of-date issues of magazines to which the Rossettis subscribed. Although he marketed himself as a lawyer, he was really a glorified law clerk whose career had dead-ended a long time before his wife left him. If anything, he was probably a dull husband rather than a tyrannical one, unsuitable for a wife William described as an energetic and capable businesswoman with a habit of landing on her feet.[31] While they were circumspect about Henry's wife's desertion, they were very worried about his little girl, whom they doted on and had nicknamed 'Lalla.' When her cousin was a baby, Christina had written her an affectionate poem, 'To Lalla, reading my verses topsy-turvy' after finding little Henrietta reading her verses upside-down. Although the Rossettis tried to intervene, Henry's wife managed to escape to the United States with her daughter, where the two disappeared. The whole process had put a strain on the family, and the timing was not ideal to introduce Siddal.

The Rossettis' fortunes did not improve. They had been back in London less than a month when Gabriele went into serious decline. On Easter Sunday it became clear that he was dying. A life-threatening combination of diabetes, an eruption of carbuncle and a general weakness testified to his wasted immune system, and his doctors were not optimistic. Unusually, Gabriele himself was hopeful, displaying an unaccustomed tencity on the morning of April 24th, when he insisted that Frances help him dress so he could take breakfast downstairs. At first he was content. 'How I have longed for this moment!' he said. Afterwards, when he sat down to read, Gabriele became so weak that Frances was forced to support his head. He was taken back to bed where he spent a feverish and restless two nights, although he was still able intermittintly to recognise and communicate with his family. When Maria asked if he was in pain, he replied, 'Where do I not feel it?' His eldest daughter noted down her father's words whenever he was able to speak. In a moment of lucidity, he said how grateful he was to have all his children around him. Maria's notes do not record what her father may have said to Gabriel or Christina, but it was on his deathbed that his true appreciation for William shone through.

'Do you know him?' Maria asked her father when William arrived. 'I see him. I hear him. He is written in my heart,' Gabriele replied. His cousin Teodorico Pietrocola and Charlotte, Eliza and Margaret Polidori were also present. Christina recorded that one of his students, Charles Cayley, turned up twice to pay his respects. The shy young man was not admitted to the sickroom, but he endeared himself to the Rossettis forever. There were also vistors that no one else but the dying man could see; Gabriele's mother appeared to him, despite his family's assurances that she had died in Italy long ago. The Neapolitan revolutionary General Pepe manifested in bed next to him, prompting a bewildered Gabriele to ask Frances how he'd gotten there. In a rare display of mercy, the spirit of Dante Alighieri stayed away on Gabriele's last night on earth. Frances remained by Gabriele's bedside, reading an Italian translation of the liturgy. Her husband responded to its prayers, holding his wife's gaze all the while. More a cultural Catholic than a devout believer, Gabriel was praying to Frances as much as he was praying to God. The fifty-three year-old woman beside him still exerted that magnetic power which he'd sensed on first meeting Frances, and immortalised in verse: 'A single moment regulates a life: / My heart became the lodestone, she the pole.' The qualities he appreciated most in his wife – steadfastness, frankness, discipline and duty – helped them both through the long process of saying goodbye.

Gabriele died in the early evening of April the twenty-sixth, aged seventy-one. His last words, 'Ah Dio y ajutami Tu' (God, help me Thou), were inscribed on his tombstone.[32] He was buried in Highgate Cemetery on the third of May. The funeral was attended by all who had been present at his death-bed, as well as Frances's brother Philip. Gabriel left immediately afterwards in order to join Elizabeth Siddal in Hastings, where she was staying in a bed and breakfast. He had received news from Barbara Smith, who was holidaying with Anna Mary Howitt in nearby Robertsbridge, that Siddal's health was so poor that hospitalization at the Sussex Infirmary was being considered. Doctors had failed to diagnose anything specific, with causes being proposed from curvature of the spine to the catch-all 'neuralgia.' Four days later, Gabriel wrote his mother from Hastings, excusing himself from using the customary black-bordered mourning

stationary because he was saving it for other correspondents. His news was exclusively about Siddal's miraculous recovery since his arrival at Hastings on the day of his father's funeral. He assured Frances that Lizzie's spirits had improved immediately, and she was feeling well enough to take a walk with Gabriel, Smith and Howitt, and to make plans to travel to Robertsbridge for a day-trip. Gabriel realised that his mother was probaby not 'in a mood for hearing of these things,' but that didn't stop him from insensitively sharing that he felt 'more at ease since seeing Lizzy,' although he conceded he 'was not the merriest of our party yesterday.'[33] Going direct from his father's freshly-dug grave to Siddal's sick-bed was another in a growing list of political errors on Gabriel's part concerning the integration of his fianceé into the Rossetti family. The relationship had already alienated his brother and Christina, and now he could add his mother to this roster, and probably by extension the Polidori aunts, whose financial assistance had not been intended to help support Gabriel's holidays with his girlfriend.

One silver lining was that the death of Frances's husband did not alter the family finances for the worse. The family pot had long been kept boiling by the efforts of others, and while Gabriele left everything to Frances, William noted that 'everything amounted to hardly anything.'[34] The Italian exile's legacy to his wife consisted of furniture, books and the copyright to all his works, which would never earn any proceeds. This meagre bequest, along exhaustion and intense grief, was the catalyst for a rare display of unguarded passion from Frances. It is impossible to know what Frances was feeling when she burned all existing copies of Gabriele's *Mistero dell' Amor Platonico*, but it seems likely that she was experiencing mixed emotions at the very least. Frances had spent the last few years caring for a very sick and depressed husband, running two failing schools, looking after a youngest daughter with serious mental and physical health problems, and worrying about an eldest son who was becoming increasingly detached from his family in every way except financially. While her sisters remained rocks of support, Eliza had just joined the Nightingale Nurses and was planning to ship out to Turkey to do dangerous work tending to the Crimean War's wounded soldiers. Her gormless, ineffectual brother Philip was no help, and Henry's marital strife and

her niece's disappearance to North America put a further strain on Frances. She had struggled to keep her increasingly fractured nuclear family together through financial turmoil, health crises and multiple house moves. That spring, she had lost both of her parents and her husband within weeks of each other. Grief had undone Frances, but only temporarily. Burning her husband's books, which had brought the Rossetti family nothing but trouble, purged Frances's anger and despair, if not her sorrow.

Like the Dowager Marchioness of Bath, who was clearly something of a role model, Frances would assume her widow's weeds with a steely dignity with which contemporary accounts seldom credit her. The men of the era, blinded by Victorian commonplaces about women in general and mothers in particular, saw her only as a compliant, gentle angel-in-the-house. While gathering round to hear Gabriele and his exile friends discourse at length on Italian politics, few of the Rossetti boys' friends had guessed at the quiet Frances's deep reserves of strength, resilience and purpose. Her capacity for strong emotion had escaped even William, the most sensitive and perceptive of her children, who had been so taken in by her outward show of reserve that his shock at her book burning reverberated into his own old age.

Frances was not the only one with mixed emotions. A week after her father's funeral, Christina wrote about this interplay of sorrow and relief in a poem entitled 'Ye have forgotten the exhortation':

Bury thy dead, heart-deep;
Take patience till the sun shall set;
There are no tears for him to weep,
No doubts to haunt him yet:
Take comfort – he will not forget: –

The poem describes a grave on which violets are growing and a turtle dove coos, in a private nod to her father's old poem which characterised his baby daughters as 'fresh violets' and 'turtle doves' / In the nest of love'. The death of Gabriele, dove-tailing with the dissolution of the Pre-Raphaelite Brotherhood, marked the end of an era in the life of the Rossetti family, but also a new beginning. About his father's death, Gabriel confessed that 'we cannot but feel in some

sort happy at seeing him released.'[35] He had a similar reaction to the end of the PRB, which he felt was signalled by Millais's acceptance as a fellow of the Royal Academy. 'So now the whole Round Table is dissolved,' Gabriel remarked to Christina.[36] Christina commemorated the decline in a wry poem about the P.R.B's 'decadence', which concluded: 'So luscious fruit must fall when over ripe, / And so the consummated P.R.B.' The rot had set in; the radical was now becoming the establishment.

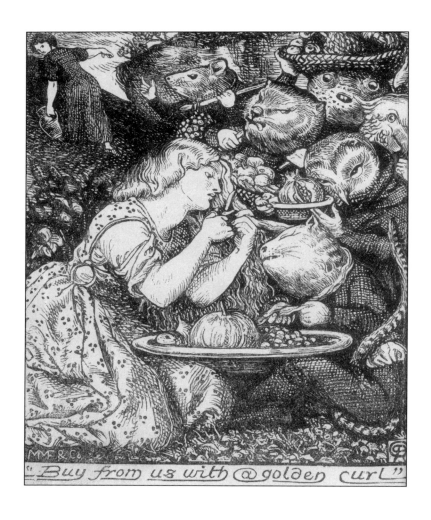

Dante Gabriel Rossetti, *Buy From Us With A Golden Curl*, 1862

The only woman to publish with the Pre-Raphaelites, Christina Rossetti was
the first successful poet associated with the movement after the triumph of
Goblin Market and Other Poems. Her brother's illustration portrays the moment
when Laura exchanges a lock of her hair for the goblins' enchanted fruit.

7

MOVING ON

While over ripe fruit may fall, it also scatters seeds, and the Pre-Raphaelite influence would continue to grow long after the original group disintegrated. This was largely due to Gabriel's influence. Gabriel and his father had rarely seen eye to eye, but the old Italian exile's rebellious, enterprising spirit survived in his eldest son, which was just what the old man had intended. Though often frustrated as the parent of a willful boy, he had raised Gabriel on a friend's advice: 'Take care…how you root up the *cattivo germe* (bad seed) which you complain of in your son. That *immerso tutto* (complete absorption) is the surest sign of genius.'[1] Gabriel's self-belief was certainly bolstered by parental indulgence. While it is easy to find the flaws in the Rossettis' approach to child-rearing, parental spoiling does not account for the fact that almost everyone else Gabriel came across was inclined to indulge him too. His self-confidence was tempered with a largeness of spirit and great lashings of frothy charm to sweeten even the most cynical of temperaments.

Like his father, Gabriel had a knack for making others believe in his genius almost as much as he did. A social animal, he never operated alone, but functioned best as the leader of a group. Undeterred by the disintegration of his painterly Brotherhood, he was determined to find himself some new knights, reassemble his artistic Round Table, and bathe modern, Industrial England in bright Pre-Raphaelite colours. Initially, he considered recruiting from the student body at the Working Men's College, where he was teaching night classes along with Ruskin. A philanthropic enterprise set up by Christian Socialists F.D. Maurice and Lowes Cato Dickinson (among others),

the College was meant to enrich the lives of ordinary working men by exposing them to the world of art. The College had opened in Red Lion Square in the autumn of 1854, and moved to 45 Great Ormond Street in 1857. Art instructors were heavily recruited from the PRB and its associates. Along with Dickinson, Ruskin and Gabriel, other teachers included sculptors Thomas Woolner and Alexander Munro, and painters Arthur Hughes and Ford Madox Brown. Later Edward Burne Jones would join their ranks. Recalling the more traditional teaching method at Sass's Academy, Ruskin set his students to the tasks of drawing spheres, leaves and pebbles. Gabriel, with typical impatience for academics, was less structured in his approach, challenging the orthodoxy of the time by teaching the students to use colour before mastering the basics of drawing, or even of light and shade. Often, he simply placed a bird or a boy before his class with the instruction: 'Do it.' Growing up in a family rife with professional educators had given him a healthy respect for the symbiotic relationship between teaching and learning. 'I draw there myself and find that by far the most valuable part of my teaching – not only to me but for them,' he explained to Hunt.[2] As in his student days at the Royal Academy Schools, he awed his pupils with bravura displays of on-the-spot drawing, 'throwing the pencil with apparent recklessness about the paper' and then applying both wet and dry colour until the finished work 'possessed all that splendid colour which…only he could attain to produce.'[3] In a mechanised age which enshrined method, rote learning and standardization, Gabriel's faith in the transformative power of art was a revelation to the carpenters, wheelwrights and masons who made up the student body. Beneath the hot and dry gas lights of the College drawing rooms, inspiration bloomed in violet carmine, yellow ochre and prussian blue. 'The spirit of the teacher was of more value than any system,' one student recalled.[4]

Gabriel was an extremely popular teacher, and impressed Ruskin by not charging the College for his time. He was, however, remunerated in other ways, not least by Ruskin's continued esteem. His humanitarian efforts also put him back in Lady Bath's good books; Aunt Charlotte arranged for her employer to come by and observe Gabriel's evening class. Gabriel revealed his other agenda when he reported to a friend that his pupils were making 'superhuman progress in PRBism.'[5]

Although Gabriel's success at the College caused Ruskin to comment on his uncanny ability to attract disciples, these aspirational working men were not ultimately chosen to sit around the new Pre-Raphaelite Round Table. Perhaps Gabriel had teetered too close to the social margins himself to comfortably tolerate constant reminders of a less fortunate fate. However patient and enthusiastic he was as a teacher, Gabriel felt his special quest called for knights who were his social and intellectual equals. No sign painter or shop keeper was going to be an adequate replacement for Holman Hunt and John Millais. As a matter of fact, he would recruit from slightly higher ranks. Already, the young Oxford students Gabriel would select as the next generation of Pre-Raphaelites were poring over back copies of *The Germ* and calling themselves the 'Order of Sir Galahad.' Of course there would be casualties of this new order. A Queen Guinevere would required, and she would not be Elizabeth Siddal. Dante Alighieri too would be shunted aside to make way for an English legend.

By the mid 1850s there were signs that Gabriel was tiring of Siddal, the most obvious one being that they were still unmarried. Yet Ruskin's interest in her was enough to guarantee Gabriel's continuing fealty. A less canny operator might have been concerned by the attention Siddal was receiving from such a wealthy, well-respected man, but Gabriel's famous lack of jealousy meant that he was able to view Ruskin's support of her artistic ambitions in a positive light: 'He is likely also to be of great use to me personally (for the use to her is also use to me)', he remarked to his Aunt Charlotte, whose long association with Lady Bath had demonstrated to Gabriel the benefits of cultivating patronage. Gabriel worked to ensure that Ruskin continued to be 'the best friend I ever had *out of my own family*.'[6] As Siddal's paramour, he benefitted directly from Ruskin's cash injections, and indirectly from his attention. After years of lavishing praise on Hunt and Millais, Ruskin was finally starting to recognise that Gabriel was special. Ruskin wrote to Gabriel that 'among all the painters I know, you on the whole have the greatest genius' and promised to be 'more really useful in enabling you to paint properly…'.[7]

Despite Ruskin's extravagant admiration of Siddal, he was no romantic rival. Thin and beaky, with thick yellow hair and a mouth

slightly disfigured from a dog bite in early childhood, the reedy John Ruskin was hardly competition for the Byronic charms of Gabriel Rossetti. His family wealth and its attendant snobbery made it unlikely that he would chose a former hat-shop assistant as a bride, and he was certainly no sexual threat, having recently been divorced by his wife Effie over his failure to consummate their marriage. Ruskin's bride had been both beautiful and willing, and although there is no knowing the true reason for his sexual rejection of her, it is likely that it had something to do with the reality of a living, breathing woman in his bed as opposed to the speechless, bloodless ideal of women in paintings. He had objected to 'certain circumstances in her person', and told Effie 'that he had imagined women were quite different to what he saw I was, and that the reason he did not make me his Wife was because he was disgusted with my person the first evening.'[8] Millais, who had no such qualms, fell in love with Effie, helped her flee the Ruskin household, and married her himself.

Marriage, as an experiment, had left Ruskin as cold as it had found him. 'The true secret of happiness,' he wrote, 'would be to bolt one's gates, lie on the grass all day, take care not to eat too much dinner, and buy as many Turners as one could afford.'[9] His admiration of Siddal, his Princess 'Ida', remained chivalric and platonic, and was closely linked to his idealization of Gabriel and Siddal as a couple. He considered his attitude toward them as benign and paternal, though at this distance it seems like a sublimation of other desires. 'I think Ida should be very happy to see how much more beautifully, perfectly, and tenderly, you draw when you are drawing her than when you draw anybody else,' Ruskin wrote to Gabriel. 'She cures you of all your worst faults when you only look at her.'[10] But this was wishful thinking, based on the misconception about art and about women that would ensure Ruskin died a disappointed bachelor. It was also based on a Victorian idealization of domestic womanhood, popularised by PRB associate Coventry Patmore's 'Angel in the House' poems. The domestic sphere, where woman reigned, existed apart from the masculine world of alienating, difficult and cut-throat business. It was a woman's job to be her husband's comfort and moral compass, just as it was his job to be her provider and protector. These roles placed enormous pressure on both men and women, particularly

men and women like Gabriel and Siddal, who were not cut from such conventional cloth. For one thing, they were not married. For another, they existed in over-lapping rather than separate spheres, working together on their drawing and painting and sharing friends.

Siddal's brief as a fiancée, to be beautiful enough to cure all of Gabriel's faults, was as enormous as it was impossible. It took another woman, however, to recognise this. While Ruskin thought that Gabriel's obsessive drawings and paintings of Siddal were a 'cure', Christina thought they were symptoms of a disease. Her brother's preoccupation with Siddal's image was compulsive and disturbing, revealing a mind so steeped in fantasy that it was a danger to itself and others. She wrote a poem entitled 'In An Artist's Studio', never published during her lifetime, about being unsettled by all of the paintings of Siddal at Chatham Place. Siddal was everywhere; the 'one face' that 'looks out from all his canvasses', and the 'selfsame figure' who 'sits or walks or leans' in every painting, whether portrayed as a 'queen in opal or in ruby dress' or a 'nameless girl in freshest summer greens'. Christina portrays the artist himself as a vampiric predator, who 'feeds upon her face by day and night.' The image in the painting is 'a saint, an angel', and is worshipped by the artist while the model herself is neglected. He has painted her 'Not as she is, but was when hope shone bright; / Not as she is, but as she fills his dream.'

Ruskin was more at ease with representations of life than with its messy reality; paintings held still and did as they were told, but people were a different matter entirely. Relationships between artists and patrons are never without their complications, and Ruskin became increasingly frustrated by Gabriel and Siddal's failure to conform to his vision of them. At thirty-five, he adopted the persona of a crotchety old man in order to protect himself from other, more confusing kinds of feelings about the beautiful young couple. He expressed himself in the language of a disappointed father, which was particularly triggering to Gabriel, who did not have a history of responding well to paternal disappointment. Although he was only about a decade older than Gabriel, Ruskin frequently chided him for staying up late and failing to keep his rooms tidy. The critic's frustration was not unique to Gabriel and Siddal. He felt it also in his relationship to other painters he patronised, like Turner, Watts and Millais. 'These

geniuses are all alike, little and big', he wrote. He complained that they were strong-willed and wrongheaded, and made him feel 'like the old woman who lived in the shoe – only that I don't want to send them to bed, and can't whip them.'[11]

He might have found an ally in Frances Rossetti, who was reluctantly resigning herself to the unwanted attachment between her eldest son and Siddal. While expansive in terms of friendships and associations, the Rossettis proved tight-knit and cliquey when it came to more intimate relations. Gabriele Rossetti had bequeathed to his children an exile's sense of the family as a sanctuary from the world outside. Introducing an outsider violated this unspoken inheritance. A deafening silence falls over Siddal's first meeting with her prospective mother-in-law in April, 1855, but we can guess, from the polite and formal terms on which she is discussed in subsequent letters, that none of the Rossetti women really warmed to her. Certainly Gabriel felt that Christina might have made more of an effort. William, no great admirer of Siddal himself, defended his sister, arguing that it was impossible for anyone to echo Gabriel's enthusiasm note for note, let alone a reserved person like Christina. Even so, when Gabriel and Christina paid Ford Madox Brown a visit, the artist recorded a 'coldness between her and Gabriel because she and Guggum do not agree. She works at worsted ever and talks sparingly.'[12] Aside from jealousy at having been displaced as the premier Pre-Raphaelite model, and their differences in class and education, Christina was apprehensive about the propriety of their relationship. Though Siddal had her own rooms in Weymouth Street, which may have been chosen for their close proximity to the Rossetti Albany Street household, her relationship with Gabriel nevertheless reeked of the improper. She came and went from Chatham Place unaccompanied and at all hours. Although Gabriel's female relatives (as opposed to William) were kept in the dark as to the details of the relationship with Siddal, it was clearly unconventional, not least because she was in the habit of posing, unchaperoned, for his paintings. There was talk of an engagement, but no wedding date seemed ever to be forthcoming. The Rossetti women, whose district visiting made them aware of social problems connected to extra-marital sex, must have suspected that there was a sexual, and therefore sinful and socially dangerous, aspect to the

relationship. In the same spring that Gabriel introduced Siddal to his family, it was Ford Madox Brown who voiced what was on everyone's mind: 'Why does he not marry her?'[13] Ruskin was wondering the same thing, even offering to help Gabriel with expenses if money worries were delaying the marriage. Still Gabriel stalled, and this procrastination may also have caused the coldness Brown perceived between Christina and Gabriel. His sister knew only too well the pain caused by a foot-dragging fiancé.

Siddal might have stood a better chance with the Rossetti women had she been a devout Christian. Little is known of Siddal's own religious beliefs, but William wrote that as far as he was aware, she had none. His knowledge of Gabriel's negative feelings towards women without faith made him uncertain on this point, and there are suggestions that Siddal was a believer. Despite Gabriel's own shaky faith, he disliked irreligious women, and had 'a certain marked degree of prejudice against women who would not believe.'[14] We have very little information about Siddal in her own voice, but her surviving poems are littered with biblical allusions and what feels like sincere Christian feeling, as in 'He and She and Angels Three', where angels carry lovers' souls to heaven where they all 'pray among themselves / And sing at His right hand.'

William's uncertainty about Siddal's faith at least reveals that she was not overtly devout in either worship or conversation, which would have been a further obstacle to genuine closeness with the Rossetti women. While they could excuse William and Gabriel's developing agnosticism, in a potential daughter or sister-in-law a lack of visible spirituality was undesirable. Yet the Rossetti sisters were not intolerant. While they had a marked preference for Anglo-Catholicism, as grand-children and children of interfaith marriages, and citizens of a multi-cultural capital city, they did not tend to shun people of other faiths. Frances, after all, had married a Roman Catholic, and was close to her Roman Catholic brothers. Christina's lifelong best friend, Amelia Barnard Heimann, was a Jew, as were her children Golde and Charlie, on whom their unofficial aunty Christina doted. Christina could be proselytising and insensitive about her friend's Jewishness but neither woman regarded religious differences as a bar to their intimate friendship.

As much as class or religious differences, it was the intensity of Gabriel's infatuation which was counter-productive to a friendship between his fiancée and family. It never occurred to the favoured eldest child that others might not share his passion for 'Guggum', but it was unlikely that William and Christina's distaste for her escaped the eagle-eyed Frances. A letter to Frances in the summer of 1855 was swollen with Gabriel's praise of Siddal, including a long, dull anecdote about a little boy being enchanted with her during a donkey ride. He devoted two polite sentences to the faltering health of Christina and his mother, and three paragraphs to a detailed study of Siddal's health. He asked Frances, who was at Hastings with Christina that summer, to travel to a local ruin and look for the initials he and Siddal had scratched on a blocked-up door during their own visit the previous spring. He also provided directions to a stone near a waterfall where he and his fiancée had again left their initials, assuring his mother they would be easy to discover. Gabriel clearly over-estimated the extent of his mother's interest in viewing lovers' graffiti dating from the same spring she had donned her widow's weeds. Perhaps he should not have reminded her of his own presence in Hastings the previous May, when he had rushed directly from his father's funeral to Siddal's side. In her reply to Gabriel, Frances rather pointedly mentioned her plans to leave flowers on his father's grave. She also sarcastically dispatched with Gabriel's apology for the tardiness of his letter: 'My confidence in your love is sufficiently firm to withstand the shock of the delay of a letter from you…' Although she offered her 'sincere regret' about Siddal's continuing ill health, Frances confessed that she was not surprised, as 'she hardly stays long enough at any place to give it a fair chance.'

Another possibility exists to explain the Rossettis' 'coldness' towards Siddal that year; loyalty to Maria. The Rossetti family had rallied around Ruskin in the wake of his marriage's collapse. While Gabriel defended him in conversation, the young painter's mother and sisters offered Ruskin hospitality and support. The discreet, reserved Rossetti women were the perfect antidote to Ruskin's assertive former wife, lavishing praise on his work and fussing around him when he was sick. When she heard he was recuperating from a minor illness, Frances was 'very glad he is better in health, for the loss of such a

man is a public calamity, as well as a private sorrow.' During this period, Maria developed a crush on the lanky critic, and at one point it seemed to the family on the verge of being reciprocated. It would have been a desirable match in many ways. Educated, cultivated and emotionally stable, Maria's experience as a teacher, translator and amanuensis would have served her well as Ruskin's wife. Her later career as an Anglican nun suggests she might even have been amenable to the sexless union Ruskin would probably have preferred.

Despite the pleasant Victorian fantasy of domestic angels offering salvation to their husbands, the reality was that no one woman could have resolved Ruskin's deep-seated and conflicted feelings about women. If he was repulsed and frightened by the nudity of the famously beautiful Effie Gray, it was unlikely he would lose his heart to the plain Maria. Ruskin wanted someone whose unattainability would protect him from sexual obligation or performance, and whom he could idealise indefinitely, but this someone also had to be very beautiful. It was Gabriel's young fiancée, rather than his eldest sister, who matched this description.

Maria, along with Gabriel and Siddal, was invited to dine with Ruskin in July, and while this event was much-anticipated by Maria and Frances, it is clear that 'Ida' remained the focus of Ruskin's attention. 'I shall like to hear Maria's account of her Ruskin dinner,' Frances wrote, rather ignoring the fact that Siddal would be there too.[15] Ruskin did enjoy Maria's company, but his glancing mentions of 'Miss Rossetti' in his letters suggest polite acquaintance rather than passionate attachment.

Having met Siddal that spring, Ruskin's parents had already taken a shine to her, offering her a room in their house to recover her health. Ruskin's father remarked that Siddal carried herself like a countess, while his normally stand-offish mother gave her medical advice during a private interview. Aside from financial help, Ruskin gave her gifts such as a beautifully bound copy of Wordsworth and precious ivory-dust to be made into a medicinal jelly. No such gifts or potions were forthcoming for the round-faced, cheerful Maria, whom nobody ever thought to compare to a countess. Ruskin had assured Siddal that he was helping her in the same way 'as I should try to save a beautiful tree from being cut down, or a bit of Gothic cathedral whose strength

was failing. He asked her to 'consider yourself as a piece of wood or Gothic for a few months…'.[16] Unlike Siddal, Maria Rossetti was no fixer-upper. Her economic self-sufficiency and education meant that she needed no Pygmalion to transform her, and it is unlikely she would have yielded to any attempts at being moulded into a new shape. In her independence of spirit and unshakeable pragmatism she resembled Eliza Polidori, whose community work she had taken over while her aunt was nursing in the Crimea. Though quieter than her siblings, Maria retained the strong-willed independence of her girlhood, and in some ways trod a more original path than any of them. Christina, by contrast, had inherited her mother's Romantic streak, which meant that she struggled more to accept that love was not always returned. Her sister's abortive relationship with Ruskin was still haunting Christina in her fifties, when she alluded to it in one of her mature works, *Time Flies*:

> One of the most genuine Christians I ever knew, once took lightly the dying out of a brief acquaintance which had engaged her warm heart, on the ground that such mere tastes and glimpses of congenial intercourse on earth wait for their development in heaven.[17]

The Rossettis were always more enthusiastic about Maria than anyone else, resolutely ignoring the obvious drawbacks of her plainness, unremarkable figure and lack of artistic talent or commercial ambition. All of the siblings would insist that Maria was the most intelligent among them, and the one who would have gone furthest had circumstances been different. Family mythology made it taboo to admit that one of the Rossetti children might just be ordinary. At a time when twenty-five was the average age of marriage for women, the Rossettis realised that the twenty eight year-old Maria was facing a single life, which perhaps explains their overly optimistic hope that Ruskin would step in as a last-minute suitor. Christina in particular had high expectations for her beloved sister. Two years before, Christina had told William that if she ever made any profit from her short stories, she would set some of it aside for Maria's dowry. In a burst of misplaced loyalty, Christina may have regarded Siddal as a rival not only for Gabriel's attentions, but for Ruskin's as well, which would

only have added to her distaste for 'Guggum.' In any case, as *Time Flies* shows, she took Ruskin's lack of interest in Maria harder than her sister. Frances too was disappointed, and the Rossetti women's enthusiasm about Ruskin gradually dissipated. Initially sympathetic to Ruskin during his annulment, by the end of the year Frances was sitting to his romantic rival Millais for his *Departure of the Crusaders*.

Maria soon re-directed her energies into her teaching, having taken on Brown's daughter Lucy as a pupil and boarder for £40 per annum. Others had offered to school and board his daughter, but Brown told Maria he preferred 'the advantages of your far greater capabilities and undoubted friendship.'[18] Although the arrangement only lasted a year, it was a successful one from an emotional point of view. Though the truth of the matter is hard to discover at this distance, Brown may have wanted to shield Lucy from his new wife's alcoholism, or he wanted to concentrate on his second family without awkward reminders of his first, or he simply wanted to save on board-ing-school tuition fees. Either way, Lucy was unwanted at home, and made welcome at the Rossettis'. More disciplined and regulated than home life with her father, life with the Rossettis still gave plenty of scope for artistic creativity and imagination. As for Maria, she was able to combine her pedagogical talents with a maternal care-taking role, reminding herself where her true talents lay.

William also had his first experience of love in the 1850s. Sibling competitiveness was apparent in his choice of fiancée; the modest, educated Henrietta Rintoul immediately found favour with his family. That Henrietta Rintoul was the daughter of Robert Stephen Rintoul, editor of *The Spectator*, rather than a cutler's daughter, did not hurt her cause. William, alert for a replacement father-figure after Gabriele's death, had found one in Robert Rintoul, a dynamic Scotsman in his sixties who envisioned *The Spectator* as an engine of 'educated Radicalism.' His sturdy physique and commanding presence were reminiscent of Gabriele in his healthy prime. Like William's father, Rintoul was passionate about current affairs, but his sphere of influence and spirit of activism made him much more politically effective than the Rossetti patriarch had been. The dearest London paper at 99p, *The Spectator* may not have fallen into the hands of the disenfranchised it sought to liberate, but it did reach those who

influenced policy. Leigh Hunt, who would succeed Rintoul as editor, credited his personal magnetism with attracting first-rate minds of his day to write for his magazine, such as Jeremy Bentham and John Stuart Mill. Rintoul supported the extension of voting rights of the Reform Bill of 1832 and the repeal of the Corn Laws, and was a proponent of the full-scale abolition of slavery. His reformist stance reflected William's own liberal beliefs, while *The Spectator's* promotion of original writing and wide arts coverage helped develop his talents as a critic. William's tenure at the paper also acted as a springboard for his career in journalism. In the spring of 1855, twenty seven year-old American painter and journalist William James Stillman founded a New York art magazine called *The Crayon*, for which William agreed to be his London correspondent, writing a regular column entitled 'Art News From London.' This was an opportunity for William not only to bolster his reputation, but to bring Pre-Raphaelitism to an international audience. His interest in American art, literature and politics distinguished him from his other siblings, who preferred looking to England or Europe for inspiration. William sensed that the United States would be a receptive arena for the new, the revolutionary in art. He was reading Walt Whitman's *Leaves of Grass* that year, and was one of the first English critics to recognise its significance. Somewhat surprisingly, given his love of love, poetry and eroticism, Gabriel loathed *Leaves of Grass*. Thirteen years later, when critical opinion was finally catching up with the American poet, William would edit the first British edition of Whitman's poems. His love of poems, such as 'I sing the Body Electric', also reveals the erotic desires beneath William's responsible, grown-up façade, providing a heartbreaking insight into the experiences of adolescence and early manhood that the twenty five year-old had been denied:

> Limitless limpid jets of love hot and enormous, quivering jelly of
> love, white-blow and delirious juice;
> Bridegroom night of love, working surely and softly into the pros-
> trate dawn; Undulating into the willing and yielding day,
> Lost in the cleave of the clasping and sweet-flesh'd day.

In retrospect, it seems obvious that the daughter of the upright

Scottish Rintouls was unlikely to allow William's suppressed ardour free reign on this scale. But she had other charms, not the least of which was the approval of William's exacting female relatives. The ambitious Rintoul family had much in common with the aspirational Rossettis, and William felt very at home during his frequent visits to their small apartments at Wellington Street, Strand, above *The Spectator*'s offices. Living above the shop, as it were, meant that the boundaries between working and domestic life were blurred in Rintoul family life, just as they had been for the Rossettis. Like Gabriele in his heydey, Rintoul was accustomed to receiving all kinds of important and interesting visitors. There William met Thackeray and also Charles Dickens's father-in-law, the music critic George Hogarth, from whose daughter Dickens would soon separate in scandalous circumstances. William was unsurprised when Thackeray and the Rintouls loyally sided with Hogarth's daughter, who was a family friend.

Though both relationships endured a prolonged engagement period, William's slow, cautious wooing of Henrietta was the opposite of his brother's whirlwind romance with Siddal. It was a very conventional courtship, which may have been why Henrietta was more successful with William's conservative female relatives than Siddal had been. Similar in habits and temperament, Henrietta got along well with Christina in particular, and the two would become lifelong friends. Henrietta was an amateur photographer and took an 1855 portrait of Christina, who regarded it as the best one ever taken of her. Where Christina was tight-lipped about Siddal, she was light and affectionate toward Henrietta, starting up a correspondence with her new friend and teasing William that he must send her love '*should you chance* to see her.'[19]

Unlike his brother, William did not enjoy unsupervised frolics along beaches or carving his initials alongside Henrietta's on old ruins, which must have been frustrating for a young man in love. Although the couple spent summer holidays together on the Isle of Wight, they were always accompanied by Henrietta's watchful mother, and certainly did not share lodgings. Feelings had been bubbling under since they had been introduced in the summer of 1851. Along with being naturally shy, William did not feel he was in a position to propose marriage to the daughter of a man for whom he

held so much respect, in terms of either finances or career prospects. He would have been making enough money to support Henrietta, if not for the fact that he was the chief bread-winner for his mother and sisters, not to mention an unofficial bank to his older brother. Though he nowhere complains, this obligation to his dependents must have weighed heavy on him at this time. If William could have been accused of not making the effort to like his brother's girlfriend, Gabriel was not much better with William and Henrietta, refusing her invitations so often that she complained to William. Tickled, Gabriel threatened to turn up at Henrietta's when he was not invited, just for a lark.

Two or three years older than William, Henrietta was well-educated, cool, intelligent and sober. 'In refinement of mind, character, and demeanour, she stood on a level which I have seldom known equalled, never surpassed', William wrote as an old man, still in awe of her.[20] In surviving photographs, her high forehead, dark wavy hair and mysterious half-smile bring to mind Da Vinci's *Mona Lisa*. Her maturity and stately bearing inspired even Gabriel to conventional displays of gentlemanly solicitude. Meeting Henrietta and her mother unexpectedly at the theatre, he summoned a carriage and escorted the ladies all the way home, though he forgot to walk them to their door. Uncharacteristically, he did write to apologise to William: 'I wish it possible you'd take some opportunity of telling them what an ass I thought myself.'[21]

Though they had been exchanging letters and visits since 1853, William and Henrietta did not become officially engaged until January 1856. William's fears about gaining her father's approval were proved justified, although her mother was marginally more in favour of the match. William recorded that, in deference to her parents' wishes, Henrietta broke off the engagement for a few months, but subsequently renewed it. It may have been during this period that William briefly allowed the spirit of Walt Whitman to take over in his summertime flirtation with Hunt's model, Annie Miller, whose voluptuous availability was in stark contrast to Henrietta's more restrained appeal. 'William takes her out boating forgetful it seems of Miss R.[intoul],' Madox Brown recorded in his diary. With Hunt away in the Middle East, Miller had cast a spell on Gabriel as well,

who spent so much time with her that even Siddal lost patience with him. 'He seems to have transferred his affections to Annie Millar [*sic*] and does nothing [but] talk of her to Miss Sid. He is mad past care,' Madox Brown recorded.[22] Annie sat for one of the attendants in Gabriel's watercolour *Dante's Dream At the Time of the Death of Beatrice*, commissioned by Ellen Heaton, a wealthy young Leeds art collector whose tastes were guided by Ruskin. Taken from a passage in Dante Alighieri's *Vita Nuova*, it shows the winged male figure of Love guiding Dante to the funeral bier where Beatrice's body lies. While stooping to kiss Beatrice's cheek, Love, dressed in bright blue robes, also holds Dante's hand. Clad in emerald green, a female attendant stands at either end of the bier, holding aloft a white canopy sprinkled with hawthorn flowers, symbols of hope. Red poppies, emblems of death and consolation, are strewn across the floor. The 'sugarplum of the universe', Mrs. James Hannay, was the model for Beatrice, while Annie Miller modeled for the maiden at the head of her bier. The picture's high-minded symbolism did not translate to Annie and Gabriel's behaviour that summer.

Despite sober promises to Hunt that he would look after Annie, Gabriel took her to dine at the disreputable Bertolini's dining rooms behind Leicester Square, and danced with her on the circular platform at the Cremorne Gardens, a notorious twelve acre Chelsea pleasure garden complete with banqueting hall, orchestra, grottoes and an American bowling saloon. A riverside family venue by day, the night-time Garden had a reputation for attracting prostitutes who posed seductively beneath its flickering gaslights. There was no chance of coming across Henrietta Rintoul, the Howitts or the Rossetti sisters there, which was perhaps the point. Entertainments included fireworks displays, balloon ascents, circus acts and pageants on an enormous scale. During the same summer that Gabriel and his friends were frequenting the Gardens, a spirited re-enactment of the storming of a fort during the Siege of Sevastopol went horribly wrong. The stage collapsed under the weight of genuine Grenadier Guards when they charged the 'Russians,' played by boys on loan from the Duke of York's school. Armed with bayonets, the soldiers injured themselves and alarmed the schoolboys. Some retreating soldiers alarmed Chelsea local Jane Welsh Carlyle when they marched

passed her on the street, carrying their white-faced wounded companions on a bier.

Such absurdities may have been closer to the chaotic spirit of the Crimean War than anyone would have liked to admit. War had come as a shock to a nation which had not clashed with European powers since 1815, when Congress of Vienna effectively drew the Napoleonic Wars to a conclusion. Major allies in the war to halt Russian expansionism into Turkey were the British, French and Ottoman Empire. Britain wanted to prevent the 'Russian bear' from taking control of the overland route to India and profitable routes in the Mediterranean. Although the war initially received strong public support from Queen Victoria's subjects, its horrors, presented in graphic reports and photos from the front, shocked and sobered readers, and would eventually lead to reforms in both the civil service and the armed forces.

In terms of the way it was reported, the Crimean campaign was the first modern war. The telegraph, railroad and steam press revolutionised war reporting. Journalists abroad could deliver their stories to London headquarters in record time, while newspapers could be rapidly produced and distributed all over England via its vast railroad network. Along with the printed work, images played an important role in the rise of the power of the press. A photographer who set up a mobile darkroom in a converted delivery van was sent out to capture images from the battle zones, marking the beginning of modern war photography. The artist William Simpson was sent out by a print dealer to render events in watercolour pictures which could be cheaply reproduced as tinted lithographs.

A lack of censorship meant that newspapers were not constrained from reporting fully on the gruesome realities of war, of from criticizing the inefficiency and mismanagement rife in the British armed forces. After reading the *Times* report on the disastrous slaughter of British troops during the Battle of Balaclava, even Tennyson went so far as to suggest that 'Some one had blunder'd,' in his famous patriotic war poem, 'The Charge of the Light Brigade' which was itself duly published in *The Examiner*. The *Times* war correspondent William Howard Russell became a hero of sorts for his exposé on the outrageously poor hospital conditions at Scutari, located opposite

Constantinople on the Asiatic shore of the Bosphorus. Russell's article inspired Florence Nightingale to lead a group of nurses out to Turkey in October 1854 with the aid and blessing of Sidney Herbert, secretary of state for war. This was a controversial move on several counts. Nursing was not regarded as a respectable occupation, and was not professionalised or regulated, nor was it yet considered women's work. Paid nurses at the time came from the working classes, and suffered from being stereotyped as dim-witted, intemperate and prone to sexual temptation. Although nursing nuns were beginning to make inroads in British hospitals, military nursing was generally performed by untrained male orderlies. Doctors were hostile to assistance from nurses, whose presence they felt undermined their authority. The association of nursing with nuns compounded this problem; nursing was suspected as a pretext for forcing Roman Catholic conversion on the sick and vulnerable. Although Nightingale was to become a national heroine, her initial efforts received bad publicity on these grounds. Of her original 38-woman nursing party, only 14 were paid nurses. The rest were nuns; 10 were Roman Catholic and 14 were Anglican Sisters. Herbert argued that the Sisters were chosen for their hospital experience and willingness to work for free, but the motives for their selection were widely perceived as religious. This suspicion was not entirely unfounded; the selection was skewed toward those with Roman Catholic and Anglo-Catholic associations, though this had as much to do with the recruiters' network of friends and colleagues as with any desire to inspire conversions. Herbert himself was a major Tractarian sympathiser who had funded the rebuilding of the medieval Church of St Mary and St Nicholas in Wiltshire, while Mary Stanley was a devout High Anglican who would in fact convert to Roman Catholicism herself during her time in the Crimea.

It would have been surprising if their search had not turned up Eliza Polidori, who had a respected track record of parish visiting, lifelong experience of nursing her invalid mother, and a spiritual commitment to High Church principles. In her forties, Eliza was also the right age; old enough not to attract unwanted romantic attention from any of her patients, but not too old to undertake hard work. Eliza longed to take advantage of this unique opportunity for adventure and experience normally unavailable to respectable,

middle-class women. Portraits done by Gabriel around this time reveal that Eliza had inherited the thin-lipped, sharp-eyed intensity of Gaetano Polidori. A slim, straight-backed figure with hair scraped back and always covered, she looks the picture of Victorian spinsterish efficiency.

Having cheered the parading Turkish troops and booed the Russians during the Lord Mayor's show, Eliza could hardly wait to express her patriotism as one of the Nightingale nurses in Scutari. Although her letters home to Frances praised the grandeur of the Bosphorus and the splendour of the local flora and fauna, no beauty compared to that of 'dear old England.'[23] Even the dark blue skies over Italy, as her boat sailed through the Mediterranean en route to Scutari, were found wanting in this respect. Although she took pride in her Italian heritage, Eliza thought of herself as an Englishwoman through and through. She was also proud to be a Londoner, and desperately missed walking her favourite city's pavements. Home was on her mind; her letters repeatedly ask after local friends and family, showing particular concern over her favourite servant, Sarah Catchpole. She repeatedly expresses her dismay there is still no news of Henry's vanished wife and daughter.

The famous Polidori disregard for fashion meant that she did not mind the unflattering, one-size-fits-all uniform of dark grey tweed dress, white cap and shoulder sash embroidered in red worsted with the words 'Scutari Hospital'. A gray cloak, straw bonnet and a veil were also included in the outfit. In defiance of the sea-sickness which laid up every other member of her party, she strode the ship's deck in stout new boots provided by her sister Charlotte. As one of the 'Ladies' of a nursing party which included nuns and lowly paid nurses, she enjoyed a high social status, sharing a first class cabin with only one other 'lady', Miss Frances Margaret Taylor, and dining with the French Captain and his officers. The twenty-two year-old Taylor was a well-connected High Anglican whose two sisters were Anglican nuns at the Sisters of Mercy at Devonport. Her family lived in Regents Park and attended Christ Church, Albany Street, and were known to Frances Rossetti and her daughters.

As a citizen of a cosmopolitan capital, Eliza was at ease chatting in Italian and French to various crew members and soldiers on board,

writing to Frances that she was sure the ship's steward was Neapolitan because his voice and accent reminded her so powerfully of Gabriele Rossetti's. When they docked in the port of Messina in Sicily, she bought 100 oranges for the French soldiers from the merchants who besieged the ship, who rowed fresh fruit and vegetables out in small boats to tempt the travellers.

When the nursing party arrived, however, Florence Nightingale refused to accept them, as Sidney Herbert had not informed her that they would be coming. Aside from not having made provisions to accommodate additional staff, Nightingale felt that Herbert had sneakily undermined her authority in sending them unasked for. She was very worried that the large number of Irish nuns in the party would stoke British fears of a sinister Roman Catholic conversion plot. This negative focus on religion would detract from Nightingale's primary mission, which was to gain public acceptance of and respect for female nursing. The nurses' leader, Mary Stanley, was widely suspected of harbouring Roman Catholic sympathies, an idea Eliza pooh-poohed: 'I like Miss Stanley very much, and she certainly has not shown in my presence any Romish tendencies.'[24] Nevertheless, Eliza and her colleagues were re-routed to the British ambassador's summer house fifteen miles away in Therapia while Nightingale tried to figure out what to do with them. Eliza did not mention her status causing ill-feeling among the lower ranks of paid nurses, but Taylor in her memoirs discussed how class tensions boiled over during the idle hours at Therapia. Taylor wrote that the Ladies had endured the paid nurses' 'coarse language' and general insolence on the way over, and were shocked when the nurses rebelled at being asked to do cooking, cleaning and general housework at the ambassador's residence. These duties of course included waiting on the Ladies. Apparently unruffled by these tensions, Eliza was put in charge of the group when Mary Stanley left to hold talks with Nightingale. Like all the Polidori sisters, Eliza had been raised to think highly of herself. She was a natural-born authority figure, and had a haughty demeanour which brooked no disobedience. Even her own nephew William Rossetti admitted she was 'by no means pliable and only partially amiable.'[25] Her letters home to Frances included instructions to look after the poor in her district, to whom she referred in a queenly manner as 'my

people', and she lost no time in calling the paid nurses 'my nurses.' She had not troubled herself over the equity of taking first-class accommodation or taking meals with the ship's captain, and she was not about to worry over asking a paid nurse to do her washing or wait at table.

The groups' spirits were raised when Captain Henry Francis Greville invited them to tour the *Trafalgar*, a 120-gun vessel which had participated in the first bombardment of Sevastopol. The band played patriotic songs for them on deck, and Eliza played with a kitten rescued from a dead Russian soldier's knapsack at the Battle of the Alma. She had inherited her mother's penchant for handsome young English soldiers. With a twinkle in her eye, the spinster told Frances that she also appreciated being rowed across the Mediterranean by 'plenty of jolly jack Tars' and a middy who was 'a very pretty boy.'[26]

Florence Nightingale never got over her suspicion of Mary Stanley, and divided her party, sending some along with Stanley to the hospital at Koulali, selecting the rest to assist her at the Barrack Hospital, Scutari. Although Frances Taylor originally accompanied Eliza to Scutari, within two weeks she and the other Ladies had joined Mary Stanley, leaving Eliza the only Lady of their party to work directly with Nightingale. A converted barracks, the hospital was a three-storey square building with a turret at each corner and a courtyard in the middle. There were four miles of corridors altogether, cluttered with patients lying largely unattended in flea-infested beds. Life inside the hospital was so chaotic that Eliza compared it to being in a vortex or a whirlpool. Nightingale was quick to spot Eliza's potential as an organiser and authority figure, and made her Superintendent of Nurses. She also put her in charge of the Stores, a move she would not regret. By June, Nightingale was writing home that she counted Eliza among 'my best.'[27] When Sydney Herbert sent Nightingale a good coat from England, she passed it on to Eliza. Her language skills came in handy in the care of a wounded Italian soldier, whom no one else could understand. She took extra pains with him, having promised Frances that she would take special care of any Italians who crossed her path. Though she honoured her Italian roots, Eliza was a true English patriot nonetheless, proudly hanging a union jack handkerchief in the nurses' quarters. In her supervision

of her nurses, William's aunt appears to have been more 'amiable' than her nephew would have believed, writing that 'I often have a goodly laugh for I have a merry set of Nurses about me that keep my visible muscles in action.'

Eliza slept in the communal nurses' room opposite Nightingale's. She woke at five or six am, uncovered the altar in the chapel, attended prayers, made breakfast for the nurses, handed out supplies to nurses from the Stores, assigned work, took stock to see whether essentials like candles, rice, barley, or salt needed to be requisitioned, opened and catalogued newly-arrived supplies, stamped all outgoing letters, sent clothes to be washed and received cleaned clothes back, made repairs using the carpentering skills passed on by her father, and helped make dinner, tea and supper. When she could, she escaped the whirlpool to lead her nurses on bracing walks around the hospital grounds, from which they could spot the minarets of the Hagia Sophia and breathe in the fresh sea air. She was fearless in her exploration of her new surroundings, haggling with market traders in Constantinople, supervising her nurses on shopping trips to fashionable Pera and delighting in being able to claim that she had made snowballs in Asia. 'This is a curious life,' she wrote to Frances, 'I wish you could fly over and see it.'[28]

Generally not one to take an interest in current events, Christina was also swept up in the patriotic excitement of the war; she was the first person to inform Madox Brown of the Siege of Sevastopol. The search committee rejected Christina Rossetti's application to become Nightingale Nurse, ostensibly on the grounds of her youth and inexperience, but also because they had been told to choose women who were unmarried, older and plain. She would have made the lower age limit of twenty-four by December when the Nurses sailed for Scutari, but Eliza's pretty, young and single niece was exactly the kind of woman the committee wanted to keep well away from soldiers. Younger women than Christina were selected, for example Frances Taylor, but these had a more impressive track record of community activism. Instead of shipping out with her aunt, Christina was forced to do her part on the home front by sharing Eliza's parish visiting duties with Maria. In any case, her shaky health would not have withstood the trials of a long sea voyage, followed by the deprivations

of Scutari hospital, which included a poor diet, flea-infested bedding and an outbreak of cholera resulting from unburied soldiers' corpses polluting the water supply. Even those in excellent health could easily fall victim to disease abroad. For instance, it was during this period that landscape painter and PRB associate Tom Seddon died of dysentery at age 35 while on a painting tour in Cairo. All things considered, Christina was much better off taking wine twice a day while acting as temporary governess in the less exotic location of Wigan in Greater Manchester. Her charges were the children of Charlotte Polidori's former pupil, Lady Frances Lindsay, sister of Lady Isabella, the beloved friend of Christina's teenage years.

While Amelia Heimann and her children watched the spectacular Lord Mayor's Show from Gabriel's studio in Blackfriars that year, Christina had to satisfy herself with a visit to the housekeeper's room at Haigh Hall, which her over-excited male pupils had decorated to celebrate the anniversary of the British victory at Inkerman. 'It was not worth walking miles to see, but it pleased them which after all was the main point,' she commented dryly. Christina may have inherited her Aunt Eliza's haughtiness, but she did not share her enjoyment of work and duty, or of other people's company. Although Christina liked children, the realities of governessing far from home were not for her, and she was relieved when illness kept her from her duties. Like her brother Gabriel, Christina had little use for the 'workaday world', but, as she was not the Rossetti family's resident genius, she had to find different ways to circumvent its demands. 'I am rejoiced to feel that my health does really unfit me for miscellaneous governessing *en permanence*', she confessed twinklingly to William.[29]

William Rossetti had no enthusiasm for the conflict in the Crimea, objecting to war in general as 'an ever-recurring and supreme bore.' As a radical he was against British 'bolstering' of the Ottoman Empire, and as a contrarian he supported Russia and thought that his country should take this 'opportunity' to 'kick out effete Turks.'[30] When conflict broke out again in the 1870s, William would continue to side with Russia against the Ottoman Empire, explaining that he did not 'feel in any degree bound to be anti-Russian by mere dint of being an Englishman.' He had no great love for Russia's 'autocratic despotism', but he felt that Russia could help liberate 'Bulgarians and

other populations' who were 'oppressed by Turks'. As for Britain's commercial interests, he determined idealistically that 'Asia contains quite sufficient room for England and Russia together.'[31]

'A maniac aunt of mine has volunteered and gone to the Crimea amongst the *nussesses*', was about all Gabriel had to contribute on the subject.[32] He kept Eliza waiting so long for a letter that she wondered if the ship to carry it over had yet to be built. Apolitical to his core, he was seldom moved to express a particularly strong opinion on international events. Years of being bored by the revolutionary reminiscences of his father and his expatriate friends had taken their toll on his appetite for politics. Presumably Gabriel kept his jokes about *nussesses* to himself when his 'maniac' aunt Eliza returned from the Crimea, sitting for him in the spring of 1856. He had to stay on her good side, or risk his relationship with his new William Marshall, a millionaire from Leeds who lived on Eaton Square. The watercolour *Hist! Said Kate the Queen*, had caught Marshall's eye on a studio visit, but it had already been promised to Aunt Charlotte. Gabriel persuaded Charlotte to exchange *Hist!* for a portrait of Eliza. The watercolour was based on an episode from the Robert Browning poem *Pippa Passes*, where singing silk-winder Pippa wanders the city on her day off, changing the lives of the people she passes with her song. *Hist* focuses on the story of Jules and Phene, where the sculptor Jules is furious at having been tricked into marrying Phene, a common artist's model whom he thought was a Lady. When Pippa passes the newly-weds' room, the song she is singing causes the disillusioned artist to see his wife in a new light, and they fall in love. It is not difficult to see why a poem praising true love between a common model and an artist appealed to Gabriel, though the reasons for Charlotte's interest in the water-colour are more obscure.

During the 1850s, Gabriel worked hard to consolidate his reputation as a painter, though he was still flirting with poetry. Like any good Victorian businessman, he understood the value of self-promotion and advertising. 'His net was spread in the sight, but not too obviously in the sight, of several birds,' William commented.[33] He was building up his patron list, which now included wealthy Leeds gentlewoman Ellen Heaton, Leeds stockbroker Thomas Plint, Marshall and Ruskin. He created an aura of mystique, rarely exhibiting

publicly, and barring even his patrons from viewing works in progress. Although this was partially a self-protective strategy from a procrastinating painter averse to negative criticism, it created an impression of specialness and exclusivity particularly attractive to the nouveau riche from the North who were looking to become cultural tastemakers. Although the established were hostile to these pretenders, they could not bring themselves to turn down their money. Elizabeth Barrett Browning wrote that Ellen Heaton 'has made herself famous in Rome by "pushing" here and there and everywhere and people laugh – they laugh!' but she still accepted her patronage.[34]

Gabriel's 'net' was not just reserved for hauling in wealthy patrons. Remembering that the Brotherhood had attracted more attention as a group than as individuals, he set about cultivating the men who would make up the second wave of the Pre-Raphaelite movement. Reflecting the middle-class aspirational ethic of his times, Gabriel found his new disciples at Oxford University, where he had been commissioned to paint murals at the Oxford Union, along with Arthur Hughes, Valentine Prinsep, William Morris and Edward Burne-Jones, among others. All were under twenty years old. Burne Jones had lurked around the Working Men's College in hopes of meeting his idol, and was thrilled at last to be introduced to Gabriel by Vernon Lushington. Gabriel was no less thrilled to have a following again. Morris and Burne-Jones, whom Gabriel decreed 'one of the nicest young fellows in Dreamland', were recent Oxford graduates heading for careers in the clergy until they fell under Gabriel's spell.[35] They were familiar with his work, and had been flattered when he agreed to contribute to their *Germ*-inspired *Oxford and Cambridge Magazine*, a publication which promoted their idealised vision of the Middle Ages, inspired by *La Morte D'Arthur*, the gothic revival and the general spirit of Oxford High Anglicanism.

Because Gabriel had embarked on the project with more enthusiasm than expertise, the murals were a failure, flaking away as the artists had failed to prepare the walls properly. Yet the visit was a success in terms of recruiting new 'Brothers', and it also turned up a new 'Sister', in the striking form of the 18 year old Jane Burden, a raven-haired stable-master's daughter whom Gabriel had spotted at the theatre. She would become the fresh face of Pre-Raphaelitism,

eventually replacing Lizzie Siddal on canvas, in Gabriel's heart, and in Pre-Raphaelite lore.

Gabriel also spread his net for established arts figures. He courted the Brownings, getting himself and William invited to two intimate soirées at their London home to hear Tennyson reading from *Maud*. Gabriel sketched the craggy, bearded poet laureate on the spot, and walked him home in the evening. The pen and ink sketch shows the poet seated on a couch in profile, one leg drawn up beside him, as he reads from a small book in his right hand. While he must have been honoured to be invited, Gabriel's insurrectionist spirit was provoked by the solemnity of the occasion. When he described the evening to Allingham, he portrayed the forty-seven year old 'A.T' as a grumpy, paranoid and precious artist whose conversation was 'one perpetual groan' and a 'neverended story' about unsympathetic reviews, hostile anonymous letters and 'literary cabals under which he is destined to sink one day.' Gabriel claimed that when the two men passed the Holborn Casino, a glittering venue where clerks, shopkeepers, apprentices and medical students gathered to dance polkas and qua-drilles with women of dubious reputation, Tennyson wished aloud that he could go in, but he feared a newspaper man might spot him and try to ruin his reputation.[36]

The sober, earnest Tennyson was more to William's taste than Gabriel's. A more somber character himself, William accepted that 'Effusiveness…was not in his line.' The younger Rossetti brother went to visit Tennyson at his home on the Isle of Wight, and the two smokers enjoyed a civilised port and a pipe after dinner. Instead of getting annoyed when the poet laureate started complaining about his fan mail, William gently suggested he write back in ink that faded over time, so that his words could never be used against him in future.

Even when people preferred William to Gabriel, he could never entirely escape his brother's long shadow. Part of the problem was that Gabriel, with as great a flair for socialization as for painting, was altogether more compelling than the reserved taxman. He was confident and handsome where the balding William was diffident and plain. Either unaware or unconcerned that social invitations were issued to himself only, Gabriel regularly foisted his younger brother's company on his hosts. During a dinner in honour of Tennyson to

which Gabriel had been invited, the hostess was forced to absent herself from the table in order to create a place for William, whose presence had not been anticipated. 'I was equal to this emergency, and *did* pass a very pleasant evening,' William reported obliviously.[37] The other part of the problem was that William simply did not exhibit any desire for social independence, and was happy to preserve their boyhood closeness at all costs. William scorned the idea of making his own friends among the dreary men at the Inland Revenue. He was happier playing the baby goat to Gabriel's leopard in his brother's magic circle of entertaining artists, patrons and assorted hangers-on. While he had given up his dreams of becoming a painter, William clung to the Rossetti family values which stressed artistic accomplishment and a rich cultural life.

In fact, he was most upset with Gabriel whenever he had to make room for someone else, such as Siddal, whom Gabriel finally married in a private ceremony in May 1860 at St. Clements Church in Hastings. This event had taken place after the couple had effectively separated for two years. Although the reasons for this separation are not known, it had been preceded by bitter quarrels over Gabriel's dalliances with other models like Annie Miller and Fanny Cornforth, and his delay in marrying Lizzie, who was approaching thirty. Ford Madox Brown's diary records scenes of dramatic bickering, misunderstandings and confrontations which seem in retrospect like the tip of an iceberg. Drama was central to a relationship between the self-consciously temperamental artists. Having learned from his family that being a Rossetti meant taking part in an inheritance of uniqueness and specialness, Gabriel could have nothing less than a 'genius' for his bride. While many of his friends validated his view of Lizzie's unique genius as both a muse and an artist, not everyone believed in her as much as Gabriel did. The Rossetti family's brittle and polite reception wordlessly demonstrated that they were not overwhelmed by Lizzie's genius. Anna Mary Howitt confessed, 'I never could believe she possessed the artistic genius which [Gabriel] ascribed to her, for what she produced had no originality in it.'[38]

The question of originality is a vexed one, complicated by Gabriel and Lizzie's romantic relationship. Unlike the middle-class Howitt, Lizzie had never received formal art training, and Gabriel had been

her only art teacher. While Gabriel's disingenuous references to Lizzie as his 'pupil' may have raised a few eyebrows, she was legitimately his student as well as his muse and lover. Like all students, she bore the imprint of her favourite teacher, and began her career by imitating him in both style and subject matter, drawing inspiration (as Gabriel did) from the literary works of Browning, Keats and Tennyson. She was getting the Rossetti family education second-hand, and proving an apt pupil. At the same time, she was developing her own style, and maintaining a dialogue with her teacher/lover through her own artistic works. As well as providing instruction, Gabriel also gave Lizzie access to his network of important contacts, including Ruskin, Browning and the Pre-Raphaelite painters. The Brownings, for instance, made polite noises when Gabriel showed them Lizzie's interpretation of *Pippa Passes*, but others were more receptive. Through Gabriel's influence, her work appeared in Pre-Raphaelite exhibitions in London and the United States, and she was considered (though not ultimately hired) as a contributor to an 1857 illustrated edition of Tennyson's poems.

After their breakup, Lizzie, having crossed various social boundaries in her unconventional relationship with the painter, could no longer market herself as a respectable potential wife for anyone of Gabriel's status. Nor, having sampled the freedoms and delights of an artistic life, could she resign herself to marriage with an ordinary man of her own class. As she approached thirty, Lizzie was aware that she was running out of options. Jan Marsh writes that it is not possible to reconstruct Lizzie's activities during the years she was not with Gabriel because 'information about her life, as with so many women, ceased when she was no longer in contact with famous men.'[39]

Another reason for the Rossetti women's lack of interest in Gabriel's affairs with Siddal was the reappearance in 1859 of Frances's beloved missing niece, Henrietta Polydore. Though Frances must have shuddered to see the shocking turn of events reported in *The Times*, the sensational nature of her recovery was indeed newsworthy. The twelve year-old Henrietta had been discovered living with in Utah with a Mormon couple under the assumed name of Lucy, where it was feared that 'Had another year passed without the successful intervention of the father, she would probably have been...married to a polygamist.'[40]

Remarkably, Henrietta's mother was still in the picture, and seems to have worked out some sort of shared custody agreement with Henry Polydore. Though based in England once she had been recovered, Henrietta also stayed with her mother in America on occasion. Her return home utterly overshadowed Lizzie, and it is unknown whether her absence was even registered by Gabriel's female relatives.

Gabriel's sudden decision to marry Lizzie had as come a complete surprise to family and friends, and there were whispers that he had done so only because she was gravely ill and was not expected to live long. None of the Rossetti family attended the ceremony, which was at the St. Clements Church, Hastings on the 23rd May, 1860. 'How They Met Themselves', painted by Gabriel during his June honeymoon in Paris, did not auger well for the newlyweds. Based on the German doppelganger legend, which held that meeting one's double was a harbinger of death, it was a watercolour in muted greens, blues and yellows. It shows a pair of medieval lovers coming upon their doubles in a dark wood. Outlined in a sickly yellow light, the pair's doppelgangers look on unmoved as the woman collapses in horror, stretching her pale hands toward her impassive double. The models for the painting are Gabriel and Lizzie. Gabriel jokingly called it his 'bogie drawing', but the work is truly unsettling, and not just because of its supernatural subject matter. In this new watercolour, the pale and fainting version of Lizzie resembled the woman Brown had complimented years before as 'looking thinner and more deathlike and more beautiful and more ragged than ever, a real artist.'[41] Christina had once worried about her brother's tendency to see Lizzie 'Not as she is / But as she fills his dream.' The problem now was that Gabriel was starting to see his new bride as she really was; anxious, depressed and desperately ill.

Perhaps tutored by the dangers of Gabriel and Lizzie's fantasy world, Christina renewed her commitment to seeing things as they really were. Retired as a muse, she committed herself fully to becoming an artist. She often wrote about the perils of illusion and fantasy in poems such as 'The World', where earthly temptation is personified as a beautiful woman who changes into a monster by night: 'By day she stands a lie: by night she stands / In all the naked horror of the truth / With pushing horns and clawed and clutching hands.'

Nor was there room for self-soothing fantasy in religion. Written in question and answer format, 'Up-Hill' describes the trajectory of the Christian soul from earth to heaven in stark realities rather than comforting platitudes. The questioner is told in no uncertain terms that the journey will be long and 'up-hill all the way'. When the questioner asks, 'Shall I find comfort, travel-sore and weak?' the ominous answer is hardly reassuring: 'Of labour you shall find the sum.'

Openly delighted that her delicate health excused her from paid work, Christina turned to writing with renewed vigour in this period, producing the poems which would make her famous. She sent out short stories and poems to magazines, and, while her work was not always accepted, she was not discouraged. Impressed by her tenacity and her talent, both brothers worked their contacts in order to help her, while Gabriel acted as editor for her poems. He gave her generous, in-depth feedback, which she took or left as she saw fit. One of his most valuable contributions was to encourage her to pay more attention to titles. Her most testing defeat was at the hands of John Ruskin. Though he found her work 'full of beauty and power', he wrote to assure Gabriel that no publisher would take on poems with so many 'quaintnesses and offences', including 'irregular measure' which was 'the calamity of modern poetry.' He concluded that Christina should learn to 'write as the public like.' The cloth-eared critic reminded Gabriel to give his 'reverent love to Ida', a sign-off which must have added insult to injury for Christina.

Fuming on his little sister's behalf, the cool and collected William nevertheless waited for nearly forty years to deliver his rebuttal. When he was in his seventies, William printed Ruskin's letter in full in a memoir, pointedly reminding readers that these same poems were published in Christina's first and most famous collection, *Goblin Market*, where they 'immediately commanded a large measure of general attention, for which Mr. Ruskin was apparently not quite prepared.'[42] The poet and friend of the Rossettis, Algernon Charles Swinburne, drove the point home with greater gusto, proclaiming Christina the 'Jael who led their host [the Pre-Raphaelites] to victory.'[43]

Jael was an Old Testament heroine who assassinated the military leader Sisera by driving a tent peg through his temple while he slept,

thus helping the Israelites achieve victory. Though it was hardly as violent as Jael's insurrection, Christina's poetical coup certainly caught everyone by surprise. No one had really suspected that the literary fame of the Pre-Raphaelites was germinating in Christina's work. William Morris's 1858 volume of poetry, *The Defence Of Guenevere* had withered on the vine after critics dismissed it as 'Pre-Raphaelite minstrelsy.'[44] Luckily for the movement, the 'overripe' and 'luscious fruit' of the early Pre-Raphaelite project had fallen in the fertile ground of Christina's imagination. The fruit grew back enchanted, borne in golden dishes by goblin men in 'Goblin Market', a strange fairy tale of temptation and redemption that held Victorian readers spellbound. It was quite the magic trick to turn painting into poetry, but Christina was equal to the task. She translated into words the Pre-Raphaelite visual aesthetic of truth to nature, close attention to detail, intense feeling and luminous colour, using language to achieve what the artists had sought in canvas and paint. In a commercially clever sleight of hand, she disguised Pre-Raphaelite realism with allegory and fantasy, thereby avoiding the critical outrage which had attended the Brotherhood's more controversial works.

The poem is about two sisters, Laura who craves the magically addictive fruit sold by goblin men, and Lizzie who resists their wares. Against all advice, Laura trades a lock of her golden hair for the goblins' delicious fruit, and once she tastes it, finds she cannot live without it and wastes away with grief. When Lizzie confronts the goblin men in order to break their hold over her sister, they try to force her to eat their fruit, grinding it against her lips. She escapes them and her resistance proves the key to her sister's salvation; when Lizzie kisses Laura with her fruit-stained lips, the poisonous juices are transformed by Lizzie's self-sacrificing love into a healing potion which releases Laura from the goblins' spell. Christina would later disingenuously claim that she meant nothing profound by *Goblin Market*, but even William, famous for toeing the family party line, disagreed on record, though of course with his customary understatement: 'Still the incidents are such as to be at any rate suggestive.'[45]

The 1862 publication of *Goblin Market and Other Poems* was a high water mark in the fortunes of the Rossettis, inaugurating a decade of the recognition and fame the family had always felt was its destiny.

The 1860s would see many of the family dreams come to fruition, but, like the goblin men's enchanted wares, the fruits of this success were bitter as well as sweet, and came at a price.

Joan of Arc, 1882

Though Gabriel is best-known for his images of voluptuous 'stunners', his early interest in female saints (stimulated by his female relatives' Anglo-Catholicism) re-emerged toward the end of his life. In an issue of the family magazine, *Hodge-Podge*, his mother had once declared Joan of Arc 'the most extraordinary female character ever recorded in history'.

8

LEGENDARY LOVE

It is not overstating the case to say that the Rossettis were unlucky in love. At the start of 1860s, Gabriel was unhappily married while his brother was newly single, bitter and vowing to remain a bachelor. William's engagement to Henrietta Rintoul had been broken in the autumn, though it is unclear which member of the couple called it off. Ever the gentleman, William claimed in his memoir that Henrietta was too overwhelmed by grief at her parents' death to marry. His daughter Helen told a different story, blaming the dissolution of the relationship on Henrietta's request for a sexless marriage. Whatever the reason, the breakup was not only hard for both parties, but it also put Christina in a difficult position with her would-be sister-in-law. Henrietta spent a day sobbing in Christina's arms, telling her 'a great deal about what is past and what now is.' But if Henrietta was campaigning for support, she had not counted on Rossetti family loyalty. The two women remained friends, but Christina made no bones about her ultimate allegiance. She immediately wrote to William about the incident, assuring him that his ex-fiancée 'cannot be dust in the balance with me, weighed against my most dear brother whom I love better than any man in the world and who has bought my gratitude by lifelong kindness.' For a man accustomed to coming second to Gabriel in everything, it must have been a timely comfort to know that he came first in his sister's heart. As had been their custom ever since they'd learned to ward off Maria and Gabriel's bullying in childhood, the two youngest Rossettis would continue to find strength in sticking together.

This strong sibling bond may have had its disadvantages when

it came to establishing romantic relationships, as the conclusion to Christina's letter indicates: 'I wish it were something better, but don't despise the love even a sister has to offer.'[1] Welcoming in terms of friendships and associations, the Rossetti brothers and sisters were inward-looking when it came to more intimate relations. Perhaps Gabriele had bequeathed to his children an exile's sense of the family as a sanctuary from the untrustworthy outside world.

It is common to consider the ways in which the demands of domesticity could threaten bonds between male friends, but few have examined marriage as a potential threat to relationships between siblings. John Tosh observes that in the Victorian era, social contact between the sexes was so restricted 'that kin offered the only emotionally sustaining relationships.' He argues further that the strong 'bond between brother and sister' is one that 'tends to be discounted today'.[2]

The Rossetti family, however, has hardly escaped attention on this account, and there has been much speculation as to the causes of their failure to experience emotional intimacy with people outside of the family circle. Some critics have wondered whether this intense sibling bond may even extended to incest between Gabriel and Christina. (Presumably Maria's plainness disqualifies her as a candidate for her brothers' attentions.) In general, speculation about incest has limited itself to heterosexual couplings, although the love displayed between the sisters in 'Goblin Market' has not entirely escaped attention in this respect. Commentators have been silent about William's potential as a sibling seducer. No evidence has so far come to light to substantiate any sexual relationships between siblings. The proliferation of these theories indicates the ways in which the remarkable Rossetti bond has continued to fascinate, drawing attention to the intense degree of sibling attachment which is often 'discounted' in the story of Victorian relationships. Speculation about incest may also point to a lingering social unease about celibacy and spinsterhood.

Whatever the reasons, romance certainly had a hard time competing with the fierce love among the Rossetti siblings. Lizzie Siddal had fallen far short of the mark in this respect; she was never to be promoted to sisterhood by the Rossetti women. Ironically, while Christina was much more welcoming to Henrietta Rintoul, in the

end William may have rejected Henrietta because she wanted to be a sister rather than a wife (if the claim that she requested celibate marriage is to be believed). Yet when William did marry later in life, he chose Lucy Madox Brown, another sister-figure. Not only was Lucy the daughter of Ford Madox Brown, a friend so close he was practically family, but the motherless girl had in fact lived in the Rossetti household as Maria's pupil, with Frances acting as surrogate mother. Maria was also godmother to Lucy's half-brother Oliver.

When choosing a mate, Gabriel and William's individual temperaments led them in opposite directions. Displaying his rebellious spirit, the leopard Gabriel aggressively pursued women who were conspicuously unlike Christina and Maria. True to his baby goat temperament, William was content to follow the lead of a woman so similar to his sisters that she was practically indistinguishable. As for the Rossetti sisters, they too stuck close to home in their romantic lives, although this is as much a reflection of social conditions as personal preference. Unlike their brothers, Maria and Christina would not have had the opportunity to meet anyone outside a supervised, approved circle of family friends. Even so, their choices within that circle tell us about the kind of male company they preferred. Christina's fiancé had been an official Pre-Raphaelite 'Brother', who, though brought into the group by Gabriel, was closer in character to William. James Collinson's earnest temperament, modesty, unremarkable looks and lower status within the PRB were not a far cry from William, which perhaps goes some way towards explaining William's uncharacteristic hostility toward him in his memoirs. It is often tempting to criticise in others what we fear in ourselves. In the soft-spoken Ruskin, a man mature beyond his years, Maria too sought someone more like William than Gabriel.

Like William, Maria and Christina found themselves in their thirties with no marriage prospects in sight. Spinsterhood was hardly a foreign concept to sisters who had been raised by three formidable unmarried aunts, but familiarity did not necessarily make this a welcome fate. The Rossetti sisters were at a distinct disadvantage in comparison to their single brother, who would not have been socially stigmatised for being unable to find a bride. The rise of the middle class, and the consequent need for a man to become financially

established before beginning a family, meant that it was socially acceptable for men to marry late, and no one was ready to take William's vows to remain unmarried seriously just yet. While Victorian convention pressured men to marry, even bachelorhood was not regarded with anything like the suspicion, fear and horror reserved for spinsterhood, nor was it as economically perilous. Single middle-class women struggled to survive as underpaid governesses or free childcare providers in the homes of siblings and extended relations. There was also the unspoken horror of prostitution, perceived as the worst fate of all. Though prostitutes were most likely to hail from the working classes, it was not impossible that a friendless unmarried middle-class woman might 'fall' into this career option.

The Rossetti sisters found themselves single at a time of social panic surrounding the large number of unmarried women. These 'surplus' women had been revealed by the 1851 census, which showed that there were 405,000 more women than men in the population. This imbalance, combined with the fact that men were marrying at a later age, meant that there simply were not enough men to go around, and that a considerable part of the female population could never hope to find a husband. Debates about what to do with these 'superfluous' females raged into the next decade. While it was acknowledged that it was not possible for all women to marry, spinsters were caricatured, belittled and criticised. 'Married life is a woman's profession', thundered the *Saturday Review*, and '...by not getting a husband... she has failed in business.'[3] When the 1861 census showed that this population imbalance persisted, the panic reached a fever pitch. In his 1862 *National Review* article, 'Why Are Women Redundant?' W.R. Greg suggested transporting unmarried women to the Colonies, a fate normally reserved for criminals. One can imagine that Greg's solution raised some eyebrows among the respectable Rossetti and Polidori spinsters.

This cultural Catch-22, where failure to marry non-existent men was treated as criminal, helps to explain the appeal of convent life among High Anglican women. Anglican Sisterhoods had existed since 1845, but it was in mid-century that they started to attract more members from the ranks of 'superfluous' Victorian women. During this period, the Rossetti sisters began seriously to explore

this radical alternative to married life. Both were formally attached to local London branches of Anglican Sisterhoods, though only Maria formally committed to becoming an Associate Sister.

Associate Sisters (also called Outer Sisters or Visitors), were potential postulants who retained their connections to the outside world while considering the option of Community life. Transitioning to full Sisterhood was not mandatory; Associates were also welcome to participate in charitable works without making any further commitment. The depth of their involvement varied, according to personal circumstance and taste. Some gave their time to volunteer activities, while others donated money or other resources, or used their connections to find 'situations' (servants' jobs) for the poor and unemployed. Some intended from the start to join the Sisterhood, while others retained permanent Associate status, either because they did not wish to become full members of the community, or because of family objections to such a radical step. Even so, formal association with Sisterhoods was different in letter and spirit to ordinary parish visiting. Uniforms were worn and protocol observed which distinguished Associates from church-going volunteers, making it clear that their commitment was spiritual as much as social.

Christina's Sisterhood affiliation appears to have been less formal than Maria's, although there is some doubt about her exact status.[4] But it is certain that she was a volunteer for the Sisters of Mercy at the convent-run Highgate Penitentiary. Also called the Mary Magdalen Home For Fallen Women, the penitentiary's mission was to reform and save the souls of its residents, former prostitutes looking to be rehabilitated. Part of Christina's role was to attract funding from her more well-heeled friends. She was thrilled when the Bishop of London acknowledged her fund-raising efforts by shaking her hand at a charity evening, although she joked self-deprecatingly that he had probably mistaken her for someone else. While Christina did not live at the Penitentiary along with the rest of the nuns and their charges, she was still considered a part of the community. As a day visitor she wore its uniform, a simple black dress with hanging sleeves and a lace-edged muslin cap with a veil, which friends observed suited her well. Maria too wore a plain uniform of black dress and cap to perform her duties as Associate of All Saints Sisterhood, Margaret

Street, which was only a twenty minute walk from the Rossetti family home.

Although as Associate Sisters they were free to live at home, Maria and Christina would still have been expected to wear a uniform and abide by community rules. As an Associate of All Saints, Maria observed the house Rule of Silence, agreeing not to ask questions of anyone except the Superior, and not to discuss the inner workings of the Sisterhood with outsiders. The work of the All Saints Sisters was in some ways a formalised extension of parish visiting. Duties included teaching, caring for the sick and infirm, looking after orphaned girls and dispensing medicine. The Sisters ran schools and an orphanage, and set up primitive nurseries, based on the *crèches* their Foundress Mother had seen when touring Roman Catholic convents in Paris. They also nursed at University College Hospital, where inroads made by the Nightingale nurses and nuns in the Crimean War had helped convince doctors of women's aptitude for nursing.

The growth of Protestant sisterhoods in England had been stimulated by High Anglican clergy who recognised an untapped resource in the well-educated middle class women of their congregations. Tractarian leaders like Pusey saw women's community activism as an obvious solution to the problem of unmarried 'redundant women.' The Anglican Church set itself apart from other institutions by promoting the idea that a woman's work outside the home was beneficial not only to the community, but to her own well-being. Committed believers, female parish visitors were smart, capable and organised, and often longed to exercise their influence outside the domestic sphere. District visiting, enthusiastically undertaken by the Polidori and Rossetti women, was a socially permissible way for women, married or single, to become active in their communities. Armed with bibles and religious tracts along with food and clothing, these women descended on the poor and the sick with the object of 'improving' their material and spiritual circumstances. They dispensed educational and health advice along with more tangible forms of charity, and wrote up reports recording the needs of various families. There was no small element of condescension in the process. Eliza Polidori, for example, airily referred to the poor of her district as 'my people.' It is very likely that these well-meaning lady bountifuls were

more appreciated for the access they provided to social services than their evangelism. Yet even opponents of High Anglicanism had to admit that the social work these women performed was useful.

It was on social grounds that Pusey and others sought to justify the foundation of new Anglican Sisterhoods, even though the first attempt had failed. The Park Village Sisterhood had inauspiciously begun in 1845, the same year that Newman converted to Rome. Anti-Roman Catholic feeling and the fear of the 'enemy within' already made these Sisters suspicious figures in their community. The short-haired nuns did not help themselves by patrolling their districts of Somers Town and Camden wearing black wool habits and silver crosses which sprang open alarmingly to reveal crucifixes. The Rossetti sisters grew up a ten-minute walk from the Community house at 17 Park Village West, and must have witnessed the strange Sisters attending services at Christ Church and making their daily rounds. These early Sisters regarded social work as secondary to their spiritual mission, and came across as rather severe and alienating as a consequence. One contemporary found that they were 'very good and earnest' but that insecurity about the exact parameters of their role in the community 'gave them a coldness and a stiffness of manner.'[5] Their role was indeed precarious and undefined, as they existed in a hinterland between official and unofficial practice, as they were not officially recognised or sanctioned by the Church. Their vows of celibacy, while sincere, were not considered binding. The upside of this was that Sisters could not be excommunicated, never having been official in the first place. As Susan Mumm explains, 'Unlike most other church institutions, sisterhoods were not created by the Church, but within it.' It was impossible for Church authorities to regulate Sisterhoods 'because the Anglican Church, having never envisioned such groups, lacked any prohibition for disciplining them.'[6]

Pusey's initial attempt to revive female monastic life in Britain had been a public relations disaster. The Rossettis' beloved Reverend Dodsworth, the incumbent at Christ Church, Albany Street who would convert to Roman Catholicism in 1851, had begged Pusey to modify the Sisters' costume, but only small alterations were made. The Sisters not only scared people in the community, but also succumbed to the more extreme religious practices feared by opponents

to Anglo-Catholicism. One fasted to death during Lent, while others ate so little they became critically ill. Interference by Pusey and various male clergy members made it difficult for the Sisterhood to function, while a confusion between social and spiritual roles led to insecurity and disorganisation. The Park Village Sisterhood fell apart and was absorbed by the Devonport Sisters in 1856, but despite its failure, it had set a precedent for female activism and organisation which would shape future Sisterhoods.

One of these was All Saints Sisters of the Poor, founded in 1851 by future Mother Superior Harriet Brownlow Byron and Upton Richards, one of Pusey's closest friends who had been involved in organising the Park Village Sisterhood. As Byron's mentor and spiritual advisor, Richards was much less prone to interfere than Pusey, and was happy to leave the Sisters to run their own Order. The Sisters all lived together in a series of interconnected houses at numbers 82, 83 and 84, Margaret Street, and worshipped at the magnificent adjoining chapel. A masterpiece of the Gothic Revival, the former Georgian chapel had been transformed by architect and High Church devotee William Butterfield. All Saints made no secret of its Tractarian affiliations. The foundation stone was laid by Pusey himself, and the construction was sponsored by the Ecclesiological Society, an architectural body which supported Neo-Gothic architecture. The result is startling even today.

All Saints Margaret Street is a riot of colour, both inside and out, with a zigzagging pink and black brick façade and an interior so ornate that even modern visitors feel disoriented stepping inside for the first time. The mosaic effect of the exterior is echoed in the red and black checks of the Minton floor tiles, while the floor of the chancel boasts patterns of tiles in six colours. Strong colours dominate, and hardly an inch of space is free from ornamentation. One third of the length of the church is dedicated to the chancel, a visual reminder of the Tractarian privileging of the Sacraments above the Word.[7] The chancel itself is entered through a pair of gilt iron and brass gates set into a low screen of Derbyshire alabaster and variously coloured marble. Haloed icons of saints are everywhere, from gilded panels and tile paintings on the wall to glittering stained glass windows. Frescoes, mosaics, carvings and bold, geometric tiling compete for the viewer's eye.

It was the kind of architectural statement that divided opinion, which was its intention. In 1872, C L Eastlake cited the All Saints Chapel as 'evidence that the secret of knowing where to stop in decorative work had still to be acquired.'[8] Ruskin disagreed: 'it challenges fearless comparison with the noblest work of any time. Having done this, we may do anything...' He saw a Pre-Raphaelite aesthetic in its splendid colour and enterprising spirit, and suggested that Holman Hunt and Millais be commissioned to do the frescoes for the unfinished interior.[9]

While the All Saints Sisters may have worshipped in splendour, they lived in Spartan, unromantic simplicity. One aspiring postulant had her romantic hopes dashed on being shown her living quarters:

> As I followed the stately mistress of the novices into the novitiate, I realised there was not much to help the imagination – a block of dark old London houses with narrow passages, made to communicate with each other, was not an ideal conventual building: it was even suggestive of sordid poverty. I thought of the stone cloisters and huge buildings I had read about, and sighed.[10]

The new Anglican orders were eager to distance themselves from the perceived sensual, gothic romanticism of Roman Catholic conventual life. Their focus on social work, routine and discipline discouraged adventure-seekers and 'morbid' young women. Anglican orders instead sought physically strong, sensible, hard-working women with community spirit. Despite cultural clichés about destitute young women being forced to join convents, the typical novice was generally in her late twenties or early thirties and firmly middle-class. All Saints, for example, only accepted women over the age of twenty-five. As well as having an intense spiritual commitment, this 'older' single woman would also have been seeking a role beyond the confines of perpetual aunty-hood or underpaid governessing.

Maria Rossetti fit this description exactly. Her age, plain looks, unremarkable figure, scholarly preoccupations and school-marmish self-confidence were unlikely to attract suitors in a notoriously competitive marriage market. She had not lived up to early family expectations regarding her academic or poetic potential, which must

have brought her some pain, but like William, she was known for her uncomplaining devotion to duty. Yet Maria was not attracted to convent life simply as a consolation prize for failing to catch a husband. Unlike her fashionable Aunt Charlotte, she had not found governessing for the children of the rich socially fulfilling. She had no taste for attending balls or fancy dinners, nor did she exhibit any desire for foreign travel. A home-body like her mother and sister, Maria liked London life best, and she was not put off by the grim realities of life for its less fortunate citizens. Intellectually stymied by the content of nursery lessons, she hoped to exercise her academic talents and charitable skills in an arena where they would be appreciated.

Maria was at a cross-roads in her life, and longed for more. Following her mother's example, she had tried to attract an older man who could inspire her intellectually, but the ascetic, sexually confused Ruskin was no warm-hearted Gabriele Rossetti. Unlike Frances and Gabriele, Maria and Ruskin simply had too much in common to achieve what Tosh defines as romantic love in the Victorian age: 'the attraction of opposites, bound to each other by ties of complementarity'.[11] Someone else would have to be found to lead Maria out of the *selva oscura* in which, like Dante Alighieri, she found herself lost in her thirties. In the end, not one person, but a whole community of women acted as Maria's guide through the dark wood of her impending spinsterhood. Her talents, which included forbearance, hard work, intelligence and charity, may not have been highly regarded by society at large, but for the Anglican Sisterhood, they were considered indispensable. Maria also had a knack for getting along with others. 'The great secret of peace-keeping,' she wrote, was 'to be such that no one can quarrel with us.' Perhaps her work experience and greater participation in the world outside the home explains her cheerful, well-adjusted outlook, as contrasted to Christina's melancholy, inward-looking tendencies. She had always been the more socially adept sister, taking particular delight in expertly hosting expatriate friends of her father. Her natural independence had been fostered by enduring long separations from her family, just as her diplomatic skills had been developed by her various appointments as resident governess.

Although the injunction of silence about Sisterhood activities means that we do not know Maria's exact duties when she became an Associate of All Saints, we do know that teaching was among them, at least in the early days; her first publication, *Letters to my Bible Class on Thirty-Nine Sundays* collects her Sunday evening lectures delivered between 1860 and 1861 to 'a Friendly Society of girls and young women.'[12] It is hardly surprising that a little girl who had impressed her siblings as an 'inspiriting muse in a pinafore' had developed a talent for teaching in adulthood. Her confidence and leadership skills inspired students' respect for her authority, while the lessons in humility she had learned as a low-status governess in foreign households modified her early tendencies towards self-regard and bossiness. Yet the self-assured tone of her lessons shows that these tendencies had not been entirely conquered. Written in the first person and littered with rhetorical questions, confident close analysis of biblical texts, and Tractarian admonitions against pride and materialism, Maria's 'lessons' often read very much like the fiery sermons she had been hearing for years at Christ Church, Albany Street.

Maria was also eager to supplement her students' understanding of the spiritual landscape with facts about the real world. For instance, a lesson on Moses compares modern Egypt's geography, climate and crops with England's. She could be whimsical as well as serious, as when she observes that a sliced pomegranate's 'two halves look something like little boxes of red currants.' She must have been keenly aware of her own Mediterranean heritage when describing an olive to her English audience as 'rather hard, salt, and bitter, much liked by the natives of the countries where it grows, though many of us would think it very unpleasant'. Revealing the Rossetti siblings' preference for English cuisine over Italian, she further informed her charges that olive oil was used abroad 'much as butter is here'.[13] These quirky observations are rare in Maria's devotional writing which was, on the whole, conventional both in language and sentiment. She did not have her sister's eye for the surprising detail or the unexpected perspective, nor did she enjoy teasing multiple meanings out of the language. Her childhood refusal to read Gabriel's story about the devil was reflected in the strict policy of censorship which shaped her own reading, and which she encouraged her 'girls' to emulate: 'we

never read a book or newspaper we should not have liked to shew to our Lord.' (10)

Maria had a good teacher's knack for making difficult and abstract ideas understandable. She used plain, simple language, and contextualised lessons by referring to contemporary events and relating them to her pupils' lives. For instance, she used a domestic metaphor to explain an episode in Isaiah 38:1, when Isaiah tells Hezekiah that he will die and so must set his house in order. Maria explains to her young female students that just as 'a house is not in order if it is dirty;...if there is flue in the corners, cobwebs all about, dust on the furniture,' so too is 'a soul...not in order either, if it is dirty; if stains of old sins are still upon it, not got rid of by prayers, and tears, and repentance...but left there to offend God's holy eyes every time He looks at that soul' (10). She made Isaiah's ancient encounter with Hezekiah more familiar to her students by transporting it to nineteenth century London, and re-envisioning God as a displeased housekeeper. What is striking about Maria's metaphor (besides the unintentional humour), is its recasting of a very male conversation in specifically female terms.[14]

She was unafraid to suggest that her 'dear girls' could exhibit masculine strength, as in her discussion of Deuteronomy 7, where the Israelites wipe out the Canaanites. This violent, genocidal story is relevant to women because 'we, like the Israelites, are God's soldiers in the midst of a sinful world; we like them are manfully to fight under Christ's banner; we, like them, are bound utterly to destroy that against which we fight...'. Like her Polidori aunts, Maria clearly viewed herself as an English patriot, in spite of her dual cultural heritage; nationalism and Christian missionary zeal are closely linked in her lessons. Some of Maria's girlhood enthusiasm for the military adventures of the *Iliad* resurfaced in these discussions. Martial metaphors abound, showing that Maria regarded her charges, not as helpless future housewives, but as strong, English spiritual crusaders: 'It is said of English soldiers that they never know when they are defeated, and so go on – fight, fight, fight, till they find themselves victorious after all. They do it for their earthly king; I will, by the grace of the Holy Ghost, do it, yea, and more, for my heavenly King. Amen' (38).[15]

The preoccupations of Maria's lessons can also be read as an oblique commentary on being the least praised of the Rossetti siblings. During this period, Christina was publishing poems in the prestigious *Macmillan's Magazine*, Gabriel was attracting wealthy patrons and preparing a translation of Italian poetry for publication, and William had been tapped to write reviews for *Fraser's Magazine* and *London Review*. Meanwhile, Maria was repeatedly exhorting her girls to exhibit extreme humility: '…I will never say or do anything in order to obtain praise; I will conceal, as far as I can, whatever might lead any one to praise me…'. While Maria's aversion to praise showed her adherence to Tractarian doctrines, it was also in some ways a convenient stance for a sister who already found herself the least praised of the Rossetti siblings. Yet Maria's humility could not quite conceal her spiritual ambition. 'None will die the death of a martyr, who is not striving to live the life of a saint' she assured her girls.[16]

Christina was much more apprehensive about living the life of a saint. Her ambivalence was informed by deep sense of unworthiness as well as apprehension about the binding intensity of such a commitment. She broke a Sunday date to visit Barbara Bodichon, not only because she helped teach a bible class on that day, but because she felt she was 'not sufficiently devout to render Sunday visiting a safe practice for me.'[17] While Maria was cheerfully recommending that her girls 'look on all bodily pain as practice for martyrdom', Christina was working on a series of nun poems which featured dark scenes of gothic distress and tortured renunciations of earthly love.[18] For instance, the aspiring nun of 'The Convent Threshold' decides after a series of graphic metaphysical nightmares to reject her lover and devote her life to God. In one dream, she addresses her lover from her own grave, where 'Cold dews had drenched my plenteous hair / thro' clay', while she 'like lead / Crushed downwards thro' the sodden earth'. Although the woman chooses a spiritual life over an earthly one, the decision does not appear to bring her happiness or peace: 'Alas for joy that went before, / For joy that dies, for love that dies'. While it is overly simplistic to suggest that Christina's poems refer directly to biographical events, their anguished portrayal of women struggling between earthly desire and divine love reveals that these issues were of profound concern to their author. Depictions of unmarried women

were not joyous hymns to independence, fulfillment and spiritual liberation, but were riddled with sadness and anxiety. For example, the speaker of 'Autumn' laments, 'I dwell alone – I dwell alone, alone', while 'Fair fall my fertile trees'. The poem ends on a sour note:

My trees are not in flower,
I have no bower,
And gusty creaks my tower,
And lonesome, very lonesome is my strand.

The poem was written two months after James Collinson's marriage to Eliza Wheeler in February 1858 at the Brompton Oratory. It was composed on April 14, the same day that Collinson sent William a letter mentioning that "Mrs. Collinson unites with me in thanking you for your kind congratulations & good wishes upon the event of our marriage."[19] While Christina had accepted that her relationship with Collinson was long over, it is never a pleasant thing to discover that an old love has gone on to wedded bliss with another, particularly where an attachment ended bitterly. The poem's manuscript title, 'Ding Dong Bell' (which Christina discreetly changed for publication) may have been a couched reference to wedding bells.

As she began her unmarriageable thirties, Christina felt she was entering the autumn of her life. Her gloomy anticipation of spinsterhood was premature. Charles Bagot Cayley, an old pupil of her father's, reappeared in the lives of the Rossettis in the early 1860s. He had long ago impressed Christina by quietly attempting twice to pay his respects to her dying father. A small, short-sighted eccentric scholar, he was the personification of an absent-minded professor. He seemed an unlikely beau for a woman who described him as 'amiable and quaint', but it was these very qualities which attracted Christina.[20] Her head would never be turned by the century's broad-shouldered, assertive male ideal. Christina's preference for someone William found 'not at all the sort of man who would be attractive to the general run of women' was partly informed by her religion, which rejected conventional Victorian notions of assertive masculinity and championed male virginity and gentleness. As William observed, 'unworldliness was no bar to the warmth of her regard, but rather

the contrary.'[21] Indeed, Cayley was decidedly unworldly and out-of-date, dressing in shabby clothes and stubbornly continuing to observe nearly obsolete social customs like paying regular morning calls on ladies. According to William, he was good-looking, with dark hair and eyes, and ruddy cheeks which enlivened his pale complexion. Like Christina, Cayley was socially awkward and a little bit mysterious, with a habit of smiling to himself as if in acknowledgement of some private joke. An abstracted and thoughtful man, he often took so long to respond to a question that his friends despaired of ever receiving an answer. When he did respond, no one understood what he was talking about.

Born in Russia to English parents in 1823, he was an accomplished linguist and translator with a keen interest in poetry. He had been educated at Cambridge and was the younger brother of famous mathematician Arthur Cayley. A gentleman scholar, he supported himself by working at the Patent Office in Chancery Lane. He could speak and write in several languages, most unusually Iroquois, a language in which he published a translation of the New Testament. Of particular interest to the Rossetti family was his translation of Dante Alighieri's *Commedia*, which was well-regarded by Tennyson, Patmore and Ruskin. Even after the death of his Italian tutor, he had remained on the periphery of the Rossetti family for years, munching strawberries on Gabriel's balcony during an all-night party at Chatham Place and attending the occasional social event at Ford Madox Brown's home. Brown confirmed the general impression of Cayley's appearance, noting that Cayley 'looks mad and is always in a rumpled shirt without collar and tail coat.' Brown found him difficult company: 'the Rossettis brought Cayley here who was as monosilabic [*sic*] and ornithological in the way of wispering [*sic*] out his gasping sentences as ever.'[22]

Cayley's publication of the *Psalms in Metre* in 1860 may have been quietly calculated to impress the devout Christina. William and Frances were subscribers, which perhaps signified their approval of Cayley as a potential suitor. Although Christina nit-picked over its notes section, she enjoyed the volume enough to give it as a gift to wealthy patroness of the arts Pauline Trevelyan, a connection she hoped would prove useful to her new suitor's career. It was obvious

that the threadbare Cayley did not have sufficient income to support a wife, and his prospects would have to improve before he could offer himself as a husband. The situation looked promising nonetheless. By the autumn of 1861, his sisters Sophia and Henrietta were calling on the Rossetti family.

Along with a new love-interest, an alternative to Sisterhood also presented itself; a writing career. Christina's literary talent was finally being recognised outside of her small family circle, in part because she had redoubled her efforts to get noticed. Always eager to flex his networking muscle, Gabriel was an enormous help to his sister, working his connections and acting as editor. He encouraged her to collect her best work and vowed to help her find a suitable publisher. Gabriel decided they should target Alexander Macmillan. Along with sending Macmillan his sister's work, he button-holed the publisher at a social event and recited one of Christina's poems. When Gabriel sent a collection of Christina's poetry to Macmillan for consideration, he sweetened the deal by offering to contribute 'a brotherly design' for the frontispiece and title page if the volume were published.[23] He also cannily pointed out that Elizabeth Barrett Browning's death earlier that year had created a gap in the market for a new great English poetess. Macmillan ran 'Goblin Market' by a test audience, reading the poem aloud to a working men's society who burst into spontaneous applause at its conclusion. While Gabriel was pleased that Macmillan accepted the poems, he discouraged the publisher from packaging the book as a children's volume. Becoming a children's author might have led to commercial success, but Gabriel realised that a poet fit to challenge Barrett Browning was unlikely to emerge from this market.

Although Christina relied on Gabriel's expertise, she was unafraid to pursue publication independently. She kept up her connections as a corresponding member of Barbara Bodichon's *Portfolio Society*, a group of women writers who circulated members' poems for critique. Although the outspoken activism of its feminist members such as Emily Faithfull and Bessie Rayner Parkes (future mother of Hilaire Belloc) insured that she kept her distance socially, Christina's experience as a Pre-Raphaelite Sister had shown her the power of association with a group.

She was successful in placing her short story 'Nick' in *The National*

Magazine, but when she failed to interest magazine editors in 'Case 2: Folio Q', she burned the story in frustration and disappointment. She quickly regretted this behaviour when Macmillan approached her to submit the story, which had been enthusiastically puffed by Gabriel. Despite Christina's best efforts to contain her passionate nature, it could still rage out of control.

Undeterred by Ruskin's negative response to her work, she boldly sent poems to family friend David Masson, Professor of English Literature at University College London and editor of *Macmillan's Magazine*. Taking her cue from Gabriel, she was learning the delicate art of social networking. She was careful, for example, to display the proper amount of feminine humility: 'I feel ashamed to add the enclosed', she wrote. She added that Masson could publish her poems if they were 'of any use', but asked him to 'pass upon them a… sentence of rejection in the (highly probable)' case that they were not up to standard.[24] In fact, the poems set a new standard for Victorian poetry. Masson immediately recognised Christina's talent; three of her submissions appeared in *Macmillan's*. Although the religious allegory 'Up-Hill' made the biggest splash in 1861, it is 'A Birthday' which remains one of her best-known poems:

> My heart is like a singing bird
> Whose nest is in a watered shoot;
> My heart is like an apple tree
> Whose boughs are bent with thickset fruit;
> My heart is like a rainbow shell
> That paddles in a purple sea;
> My heart is gladder than all these
> Because my love is come to me…

No student of Christina's poetry thus far would have predicted that an ecstatically upbeat celebration poem would bring Christina lasting fame. Her customary tone was heart-broken and melancholy, often spiced with a dash of gothic horror, while her favourite subject was religious struggle. Bursting with images of fertility and abundance, and shining with Pre-Raphaelite colours and textures, this poem would intrigue Christina's readers for years to come. William

was repeatedly asked to divulge the story behind his sister's 'outburst of exuberant joy', but he confessed that he was 'unable to do so'. William's turn of phrase is nicely ambiguous; it is unclear whether he is 'unable' because he does not know, or whether he knows and is not telling. The events of Christina's life yield few clues. She wrote the poem in 1857 in the dreary month of November. Perhaps the poem's 'rainbow shell' and 'purple sea' were drawn from memories of that year's seaside holiday at Herne Bay, where she had experienced the Wordsworthian 'zest of wilder nature' and enjoyed 'rocky glen and rainbow crowned waterfall'.[25]

Jan Marsh wonders whether Christina's happiness might be related to a brief romance with the painter John Brett, who painted her unfinished portrait that year and whose work *The Stonebreaker* was a hit at the 1858 RA Exhibition. It is certainly a possibility. At the time, Brett was living in nearby Camden Town with his brother and sister Rosa (also a painter), and was an associate of the Pre-Raphaelite painters and Ruskin. There were whispers of a marriage proposal, but no real evidence has been discovered. If Christina did receive a proposal, it is odd that William, who is reasonably forthcoming about other broken engagements, would gloss over this one, especially as he happily admitted that John Brett 'did appear to be somewhat smitten with Christina', dating his crush toward the early 1850s. In 1860, Christina composed a tart rejection poem, 'No Thank You John', to which she added a note: 'The original John was obnoxious, because he never gave scope for "No thank you!"' She contradicted herself later, assuring Gabriel that 'no such person existed or exists.'[26] Whether or not Christina received a proposal from John Brett, it is extremely unlikely that the painter is the addressee of this poem's exasperated speaker who says, 'I'd rather answer "No" to fifty Johns / Than answer "Yes" to you.' A discreet poet like Christina who had a 'horror' of her poems being interpreted as 'love personals' would hardly announce a rejected suitor to the world in this way. Jan Marsh notes that in the spring of 1861 Christina and Maria paid a friendly visit to Brett's studio, which suggests that the couple had put any affair of the heart behind them. Marsh elegantly sums up this episode: 'It is all something of a puzzle.'[27]

This would have pleased Christina. Raised on charades, chess

and riddles, Christina always enjoyed a good puzzle. Her mysterious poems often leave suggestive 'clues' which, upon closer examination, almost always turn out to be red herrings. Her delight at thwarting detection forms the core of one of her most characteristic poems, 'Winter: My Secret'. Composed only five days after 'No Thank You John,' it is an extended tease which refuses to divulge the secret at its heart. Ultimately, the secret becomes less important than the ways in which it is hidden. 'You want to hear it? well: / Only, my secret's mine, and I won't tell,' the first stanza taunts. Later the poem suggests that '...there is no secret after all / But only just my fun.' Just as the speaker has to protect herself from winter's cold with 'a mask' and 'a shawl, a veil, a cloak and other wraps', she must protect her secret:

> I cannot ope to every one who taps,
> And let the draughts come whistling thro' my hall;
> Come bounding and surrounding me,
> Come buffeting, astounding me,
> Nipping and clipping thro' my wraps and all.

The game continues with the suggestion that summer may thaw her resolve. But this assurance is whipped away at the poem's conclusion: 'Perhaps my secret I may say, / Or you may guess.'

We may guess, but we will never know for sure. What we do know is that this discreet attitude in her work was reflected in her life, and was respected by the people around her. There is a central irony in the secretive personality, which is that it is both self-effacing and attention-seeking. Christina both wanted and didn't want to be noticed, and so she contented herself with enjoying the interplay between revelation and concealment. In some ways, this was a strategy to accommodate the contradictions of her personality and upbringing. Like Gabriel, she had been a temperamental, explosive and demonstrative child, but as adulthood approached, gender expectations drove these aspects of her self-expression underground. Behaviour which was regarded as charming and eccentric in a man was showy and suspicious in a woman, particularly an Anglo-Catholic woman whose religion encouraged self-renunciation and humility. Christina faced a dilemma in trying to reconcile feminine modesty and burning

ambition. As was her custom, she turned to the bible for answers, and there she found that the parable of 'the lowest room' was tailor-made to fit her competing needs. Luke 14: 10–11 explains the tactical advantages of humility: 'when thou art bidden, go and sit down in the lowest room; that 'when he that bade thee cometh, he may say unto thee, Friend, go up higher…' The lesson here is that '…whosoever exalteth himself shall be abased; and he that humbleth himself shall be exalted.'

She was fully aware of the ironies of this metaphysical puzzler: 'Give me the lowest place / Not that I dare ask for that lowest place…' she wrote in 'The Lowest Place'. This paradox appealed to Christina both as a games-player and a sincere believer, and she strove to rise (or lower herself) to the challenge. That this was a genuine struggle comes across in her many poems on this theme. She was not always sure this was a game worth winning. 'The Lowest Room', for instance, hints at the frustration which underlies this process:

So now in patience I possess
My soul year after tedious year,
Content to take the lowest place,
The place assigned me here.

Christina was not always good at taking the lowest place, particularly where matters of her career were concerned. For example, in October 1861, she agreed to stay temporarily at Highgate Penitentiary only on the condition that the nuns would allow her time off to correct proofs of her poems, which she was preparing for publication.

Christina was also not particularly graceful at taking the 'lowest place' when it came to Gabriel's affections. Frosty relations between the Rossetti women and Lizzie persisted, despite Gabriel's marriage, partially because his sisters were now being kept out of the loop. 'Who, think you, is married? Gabriel…' Christina casually informed Amelia Heimann, sniping that 'on his side it was an attachment of many years standing.' She thought the couple might be honeymooning in Paris, but the fact that she did 'not know for certain' is indicative of the distance between Gabriel and his family. By August, the Rossettis still had not congratulated their new sister-in-law in person.

'His marriage would be more of a satisfaction to us if we had seen his bride,' Christina complained.[28]

The situation was considerably aggravated by Lizzie's full-blown substance abuse problem. In this case, the drug treatment had proven more dangerous than her illness. Lizzie had become a habitual drinker of laudanum, a medical remedy made of opium and alcohol. As inexpensive and as easily obtainable as castor oil and liquorice, opium mixtures were socially permissible because their narcotic effects were understood to be purely medicinal rather than recreational. Though there was some suspicion that they might be dangerously addictive, most people regarded opium tinctures as no more harmful than any over-the-counter painkillers. Opium knew no class boundaries; its low cost, especially when weighed against high doctors' fees, made it as popular among the working classes as it was with well-to-do housewives. Globalisation was also at work here. While Indian opium dominated the drug trade in Asia, most of the opium consumed in nineteenth century Britain was imported from Turkey. It was preferred to the Indian product because it had a higher morphia content, and vigilant Ottoman inspectors were known for preventing its adulteration.[29] The drug's cheapness and accessibility were a result of Britain's trading links with Turkey, which had been recently strengthened by Allied victory in the Crimean War.

Opiates were particularly popular with women, as they treated a wide spectrum of symptoms and complaints not understood by the medical establishment, including psychological distress. Opium-based tinctures as were used as 'quieteners' for women as well as children. Laudanum in particular made drinking alcohol socially permissible for women. Like many other middle-class women of the age, Siddal had become addicted over time to a drug initially taken on her doctor's advice. Sold at chemists in its laudanum version, opium could also be purchased without prescription in the form of powder, pills, teas, syrups elixirs and cordials. One popular children's-strength version, Godfrey's Cordial, sweetened opium with treacle. Along with treating chronic disorders such as neuralgia and rheumatism, the drug was also used to alleviate ordinary stomach upsets and everyday aches and pains. Withdrawal from the drug, causing diarrhea, vomiting and mental distress, sometimes became indistinguishable from illness. Yet

because its addictive dangers were not recognised or pathologised, many Victorians (particularly women) obliviously lived their entire lives as low-level addicts. But in Lizzie's case, the drug itself entirely eclipsed the other causes of her persistent ill health, darkening a mind already grown shadowy with depression. 'Married life cannot be exactly happy when one of the spouses is perpetually and grievously ill', William observed, adding tactfully that his sister-in-law 'was compelled no doubt under medical advice to take laudanum or some opiate continually, and stimulants alternated with opiates.'[30]

The situation was aggravated by an unstable domestic life. Like many couples before and after them, Gabriel and Lizzie had discovered that marriage was not a magic fix for their problems. They had essentially been together for the better part of a decade, and marriage did not, as perhaps was hoped, renew the first flush of their romance. Compounded by a long engagement and multiple break-ups, the problems had started long before their marriage. Gabriel's reluctance to set a wedding date and his obvious dalliances with other models of dubious background such as Annie Miller and Fanny Cornforth contributed to tensions between them which never really eased. By the time Gabriel finally gave in and married Lizzie, their relationship had already been strained to the breaking point, which he acknowledged in a letter to Frances: 'Like all the important things I ever meant to do…this one has been deferred almost beyond possibility. I have hardly deserved that Lizzy should still consent to it, but she has done so, and I trust I may still have time to prove my thankfulness to her.'[31]

Guilt and obligation were not the firmest of foundations on which to build a marriage, particularly not for a man who idealised romantic love. Lizzie was equally idealistic, and it is no wonder; her life had followed a fairytale trajectory from humble shop-girl to painter, poet and Queen of the Pre-Raphaelite models. Her final transformation into a married women jealously chucking Gabriel's studies of 'stunners' into the Thames must have been as much a shock to her as it was to her new husband. There are competing accounts about whether or not Gabriel continued his physical affairs with other women such as Cornforth, but the damage to his relationship with Lizzie had already been done. The fact that the speculation continued then, as now, suggests at least that there was significant room for doubt about

his fidelity. This can't have been very reassuring for his new bride, regardless of whether there was smoke without fire.

It turned out that Lizzie was no better suited to the role of docile Victorian home-maker than Gabriel was to the role of the respectable husband. 'She had very little of a housewifely turn', William noted wryly.[32] The memoir of her new friend, Burne-Jones's wife Georgina, hints at a reason; Lizzie still harboured artistic ambitions. The two friends began to collaborate on a collection of illustrated fairytales, but the project foundered for reasons which suggest creative frustration as a cause of Lizzie's depression: "It is pathetic to think how we women longed to keep pace with the men, and how gladly they kept us by them until their pace quickened and we had to fall behind', Georgina wrote.[33]

While many mid-Victorian middle-class married couples, like their close friends William and Jane Morris, were moving to the suburbs to raise families, Gabriel and Lizzie stayed in London. Although he enjoyed a civilised country retreat, Gabriel, like his siblings, was urban at heart. He was 'fat and flourishing', and though he was concerned about the extra expenses marriage incurred, he had enough money to rent an additional suite of rooms on the second-floor of Chatham Place.[34] He proudly informed Bell Scott that a spare bed was now available for guests. Cautiously optimistic about Lizzie's pregnancy, he started applying his talents to domestic life. He designed wallpaper for the drawing-room. Floor-to-ceiling fruit trees would appear on a brown or blue background decorated with stars. The doors and wainscoting would be painted green, a colour which for Gabriel symbolised hope.

The painter's new interest in interior decoration was inspired by William Morris's Red House in Bexleyheath, which Gabriel enviously described as 'more a poem than a house.' Morris had embraced married life in the suburbs, designing his dream house with the help of architect Philip Webb. Influenced in part by the neo-gothic stylings of Butterfield, the Red House was a two-storey home constructed of bricks made from local red clay. It was laid out in an unusual L-shape which created a courtyard garden. Although it showed a gothic influence in its irregular, steep roofing, deep porches, brickwork and arches, the house was also modern in the sense that it was constructed

around the needs of the family, and was designed to integrate well with its surroundings. The Red House's purpose was to combine old-fashioned beauty with seamless functionality, serving in some ways as a metaphor for modern marriage. The furnishings and decorations were partly inspired by the medievalism of the second wave Pre-Raphaelites; Burne-Jones designed stained glass and tapestries for the interior, and the handcrafted furniture echoed the spirit of the gothic revival. Like Mr. Wemmick in Dickens's *Great Expectations*, whose humble suburban house is accessed by a mini-drawbridge, Morris wanted his home to be his castle.

Gabriel and Lizzie also helped decorate the Red House and were frequent visitors, along with Burne-Jones and his wife Georgina. The summer of 1860 was a golden one for these second-generation Pre-Raphaelite Brothers, who enjoyed holding impromptu bowling matches in the hallway, playing hide-and-seek and having 'bear-fights in the drawing-room' during breaks from painting medieval patterns on the walls and ceilings. Gabriel amused himself by writing 'As I can't' on blank labels awaiting Morris's aspirational new motto, 'If I can'.[35]

The Red House inspired Morris to turn his attention toward interior design, and in order to translate his new artistic interest into a commercial venture, he created Morris, Marshall, Faulkner, & Co, the design firm which would become Morris and Co. in 1875. Casually referred to as 'The Firm', its founder-members included Gabriel, Burne-Jones, Webb and Madox Brown, along with Charles Faulkner and Peter Paul Marshall. Its 1861 foundation inaugurated the Arts and Crafts movement. A blend of domestic perfection and bohemian idealism which brought art and life closer together, the group's aims reflected a new Pre-Raphaelite ambition: to reshape the everyday world. Unique, handcrafted household objects would compete with cheap, mass-produced glassware, furniture and textiles. Commodities would be valued for beauty and individuality rather than machine-made regularity, recalling a golden age of painstaking English craftsmanship. In an era which enshrined hearth, home and family, domestic interiors would become works of art.

The Firm's offices were near Gabriel's old digs in Red Lion Square, and, according to William, business was conducted following the

PRB model, with 'Light or boisterous chaff among themselves, and something very like dictatorial irony towards customers…'[36] Gabriel joked that Morris's leadership was based on the size of his investment rather than his business savvy. Despite Brotherhood-style hijinks, the Firm was a serious business run by a group of family men working hard to make it succeed. The group were quick to diversify, offering their expertise in stained glass and textiles to compete for contracts in church restoration and redecoration projects, as well as for secular public spaces and domestic interiors. This male nesting instinct was not perceived to be in conflict either with masculinity or with Pre-Raphaelite artistic ambition. 'If a chap can't compose an epic poem while he's weaving a tapestry, he had better shut up,' Morris commented cheerfully.[37]

Exhausted by years of illness complicated by laudanum dependency, and emotionally strained by the suspense of nearly a decade of on / off relations with Gabriel, Lizzie Rossetti was not so sanguine about balancing the demands of art and home life. At first she enjoyed helping her friends decorate the Red House, visiting them often both with and without her husband. She had also regained her place as her husband's muse and Queen of the Pre-Raphaelites; she was the model for *Regina Cordium* (*The Queen of Hearts*). He told Bell Scott the new work proved that he did not just paint 'Servant gals', probably a reference to *Bocca Baciata* (*The Kissed Mouth*), for which Fanny Cornforth's had modeled the previous year.

Gabriel may have painted *Regina Cordium* by way of a peace offering to his wife, meant to reassure her that she was still the queen of his heart. After all, hearts was the suit Gabriel had always preferred to play since childhood. But in truth, there was no mistaking that *Bocca Baciata* indicated a new, adult direction in Gabriel's artistic and sexual tastes. Though only the face of his voluptuous paramour appeared, there was no mistaking the erotic content of the picture. It had been purchased by Boyce, who adored the 'superb' painting so much that Arthur Hughes joked he would 'kiss the dear thing's lips away'.[38] It shows the head and shoulders of a beautiful young woman, framed by her extravagant red-gold hair which echoes the colours of the marigolds in the background. The apple at her left elbow symbolises both temptation and a loss of innocence, while the marigold she holds in her right hand is an emblem of grief. These negative associations

are complicated by the white rose in the woman's hair, symbolising innocence. How can a woman be both innocent and fallen? The clue is in Boccaccio's original story from *The Decameron*, from which the painting's title is borrowed. It tells the tale of a sexually experienced princess who successfully passes herself off as a virgin bride. Nothing about the subject matter or its treatment would have been reassuring to Lizzie, the deposed Queen of Hearts.

On the second of May 1861, Lizzie's sorrows were compounded when she was delivered of a stillborn daughter. 'Lizzie has just had a dead baby,' Gabriel reported brutally to Brown and Burne-Jones, making no attempt to disguise the rawness of his feelings. To his mother he wrote, more delicately, 'Lizzie has just been delivered of a dead child. Do not encourage anyone to come just now: – I mean of course except yourselves.'[39] The ambiguity of this invitation is deliberate, and presumably the Rossetti women took the hint and stayed away. Less than two weeks after the stillbirth, Charlotte Polidori, who was travelling in Florence at the time, wrote to her sister Margaret of her 'great relief...that poor Lizzie had got through her trouble.'[40] That the Polidori aunts were thus persuaded speaks to the distance between Gabriel's wife and his family.

In the wake of her grief, decorating parties at the Morris's dream home, which now boasted a baby daughter and another little girl under two, turned nightmarish. Lizzie felt the odd one out among this group of friends who were as aspirational about parenthood as they were about artistic achievement. Four months earlier, the christening of Morris's first daughter had been commemorated by a medieval-style banquet and an overnight celebration at the Red House. A separate men's dormitory had to be set up in the drawing room to accommodate the overflow of guests. Georgina Burne-Jones had noticed that Gabriel was uncharacteristically quiet during the party while Lizzie was short-tempered and snappish. Perhaps Gabriel's refusal of wine in favour of water during the meal was taken as a silent rebuke by Lizzie, then heavily pregnant.

Lizzie fled the Red House abruptly during a visit in 1862, coming home penniless to a dreary London in October. It was not the first time she had behaved in this way; during the summer she had pulled a similar stunt at the Brown's house, leaving for Blackfriars without

notice while her friends were out. Gabriel wrote his mother in a panic from the Yorkshire home of his patrons, the Heatons, where he had been staying in order to complete Mary Heaton's portrait and to work on Firm-commissioned stained-glass designs for the Heatons' home. Frances rushed over to Chatham Place to provide Lizzie with some much-needed funds and, presumably, to check up on her. From that autumn onwards, Lizzie continued to behave erratically. When Georgina and Edward Burne-Jones paid a visit, they were upset to find her sitting dejectedly by an empty cradle. "Hush, Ned, you'll waken it!'" she remonstrated.

While Gabriel tried to disguise his grief under what Georgina Burne-Jones called his 'surcoat of jesting', his devastation over his lost child was apparent. Years afterward, while watching a friend's child playing at a party, Gabriel said, "'I ought to have had a little girl older than she is.'" He had grown up in a home where children were revered, with an affectionate Papa who was so protective of his progeny that he superstitiously refused to step over them when they were crawling on the hearth rug. The father's superstitious nature survived in the son. When Lizzie tried to give her unused baby clothes away, Gabriel begged Georgina not to accept them. 'But don't let her, please,' he wrote. 'It looks such a bad omen for us.'[41]

Gabriel sensed there was more tragedy on the way, and he was right. On February 10, 1862, Lizzie, Gabriel and Swinburne dined together at the Sablonière Hotel in Leicester Square, a foreign establishment catering to European travellers, known for its excellent French dinners. During the 1830s, Gabriele Rossetti's old friend Paganini had stayed there during a famous London concert tour and been mobbed by fans on its steps.

According to the inquest, Gabriel took Lizzie home after dinner and went out to teach at the Working Men's College. He returned to Blackfriars after 11pm to discover his wife unconscious. Despite the efforts of four doctors, which included pumping the patient's stomach, the overdose was too much for her. Several quarts of water were injected into her stomach and washed out, leaving a strong smell of laudanum in the room. Lizzie died at around 7.30 on the morning of February 11. She was thirty-two years old.

William rushed over to Blackfriars from Somerset House that day

to find a shocked and grieving brother and Brown, who had been with Gabriel since 5 am. His sister-in-law's beauty had not been diminished by death, and he remarked in his diary how peaceful she looked. He could not stop thinking of the following lines from Dante Alighieri's *Vita Nuova*: "'Ed avea in se umilta si verace Che parea che dicesse, Io sono in pace," later providing Gabriel's translation: "And with her was such very humbleness / That she appeared to say, I am at peace.'"[42]

Self-protectively, William transformed his sister-in-law's drug overdose into the stuff of ageless Italian love poetry. Already, Siddal's death was being incorporated into the Rossetti family legend, although it was ironic that her tragic end was what finally made her a part of the clan. Gabriel endorsed this fatalistic vision by placing his manuscript poems in his wife's coffin to be buried with her. He had neglected his wife for the sake of those poems, the grief-stricken Gabriel explained; burying his work with his wife served a kind of morbid poetic justice. Brown, who had lost a first wife himself, resisted these Rossetti family dramatics, appealing to William to stop what he saw as Gabriel's futile gesture. Having never opposed his brother before, William was not about to start an argument with him now, particularly in the presence of his wife's corpse. The younger brother refused to interfere and Lizzie was buried with her husband's poems. Finally, she had accomplished something big enough to impress the Rossettis. 'Gabriel's poor Lizzie is dead', wrote Christina, 'and Gabriel is in sorrow I will not attempt to describe.'[43] Although Lizzie was buried in the Rossetti family grave at Highgate, family reservations were still registered in the sparse inscription 'E.E.R. 1862'.[44]

Her death would quickly become the stuff of urban legend. Rumours (never entirely confirmed or denied) would fly about the existence of a suicide note pinned to her dress, which Ford Madox Brown destroyed, though no one could agree on what the note read. In another version of the story, by Gabriel's biographer and secretary Hall Caine, the note was left on the bed-side table, and Gabriel refused to reveal its contents. Later biographers Violet Hunt and Helen Rossetti Angeli disagreed about the note's contents, but their conclusions are based on oral family tradition rather than documented sources. Some suggested that Lizzie had been pregnant

again, and that Gabriel had been visiting with Fanny Cornforth that fateful night rather than teaching. The one thing everyone agreed on was that the death was suspicious.

An inquest was held. Gabriel's loyal housekeeper Mrs. Birrel swore that the couple had been getting along well, Swinburne testified to Lizzie's good state of mind on the night on her death, and Gabriel gave evidence of his movements that evening. Lizzie Rossetti's death was declared accidental, but this did not put an end to speculation about suicide. Although it is not possible to ascertain the whole truth of the matter, it is not unlikely that a woman suffering from depression, drug addiction, creative malaise and a marriage gone sour would have decided to take her own life. In any case, Gabriel held himself responsible, and his guilt about Lizzie's untimely death would haunt him for the rest of his days.

Like his other siblings, he had found that the wider world could not compete with the comforts and consolation of the Rossetti family nest. After her funeral, he left Chatham Place and moved back in with his brother and sisters at Albany Street. He would never inhabit his Blackfriars rooms again, now that they were the site of so many painful memories. In his grief, Gabriel started making plans to find a house big enough to accommodate all the family, including the rheumatic Margaret Polidori. Profound grief can be the only explanation for Gabriel's unrealistic plan to invite Swinburne to come and live with the family. Swinburne, a black sheep aristocrat who had a drinking problem and a masochistic taste for being flogged, might have cheered up Gabriel, but it is doubtful his antics would have had the same effect on the Rossetti women. A few weeks with his mother and sisters in the quiet Albany Street household, whose days and hours were organised by the Church calendar, were sufficient to make Gabriel realise that this would not be a workable living arrangement.

A social animal like his father, Gabriel was borderline phobic about being alone, and would have welcomed with open arms the callers that the Rossetti women regularly discouraged. He rose late in the day and liked to stay up most of the night. It is hard to imagine the Rossetti women, who spent a significant amount of their time working to find 'respectable' careers for single young women, being particularly pleased about receiving the stream of voluptuous

models of dubious reputation coming to sit for the head of their house. Gabriel's decision not to invite mother, sisters and aunty to join his tenants Swinburne and the recently divorced author George Meredith when his new house was ready, inspired a masterstroke of understatement from William: 'that would not be the most apposite of homes for his female relatives.'[45]

Across the river from Battersea, Gabriel's new Chelsea neighbourhood was far from the northern Regent's Park area the Rossetti women felt was their home. Their social, religious and working lives all took place no farther south than Oxford Street, and removing themselves to Chelsea would have meant long commutes to church, friends and work at Highgate Penitentiary and All Saints. Maria was still teaching Italian to private clients, none of whom was located anywhere near Chelsea. Although they would never have confessed it out loud, the Rossetti women must have heaved a sigh of relief when Gabriel took temporary lodgings at 59 Lincoln's Inn Fields in April. In fact, relief would be the defining emotion of the Rossetti family as it headed into the mid-Victorian period.

Years of 'toiling and moiling', of networking and grafting, had finally paid off. William was making a solid wage at the Internal Revenue. Maria, though still governessing, was finding spiritual fulfillment as an Associate Sister of All Saints. With the quiet attentions of Charles Cayley and the success of her first volume of poems, long-awaited love and fame would finally come for Christina, and Gabriel was starting to enjoy bachelor freedom and financial success. Yet as is so often the case with high-achievers, success was not enough to quell any lingering insecurity. Like the two occupants of the family grave in Highgate, the Rossetti family ambition refused to be put to rest.

Dante Gabriel Rossetti, *The Girlhood of Mary Virgin*, 1848–9

In Gabriel's first major work, his sister Christina modelled for the Virgin Mary, while their mother Frances modelled for St. Anne. The Virgin's embroidery reappears in *Ecce Ancilla Domini*.

Dante Gabriel Rossetti, *Ecce Ancilla Domini*, 1849–50

Gabriel used his family again for his second major painting; Christina modelled for the Virgin Mary, while William was the model for the angel Gabriel. The painter rechristened his 'blessed white eyesore' *The Annunciation* in 1853 to avoid accusations of popery.

an Everett Millais, *Lorenzo and Isabella* 1848–9

her Pre-Raphaelite Brothers used the Rossetti family as models. In Millais's
renzo and Isabella, William (as the doomed Lorenzo) offers a symbolic blood
nge to Isabella, while Gabriel downs a glass of wine on the far right of the table.

Dante Gabriel Rossetti, *Found*, 1853 (unfinished)

Fanny Cornforth was the model for the prostitute in this unfinished work, which Lewis Carroll deemed 'one of the most marvellous things I have ever seen done in painting.'

William Morris *La Belle Iseult*, 1858

A young Jane Morris modelled as King Mark's adulterous queen from Malory's
epic *La Morte D'Arthur*, forecasting the role she would play as the object of
Gabriel's worship a decade later.

Dante Gabriel Rossetti, *Beata Beatrix*, 1866–70

According to his brother William, this picture of Lizzie Siddal modelling for Beatrice showed 'the painter's lost wife, portrayed with perfect fidelity out of the infinite chambers of his soul'.

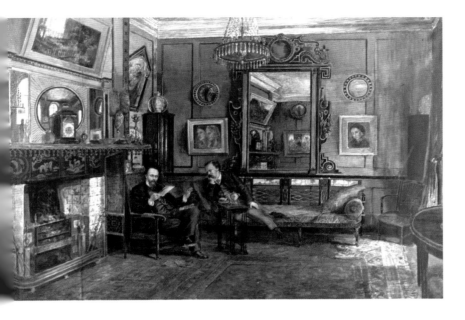

[. Dunn, *Tudor House*, 1882

[...]riel reads proof copies of Sonnets and Ballads to a rapt Theodore Watts-
[...]nton in Tudor House's sitting room. On either side of the mirror, Gabriel's
[...]traits of his mother and Christina (left) and Christina (right) look on.

Dante Gabriel Rossetti, *Veronica Veronese*, 1872.

William Bell Scott, John Ruskin and Gabriel Rossetti in the garden at Tudor House, by William Downey, 1862

Ruskin declared that Gabriel 'was really not an Englishman, but a great Italian tormented in the Inferno of London'. Less romantically, Bell Scott foresaw trouble in Gabriel's 'confusion between external realities and mental impressions'.

9

UNA SELVA OSCURA: MIDDLE AGE

Georgina Burne-Jones was the first to notice that she and her bohemian friends were getting older. During one of Gabriel's Cheyne Walk parties in April 1865, she was startled to see that Ford Madox Brown's thick, dark hair had gone completely grey. With a chill, she realised that this glittering circle, comprised that evening of (among others) her husband, the Morrises, Swinburne, Bell Scott, F.G. Stephens, Arthur Hughes and Alexander Munro and their wives, as well as the Rossetti brothers, were mortal after all. If Georgina needed any further reminder, Lizzie Siddal's drawings hung in silent reproach in Gabriel's long, seven-windowed drawing room, 'where if ever a ghost returned to earth hers must have come to seek him'.[1] Outside, the moonlight glimmered coolly on the Thames. Christina Rossetti, who needed no prompting to contemplate mortality, had excused herself from attending the party. The Rossetti women were fully occupied attending special Passion Week services.

At the date of this April party in 1865, Gabriel was thirty-seven, and even the younger, second-generation Pre-Raphaelites were entering their thirties. No longer an *enfant terrible* on the London scene, Gabriel had been welcomed into the popular Garrick Club whose membership consisted of artists, actors and respectable literati like Dickens and Thackeray, as well as his old Pre-Raphaelite Brother John Millais. The sociable Gabriel immediately started campaigning to get Brown elected to membership, but an informal survey of the club revealed he would most likely be blackballed and the plan was

dropped. Once, Gabriel had begged Brown to tutor him in painting, but now the student had surpassed the master. Like Georgina Burne-Jones, Gabriel had lately been thinking about the gulf between past and present. While re-framing and retouching *The Girlhood of Mary Virgin*, he mourned the younger version of himself: '…it quite surprised me (and shamed me a little) to see what I did sixteen years ago when I was twenty.'[2] He told Brown that the painting seemed to him 'the work of quite another crittur' and that it was 'a long way better than I thought.'[3]

His routine of painting during the day and staying up talking most of the night started to take its toll on his looks as he entered middle age. Friends had already noticed that Gabriel was exhibiting the family tendency to plumpness, and William was struck by his brother's increasing resemblance to their father. A pronounced wrinkle had appeared over the bridge of his nose, making his heavy-lidded gaze appear even more intense. He wore a goatee beard and moustache, leaving his cheeks clean-shaven. Although he had not gone bald like William, Gabriel's hairline had started to recede, drawing attention to the high, rounded forehead which some said made him resemble Shakespeare.

William, a bearded bachelor who had long ago abandoned attempts to conceal his bald pate with a scratchy wig, had always been old before his time. He found the transition to middle age easier than did his brother. His more active lifestyle, which involved a long commute to work from Cheyne Walk to Somerset House, kept the taller brother fit and trim, as did his natural inclination towards moderation. He spent Monday, Tuesday and Friday nights at Cheyne Walk, and the other days of the week at the family home in Albany Street, where he could rest up from the dormitory atmosphere of his brother's house. William disapproved of what he called his brother's lounging indolence, but was at a loss as to how to motivate him to take better care of himself.

As usual, he submitted to Gabriel's will while he was his tenant, though he grumbled that it was impossible to get any of his own work done in the house. Gabriel demanded his younger brother's presence for all-night chats with friends in his studio, whose new fangled gas-standard lighting William found unsuitable for writing. It was much

easier to write his criticism and reviews at Albany Street, where his less demanding sisters catered to his needs. At Cheyne Walk, the roles reversed, and William became caretaker to his brother. Unlike the other tenants, William had no study of his own, and soon gave up trying to write at Tudor House, instead keeping a book at his side to read during rare stolen moments of quiet. Exhausted from these evenings, he rose early to embark on the long journey to Somerset House, noting resentfully that Gabriel never appeared to share breakfast with him. William never tried to seek a compromise. He told himself that his brother's 'convenience dictated his habits, and persons in his company had to adapt themselves as best they could.' There is another side to the story, which is that Gabriel's sober, responsible brother needed to be given permission to enjoy himself. An extraordinary productive work-horse of a man, William had been managing full-time work and a journalism career since an early age, not to mention acting as the de facto Rossetti *pater-familias* since the death of his father. It would have been impossible for him to admit to pleasure-seeking for his own sake, and so it was convenient to re-frame his own forays into his brother's irresponsible lifestyle as a further exercise in self-sacrifice. While William craved 'the conveniences of regular quiet occupation', he simply 'did without them.'[4] William's characteristically fernickety complaints about insufficient lighting and the lack of a study could not conceal his obvious attraction to the exciting day-for-night lifestyle available to him at Cheyne Walk. Cooped up in a tax office since the age of fifteen, William's creativity thrived in the company of Gabriel's artistic friends. Their eccentricities and affectations delighted a man who had little time or spare cash to indulge himself. He watched with amusement as Whistler and Gabriel competed to collect Chinese blue-and-white china, in vogue since its 'discovery' by fashionable Parisians in the late 1850s. William affectionately remembers Gabriel coming home after a shopping expedition: 'as he dropped into an easy-chair, he called out "Pots! Pots!" with a thrilling accent' which 'spoke at once of achievement and of despondency.'[5]

Along with a torrent of literary and artistic criticism, William finally published his translation of Dante's *Inferno* which he had finished in the late 1850s when he was only in his late twenties. It

was typical of William to be prematurely attracted to a work famous for chronicling the difficulties of middle age. His book was not rapturously well-received, and its first sentence immediately tells us why: 'The aim of this translation of Dante may be summed up in one word – Literality.' His insistence on 'literality' resulted in a blank verse translation which flattened both the beauty of the Italian *terza rima* and the mind-blowing metaphysics of Dante's medieval allegory. William's approach as a translator was the exact opposite of Gabriel's, whose preface to the 1861 reprint of his *Early Italian Poets* proclaimed that 'literality of rendering' was 'altogether secondary' to the translator's 'chief aim', which was to make sure 'that a good poem shall not be turned into a bad one.' It was plain that Gabriel was by far the more talented and creative brother. William's stubborn adherence to literality in translation had less to do with challenging his brother's dominance than it had to do with settling scores with their father, whose refusal to accept 'literality' in Dante had ruined his career and nearly ruined the family. In his preface, William writes that he is reluctant to 'express adherence to or dissent from any of the various theories and interpretations'. This intention is undercut by his determined conclusion that 'To take [Dante] literally is enough, and more than enough, for most men.' This filial disloyalty, though subtle, was certainly noticed by his father's old friend, Thomas Keightley, who told William, 'It really vexed me to see but one allusion, and that rather a slighting one, to your Father's theory. I infer from this that you reject it, like Gabriel.'[6]

This declaration of family loyalties may also have been written with an eye towards his mother, who, perhaps sensing that William was being left behind by Gabriel and Christina's successes, financed the book's 1865 publication. He also made certain to compliment Cayley's Dante translations in his preface, which undoubtedly pleased Christina.

It was obvious that the unpublished Maria, the oldest and once considered the cleverest, now risked being left behind. Taking her cue from William, Maria began working on her own book that year, a primer meant for students and teachers of Italian. The nature of the project meant that, like William, Maria entered the field with a literal, rather than a literary translation. Her book translates 100 Italian

anecdotes 'into the most literal English' on the theory that 'their re-translation' by students 'will result in the Italian of the original.'[7] Christina reported to Gabriel that she was helping her big sister with the project, sibling rivalry mixing with family pride: 'I have a great fancy for her name endorsing a book, as we 3 have all got into that stage'.[8] She was also imitating Gabriel, who had helped his siblings by contributing illustrations for Christina's poems and the cover for William's *Inferno* translation. Although they were now embarking on solo projects, the sibling spirit of collaboration that had been fostered by Frances's commonplace book and in-house magazines, persisted. What Christina didn't mention, but what Gabriel must have known, was that she was about to surpass both her brothers in the publication stakes. The second edition of *Goblin Market* was coming out soon, and she was hard work on her next volume of poetry, *The Prince's Progress*.

William broke with family tradition in not dedicating his work to a family member, surprising everyone by dedicating his book to his old love Henrietta Rintoul. It would be amusing to imagine that dedicating the *Inferno* to an old girlfriend was a commentary on their relationship, but that kind of irony was not William's style. In fact, the dedication is yet another instance of literality; he was fulfilling to the letter a promise made long ago to Henrietta during their engagement. Though their relationship had ended, and the friendship between Henrietta and his family had cooled, William felt honour-bound to keep his word. Ever the gentleman, William had discreetly obtained his ex-fiancé's permission via Christina. Naturally William only provided Henrietta's initials on the dedication page: 'To H.R'. The dedication, whose restraint is in its way as romantic as the floweri-est of tributes, indicates that William was not as satisfied with his bachelor status as he claimed. That same year, he stood as best man at Holman 'Maniac' Hunt's wedding. The vast majority of his friends were now married with children, and William, at 36, was well past the age when most Victorian men settled down.

Even his own brother, as a widower, was hardly lacking for female company. Gabriel had lost no time in moving his on again / off again mistress Fanny Cornforth into Cheyne Walk to be his 'housekeeper'. Although she would keep a separate residence nearby which Gabriel paid for, she came and went freely from Tudor House. Though Fanny

and William got along well, it must have been lonely for William to witness the rekindling of this affectionate relationship. Friends recorded tender scenes between the couple more reminiscent of the conventional domesticity of husband and wife than ex-prostitute and philandering artist. Gabriel was fond of swearing, and used to tease Fanny with off-colour phrases until she threatened, 'Rizetti, I shall leave the room! – I'll put you out in the scullery!'[9] His pet-names for her were 'Lumpses' and 'elephant', as her youthful voluptuousness was giving every indication of turning to middle-aged fat. The nicknames were affectionate, and he still found her very attractive, continuing to paint and draw her, and to take her on visits to friends and even to Paris. He posed her for a garden photograph where she leans in three-quarter profile against a mirror, her doubled image hinting at the doppelganger legend which always fascinated Gabriel. Taken by William Downey, the photograph is said to have influenced his neighbour, the American painter James McNeill Whistler's famous painting of his own mistress before a mirror, *Symphony in White 2*. Whistler's painting appeared at the 1865 RA exhibition with a Swinburne poem, 'Before the Mirror' pasted in gold leaf onto the frame, just as Gabriel had done in his early career.

Boyce recalled dining with Gabriel and Fanny in December 1862, after which Gabriel gave him a pencil sketch of her reclining on his couch, her hair attractively fanned out around her. Ironically, her background and former profession meant that their relationship was in some ways less cynical and more direct than relationships with women nearer his own class. Though economic and social inequalities are not to be discounted, she was, more so than any other women outside of his sisters, his friend. Theirs was in many ways a more honest and adult relationship than his marriage had been. Fanny didn't have to be the perfect ideal of Pre-Raphaelite beauty; in fact, Gabriel's ideas about beauty changed with her appearance. Nor was Gabriel under pressure to act the role of the chivalrous, faithful knight. Having been known to Gabriel for so long, Fanny did not have to maintain an idealised mystique, nor does she appear to have felt a pressure to conform to or perform for his social circle. He sometimes poked fun at her cockney accent, but he never tried to modify it or 'teach' her to speak like his friends.

Having already 'fallen' irretrievably, Fanny enjoyed a freedom of movement denied to respectable women, accompanying Gabriel to painters' studios unchaperoned, and dancing the night away in Cremorne gardens with his new friend Whistler. She had no artistic pretensions herself, and viewed their relationship with the same clear-eyed pragmatism that Gabriel did. As there was never any question of marriage, she was spared having to run the gauntlet of Rossetti women and Polidori aunts. Years of self-sufficiency on the street had also taught Fanny to look after herself. Although she had reportedly been heartbroken when she learned Gabriel had married, her reaction was not to pine away but to quickly find herself a husband, mechanic Timothy Hughes, who kindly evaporated when she effectively moved in with Gabriel after Lizzie's death. She harboured no romantic illusions about the resumption of her relationship with Gabriel, and was careful to look after her own economic interests. When Gabriel gave Boyce first refusal on one of his paintings, Fanny reminded them that the painting officially belonged to her, and offered to sell it to Boyce herself.[10] Fanny shared this pragmatic approach with Annie Miller, who reappeared in Gabriel's life at about this time in need of funds, posing for him as *The Woman in Yellow* and *Helen of Troy*. She had resisted Holman Hunt's attempts to mould her into his ideal, middle-class mate, and had set about reinventing herself. Soon she would marry a military Captain, completing her transformation into a 'respectable' woman. While Gabriel could be careless with women's hearts, he was unusual in his respect for their heads.

Not everyone was comfortable with Gabriel's domestic arrangements. The writer George Meredith whom William observed had 'the face of a man not easily hoodwinked by the shows of the world', remained only a nominal tenant for a short time, and disapproval of Fanny may have been a factor in his quitting the house permanently.[11] During his time at Cheyne Walk he was working on 'Modern Love', a sonnet sequence chronicling the painful disintegration of a middle-class marriage. His tolerance for unconventional relationships was at a particularly low ebb, as his wife had recently died after leaving him for the painter Henry Wallis. As for Gabriel's other tenant, Swinburne's loyalty to Lizzie meant that he never warmed to Fanny. Ruskin too was not a fan, probably for the same reasons as Swinburne. Perhaps

surprisingly, Gabriel's brother and mistress do not appear to have clashed. Then again, Fanny, who had no artistic or intellectual ambitions, and would never have been considered as a wife, was perhaps less of a threat to the Rossetti brothers' relationship that Lizzie had been.

Christina, however, was still feeling rivalrous. Jubilation over her literary success made her temporarily soften toward Lizzie, and she offered to publish some of Lizzie's poems alongside her own in a future volume. When Gabriel sent his wife's numbered poems to her, Christina's reaction was mixed. She responded politely, but equivocally: 'Fine as II is, I don't admire it more than III and V: perhaps III is my own favourite, piquant as it is with cool bitter sarcasm...' Frances had enjoyed VIII, but Christina felt it was 'not in the first rank.' She told her brother that the poems brought 'poor Lizzie herself before one, with her voice, face and manner', which was hardly a ringing endorsement from someone who had not particularly enjoyed Lizzie's company. She sent the poems back to Gabriel nine days later. Although they were 'beautiful', she wondered if they were 'too hopelessly sad for publication *en masse*?'[12] A famously melancholy poet herself, Christina knew this line of argument was feeble, but defensively suggested that her verses were 'jovial' in comparison to Lizzie's. Perhaps it would be more appropriate for Lizzie's poems to appear in a volume of Gabriel's poetry than her own?

Ultimately, neither Christina nor Gabriel would publish Lizzie's work. Despite her personal reservations, the same imaginative sympathy that had shaped her critique of Gabriel's objectification of his fianceé in 'In An Artist's Studio' was at work in the long poem she was currently composing, 'The Prince's Progress'. The poem told the story of a handsome prince whose beautiful bride dies waiting for him while he dawdles on his journey to her palace. On his way, he wastes precious time dallying with a milkmaid and adventuring with an alchemist, and when he finally arrives, his bride's handmaidens tell him he is

Too late for love, too late for joy
Too late, too late!
You loitered on the road too long,
You trifled at the gate;

(ll.481–484)

The parallels with Gabriel and Lizzie were obvious. Christina saw the dangers in her brother's habit of procrastinating in work and in love. Like Christina's Prince, Gabriel had waited too long to claim his bride. Despite her personal dislike of Lizzie, she sympathised; Christina too had experienced first-hand the agony of a long courtship with an indecisive fiancé. Her poem, which she called 'my reverse of the *Sleeping Beauty*', warns of the risks women take in believing in rescue fantasies and fairy tales.[13] This anti-fairytale suggests that Christina herself was no longer waiting for romantic rescue, and that perhaps professional success as a working poet had filled the gap left by James Collinson. There was also the prospect of new love, in the timid form of Charles Cayley who was by this time paying court. The earnest scholar may not have been a traditional prince, but this was an advantage, as Christina no longer wanted one.

Now in her thirties, Christina was growing more confident. Adolescent cynicism had matured into a dry wit. Her acid tongue had been somewhat diluted by life experience, and her tendency toward over-earnest 'self-respect' was leavened with an increasing willingness to poke fun at herself. She delighted in a caricature Gabriel drew of her smashing up the furniture in a rage, which had been inspired by a *Times* review which read: 'Miss Rossetti can point to work which could not easily be mended.' Lewis Carroll's photographs of her show that, like her mother, who was known for her good complexion, Christina was aging well. She was still slim, and her hazel eyes, smooth olive skin and rich dark hair lent an exotic edge to her English beauty. Gilchrist's daughter Grace would later remember Christina's 1863 visit to her family home in Surrey: 'To my child's eyes she appeared like some fairy princess who had come from the sunny south to play with me.'[14]

Christina was also starting to come out of her shell: '*To be tooked and well shooked* is what I eminently need socially...' she wrote to Gabriel.[15] She developed a tentative sense of adventure, eagerly anticipating a summer trip to Italy with William and her mother. It would be her first trip abroad. Maria remained at home, for reasons which remain obscure, but probably had to do with work and volunteering commitments at All Saints. Later in the summer of 1865 she would become ill again, so perhaps she was already not feeling up

for arduous travel in May. It seems a shame that she stayed behind, given that she had started work on a book for beginners in Italian. Of the four siblings, Maria was often singled out as the most Italian in appearance, and it had been her father's expatriate friends who had found her unfashionably dark looks more attractive than did the English. William recalls, 'In person she was extremely Italian – according to my father, extremely like his mother (bearing the same Christian names), a Vastese of the Pietrocola family; complexion more than commonly dark, hair thickly curling and black, eyes large, dark, and speaking.'[16] Though William developed an adult passion for Italian politics, it was Maria who had listened most attentively to the views of her father's compatriots when she was a child. She taught Italian alongside religious instruction, and the two were intertwined in her heart and mind. Maria was also a Dante enthusiast who would surely have benefitted from a trip to Italy during the year that Florence was celebrating the sixth Centenary of the poet's birth. During a party that the Rossettis gave that year, she gave guests an impromptu tutorial on the structure of Dante's Inferno, illustrating its concentric circles with a pencil.

Gabriel did not express any interest in accompanying his family on their trip to Italy, which is odd, given that Gabriel's literary fame rested on his translations of Italian poetry. As a bi-lingual child of a Neapolitan exile his lack of curiosity about his homeland is striking. Perhaps growing up with a father in exile had given him a sense of paranoia about leaving home.

A great traveller himself, Holman Hunt was puzzled by Gabriel's lack of interest in Italy: 'It surprised me that Rossetti, of Italian blood, had no longing to satisfy his eyes with the sight of native soil...'[17] Partially, this was because Gabriel disliked the inconvenience of travel in general and sea voyages in particular. While a gentlemanly tour of Belgium was rapturously recorded by William in 1863, Gabriel reported only 'very moderate results as regards enjoyment.'[18] Like the Polidori sisters, he was also, in his own way, an English patriot. 'He liked England and the English better than any other country and nation,' William wrote.[19] At heart, he was as much a homebody and a Londoner as his mother and sisters, though his gender and outgoing personality led people to assume otherwise. Arthur Benson,

for example, took it for granted that 'Christina Rossetti, unlike even her brother, had no leanings to the home of her race', even though she was the one who visited Italy while Gabriel stayed at home.[20] While he appreciated the masculine sanctuary of the gentlemen's club, Gabriel, like his father, was most content when holding court in a familiar domestic environment.

There was also the troubling spectre of the Rossetti patriarch to contend with. The siblings were acutely conscious that their father had died pining for the land of his birth. While his body may have been safely contained in nearby Highgate Cemetery, his spirit would be inescapable in Italy. Gabriel had not enjoyed a smooth relationship with his father, probably because the two were so alike. As stubborn as they were charismatic, both father and son had a tendency to let their obsessions rule their lives, often at the expense of others. They were both idealists given to viewing situations through a haze of romance rather than in the stark light of reality. Gabriel pursued art and female beauty with the same vigour with which his father had chased down Masonic symbols in Dante Alighieri. Like his father, he was socially democratic, as comfortable talking with organ-grinders and servants as with London's intelligentsia. There were powerful differences as well, particularly when it came to Italy. Nowhere was this more apparent than in Gabriel's interpretation of Dante's Beatrice, who, if she symbolised anything, was for him the ultimate, flawless reflection of the true artist's immortal soul.

Gabriel never shared his father and William's keen interest in Italian politics, preferring its ancient poetry and art to its current affairs. As a child and young man, he had been bored by his father's friends and their incessant talk of exile from a land he had never known. In middle age, not only did Gabriel make no move to visit Italy, he did not seem interested even when Italy came to him. When rapturous crowds, including his mother and William, welcomed Italian military hero Garibaldi to London in April 1864, Gabriel stayed at home, declining a friend's offer to view the triumphal procession from his Pall Mall balcony. Curiously, it was his English friends such as the Brownings, Swinburne, and George Meredith who would take up the cause of Italian unification in print, while Gabriel kept quiet on the subject. He felt that Italy belonged to his youth, while his

adulthood was England's. Gabriel's Preface to his *Early Italian Poets* made this clear: 'In relinquishing this work (which, small as it is, is the only contribution I expect to make to our English knowledge of old Italy), I feel, as it were, divided from my youth.' This division also represented an Oedipal quest for his own identity. He included an ambivalent acknowledgement of 'my father's devoted studies, which, from his own point of view, have done so much towards the general investigation of Dante's writings.'[21] That damning, 'from his own point of view' suggested that it was one which the son did not share. Significantly, it was Robert Browning's *Sordello* which Gabriel quoted in his Preface, rather than any of his father's poems. This gesture was as much of an acknowledgement of his dual heritage as it was a declaration of literary independence. Under the watchful guidance of his mother, English literature had been his first love in childhood, and he read English before Italian. It was Shakespeare, not Dante, who had been his first favourite writer. 'English imaginative literature – Poems and Tales, here lies his pabulum', William Allingham observed.[22] He loved the English language, the sound and feel of it on his tongue. He was a tremendous reciter of English poetry whose sonorous voice and instinctive feel for Anglo-Saxon rhythms enraptured his listeners. Entitled and celebrated from the start, this pampered eldest son had never worried about 'fitting in', or whether his Anglo-Italian background qualified him for an identity crisis. He had never permitted xenophobic grumbling to keep him from pursuing his goals. Gabriel was not an exile like his father; he was right at home in England.

Yet other British natives tended to see Gabriel as Italian rather than English. 'He was really not an Englishman, but a great Italian tormented in the Inferno of London', Ruskin declared romantically, summing up the general view.[23] Yet Gabriel belonged to modern London, not medieval Florence. An aggressively cosmopolitan capital, the city did not force Gabriel to label himself according to nationhood, but bestowed on him a new identity altogether: that of a Londoner. He was a member of three prominent London gentlemen's clubs: the Burlington Arts, the Arundel and the Garrick. He preferred to paint native London girls, though there was no shortage of pretty foreign faces on the city's teeming streets. His wife had

been a Londoner, and his current mistress was a genuine Cockney. The vast majority of his friends lived and worked in the metropolis, and he liked nothing better than to drag them along for walks in one of his favourite places, the Regent's Park Zoo. As much as he did to promote Dante Alighieri's work, just as great an achievement was his popularisation of the forgotten London poet William Blake. His connection to Italy was, he felt, familial, instinctive and imaginative, transmitted in the blood.

Perhaps the greater freedom of movement given to men also allowed for this cavalier attitude. He could come and go as he pleased, unaccompanied and unchaperoned on as many adventures as he chose. Christina, by contrast, was restricted by the social customs of the day. While other, less conservative women of her acquaintance like Barbara Bodichon and Bessie Rayner Parkes roved around the Continent unchaperoned by male relative or maiden aunt, they were the exception rather than the rule, and their liberty also rested upon independent wealth. She had only been abroad once before when William took her and Frances on an 1861 tour of Paris and Normandy during his holiday from Somerset House. So it was that Christina was in her thirties before she had the chance to visit Italy. She had awoken to inauspicious thunder and lightning on the morning of her departure, but the spring weather had cleared up by the time the Rossetti party boarded their boat to Calais en route to Paris.

It must have been disorienting to suddenly find themselves among the crush at the 1865 Paris Salon, where Manet's scandalous *Olympia*, a bold, modern picture of a nude reclining prostitute, was that year's talking-point. What Christina, who was familiar with the less glamorous realities of prostitution, thought of the picture is unrecorded, but she probably shared William's opinion that it was 'an extreme absurdity'. A sudden downpour had made the ground floor corridors slick with rainwater during her visit and must have made Frances worry for her daughter's health. William was, however, in ecstasy, and went back alone to the Salon the next day. He was accustomed to traveling with other energetic young gentlemen like his brother and William Bell Scott, and does not appear to have adjusted his itinerary to account for his aging mother and delicate sister. Christina did not share her brother's unflagging enthusiasm for urban sights

and sounds, preferring 'nature treasures' to 'art treasures'. William too had his frustrations. For instance, Christina, who had not been to a play since she was eighteeen, flatly refused to accompany him to the potentially immoral *Théatre Francais*.

This Rossetti family breakaway party must have made an odd trio as the sober, bearded bachelor and his unfashionably dressed spinster sister and widowed mother made their stately progress through the recommended galleries and churches. They stayed for a week in Paris before heading on to Italy via Switzerland. Christina started to perk up as they crossed the Alps into Italy. She had been longing for a break from urban sight-seeing and William's tireless itinerary. Here was the picturesque splendour the Romantic poets like Wordsworth had promised her. Small goats and black and white sheep dotted the landscape, while pink Alpine roses and blue forget-me-nots bloomed prettily along the Gotthard Pass. Simultaneously awed, excited and saddened, she welcomed the sublime mix of emotions that the Romantics had taught her to expect. They spent the first night in Bellinzona, the capital of Ticino, where the Italian language was music to Christina's ears.

William had his eye on other native attractions. The women on 'the Italian side of the mountains', William felt, were suddenly more beautiful than those on the German-speaking side. It was here that he felt the burden of his bachelorhood. Longingly, he watched a group of young women at twilight singing as they stripped vine branches. At the Airolo Hotel, his appreciative gaze followed 'a very pretty, indeed beautiful girl…' But he could hardly do anything about it in the presence of his mother and sister.[24]

Even so, Italy proved enchanting for William and Christina. The next evening, they took a boat ride together on Lake Como. William, probably missing the male company he was used to at home, passed the time chatting companionably with their handsome Italian boatman. As they glided past the castle, towers and picturesque ruins that dotted the lake's shores, they thrilled to hear a nightingale singing from the wooded hills, like an emissary from the Romantic poets they so loved. It was, for Christina, a perfect moment. She remembered it years afterwards in her poem, 'Later Life':

So chanced it once at Como on the Lake:
But all things, then, waxed musical; each star
Sang on its course, each breeze sang on its car,
All harmonies sang to senses wide awake.
All things in tune, myself not out of tune…

Christina, who often felt awkward, shy and out of place, was
accustomed to anticipating fulfilment in heaven, not experiencing it
on earth. She came close to feeling at home in Italy, though it is
important to note that she does not push things so far as to suggest
that she is completely 'in tune' with the land of her father's birth. She
will only admit, with characteristic distance and reserve, that she is
'*not out of tune*'.

Did Frances Rossetti also hear the nightingale's song that night?
She had elected to skip the boat ride and stay behind in their lakeside
hotel, though in general, her energy during the trip often outstripped
her youngest daughter's. The Polidori longevity meant that the sixty-
five year old was, by all accounts, a good-looking, healthy woman
who impressed people with her 'handsome full-coloured face and
rich-toned voice of sincere and touching intonations.'[25] What were
her thoughts as she readied herself for bed? Her feelings must have
been mixed as she descended the Gotthard Pass earlier that day,
entering the land of her husband's birth without him, and without
his oldest son. She may have thought about her husband's illigitimate
first son, dead in infancy, and his mother Donna Peppina, presuming
she knew of their existence in the first place. She must have imagined
her husband on this trip, the delight he would have taken in showing
off his children to a united Italy, and Italy to his children. He had
died in exile, his dream of return unrealised. She would also have
remembered her brother John, and his lonely trek across the Alps
after being dismissed as Byron's physician. Frances would certainly
have contemplated her own Italian roots, and the long journey her
father had taken from Tuscany to England.

Given that their father was from the South, it is strange the
Rossettis restricted themselves to Northern Italy. Perhaps it would
have been too painful for Frances to visit her husband's birthplace,
or possibly the socially evasive Rossetti women were avoiding the

patriarch's surviving relatives along with the punishing Southern summer. 'I am glad of my Italian blood', Christina wrote, but the Rossettis' Romantic pride in their Italian roots seems to have been reserved for landscapes, galleries and art works rather than people.[26] Nor did they visit the Polidori cousins in Florence, whom Charlotte had seen during her 1861 trip to the city. They may also have avoided Florence out of fear of a Rossetti family ghost, the city's native son, Dante Alighieri, whose sixth centenary the city had celebrated shortly before the family began their trip. The Dante studies which had been the cause of their father's ruin were a painful memory to be avoided. Even so, they were secretly pleased when their guide in Brescia recognised their surname and revealed that he had known Gabriele in London.

William came across as the most 'Italian' of the group. Passport officials in Verona suspected he was a Venetian immigrant until he assured them he was '*nativo Inglese, figlio d'un Napoletano*' [native English, son of a Neapolitan]. He thought his sister had the strongest native feeling for Italy. 'Had she henceforth lived in Italy…she would, I believe, have been a much happier woman than she was.'[27] This is a puzzling statement, as Christina often reiterated her pride at being at Englishwoman and a Londoner. Few if any of her acquaintances were Italian, and though she wrote some (unpublished) poems in her father and maternal grandfather's native language, the vast majority of her work was written in English because, as she explained to a correspondent, 'I think in English.'[28] Less than a week after her return to England, she wrote 'Enrica' in admiration of an Italian woman whose full-blown Southern warmth, 'natural grace' and instinctive courtesy make Englishwomen's 'trim, correct' behaviour appear 'cold' and unnatural by contrast. Yet Christina's final stanza is a staunch a defense of Englishness in general:

> But if she found us like our sea
> Of aspect colourless and chill,
> Rock-girt; like it she found us still
> Deep at our deepest, strong and free.

While she enjoyed her trip to Italy, it was the only one she would

ever take. It was William who would return, again and again, for the rest of his life. Italy provided William with a rare, liberating chance to differentiate himself from his brother, whose indomitable will usually meant that he controlled the holiday itinerary. As the official guide and protector of his amenable and inexperienced mother and sister, William was free to indulge his insatiable appetite for politics as well as for museums and galleries. Every hotel owner seemed to want to claim that Garibaldi had stayed in his establishment while many guides, boatmen and concierges were ex-soldiers eager to tell their stories to William. Without his charming brother along to effortlessly upstage his social efforts, William was able to take a cautious step into the limelight of others' attentions. Politics would remain the one area in which William could outshine his brother.

As a younger son who had been arbitrarily denied opportunites freely given his tearaway brother and sickly sister, it is hardly surprising that William harboured insurrectionist sympathies. Unlike the rest of his family who were sympathetic but not effusive about Italian unification, William had always been a passionate supporter of Continental revolutionary movements. He had originally cultivated his revolutionary passion as a way of relating to an abstracted father obsessed with the old country. While Gabriel openly rebelled against their father's myopia, William ploddingly tried to win his approval by conscientious study. He undertook his trip to Italy under the imaginary paternal gaze Gabriel always worked so hard to avoid.

Though Christina tired of William's professorly cultural outings, sometimes pleading sore feet and exhaustion to avoid them, she was still more pliable than Gabriel would have been, and more understanding of her brother's need to enjoy himself during his escape from Somerset House. William interpreted her support and their good times as evidence that Christina would have been happier living in Italy, when in reality he was the person whose politics, interests and passions were more in line with Continental values. His financial responsibilities to his mother and sisters limited his prospects, just as they had ever since he was fifteen. The unassertive youngest brother, constitutionally unable to express his yearning for freedom from the family, found it easier to ascribe his fantasies of another life to his sister. He was amazed when she closed off one clear escape route by

refusing Charles Cayley's offer of marriage in the summer of 1866. 'She would have been far happier, and might have become rather broader in mental outlook, and no one would have been any the worse for it,' he argued, and not without reason.[29]

Left behind to look after William while Frances and Maria went on holiday in Eastbourne, Christina had confessed herself listless and bored that summer. She complained of 'stagnation' telling Amelia Heimann that she had a tendency to 'yawn not occasionally in spirit,' while conducting 'some bland intercourse with my kind.'[30] Yet when the opportunity came to change her life in diminutive form of Charles Cayley (who had timed his proposal to coincide with her mother and sister's absence), she did not take it. As with her rejection of Collinson fifteen years before, Christina apparently cited religious incompatibility as a bar to their union. William was astonished when Christina turned Cayley down. While he admitted that Cayley was not many women's romantic ideal, he had been under the impression that the man's other virtues had won her heart. The fact that Christina was now an ineligible thirty-five years old and could not realistically expect another marriage proposal might have mitigated in Cayley's favour. Concluding that money was the real problem, William offered to let the cash-poor Cayley move into the Rossettis' house, effectively taking him on as another dependent. Christina refused her brother's help. 'As to money I might be selfish enough to wish that were the only bar, but you see from my point of view it is not,' she wrote, though she named no other obstacles.

According to William, she had interrogated Cayley's religious beliefs, and found them somehow wanting. William's assertion that she loved Cayley is supported by her unpublished Italian poems '*Il Rosseggiar dell'Oriente*, [*Reddening of the East*], which she wrote in response to Cayley's published sequence of poems entitled *The Purple of the West*. This 'Reddening' suggests not only the heat of passion, but also the embarrassment of blushing cheeks. At 35, Christina wasn't sure she was ready to receive love again after so long a hiatus, or whether it was unseemly of her to accept it. She had been raised with her mother's Romantic notions of what love was like, and to which the experience of her only other model, her brother Gabriel, had conformed entirely. Could love come twice in one lifetime, and

to one who, like Jane Austen's older spinsterish heroine Anne Eliot in *Persuasion*, had perhaps lost her bloom? Characteristically, Christina plays her cards close to her chest. Each poem is delicately poised between disclosure and self-protection. Like 'Winter: My Secret', they tease with possibilities. The first, 'Amor Dormente' ('Love Sleeps'), is a farewell poem which tells a 'Beloved lover' that 'To me is forbidden the love / That has already killed my heart'. The second, 'Amor Si sveglia?' ('Love Awakens?') coyly discusses the possibility of a newly-awakened love, but assures the lover repeatedly, 'Still I would not say it'. The last few poems look forward to a reunion in heaven rather than union on earth, while the final poem decides, 'I will resign myself.../ waiting for 'Vast heaven beyond brief hell – / Beyond the winter, spring.'

Christina's letter to William seems to suggest that she did not return Cayley's feelings, or perhaps that she had changed her mind, as she writes about being 'loved beyond my deserts', deciding to see less of Cayley because it might add 'to his hamper and discomfort.' She added that 'if he *likes* to see me, God knows I like to see him'.[31] Perhaps a marriage of convenience between friends, which is how it would appear to others, had thrown her independent spinster-hood into relief, revealing its freedoms as well as its restrictions. Like Gabriel, Christina was self-confessedly work-shy, and avoided life's laborious and unrewarding chores. She was already bored with looking after the household and William's needs. She confessed that she found 'very easy household tasks a burden' and struggled to keep up 'a courteous aspect towards my dear brother', though she did 'fidget and grumble in the privacy of my own breast.'[32] Marriage to Cayley, and his presence in her brother's house, would have given her two men's lives to organise. With her tiresome chores doubled, she would struggle to find time for her own writing, and this problem would be compounded by Cayley's career as a translator, which would have taken priority over her own. As an Italian speaker and poet herself, Christina would have been expected to become her husband's perma-nent, unpaid amanuensis, even though she was the more successful writer of the pair. She was no longer the naïve girl she was at 17, when she had fallen hard for Collinson, and was perhaps taking other, more adult concerns into account in her decision to remain independent.

Christina was as reticent in person as she was courageous in verse, and marriage might simply have seemed a bridge too far, bringing with it not only more domestic work, but the dread of additional social obligations. If she and Cayley remained friends, things would go on as they were, with the couple being free to come and go in each other's lives, leaving Christina free to pursue writing and religious life. And in fact, this is just what happened, with the bachelor Cayley remaining a very close friend all her life.

While William had little patience for the religious convictions he felt kept Christina from 'broadening her outlook', he was more than willing to accompany Gabriel on supernatural adventures. True to Romantic fashion, Gabriel's relationship with Lizzie extended beyond the grave. The spectre of Lizzie continued to haunt both Rossetti brothers, quite literally. The Spiritualist craze sweeping London saw the pair participating enthusiastically in seances and other occult activities such as spirit-rapping, mesmerism, table-turning and ouija board readings. Though William worried about his brother's tendency 'to think that some secret might yet be wrested from the grave', he did little to discourage Gabriel's attempts to contact his wife, and in fact participated in them.[33] Perhaps it wasn't his wife's secret Gabriel was after, but her permission. Under the same garden marquee which hosted various seancés, he collaborated with photographer John R. Parsons on a series of glamorous photographs of Mrs. Jane Morris. These images of Morris's wife draped across a divan or leaning across a chair back may or may not have revealed the beginnings of their mutual attraction, but at the very least they announced the presence of a striking new muse. Was Gabriel trying to contact Lizzie's spirit as a way of securing his old muse's blessing? If so, as later events prove, the ghostly Lizzie was not about to cooperate in her own overthrow.

Though a religious skeptic, William was able to suspend his disbelief in dealing with figures such as Mrs. Marshall, the 'washerwoman medium' of 7 Bristol Gardens, whose tools of the trade were a large table, a ten year-old girl and a pencil and paper for recording responses from beyond. Professionals were not always required. Amateur seances were often organised as semi-social events at Tudor House and in the homes of friends. Lizzie communicated with both brothers during various table-rapping sessions, though her answers

to their questions were often as general and vague as modern newspaper horoscopes. Specifics were avoided. She refused to be drawn, for example, on the question of Christina's future health. Even the Rossettis' uncle John Polidori was reputed to have made an appearance one evening. When William asked his uncle if he was happy, Polidori rapped out 'Not exactly'.

Christina was predictably acerbic about these spooky visitations. It was irritating to see the agnostic William, who haughtily renounced the 'supernatural mythology' of Christianity, embracing spirit cabinets and ouija boards. When Gabriel enthused about an evening he and William spent watching superstar American conjurers The Davenport Brothers escaping from elaborate rope bindings with supernatural help, their sister remained skeptical, identifying 'simple imposture'.[34] Christina was not the only sceptic where the Davenport Brothers were concerned; P. T. Barnum took delight in exposing their techniques a year later in his book, *The Humbugs of the World*. Whether or not these dealings with the dead were bogus, their effect on the superstitious Gabriel was real enough. These domestic experiments with the occult blurred the boundaries between parlour entertainment and something more sinister. Bell Scott, who once broke up a Tudor House séance by demanding that the medium's feet should be visible at all times, felt these sessions fed into 'a confusion between external realities and mental impressions' which was dangerous for an imaginative man like Gabriel.[35]

The messy realities of real death interested Gabriel less than ghostly afterlives. When his aunt Margaret died at in February 1867, he told Frances that he was too busy working on a picture to attend her Highgate funeral. Maria, by contrast, cancelled her teaching commitments until further notice while the Rossetti women and remaining Polidori aunts grieved Margaret's loss. Not long afterwards, they moved from Albany Street to Euston Square, perhaps hoping for a fresh start. The Polidori brothers did not have to be taken into account; Philip had died in 1864 of a rapidly-advancing illness, while Henry lived in Gloucester.

It was in the late 1860s that the real trouble started, heralded by the return of Dante Alighieri's ghost. Summoned by devoted Spiritualist Seymour Kirkup, Dante had let it be known that Gabriele Rossetti

had been correct to challenge the existence of a literal Beatrice. When asked if Beatrice had been a real Florentine lady, Dante's spirit replied uniequivocally, '*Era un' idea della mia testa*' [she was an idea in my head]'.[36] Kirkup assured William that the visitation had not been trickery; after all, Dante Alighieri was appearing to him at least three times a week, though he had to sometimes fight for elbow room as the ghostly crowd in Kirkup's Florentine home occasionally swelled to fifty. Sometimes the kindly medieval poet left gifts like a lamb and a puppy.

Strange offerings from the animal kingdom were also turning up at Gabriel's house, although these were acquired by commercial, rather than supernatural means. Joining in the general Victorian enthusiasm for animal collecting, Gabriel regularly patronised Jamrachs, an exotic animal dealer's East End establishment. The German immigrant Charles Jamrach was famous for supplying PT Barnum's circus and for re-capturing one of his own runaway tigers before it had the chance to savage locals on the Ratcliffe Road. These days, the RSPCA would have been called to confiscate Gabriel's sloppily assembled zoo, but animal collecting in the nineteenth century was largely unregulated. For instance, Jamrach offered Gabriel an elephant for £400 pounds, though the animal was hardly suited for an English back garden.

Things at Tudor House were taking a decidedly Gothic turn. Animals in Gabriel's menagerie were turning sinister, like something out of his sister's *Goblin Market*. The raven bit the head off the barn owl; the deerhound ripped up a servant's dog; cats ate the rabbit; the dormice ate the throat out of one of their own; the hedghog ate the pigeon. Other deaths followed. A phobic servant killed the lizard; two parakeets and a tortoise starved to death; a pigeon became paralysed; a New Zealand owl drowned in a tub of water. When the hedghog turned up dead, Gabriel suspected foul play by the servants.

Similar accidents did not befall Gabriel's fine china collection; it was living creatures that had trouble surviving at Cheyne Walk. They required a proper environment and consistent care and attention, things Gabriel was not temperamentally suited to provide. The thrill of acquiring new animals for his collection outlasted his interest in them, which suggests uncomfortable parallels with the women in his

life. As a boy, when Gabriel discovered that captured frogs had died in his hands, he simply re-released their dried-out corpses into the pond. In adulthood, Gabriel abdicated responsibility for his animals' deaths in the same spirit, though the difference now was that he no longer thought they might come back to life.

As was their habit, the family rallied round to shield Gabriel from the truth. William re-enacted his boyhood role as a by-stander to Gabriel's neglect, merely recording each animal's grisly demise in his diary without judgment and without intervening himself in their care. 'There is no accounting for the death of animals, one day so well, and the next gone,' Frances wrote airily to Gabriel following the untimely demise of yet another owl.[37] This maternal rationalisation illustrates Frances's unconscious favouritism. Despite her own love for animals, obvious from the chronicles of the Rossetti family's beloved cats and kittens, she went along with the pleasant fiction that the death-rate in Gabriel's menagerie was unaccountable. Gabriel's latest assistant, Henry Treffry Dunn, was more clear-eyed, noting that his employer 'had not any great love for animals', and described his interest as 'a passion he had for collecting, just as he did books, pictures and china...' Gabriel kept a raccoon in a packing case covered with a slab of Sicilian marble. During Dunn's first visit to Tudor House, the artist hauled the raccoon out by the scruff of the neck, holding it aloft as it hissed and kicked. 'Does not it look like the devil?' Gabriel asked admiringly.[38]

The dark menagerie in Gabriel's garden was also a distraction from what was not there: children. Now in her sixties, Frances had just started to worry about Rossetti heirs. While she did not bring this up directly with her son, her letters let us know that grandchildren were on her mind. She tiptoed around the issue with Gabriel, who was likely to chafe under perceived criticism. 'I hardly know with what eye you would regard the many children who play and swing in the garden here,' she wrote him during her holiday in Brighton. 'I fear that...you would cast a withering look at them, especially on hearing their not infrequent cries.'[39] Gabriel was in no mood to reassure her. 'I loathe and despise family life!' he told Allingham.[40]

In an era which enshrined the family, this was a daring stance to adapt. Gabriel's vehemence had several motives, beyond pressure to

continue the Rossetti family line. He was, during this period, visibly more worried about contributing to the Rossetti family literary legacy than to the biological one. This should have come as no surprise to Frances, as she had always stressed achievement and ambition over ordinary accomplishments. Gabriel regarded poetry as a higher form of art than painting, and was starting to regret giving it up in youth to pursue a more commericially viable fine arts career. Now that he had achieved some financial security, his attention was returning to poetry. This was also motivated by a sense of competition with his siblings. Though his Italian translations were respected, Christina was indisputably the Rossetti sibling most famous for original poetry. Aside from having two volumes out, she was regularly published in illustrated magazines and annuals. An article in the *Saturday Review* had named Christina, along with Emily Bronte and Elizabeth Barrett Browning, as one of the three 'real' poetesses of England. It was rumored that Gladstone, the Prime Minister could recite her poem 'Maiden Song' from memory. On the 18 of February, 1869, the Rossetti family attended a concert at St. James's Hall, Piccadilly, which featured Christina's 'Songs in a Cornfield' set to music by Sir George A Macfarren and sung as a cantata for female voices. Rossetti family pride was on display that evening; Christina had taken special pains to make sure her name was printed correctly in the programme. The poem's melancholy was typical of Christina, featuring maidens singing sadly of false love, abandonment and death, and William predicted that the piece would not be a popular success because 'the poem and its music continue progressing in cheerlessness to the close'.[41] Gabriel, no stranger to melancholy himself, was clearly impressed. A fortnight later, spurred on by competition with his younger sister, he sent Frances some sonnets 'which are such a lively band of bogies thay they may join with the skeletons of Christina's various closets, and entertain you by a ballet.'[42] Maternal approval was still of great importance to the Rossetti siblings.

Even William's poetry was appearing in print; his 1849 narrative poem, 'Mrs. Holmes Grey' was published in the *The Broadway Annual* in February 1868. While it received only one lukewarm review, friends were supportive. George Meredith had tried to convince William to publish it before. Swinburne was rapturous in his praise, which may

have been motivated as much by his gratitude for William's vigorous defence in print of his own scandalous work, *Poems and Ballads, 1866*.

What William lacked in artistic talent he made up for with a keen critical eye that could identify originality in others. Swinburne's poems, whose subjects included sado-masochism, atheism and necrophilia, had been so lambasted by outraged critics that the original publisher had withdrawn them from circulation. In Swinburne's work, which was partially inspired by Baudelaire's ideas about 'art for art's sake', William saw a new direction for English poetry, and published a pamphlet arguing that 'It is not the direct function of a poem or other work of art to improve the morals of the reader...' Never one to miss an opportunity to promote his family, William was sure to mention Gabriel and Christina's influence on Swinburne. His cursory mention of 'the few original poems of D.G. Rossetti which have been published' paled in comparison to his praise of Christina, who possessed 'an internal sense of fitness, a mental touch as delicate as the fingertips of the blind.' According to William, there was 'no poet with a more marked instinct for fusing the thought into the image, and the image into the thought...'

Gabriel's self-consciousness about being largely unpublished as an original poet was compounded by his brother's praise of another competitior, William Morris, whose 1858 poems, *The Defence of Guenevere*, had been dedicated to 'My Friend / Dante Gabriel Rossetti / Painter'. Once, Morris had been Gabriel's acolyte, but now he was an accomplished designer and poet, winning praise from Gabriel's kid brother for poems 'as rich as a painted window flooded with afternoon sun, and as dreamily sonorous as the choral chant from the further end of the cathedral.'[43] Fast approaching forty, and surpassed by his disciples and his little sister, Gabriel was under pressure to publish some original poetry soon, before he was out of the running altogether.

Romantic disillusion was another motivating factor in Gabriel's distaste for ordinary family life. By this point, his was not the only Pre-Raphaelite marriage which had failed to live up to expectations. Edward Burne-Jones was involved in a messy affair with a red-headed Anglo-Greek model Mary Zambaco. The Morrisses were also in trouble. Financial difficulties had forced them to give up the Red

House and move back to London, where Morris could keep a close watch on Firm business, a tall order considering his broken heart. Jane Morris had, for reasons unknown, brought an end to their sexual relationship. Later she would claim that she had never loved him. Although this circle prided itself on unconventionality, its bohemian-ism did not extend to divorce. Aside from the practical difficulties arising from tricky Victorian divorce laws, there would have been the larger defeat of officially admitting that the second Pre-Raphaelite Round Table was dissolving. Once, the Morrises had planned on moving the Burne-Jones's into the Red House to live in communal splendour. Now it looked as if they were all going their separate ways. As was the Rossetti habit, Gabriel looked to literature to help him come up with a radical solution. If the Pre-Raphaelite knights were going to scatter, they would do it in style, and in a manner befitting the medieval revival. Taking his cue from chivalric legend, Gabriel fell in love with Jane (now in her late twenties), and the two became a kind of Launcelot and Guenevere to Morris's King Arthur. Techni-cally, chivalric convention forbids sexual consummation, but it seems unlikely that two sexually mature adults like Gabriel and Jane took this concept that literally.

Nostalgia played a part here; being with Jane recalled the younger, carefree days in Oxford when they met. Gabriel realised that for too long, he had devoted himself to producing pot-boilers and replicas for 'filthy lucre's sake', and he now devoted himself to recapturing the artistic excitement which had driven his early career.[44] Other muses were considered for the role of Gabriel's new Beatrice. Aspiring actress Alexa Wilding, discovered walking on the Strand, initially seemed a good candidate. She was auburn-haired and so voluptuous she was 'almost a *giantess*', who modeled for *Venus Verticordia*, *Monna Vanna*, *Lady Lilith* (1866), *The Loving Cup* (1867), among many others.[45] She would be the famous face of his *The Blessed Damozel* (1878), leaning on the golden bar of heaven with lillies in her hand and stars in her hair, as described in Gabriel's poem of the same name. She even appeared in a reworking of *Regina Cordium*, but she was not destined to be the queen of the artist's heart. As much as he appreciated stunning physical beauty, Gabriel longed for a deep emotional connection of the kind more readily available in a woman he already knew. For

sexual compatability, he had Fanny Cornforth, but she wouldn't do as his Beatrice. The frank intimacy which characterised their relationship got in the way of the process of romantic idealisation which inspired Gabriel. Rossetti family snobbery may also have played a part. Marriage to Morris meant that the low-born Jane had successfully transitioned to the middle class, and was thus a more suitable subject for legendary love than the ex-prostitute who made Gabriel laugh with her Cockney accent and malapropisms. He craved ideal, rather than real intimacy.

Reviving his shared history with Jane Morris inspired him anew, acting as an antidote to the disillusionment of middle age. He began painting and drawing Jane obsessively, in a manner reminiscent of his early infatuation with Lizzie Siddal. The literary subjects she posed for made reference to unhappy marriage and infidelity. She appeared as Dante's *La Pia* (1868), a woman falsely accused of adultery and murdered, and as Malory's *Yseult* (1867), who falls in love with the knight escorting her to marry his king. A darker motive influencing his pursuit of Jane might have been envy of Morris's growing reputation as a poet. The Latin inscription on Gabriel's 1868 portrait, 'Mrs. William Morris', amounts to a breathtakingly proprietorial announcement: 'Famous for her husband, a poet, and most famous for her face; so let this picture of mine add to her fame.' As he had hoped, his new muse was also inspiring him to write poetry again. The conclusion of 'A Portrait', the sonnet related to this picture, claims Jane Morris even more explicitly: '…Let all men note / That in all years (O Love, thy gift is this!) / They that would look on her must come to me.'

Although the couple gestured at discretion by using Gabriel's agent Charles Augustus Howell as their go-between, Gabriel's personality made their affair obvious to everyone, and just how far it had gone was a topic of much speculation among their friends. Even the married Bell Scott, who had a mistress himself, was taken aback by Gabriel's behaviour towards Jane during a dinner party. 'I must say he acts like a perfect fool if he wants to conceal his attachment, doing nothing but attend to her, sitting side-ways towards her, [and] that sort of thing,' he wrote. He also noticed that Morris was keeping a wary eye on Gabriel 'all the time…'[46]

William, whose unswerving devotion to his brother was truly

chivalric, knew better than to try to stop him. Publicly, he would characterise the affair as merely artistic. Jane's 'astonishing' face was 'created to fire his imagination, and to quicken his powers…'[47] Indeed, her huge, luminous eyes, pale skin, full lips, large nose and prominent jaw do have an arresting effect. With her dark, wavy hair and long, sculptural eyebrows which threatened to meet in the middle, she had the kind of looks which, as the photographs show us, distinguished her appeal as decidely unconventional. As had been the case with Lizzie Siddal, her unusual looks were not universally admired. In Ruskin's opinion, Gabriel's use of Jane as model for the Virgin Mary yielded 'a Madonna with black hair in ringlets like a George II wig and a black complexion like a mulatto.'[48] Despite his artistic eye, physical appearance was not everything to Gabriel. Intellect was important to him as well; his mother's early warnings against 'brainless' women governed his romantic tastes. Later he would criticise a friend for marrying a younger woman with 'lots of golden hair but no brains under it'.[49]

Although William keeps our attention strictly above-the-neck, Gabriel's paintings do not shy away from Jane's body. In an era whose female ideal was small, plump and hourglass-shaped, Gabriel delighted in the frequently uncorseted Jane. He emphasised her unfashionably tall height whenever he got the chance, as in *La Pia*, where she is practically doubled over just to fit into the picture space, her impossibly long, muscular neck bent to keep her head from brushing the frame. Jeanette Marshall, the daughter of Gabriel's doctor, would find *Proserpina*, 'a glorified portrait of Mrs. Morris', wanting in this respect: '…her figure is not nice; so long-waisted!'[50]

Gabriel's obsession with Jane Morris replaced his passion for collecting china, which all but ended in this period. William was concerned when Gabriel began to suffer from insomnia, brought on, he thought, by 'painful thoughts…connected with his wife and her death.'[51] His hypochondria during this period echoed their father's, as he began to claim he was losing his eyesight. Several doctors confirmed that this was not the case, but Gabriel was convinced he was going blind. To his brother's embarrassment, he started wearing one pair of glasses over another, even in company. He seems to have borne his genuine complaint, recurring hydrocele (a fluid-filled pocket that appears near the testicles), with more stoicism, returning to his easel

mintues after undergoing minor surgery. Despite the apparently psychological nature of his failing eyesight, the family never challenged Gabriel's perspective. Frances was indulgent as always, obligingly writing letters to her eldest son in large print. 'Be sure nobody loves you more than does your mother,' she wrote urgently.[52] William took his brother's condition very seriously, writing to Bell Scott that Gabriel would drink prussic acid rather than face life as a blind man. Even the spectre of suicide could not induce William to challenge his older brother: 'I could not and never do dissuade him, for I quite agree in the point of view.'[53]

Friends noticed that Gabriel was becoming excitable and moody. His recent poetic productivity had convinced him that it was time to bring out a volume of original poetry, but there was one sticking point; he had buried many of his best poems along with his wife. Howell had apparently come up with the grisly solution of digging up Lizzie's grave to retrieve the manuscript poems from her coffin, and by August 1869, Gabriel had reconciled himself to this idea, instructing Howell to proceed. After instructing Howell that strict secrecy was to be observed, Gabriel went to visit Scott at Penkill, where he felt uneasy and unwell, and slept badly. He began drinking heavily, leaving enough empty whisky tumblers in his room to cause comment. Scott claimed that Gabriel was morose and suicidal, one day contemplating throwing himself off a high precipice to his death. When a wild chaffinch perched on his finger, Gabriel was convinced that the bird was his wife's spirit, bearing ominous tidings.

The secrecy of the proceedings added to his burden. Naturally, he kept his plans from his mother and sisters, but in this rare instance, he also chose not to tell William, though there were hints. In an effort to ward off possible administrative confusion over which family corpse was to be exhumed, he asked William to remind him when Margaret Polidori died and the location of her grave, casually burying the request in a 'P.S.' and charging William to find out this information without asking their mother. It is a sad postcript in another way, revealing that Gabriel had never visited his aunt's grave at Highgate. Later he asked Howell to find out if anybody had been buried in the Rossetti family tomb since Lizzie's death, which suggests he was not a frequent visitor of his wife's grave either.

When he returned to Cheyne Walk, Gabriel tried to comfort himself with the purchase of a wombat, an awkward, plump Australian marsupial long regarded as a jokey Pre-Raphaelite mascot. Passive-aggressively, he named the shuffling creature 'Top', his nickname for William Morris, and composed a welcome poem:

Oh! How the family affections combat
Within this heart; and each hour flings a bomb at
My burning soul; neither from owl nor from bat
Can peace be gained, until I clasp my Wombat!

While wombats are closely associated with the second generation Pre-Raphaelites, who had incorporated little wombats into the Oxford Union frescoes, wombat worship originated in the Rossetti family. Christina and William had first been taken with the creatures when they spotted them at the Zoological Gardens. One of the merchant men had 'like a wombat prowled obtuse and furry' through Christina's 'Goblin Market'. When Gabriel reported that his wombat was 'A Joy a Triumph a Delight a Madness', Christina sent Gabriel her own tribute in Italian, deciding 'Uommibatto' was a convincing Italian word for the animal.[54]

No amount of cutesy pet cuddling could disguise the fact that something was amiss, although none of the siblings could put their finger on it. William noticed that though he looked well, Gabriel was complaining of insomnia and heavy sweating and was taking quinine. He was also being disagreeable. On a visit to Euston Square, he read his new poem, 'Eden Bower', an erotic work whose subject was Adam's sexy, apocryphal wife Lilith. Maria fled the room at the first line, while Christina excused herself after the first few stanzas praising '…Lilith the wife of Adam… / Not a drop of her blood was human, / But she was made like a soft sweet woman.' History is silent on whether Frances was present at this reading, but even she would have struggled to support her son's choice of reading material for the Christian family hearth. Ever-worshipful, William was enraptured. Gabriel gleefully reported driving his sisters from the room to Bell Scott, adding that the poem was his best yet. He must have known how much the poem would offend his sisters, not only as Christians,

but as women. This act, couched as a joke on his overscrupulous old-maid sisters, had an undercurrent of hostility.

This aggression masked a guilty conscience. A fortnight later, William received an extraordinary letter from Gabriel, explaining that Lizzie's grave had been dug up and the manuscript poems retrieved. Howell, lawyer Henry Vertue Tebbs, two workmen and medical witness Dr. Williams had been present, though Gabriel had elected to stay away, waiting at Howell's home while the deed was done. He was now awaiting the poems, which were being disinfected by Dr. Williams, after being found to be foul-smelling and 'soaked through and through'. A worm had burrowed through the text of 'Jenny'. This grisly episode has often been characterised as a violation of Lizzie Siddal, but just as important here was Gabriel's betrayal of his brother. Gabriel was well aware that from William's perspective, more shocking than the disinterment itself was his act of concealing it. What would this mean for the future of their relationship? 'I trust you will not…think that I showed any want of confidence in not breaking this painful matter to you before its issue', Gabriel wrote, adding insensitively that he didn't know anyone so well-suited to helping him as Howell, a notion that offended William. Howell, who sometimes sported a red sash to back up his dubious claims that he was a Portuguese aristocrat, was well-known for advanced wheeling and dealing, but not for discretion or trustworthiness. Universally described as a gossip and a fantasist, he nevertheless was so charming, entertaining, and such an excellent salesman that few clients or friends ever had the heart to banish him from their drawing rooms. He regularly reduced Gabriel to tears of laughter with his absurd stories and grandiose exaggerations, which Gabriel sent up in a limerick:

There's a Portuguese person named Howell
Who lays-on his lies with a trowel:
Should he give-over lying,
'Twill be when he's dying,
For living is lying with Howell.

William was hurt that Gabriel had chosen to confide in such a character while leaving his younger brother in the dark. Even after the

disinterment, he did not trust William with his secret, first discussing the matter with his assistant, Jane Morris and Scott. To his brother, he confessed his relief that the Home Secretary had waived the legal requirement of informing Frances Rossetti of the proceedings. Otherwise, he would have had to 'invent some pretext' for changing his 'wife's place of interment'. He was sure William would agree with him that it was best 'that our family should not know it.'[55]

Predictably, William offered his unconditional support. He rationalised that being deprived of the manuscript poems along with his wife meant that Gabriel had been doubly bereaved. Furthermore, retrieving them did not invalidate their original sacrifice.

> My frank opinion is that you have acted right on *both* occasions. Under the pressure of a great sorrow, you performed an act of self-sacrifice: it did you honour, but was clearly a work of supererogation. You have not retracted the self-sacrifice, for it has taken actual effect in your being bereaved of due poetic fame these 7 ½ years past: but you now think – and I quite agree with you – that there is no reason why the self-sacrifice should have no term.

He suppressed his hurt feelings, telling Gabriel he understood why he had been kept out of the loop, assuring him that 'you and I know each other of old, and shall continue to do so till (or perhaps after) one of us is a bogey.'[56] William's words reassured his brother, who was inspired to make various gestures of reconciliation, including the offer to let William help with the 'unpleasant' work of transcribing the poems, after which the original, foul-smelling pages would be burned. He also promised to dedicate the book to William, though even this was a backhanded compliment, as Gabriel really wanted to dedicate it to Jane, whom he euphemistically referred to as the 'one possibility which I suppose must be considered out of the question.'[57]

William may not have shown it, but he was wounded by this episode. His 1895 memoir laid the blame on 'friends' who had egged on a reluctant Gabriel. Though professing his reluctance to name names, William made sure to mention Howell, with whom he had been in competition for his brother's affections. Twenty five years later, he wrote, 'The subject, in all its bearings, is a painful one, and I shall not

dilate upon it.'[58] Despite William's reassurances, it was evident that a 'bogey' of sorts had been released from Lizzie's grave. Like the worm blindly gnawing a hole through Gabriel's poems, mistrust and a sense of betrayal started to eat away at the Rossetti brothers.

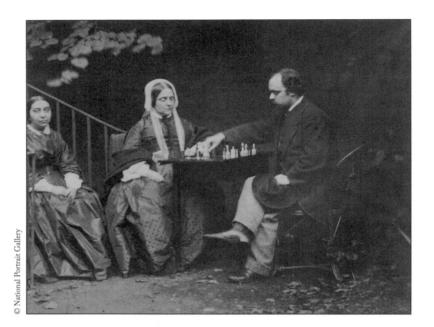

Maria, Frances and Dante Gabriel Rossetti photographed by Lewis Carroll in 1863

Scholarly and self-possessed, Maria was the most cheerful Rossetti sibling.

10

HALF-SICK OF SHADOWS: MARIA'S ESCAPE

While everyone's attention was on Gabriel, Maria had been quietly planning her escape from the Rossetti family. She continued uncomplainingly in her daily round of teaching, volunteering and looking after William's house, but at the age of forty-two, she was ready to devote herself to something more meaningful. When William magnanimously informed her that his newly-drafted will made her the beneficiary of the house in Euston Square, she surprised him by refusing the honour. She was getting married. Of course, no ordinary husband would do for the first Rossetti daughter; Maria was becoming a bride of Christ. She would wear a wedding dress when formally received as a Novice by the All Saints Sisterhood of the Poor. After the trial period of her novitiate, essentially a long engagement which would last up to two years, Maria planned to formally devote her life to Christ in a ceremony called 'Profession'. She would cut off her long dark hair (now laced with gray), don a veil and a crown of flowers with the words 'Be thou faithful unto death', and receive a ring and a new name, 'Sister Maria Francesca'. In resigning her surname, she would no longer be a Rossetti.[1]

This was the first time she had mentioned this intention to her brother, and although in some ways it was not unexpected, it still came as a shock. Joining an Anglican Convent in mid-century Victorian England was a drastic step. Anglican sisterhoods had only

THE ROSSETTIS IN WONDERLAND

been extant since 1845, and were regarded at best as a new-fangled religious fad and at worst a sinister conspiracy to corrupt English women. Reports abounded of the coercion and abuse of innocent girls imprisoned in Protestant Sisterhoods by clergy harbouring Roman Catholic sympathies. Women who joined early sisterhoods were characterised as young, naive 'stolen daughters', even though the women were in their late twenties and early thirties, and convent life was voluntary.[2] Sisterhoods were a threat to a major Victorian institution: the family. Involuntary spinsterhood was one thing, but celibacy as a career and lifestyle choice was another thing entirely. If women started rejecting their traditional roles as mothers, sisters and daughters, and instead became independent agents serving their own community, what would be the long-term implications for traditional family structures? Furthermore, there was an unsettling lack of male influence over these religious female communities, which had a woman at their helm, provokingly called a 'Mother Superior'. Sisterhoods provided unlikely common ground for both secular and religious female radicals. Gabriel's feminist friend Barbara Bodichon, last seen hitching up her skirts to wade across a stream unencumbered, wrote, 'Happier far is a Sister of Charity or Mercy than a young lady at home without a work or a lover.'[3]

Apparently, Maria Rossetti agreed. Her attempt to join her siblings as an author in her own right had fallen flat. Sales of her Italian primer were disappointing, and it seemed evident that she was not destined to challenge her siblings' literary and critical accomplishments. Excuses had been made for this literary failure. Christina said that had Maria been free of the duties of the eldest daughter, she 'would have become famous'. Maria had been forced, like William, into a position of premature responsibility when their father's fortunes failed. Christina had simply been too young to go out to work, and thus had been able to stay at home and develop her talents. Gabriel claimed that Maria was 'the Dante of our family' who 'might have topped us all', had she ever come into 'her proper inheritance.'[4] But even Gabriel had to admit that his older sister had never possessed Christina's native genius.

Having begun as the academically bright sister with the most promise, Maria had become the most obscure Rossetti sibling. No

one since Ruskin appeared to take much notice of Maria. While art-world habitués like the poet Robert Browning and photographer Julia Margaret Cameron were polite to Maria when they came to call, it was clear that they were courting the publicity-shy Christina. It must have been painfully obvious during social occasions such as the large party Frances held in October 1868, that important guests like the Morrises, the editor of *The Argosy*, and the American writer Sophia May Eckley were there to network with Christina and William. Maria invited a friend, a devout ex-pupil by the name of Mrs. Hunnybun, who probably had even less of a chance of captivating the crowd than Maria. While the other siblings flit colourfully through most important literary and artistic memoirs of the day, Maria is absent, and where we glimpse her, she is a silent, shadowy presence. American editor and journalist William Stillman's report that an 'ardent, beautiful religious spirit burned in her, mute' is typically vague.[5] Stillman, who was at this time introducing her brother Gabriel to the delights of chloral, was not a man to whom she would have revealed herself. Like her sister, Maria was socially reserved in mixed company, but her burning religious spirit was vocal rather than mute, at least among women. Her published lectures to her bible class reveal her as an assertive, confident teacher, and this publication, along with her Italian language exercise books, speaks to her desire to communicate with a wider audience beyond the confines of the schoolroom. Before she joined the convent, there would be one last attempt at literary success. She surprised William again by showing him a manuscript she was working on, *A Shadow of Dante*, meant to promote the Florentine poet to English readers. The Rossetti brothers had both made their contribution to Dante studies in English, and now Maria was staking her claim. The project would of course be a family affair, in some ways doubling as a farewell to her family life.

The first thing to resolve was which English translation of Dante's *Commedia* to use. With apologies to Charles Cayley, she chose William's translation of the *Inferno*. Showing that she possessed the family knack for networking, she wrote to the American poet Henry Wadsworth Longfellow to ask permission to use his recent translation of *Purgatorio* and *Paradiso*. This was not an obvious first choice, as Longfellow's 1867 blank verse approach had received mixed

reviews. Nor was he a family favourite. Longfellow had been an early American fan of Pre-Raphaelite painting after visiting the American exhibition in Boston in 1858, but this didn't recommend him to the Rossetti brothers. Gabriel referred to Longfellow's famous *Song of Hiawatha* as '*Wishiwasha*', while William couldn't understand why Ruskin was such an avid supporter of the poet, when it was clear that Walt Whitman was his superior. Longfellow was on the Rossetti family brain in this period. At the same time that Maria was working from his translation, William was introducing a selection of the American poet's work for a Moxon edition. The introduction was lukewarm, admitting that Longfellow was 'handsomely installed' as 'a literary artist in poetry', but that 'it would not be true to say that his art is of the intensest kind or most magical potency'.[6] In her later work on Dante, Christina would insist on using Cayley's translation instead of the better-known Longfellow version. The Rossettis' dismissiveness of America's most famous nineteenth century poet also smacks of literary competition. William's *Inferno* translation had come out in the same year as Longfellow's *Commedia*, inviting unfavourable comparison and sales. While immune to jealousy about other painters, Gabriel was not above being envious of successful poets like Longfellow, who was feted on his arrival in England in the summer 1868. He was received by Queen Victoria, photographed by Julia Margaret Cameron and awarded honourary degrees from Oxford and Cambridge. Longfellow's visit to Gabriel's studio turned awkward when it became clear that the venerable American poet was under the impression that Gabriel was the painter and William the poet of the family. But Gabriel's Queen put the American upstart in his place. When Longfellow told the Queen he was surprised at how famous he was in England, she replied: 'O, I assure you, Mr. Longfellow, you are very well known. All my servants read you.'[7]

Even if he couldn't tell one Rossetti brother from another, Longfellow was aware of the importance of the Rossetti family in Dante studies. He had used Gabriel's *Early Italian Poets* translations of Dante sonnets, and had cited Gabriele Rossetti's theories in the notes to his translation, even though he upheld the majority view about the Profesore's dubious scholarship. To Gabriele, Dante's poem had become 'only a colourless medium through which he saw the

allegory…rise in gigantic proportions: Like a morbid eye that in the human form beholds only a skeleton.'[8]

Maria quietly agreed with this assessment of her father, although her title paid an English tribute to his 1846 poem, *Il veggente in solitudine*, a section of which was entitled *L'ombra di Dante*. More of an academic than a poet, Maria was alive to the merits of blank verse translation, which included literality. As an Italian language teacher, she had promoted literal fidelity in her *Exercises in Idiomatic Italian*, but she also viewed literality as a way of eliminating confusion, at least for beginners. She decided to 'sacrifice' the rhymes of the *Commedia* to 'faithful literality', in order that new English readers of Dante would be better able to understand his thoughts and ideas.[9] She wanted her readers to appreciate his philosophy over his poetry. Furthermore, literal understanding curbed the kind of interpretative poetic license which had gotten her father in trouble. Literal translation was safer because *literary* translation risked blasphemy. Maria's main purpose was Christian and didactic, as she explained to Longfellow: 'It has long been a matter of surprise and regret to me that a book so truly elevating and ennobling as the *Commedia* should be confined in its use to decidedly literary people,' she wrote.[10] From a Rossetti family member, this statement borders on heresy. After all, Maria's father, the agnostic William and the non-practicing Gabriel would surely be counted among the 'literary people' whose claims on Dante she regretted. Although she dedicated the book to the memory of her father, she cheerfully disagreed with him by championing the real over the allegorical Beatrice in her book's third chapter.

Maria's use of literal translation also picked a fight with her sister, who had gone on record with her belief that literal translation of the *Commedia* was 'indefensible'. Translating Dante into prose or blank verse was to 'strip', 'chasten' and 'deform' his work, and was the poetic equivalent of 'substituting' a tiresome drum beat for the 'majestic swelling and sinking' of 'organ music'.[11] Christina wrote this two years after William's blank verse *Inferno* came out. What William thought of Christina's damning words is unrecorded, but Maria's use of her brother's verse translation showed where her loyalties lay. Christina and Maria were normally in agreement with each other, as were William and Gabriel. When it came to translating Dante,

the siblings separated into artistic and scholarly camps. Gabriel and Christina were united in championing the power of Dante's language, while Maria and William prioritised a technical understanding of his metaphysics. William and Maria were like the literal translations they defended; faithful, functional and a little bit ordinary. Their work was the drum beat to Gabriel and Christina's more impressive organ music. Maria's request for William (rather than Gabriel) to design the cover for her book, acknowledged their shared sensibility. Gabriel did design the circular frontispiece which played with these family issues of translation. It shows three receding profile views of Dante: the first as a young man, the second as an old man, and the third as the old man's shadow. It is topped by the words taken from Purgatorio 3:26: '*Il corpo Dentro Al Quale It Facea Ombra*' ['The body in which I cast a shadow'], which refers to the spirits' amazement that the corporeal Dante casts a shadow. Gabriel's frontispiece functions as a morbid Rossetti family in-joke. Even though Dante had long ago joined the spirit world, his shadow still fell over the Rossettis in general, and over Maria's new work in particular. There was also the shadow of their father to be considered.

Maria was accustomed to shadows. An awareness of her subordinate position, both within the family and as a writer, is evident in Maria's defence of her own English study of Dante: 'A shadow may win the gaze of some who never looked upon the substance, never tasted the entrancement of this Poet's music, never entered into the depths of this Philosopher's cogitations.' While she acknowledged her existence on the margins of Dante studies, Maria was also keen to show she had something to offer. Her book was conceived not only as a declaration of independence from her siblings, but also as a declaration of ownership; Maria hoped to reclaim Dante as a primarily Christian poet. She told Longfellow that she wanted her readers to 'profit as Christians' from Dante's 'transcendent...exposition of the free-will of man, and of the life to come.'[12] Her introduction to the volume made this aim explicit. Maria hoped readers would 'be spiritualised by his spirit and upborne on his wings', because 'great as is the profit derived by the mind from the study of the Commedia, greater, far greater, is the profit accruing to the soul'.[13]

John Ruskin would take exception to her approach, grouchily

dismissing it as 'evangelical nonsense'. Maria's lack of worldly experience meant that she was incapable of writing about 'revenge, lust, treachery and lots of things', and that 'she is very conceited to think that a girl can interpret Dante in such respects.'[14] It is clear that if there ever was an attraction between Ruskin and Maria, it was long over. This critique is as wrong-headed as Ruskin's earlier dismissal of Christina's 'Goblin Market' on the grounds that the public wouldn't like it. His opinion of the Rossetti sisters suggests more about Ruskin's uneasiness around female accomplishment than it does about the limitations of their work. No previous scholar argued that religious faith was an obstacle to grasping Dante's complex Christian allegory, and being 'a girl' would hardly have prevented Maria from understanding the darker currents of the *Commedia*. Nor is it correct to characterise her as naïve regarding the sins of Dante's characters. Maria's active social work among London's poor, permissible precisely because of her sex, regularly exposed her to the darker aspects of human nature which the *Commedia* explores. What his evaluation really exposes is the extent to which relations had broken down between Ruskin and the Rossetti family. After Lizzie's death, Ruskin had retreated, finding he did not like Gabriel's developing Venetian style of painting, whose open sensuality he felt was coarse. 'Come back to me when you have found out your mistake', he wrote.[15] Now a commercially successful artist, Gabriel tired of his old mentor, inevitably throwing over this artistic father-figure in favour of pursuing his own independence. In any case, there was no lack of young artists on the lookout for a mentor; Ruskin had quickly replaced Gabriel with the younger, more mouldable Edward Burne-Jones. According to William, the pair had barely seen each other during the mid sixties, and had last met in August 1868, when Ruskin tried to involve a reluctant Gabriel in charity work.

In the spring of 1870, Gabriel lost his last remaining father-figure. Old Williams, the Rossetti family odd-job man who had posed as Mary's father in Gabriel's first important oil, *The Girlhood of Mary Virgin*, died at the age of 80. Frances told Gabriel that Williams had never stopped asking after him. That same spring, Gabriel's *Poems*, 1870 was published to critical acclaim and commercial success, although close observers noticed that the positive reviews were all

authored by Gabriel's friends, a practice Scott called 'working the oracle.' William advised his brother against 'diplomatising' for good reviews, warning that it would only agitate 'the soreness of outsiders'.[16] Although Gabriel did not heed William's advice, its warning against 'outsiders' probably hit home. Mistrust of outsiders (and even insiders) would be one of Gabriel's leading characteristics in the new decade. In his early forties, Gabriel found himself fatherless, mentorless, and widowed. The artistic success he so desperately craved had come to him, but at a price.

Gabriel started showing signs of paranoia, instructing Dunn to lock up his letters as he was convinced someone was tampering with them. At her brother's request, Christina started burning bundles of letters he had accumulated over the years. Perhaps this kind of busywork provided a welcome distraction from the fact that she was not writing much poetry that spring. She had been spending her time writing short stories and negotiating with her various publishers. Dissatisfied with the terms offered by Macmillan, she switched to F.S. Ellis for the publication of her children's poems, *Sing-Song* and her stories, *Commonplace*. Gabriel was the first to detect something amiss in Christina's short stories, which he found 'not dangerously exciting to the nervous system'. He advised Christina that 'your proper business is to write poetry and not Commonplaces', and her public agreed.[17] The volume received mixed reviews and failed commercially. Christina was so disheartened by its failure that she released Ellis from his obligation to publish *Sing-Song*. Her devastation was compounded by Gabriel's poetic success. With his friends' reviews preparing the groundwork, and the literary gossip surrounding his wife's disinterment, his *Poems* became the publishing sensation of the year. The initial print run of 1,000 copies sold out in less than a month, and the work would be in its fifth edition by December. Gabriel had displaced his sister as the foremost poet of the Rossetti family, and she struggled to accept her demotion. 'We are not all D.G.R.s', she wrote regretfully to Ellis. Christina worried that her best years were behind her, and that her inspirational fire might never be rekindled. Gloomily, she offered the dim hope that 'a few posthumous groans may be found among my remains.' She bridled when Gabriel passed on Stillman's suggestion that she try writing poems about contemporary politics. 'Here is a

great discovery,' she wrote sarcastically, "Women are not Men" – and you must not expect me to possess a tithe of your capacities, though I humbly – or proudly – lay claim to family likeness.'[18] This statement, full of contradictions and conflicting emotions, is classic Christina Rossetti. She is both humble and proud, complimentary and derogatory, sarcastic and sincere. Her poetic ambition is obvious, but is clearly in conflict with her conservatism, and her beliefs about her duties as a woman and a sister. Although it smacks of sour grapes, her observation that 'Women are not Men' was apropos, not in terms of literary ability, but opportunity. While women were making inroads into the masculine world of English poetry, they were limited not only by cultural beliefs that women could not equal men in poetical talent, but also by social constraints. Where Gabriel, for instance, could negotiate with publishers directly, Christina's brothers made arrangements on her behalf. Gabriel's sex gave him free entry into the clubbable world of literary London, allowing him to feel more comfortable and accepted in its environs, and more entitled to its praises. While Christina was meekly wondering if it was appropriate to meet her publisher face to face, Gabriel was sending Ellis a jokey limerick about the critic Eneas Sweetland Dallas, whose name he was delighted to discover rhymed with 'phallus'.

William was disappointed when Gabriel declined to accompany him on his summer holiday to Florence, although he had to avoid Italy in the end because of the outbreak of the Franco-Prussian war that summer. Nevertheless, he was thrilled with his brother's poetic triumph and commercial sales, which he claimed were only slowed by the death of Charles Dickens in June. *The Times* reported Dickens's last words: 'Be natural my children. For the writer that is natural has fulfilled all the rules of art.' This advice could not have been further from Gabriel's artistic mission, which put into practice the philosophy of 'art for art's sake', a credo which would later see Oscar Wilde sporting a green-dyed carnation as a tribute to the artificial in art.

A monument to artificiality, Gabriel's stuffed wombat now stiffly greeted visitors to Tudor House. As a superstitious man, it is odd that Gabriel did not regard the death of his pet wombat, which occurred within a month of the creature's arrival, as a bad omen. Instead he drew a caricature of himself weeping over its corpse, with a willow

tree and tombstone in the background. That his ghoulish humour was still in place, even after the disinterment of his wife, seemed to everyone a good sign at first. In fact, it was an early indicator of his deteriorating mental state.

Dimly conscious of her son's worrying behaviour, anxious over the anticipated loss of Maria to convent life, and worried by a fresh decline in Christina's health, Frances decided to draw her children together for 'strictly a family' Christmas dinner. This would be exclusively 'a Rossetti family meeting', as Charlotte was with Lady Bath and Eliza Polidori's ill health was keeping her bed-ridden. The Rossettis were not alone in craving togetherness that year. The Franco-Prussian War had begun in July, and although Britain was not involved, the conflict was distressing to a population for whom the horrors of the Crimean War had barely receded. Frances worried about an English friend living abroad in France and anxiously joked that the family turkey might be delayed in its arrival from Boulogne.[19] Though both were against warfare in principle, it was in Christina and William's nature to champion the underdog, and their sympathies ultimately were with France. Austria's oppression of Italy had not been forgotten, and all the Rossetti children remembered their father in nurturing their dislike for this empire's ambitions. Christina composed two anti-war poems on the subject while Gabriel wrote a scathing satire on 'harlot' French capitulation to the German states, which he partially saw as just desserts for France's refusal to support Italian resistance.

He was becoming cranky and disagreeable, swearing so aggressively at Boyce during a game of whist that his good friend was taken aback. His eccentricities started to take on a hostile character, as when he set his Canadian marmot, a woodchuck-like creature, free to snuffle around guests' legs during dinner. Christina correctly predicted that, in her brother's care, the animal was not long for this world. Gabriel was still hosting séances in the house, inviting mesmerists such as the German Dr. Bergheim, who astonished the company with feats of hypnosis demonstrated on his young female assistants. The marquee in the garden was decorated specially for such events with couches, chairs, Persian rugs, china, Indian cabinets and seasonal flower arrangements. Skeptics were not welcome.

Experiments with altered states of consciousness were not confined

to the garden; they entered the studio as well. A trance was the subject of *Beata Beatrix*, an oil commissioned in 1866 but not delivered to the Cowper-Temples until the spring of 1871. William recognised the model as 'the painter's lost wife, portrayed with perfect fidelity out of the infinite chambers of his soul'.[20] It would become one of his more popular paintings, inspiring various patrons to request replicas. Inspired by Dante Alighieri's *Vita Nuova*, the painting shows a red-headed Beatrice seated on her balcony, 'rapt' in a 'trance'. Her eyes are closed and her head is tilted upwards, bathed in golden light. A haloed red bird, 'a messenger of death', drops a white poppy in her hands, while a sundial marks the hour on the balcony wall behind her. In the background, the 'figures of Dante and Love' lurk ominously in the Florentine street. Completed in 1870, the same year that the poems retrieved from Lizzie's grave were published, the painting doubled as a memorial to his wife. Gabriel was eager to emphasise to the picture's new owners that it was 'not intended at all to *represent* death, but to render it under the semblance of a trance', depicting the moment when Beatrice 'through her shut lids, is conscious of a new world'.[21] Finishing the *Beata Beatrix* was cathartic for Gabriel; Lizzie was now safely confined to a liminal state in art as well as in his life. He was now ready and able to devote his full attentions to her successor.

Gabriel's love for Jane Morris had grown to epic proportions, and seems to have been an open secret. In order to escape prying eyes, he joined Jane at Kelmscott, a stone manor house near Oxford with which he was co-tenant with Morris. Conceived as a country retreat for Gabriel to work and Morris's family to enjoy their holidays, it doubled as a rural idyll where he and Jane could conduct their affair. In the summer of 1871, Morris gave his tacit permission by travelling to Iceland, leaving his children and Jane alone with Gabriel. What the locals thought of this bohemian arrangement is unknown, but it certainly confirmed rumours of a consummation in the minds of mutual friends. The couple took long walks through the surrounding villages, taking in the river and the picturesque thatched farm-buildings which Jane said looked like purring cats waiting to be stroked.

Although he still had some trouble sleeping at night, grumbled about the ugly Samson and Delilah tapestry decorating his studio

and bemoaned the August heat which made him abandon waistcoats for billowy shirts, the pleasures of the countryside at least drew him outside during the day, and he enjoyed composing poems on a river island which he reached by crossing a little bridge. Soon he was confessing to friends that he couldn't remember why he preferred living in London. During that blissful summer, he wrote what have become known as the 'Kelmscott Love Sonnets' in tribute to Jane. He was also painting and drawing, not only Jane, but portraits of her girls. He preferred the younger May, who was the same age as his daughter would have been had she survived.

The presence of Jane's young daughters completed the illusion of legitimate family life, though Gabriel was more keen to assume Morris's husbandly role than his fatherly duties, noting gratefully that the 9 and 10 year-old May and Jenny were old enough 'to amuse themselves all day long without needing to be thought about by their elders.'[22] Hearing about them stirred Frances's grandmotherly ambitions, and she hoped that Gabriel would take an interest in fatherhood. She wrote eagerly that 'childhood is in itself so endearing and interesting, above all under unconventional, spontaneous conditions...'[23] He had been fond of Jane's daughters even before that summer, giving them little gifts such as a copy of *Alice's Adventures in Wonderland*. He was no Lewis Carroll, however; Gabriel was more enraptured by twilight walks with the Morris girls' mother than with the girls themselves. Although it is not clear how much his mother and sisters knew about his relationship with Jane, their letters show that they liked 'Mrs. Morris'. Maria even tutored her in Italian. Whether this is evidence of a surprisingly laissez-faire approach or an extension of the latitude given a favoured eldest son is debatable, but there is no record of the Rossetti women objecting to the arrangement. Still, Frances perceived that there was something amiss. Gabriel hinted at his sorrows when he sent his mother a newly-written poem, 'Sunset Wings'. The poet describes his sorrow as he watches a flock of starlings at sunset: 'Unto the heart they seem to cry, Farewell, / No more, farewell, no more!' The setting sun and the onset of autumn all point to the painful fact that Gabriel's idyll with Jane must end with the summer. Frances got the message, attempting to console her son with a comforting rationalisation: 'I believe all true poets have a vein of melancholy.'[24]

Rossettis didn't experience banal emotions like sadness; rather, they were poetically melancholy. Gabriel's sorrow, like Christina's, belonged to a higher order of human feeling which inevitably led to the creation of true art. Such a belief had helped Frances to endure her brother's suicide, and her own husband's deterioration in his later years, but it did not help Gabriel, who was all too ready to pursue this dangerous Romantic philosophy. As always in the Rossetti family, sacrifice of self in the pursuit of Art was encouraged. Gabriele Rossetti's family motto, 'Break Not Bend', proudly emblazoned on his eldest son's stationery, was about to be put into practice.

The family patriarch was on everyone's mind that long hot summer. The grass had only just grown back around Lizzie's grave when a proposal to raid the Rossetti family tomb came anew. There was a public movement in Italy for a ceremonial reinterment of Gabriele's remains in the Church of Santa Croce, Florence. Years after his death, he was finally being officially recognised as an important Italian patriotic poet. Gabriel, no great visitor of graves, was the only one in favour of the move, and Gabriele remained with his daughter-in-law in the family tomb at Highgate.

A heavenly summer for Gabriel was a hellish one for Christina, who was soon to be diagnosed with Graves Disease, an incurable disorder involving an overactive thyroid. Developing over a number of years, it was easily misdiagnosed or missed by doctors, and was probably at the root of Christina's lifelong struggles with vague, neuralgic symptoms. Abscesses appeared on her gums, and she became so feverish that her family feared for her life. She was so weak that she sometimes couldn't take solid foods, and developed the bulging eyes characteristic of hyperthyroidism. Dr. William Jenner was called in. Christina preferred Jenner's sensitive bedside manner to the brusque and dismissive approach many other doctors of the era displayed when dealing with women's complaints. She was not alone in her assessment. As physician to Queen Victoria and Prince Albert, Jenner had come a long way since the early 1850s when he had first met William and Maria in their flat over a chemist's shop.

Recent medical research has suggested links between Graves Disease and psychological disorders such as depression, a connection which might explain Christina's famously melancholy outlook.

Although she survived, she would suffer from the disease for the rest of her life. It was in this period also that she lost her looks, suffering not only from protruding eyes but also darkened skin and a goitre, ill-disguised beneath a white neckcloth. She compared herself to 'an inflamed negro of the wrong colour.'[25] Christina's comment highlights common prejudices of the time among London's middle-class white intelligentsia, who had little social exposure to non-European peoples or cultures. It is worth nothing that both Christina and William deplored slavery and had supported the North in the American Civil War. While today our attention is drawn to Christina's casually racist language, her failed attempt at humour also captures the Rossetti family mood of nervous anxiety. Death was clearly sniffing around, and everyone was on edge that summer. Even Frances was not immune to this vertiginous fatalism. Unkindly and uncharacteristically, she once lapsed into semi-hysterical laughter at her daughter's grotesque appearance.

Friends rallied round, including Henrietta Rintoul and Holman Hunt who sent Christina basil leaves from the cave of Abdullam in Isreal, where the biblical David had hidden from Saul's wrath. Christina would have appreciated the religious connotations, perhaps thinking of herself as girding up her strength in retreat, waiting to rejoin the world and claim her kingdom. Despite her illness, she pressed ahead with plans to publish the troubled *Sing-Song*, with illustrations by Arthur Hughes, hoping it would restore her poetic reputation. Dedicated to Charles Cayley's infant niece, it was the only book Christina dedicated to someone outside the family circle, and was as close as she dared come to publicly acknowledging their relationship. It was an oblique reward for Cayley's unflagging loyalty and friendship, despite her rejection of his marriage proposal. The ghost of regret lingers in the dedication of the nursery rhymes to a Cayley baby which might, in other circumstances, have been theirs.

Gabriel only visited his sister twice that summer because, as Christina noted drily, 'his nocturnal habits are not adapted to a sickroom.'[26] Gabriel was also developing a dependence on chloral hydrate, a drug which he had begun to take in the spring of 1870 to combat his insomnia. Thought to be safer than opiates, it was rapidly absorbed after ingestion and brought sufferers sleep in under an hour.

Unfortunately, it was incredibly addictive and had life-threatening side-effects including: cardiovascular disorders, breathing problems, kidney and liver dysfunction, diarrhea, nightmares, hallucinations, paranoia, confusion, poor coordination and incoherence. Withdrawal from the drug could cause life-threatening seizures. Physician Gordon Stables's 1875 exposé in the *The Pall Mall Magazine*, 'Confessions of an English Chloral Eater', would warn people of chloral's dangers, but by then it would be too late for Gabriel. As William quickly noticed, the cure for Gabriel's insomnia was worse than the disease. Willful, impulsive, and vulnerable to the delights of instant gratification, Gabriel was a prime candidate for addiction, and he eventually started washing down his doses with a large whiskey chaser. He would discover the hard way that mixing chloral with alcohol leads to the depression of the central nervous system, which can cause coma or death.

When Gabriel did rouse himself sufficiently to see Christina, he was shocked by her transformation into 'a sad wreck of herself.'[27] She might easily have had the same reaction to her brother. Maria, no longer the plainest Rossetti girl, was also unwell that summer, though less seriously than Christina. Mother and daughters adjourned to Folkestone to take the healing summer sunshine and sea air. Frances was forced to precede her daughters to Euston Square by William's return from his holiday, which gave Christina and Maria a rare chance to exclusively enjoy each other's company. Christina was conscious that Maria's tenure as a Rossetti was drawing to a close. She must have wondered how many more holidays they would enjoy before Maria abandoned the Rossetti sisterhood for the Sisterhood of All Saints.

The Folkestone sea air was not enough to cure Christina. By January she started to suffer frightening symptoms, such as loss of appetite, difficulty breathing, vomiting and heart palpitations which made her fear for her life. She was no better by spring. Even the unflappable Dr. Jenner was alarmed, informing the family that her life was in danger, though her case was not beyond hope. It was her sister who helped discover the diagnosis of Graves Disease, after she talked to a physician friend. Eliza Polidori's nursing skills were coming in handy, and she cared for Christina during this illness, freeing Frances and Maria to look after William's needs. Though its women contributed

financially to the household, it was understood that the performance and supervision of domestic duties still fell within their remit. While they still retained Eliza's loyal servant Sarah Catchpole, other domestic workers came and went with regularity. The indomitable Charlotte Polidori had bought the lease for 56 Euston Square for 52 ½ years for £1,000, and the Rossettis were now effectively her tenants, paying their monthly rent to her. She was more fairy god-mother than landlord, excusing the long-serving Eliza from the £40 rent William had formerly collected for her tenancy of the second floor rooms. Charlotte, who stayed with the Rossettis whenever she was in London, considered the house a financial investment, and would bequeath it to William on her death. This sense of financial security must have brought the money-conscious Rossettis a measure of comfort in otherwise dark and difficult days.

Though not a superstitious woman, as night fell on Sunday 9 June, 1872, Frances could not shake the feeling that something was terribly wrong. She felt an overwhelming need to visit Gabriel, who had been 'unwell' and was staying at his friend Dr. Thomas Gordon Hake's house in Roehampton. Frances was half-preparing to leave when William arrived, breathless with the news that Gabriel was at death's door. If his mother and sisters wanted to say goodbye, this was their chance. Frances and Maria were bundled into the fly William had hired, and they set off to collect Brown. Christina was distressed that she was too ill to leave her bed, and was forced to stay behind with Eliza. During the journey to Brown's house in Fitzroy Square, William told his mother and Maria a highly censored version of events. He had been keeping the seriousness of Gabriel's situation from them, in an effort not to worry them, or so he said. This was also self-protective. During the past week, Gabriel had been suffering from a full-scale breakdown which had driven William to his limits.

Perhaps William felt guilty that he had seen this coming, and done nothing to stop it. Not only was Gabriel clearly addicted to chloral by this time, but also he had started to suffer delusions of persecution. These had started reasonably enough, as a reaction to a blistering article and pamphlet by minor poet Robert Buchanan which identified Gabriel as the ring-leader of the 'Fleshly School' of poetry, whose members included Morris and Swinburne. Each poet

was an 'intellectual hermaphrodite' who wanted to 'extol fleshliness'; 'aver that poetic expression is greater than poetic thought'; and to claim that 'the body is greater than the soul, and sound superior to sense.' The worst of these was Gabriel, 'a full-grown man, presumably intelligent and cultivated, putting on record for other full-grown men to read, the most secret mysteries of sexual connection…' His 'simply nasty' sonnet, 'Nuptial Sleep', came under fire because its erotic themes were 'neither poetic, nor manly, nor even human'. He was also a bad, unmasculine painter who was too 'sensitive' to exhibit. Buchanan did not limit his criticism to Gabriel's work, expanding the attack to include his family. Gabriel was merely an over-indulged brother, 'a painter and poet idolised by his own family'. William was 'the editor of the worst edition of Shelley which has yet seen the light'. Clearly, Buchanan had not forgotten William's throwaway insult, in his 1866 pamphlet on Swinburne's *Poems and Ballads*, that Buchanan was 'a poor and pretentious poetaster'. Buchanan hacked at Gabriel's family background again in an article which dismissed him as 'an amatory foreigner, ill acquainted with English.'[28]

At first Gabriel tried to laugh it off, but many of Buchanan's criticisms had hit the mark. Gabriel's poems were sensual and erotic, and it was true that he was doted on by his adoring circle of family and friends. Soon he had composed a response, 'The Stealthy School of Criticism', which was published in *The Contemporary Review* in October 1871. William had prudently advised a dignified silence, but this was not in Gabriel's nature. He began his rebuttal with an extended metaphor comparing his upcoming critique of Buchanan's work to handling dead dog carcasses in the street. Of course, this only fanned the flames. Buchanan's article was expanded and reissued as a pamphlet in May 1872, after which other papers picked up the story of the literary controversy. Boosted by regular doses of chloral, his father's old paranoia resurfaced in Gabriel as imagined enemies lined up in ranks against him, including Robert Browning, whose new poem *Fifine at the Fair* Gabriel decided was a personal attack. Gabriel also believed Lewis Carroll was sending him up in his new poem, *The Hunting of the Snark*. Formerly friends with these poets, he cut them both. When Browning asked William what was wrong, the younger Rossetti brother was evasive, hampered by loyalty to Gabriel

and his own sense of decorum. William did what he always did in stressful family situations. He kept up his end of the bargain in supporting Gabriel and hoped for the best.

Just as William had learned that there was nothing he could do to stop his brother, Gabriel had learned that he was unstoppable. It was not rare for Gabriel to look defiantly at William over the brim of a wineglass full of the whiskey with which he washed down his medicine. Drastic action on William's part would have violated the relationship template which had been set up from infancy. As always, the goat allowed the leopard to have his way, hence the series of almost comical measures William and his doctors took to regulate Gabriel's out-of-control behaviour, including instructions to pharmacists to secretly dilute the chloral they gave him. Dunn and Hake were also in on the act, diluting it to the point that Gabriel became suspicious. We now know that chloral exacerbates all of the symptoms exhibited by Gabriel, including hallucinations, depression, paranoia and malaise, and that it interacts particularly badly with alcohol.

On Sunday June 2, William had arrived at Tudor House to find a man he hardly recognised as his brother raving incoherently about spies and enemies closing in. He was also hearing voices. On Wednesday the 5th of June, 1872, William gave up recording events in his diary in despair, having reached the conclusion that his brother had gone insane. Drs. Marshall and Maudsely were called, and, at a loss, they recommended rest. Gabriel claimed that Maudsley, an expert in mental disorders, was really an enemy disguised as a doctor. During the cab ride from Chelsea to Hake's Roehampton house, Gabriel heard a bell ringing that no one else could hear. The next day he thought a local traffic jam was a public demonstration against him. In the evening, Gabriel asked his brother to read him an extract from Merivale's *Roman Empire*, and William stopped in horror when he realised that the passage Gabriel wanted to hear concerned Roman emperors deliberately driving their senators mad. The brothers sat up all night talking, but William never revealed the content of their conversation. The next day, when Gabriel failed to rise by 4pm, a local doctor was called, who diagnosed a coma induced by 'serum on the brain'. He forecasted imminent death or permanent brain-damage, which sent William on a dash to Bloomsbury to collect his mother and sisters.

As Frances and Maria waited anxiously in the fly, wondering if they had already missed the chance to say goodbye to Gabriel, Brown ran off to collect Dr. Marshall. The group did not reach Roehampton till 10pm, where they found Gabriel far from out of danger. While William was gone, Hake had found an empty laudanum bottle rattling in a drawer in Gabriel's bedroom. It was at this moment that William realised his brother had attempted suicide, and that his female relatives must never know. Once the doctors realised it was a drug overdose, they brewed a pot of coffee and forced the half-conscious patient to drink it down. Gabriel survived, but walked with a limp for six months, as being comatose from Saturday night through Monday had damaged his leg.

He went to recover in the Scottish country house of wealthy patron William Graham, MP. Friends looked after him in rotations, and gradually, he improved. The real turning point was when he went to Kelmscott. Though his friends were apprehensive, as guilt over his relationship with Jane had been widely blamed for his breakdown, being with her helped him recover. Tellingly, William had no part in his brother's rehabilitation, because 'I might be depressed, and therefore depressing.' He might also have been thoroughly fed up. He had already decided that Gabriel could not stay in Euston Square because he 'would just then have caused the most wearing anxiety.'[29] Christina's illness was keeping the family sufficiently occupied, and William did not want to spend his days in the office worrying that a weakened Gabriel might confess his suicide attempt to Frances. The ultimate insult to Rossetti family life was the wish to quit it.

Christina was the most compliant with this unspoken rule. With her brother's near-death and Maria's impending departure, Christina clung more tenaciously than ever to the family home. She felt she had missed her opportunity to strike out on her own, despite the unstinting devotion of her rejected suitor. She and Cayley continued to correspond and meet regularly for cultural days out at the British Museum or tea and whist at Euston Square. In the autumn of 1872, Cayley sent her some poems on the birth of Venus which assured her of his permanent affection, judging from her poetic responses, 'Venus's Looking Glass' and 'Love Lies Bleeding'. Christina's first poem referenced a violet-coloured flower, native to Italy but introduced to

England in 1824, just like the Rossetti family itself. She was thinking of her father during this period, remarking to a friend on Gabriele's preference for the blue Adriatic over the green Atlantic. 'Venus's Looking Glass' was a sonnet about missing the flower in the summer, but being glad to see it bloom again in autumn. The choice of flower played on Christina's Anglo-Italian identity, as well as her reluctant absence from London throughout August. When William suggested she prolong her stay in Glottenham, she insisted on returning because she felt 'languid and sometimes low here.'[30] Encoded in her sonnet's language of flowers was Christina's confession that she had missed Cayley. Mythologically, 'Venus's Looking Glass' flowers were created from the shards of Venus's magical mirror, which reflected images that were superior to reality. Christina's poem hinted that a real relationship might have ruined the unique beauty of their unfulfilled love. Reflecting on missed opportunities was potentially less disappointing than taking a romantic risk. This also suggests her awareness of how the awkward pair might look to others: would anyone credit the beauty of a union between a pop-eyed, aging spinster and a delicate, balding bachelor? Thinking fondly of each other in secret was the only available option. She alluded to this special significance when 'Venus's Looking Glass' was published in 1875, observing in a note that she should have called the poem 'Love-in-Idleness', a flower which means 'you are in my thoughts'.

The sonnet following 'Venus's Looking Glass' in the 1875 collection, 'Love-Lies-Bleeding' continues this theme. It was a poem Christina associated with 'Venus's Looking Glass'; the poems were first published as a pair in *The Argosy*, January 1873.[31] 'Love-Lies-Bleeding' was a flower which symbolised one who was 'hopeless, not heartless', and the poem shows that however much she missed Cayley, Christina had resigned herself to the fact that they could never be together:

In youth we met when hope and love were quick,
We parted with hope dead but love alive
I mind me how we parted then, heart-sick
Remembering, loving, hopeless, weak to strive : –
Was this to meet? Not so, we have not met.

As autumn turned to winter, Christina was feeling her age. Her best friend, Amelia Bernard Heimann had recently become a grandmother. Amelia's daughter Golde, the little girl who used to eagerly await Christina's gifts of stamps for her collection, was now a mother. 'How the young people grow up and put one out of date,' Christina wrote wistfully. Though she was the author of a new book of nursery rhymes, Christina would never read them to her own children. The Victorian era is rich in childless poets who loved and wrote for children, such as Lewis Carroll and Swinburne, but it is unclear how Christina felt about joining their ranks. Though she enjoyed playing with her friends' children, she was not overly sentimental about babies, and had long protested that she was not a children's poet. *Sing-Song* appears to challenge this stance, but its poems, a great hit with critics, were too dark and adult to be a hit with children, or at least to persuade their parents to add the volume to the nursery shelves. Many poems display her characteristic morbidity and brutal frankness, and dead and dying babies abound, with illustrations to match: 'Why did baby die? / Making Father sigh? / Mother cry?' Death is a leading theme, as in this poem about burying a dead bird:

Dead in the cold, a song-singing thrush,
Dead at the foot of a snowberry bush, –
Weave him a coffin of rush,
Dig him a grave where the soft mosses grow,
Raise him a tombstone of snow.

Christina was not the only morbid Rossetti sibling that year. When Gabriel returned to Kelmscott after the subdued Rossetti family Christmas celebrations, William was left to see in the New Year with Dunn at Cheyne Walk. It had been, he reflected, 'the most painful year I have ever passed'.[32] After his brother's breakdown, William was a changed man. Quietly, he began to distance himself from Gabriel, no longer spending every spare evening at Cheyne Walk, attending to Pre-Raphaelite business. He began, in other words, to make his own life. His unexpected announcement that he would marry Madox Brown's daughter Lucy, whom he had first met when she was seven, shocked his female relatives. Friends were also sceptical,

particularly those of John Payne, a younger poet who had been courting Lucy. Rejecting the dashing Payne for the staid William was akin to exchanging 'a tongue of flame for an icicle'.[33] Although unkind, this assessment was not untrue. Icy reserve was a well-known characteristic of the Rossetti family, or at least the branch of it that remained sequestered in Bloomsbury, as Lucy would soon discover. William's marriage was shot through with a frosty practicality: even in his choice of bride, this good son was proving that he would never stray too far from the family. After all, Lucy's father had been an unofficial Pre-Raphaelite 'brother' from the beginning, and Lucy was already close to William's mother and sisters.

Fourteen years older than Lucy, William had modelled his relationship on that of his own parents with respect to age difference. Like Frances, Lucy was bright, mature and intellectually independent, although it would turn out that the Rossetti household wasn't roomy enough to accommodate another woman with a big personality. Christina's reaction to William's engagement gives a preview of trouble to come: 'If dear Lucy and you are as happy as I would (if I could) make you, earth will be the foretaste and steppingstone to heaven.' These sentiments, certainly shared by Maria, Frances and Eliza Polidori, were echoed in her letter to Lucy, where her new sister-in-law was reminded that 'earth is an anteroom to heaven (may it be so, God's mercy to us all)...'[34] The trouble was, the agnostic Lucy didn't believe in heaven, or at least not the heaven that ruled and regulated the lives of the Rossetti and Polidori women. As a teenage boarder and student she had known her place, but now there was a reversal of fortune. As mistress of the house, the thirty year-old Lucy would not so willingly bend to its rules. Of course, the Rossetti women were not fond of bending, and so in the end the house had to break. In July, Christina reported to Gabriel that the 'house party is broken up!!' adding that William was 'cut up... at losing our dearest Mother'. She added tartly that there was no help for it, as 'I am evidently unpleasing to Lucy'.[35] On October 1, 1876, Frances and Christina moved into a house at 30 Torrington Square in Bloomsbury which they shared with Eliza and Charlotte. Diplomatically, William took Lucy and Olivia to Cornwall while his sister and mother moved out.

In some ways, this was simply a feat of bad timing. Christ Church, Albany Street, always a centre of Anglo-Catholic activism, had turned its attention toward conversion in the 1870s. Along with All Saints, Margaret Street, it had participated in the 12 Days Mission in November 1869, offering special sermons, extended hours for confession, opportunities for the renewal of baptismal vows and special instruction classes for men and women looking to convert. The idea was to attract many of the poor to the parish with splendid displays, not only of oratory, but of ritual. Burrows, a close friend of Christina and Maria who ran the parish at the time, was taught that 'the poorer classes learn by the eye as well as by the ear', and encouraged the use of icons, flowers, incense and impressive choral processions to attract converts.[36] This emphasis on the visual as well as the aural aspects of worship had always been central to Anglo-Catholic practice, and proved an effective recruitment tool. It presented a colourful, inspiring alternative to the dismal, Dickensian bleakness of London life, insisting that the transformative power of music, beauty and visual splendour were not the exclusive preserve of the cultured and the wealthy. There was great excitement around this mission activity, a sweeping didactic fervour that saw outdoor services in which the choir and congregation formed a singing procession which wove its way through the neighbourhood, reminding locals of their religious obligations and tempting newcomers to follow them back to the church for evening services.

While this kind of activity was not to everyone's taste, it did not inspire the fervent anti-ritualist protests of the 1850s. Anglo-Catholicism was starting to attract mainstream acceptance, partially through public awareness of its social reforms. The Missions of this period were intended to attract and include the poor of the parish. Widening access was on the High Church agenda in this period, and this was achieved through mission work and also the abolition of pew rents, an issue which particularly exercised the Rossetti women. In order to raise funds for the church, wealthier families paid a yearly fee to secure private pews. These pews had swinging doors which were locked to prevent any incursions. This meant that poor people of the parish sat in the worst positions or were forced to stand. Fuelled by memories of being bullied out of their childhood church over pew

rents, the Rossetti women energetically supported the cause. While they could be intellectually snobbish and exclusive when in came to their own domestic circle, they felt that class inequalities should not cross the threshold of God's house. Christ Church, Albany Street had done away with pew rents in 1865, but it was still a wide-spread practice in other parishes.

In protest, Maria wrote a short story called 'Pews: A Colloquy', in which several characters discussed the issue during a luncheon party. It is an unremittingly didactic piece of propaganda rather than a polished literary piece. The doctrinally and socially sound arguments of the hero, a manly clergyman who works in a local Mission district, ultimately prevail over the bourgeois objections of his lunch companions. Christina wrote a similar dialogue story, but her 'Pros and Cons' is much more witty and confident, and her characters more colourful, such as the aptly-named Miss. Crabb who peers waspishly through blue spectacles and Ms. Plume who waggles 'a fascinating finger' of objection at her Rector.

It was during the 1870s, with Maria and Christina's increasing involvement in the activism of the Anglo-Catholic Church, that the religious differences between the Rossetti brothers and sisters really started to matter. It became obvious that William's agnosticism and Gabriel's dissipated, materialistic lifestyle were not compatible with the beliefs and values that shaped their sisters' lives.

Pre-Raphaelitism was back with a vengeance, only now it had gone commercial. No longer considered a weird fringe movement, its aesthetics had gone mainstream. In 1876, one journalist observed:

> We have now in London pre-Raphaelite painters, pre-Raphaelite poets, pre-Raphaelite novelists, pre-Raphaelite young ladies, pre-Raphaelite hair, eyes, complexion, dress, decorations, window curtains, chairs, tables, knives forks and coal-scuttles. We have pre-Raphaelite anatomy, we have pre-Raphaelite music...'[37]

The ironies of this commercialised Pre-Raphaelitism did not escape Rossetti family-watchers, such as cartoonist Max Beerbohm, who sketched a plump Gabriel displaying colourful fabrics from Liberty and Company to a disapproving Christina. The department

store opened at 218 Regent Street in 1875 as 'East India House', selling a whiff of exoticism along with its imported silks and shawls from the East. By the 1880s, it would expand to offer furniture, carpets, jewellery, wallpaper, pewter, porcelain and homewares. Tired shoppers could take a break, and a restoring cup of tea, in its 'Arab Tea Room'. As well as capitalising on the current London rage for Orientalism, its ethos of offering unique luxury goods in an age of mass-production tapped into the market that The Firm had created. Its founder, Arthur Lasenby Liberty, was inspired by London's bohemian artists, who were not only his customers, but also part of his brand identity. He bragged about his visits to painters' houses and studios in interviews with the press, and as the century wore on, his store became firmly identified with the alternative and the unconventional. Gabriel had a Liberty's account to buy props and draperies for use in his paintings. Ruskin, Burne-Jones and Whistler were also customers.

Fashionable women started to want to dress 'artistically', after Jane Morris, seeking embroidered fabrics in unusual shades of terracotta, indigo, sage and saffron as monochrome gave way to multiple colours, subtly faded for an 'authentically' antique feel. Smocking at the wrist and neck, as well as square-cut bodices and natural waists, added a neo-medieval flair. Liberty's did not limit itself to clothing only, extending into homewares as its reputation grew. Ceramics and textiles from Japan and the Far East were on offer, as well as exotic rugs and carpets and plenty of Gabriel's favourite 'blue and white' china. Famous for popularising Pre-Raphaelite fashions in clothing and furniture among the Victorian middle classes, Liberty himself became known as 'The Man Who Killed the Best Parlour'.

The stern, black-clad Christina Rossetti in Max Beerbohm's sketch certainly looks as if she is about to accuse Liberty and his ilk of murder. 'What is the use, Christina, of having a heart like a singing bird and a water-shoot and all the rest of it, if you insist on getting yourself up like a pew-opener?' the cartoon Gabriel pleads with his unyielding sister among the bolts of bright Liberty fabrics.

Christina was comforted by an entirely different aesthetic. While Liberty's stylish female customers modelled increasingly exotic dresses in turquoise, gold and claret, members of Christina's Anglo-Catholic parish were bringing colour to London's streets in their own way.

Not far from the Regent Street department store, parades of singing parishioners led by surpliced clergy and choir filled the city with song and spectacle. New recruits crowded the free pews as their senses were dazzled by the glittering stained glass windows, kaleidoscopic tile-work and sweet-smelling incense at gothic revival churches like Maria's beloved All Saints, Margaret Street. Twentieth century critic Iain Nairn's evaluation offers this tongue-in-cheek evaluation of its visual effect:

> To describe a church as an orgasm is bound to offend someone; yet this building can only be understood in terms of compelling, overwhelming passion. Here is the force of Wuthering Heights translated into dusky red and black bricks, put down in a mundane street to rivet you, pluck you into the courtyard with its hard welcoming wings and quivering steeple.[38]

While they would have looked askance at Nairn's extended metaphor, this kind of passionate revivalism undoubtedly raised the Rossetti women's spirits (if not their libidos) in the dark days of Christina's illness and Gabriel's madness. Christ Church, Albany Street also participated in the successful missions of the 1870s which dovetailed with William and Lucy's courtship and marriage. Christina published a book of prayers, *Annus Domini*, introduced by her beloved Reverend Burrows. Gabriel complimented his sister on her book, but grumbled that the Reverend's introduction didn't add very much. Christina's increasing missionary zeal can be seen in her didactic correspondence with her prospective sister-in-law, which makes it fairly plain that Lucy would be under spiritual pressure to convert. Increasing this pressure was Maria's proposed exit from the Rossetti household to join the Sisterhood. Christina was clearly looking for a replacement sister, but the agnostic, pretty young aspiring painter William had chosen would never be able to fill Maria's sensible shoes.

Adding to the family's anxieties was the fact that Maria was once again very ill, and was sent to All Saints convalescent hospital in Eastbourne to recover. Frances joined Maria at Eastbourne that summer because she wanted 'the full enjoyment of her company before I lose her.' Coming on the heels of each other, the two weddings (William

to Lucy and Maria to Christ) were not received as a cause for celebration, and the mood of the household was sombre. Frances and Christina felt bereft without Maria, and faced the added strain of their religion's requirement that they feel happy for her. This was easier said than done. 'I fear we shall soon lose Maria from our hearth in favour of her new "Home"', Christina confessed to Gabriel.[39] Gabriel in turn worried that Maria's exodus meant the loss of the most stable and happy Rossetti, remarking to his mother that Maria was 'much the healthiest in mind and cheeriest of us all, except yourself. William comes next, and Christina and I are nowhere.'[40]

Though Maria was not joining a closed order, and would return to visit her family most Saturdays, things would not be the same. Frances told Gabriel that 'I honour her motives in carrying out her self denying aspirations, but shall deeply feel her absence from home'.[41] It could not be denied that Maria had chosen an alternative family. Swallowing his objections, William wrote graciously: 'I know, my dear Maggie, that your longing is to die to the world, and live to Christ: to suffer, work, love, and be saved by love. There are other ideals than this, but not greater ideals…'[42]

Unlike Gabriel, the diplomatic William made sure to include his family in his wedding ceremony, asking Frances to act as his witness along with Brown when he married Lucy on 31 March 1874 at St. Pancras Register Office. Afterwards there was a small wedding breakfast which William Morris wished he had the courage to skip, complaining about having to 'waste a day out of my precious life in grinning a company grin at you two old boobies.'[43] Brown had invited him as a business partner in The Firm as well as a friend, and Morris felt obliged to attend. He would shortly win Brown's animosity by dissolving the partnership, reinventing The Firm as Morris and Co. in 1875. Though Morris had never held William in high esteem, his vehemence expressed a displaced hostility over Gabriel's relationship with his wife. He was pained by the painter's omnipresence at Kelmscott, where Gabriel had been living more or less permanently since the beginning of 1873. While this civilised arrangement seemed tolerable in theory, in practice it was harder to endure. Gabriel was equally unenthusiastic about meeting Morris on the occasion of his younger brother's wedding. He avoided the evening party altogether

and complained to his brother about having to attend the wedding breakfast.

Frances could not have failed to notice that her son and daughter-in-law had not required God's blessing. William was aware that his agnosticism caused his 'excellent religious mother many a pang', and he suspected that she and his sisters continued to pray for his conversion.[44] William's marriage ceremony also caused Frances another 'pang' as it marked the exodus of the Polidori sisters from the Rossetti household. While Frances and Christina were prepared to put up with another unbeliever in the family home, the formidable Charlotte and Eliza were not. When William's new bride had suggested making improvements to the drainage at Euston Square, Eliza replied tartly, 'In my time, we left all that to God Almighty.'[45] Shortly after the wedding, the Polidori sisters huffily decamped to nearby 12 Bloomsbury Square, where they were often paid extended visits by Christina and Frances, in flight from Lucy. Even Maria appeared to be avoiding the family home, not visiting till three months after what she called, tongue-in-cheek, Lucy's 'enthronement'.[46] She had also gently rebuked Lucy on overhearing her refer to her novice's habit as 'a mass of black', correcting her as to the particulars of her costume.[47] She noticed that William, caught in the middle, was looking tired and worn out. Grief also doomed this experiment in communal living. In August, Lucy miscarried the newlyweds' first child, while in September Henrietta Polydore finally lost her long-standing battle with consumption.

That Gabriel did not immediately warm to Lucy is surprising, given his history of friendship with independent artistic women like Anna Mary Howitt and Barbara Bodichon, but his reservations about her reflected his deteriorating relationship with William more than personal animosity toward Lucy. Guilt about what he had put his brother through, as well as the uncomfortable role reversal which saw perennial bachelor William getting the girl, had unsettled Gabriel. His uncompassionate reaction to the sudden death of Lucy's first cousin Elizabeth highlights his disapproval. While shopping for the beautiful London fabrics so fashionable that year, the thirty-five year old Elizabeth Clara Cooper had collapsed and spent her last twenty-four hours dying in agony in a silk mercer's back room. In a

letter to Fanny Gabriel groused about Lucy's insistence on holding Elizabeth's funeral at Euston Square, giving the impression that he had heard about it from his disapproving mother and sister, who were staying with him at the time. Christina wrote to assure William that it was all right for Elizabeth's grieving mother to remain at Euston Square for an extended visit, but her assent is less than enthusiastic: 'the funeral passed, there is really nothing I should designate as dullness in the prospect.'[48]

William's mother and sisters had agreed to an uncomfortable *détente*, or, in William's words, 'an armed truce' on the issue of the newlyweds' religion. As the family's practiced diplomat, William managed to rebrand his 'open disbelief' as an indication of intimacy, insisting that Frances 'preferred' his agnosticism to 'hypocritical conformity.'[49] Though quite hard on their own sex, the Rossetti women were always more morally flexible when it came to the male side of the family. Rather than admit to conflicts with Gabriel and William, it was easier to blame the women in the brothers' lives. This had been a drawback for Lizzie Siddal, who in some ways took the fall for Gabriel's bad behaviour, and it would also be a sticking point for Lucy. William acknowledged that his mother and Christina were disappointed that he had not married someone who shared their religious beliefs.

As it had been with Lizzie, jealousy was also a factor here. Christina and Frances were no longer the most important women in William's life, and there was some awkward scrambling for dominance in the new household. Effectively, Lucy was now mistress of the house which the Rossetti women had ruled unchallenged for years. A conflict-avoider by nature, William made a bad situation worse by refusing to involve himself in the women's domestic squabbles. Having thrived in the socially stimulating environment of her father's house, which hosted regular gatherings of London's artists and writers, Lucy tried to remake her new home in the image of her old one. Christina and Frances, accustomed to sedate teas with a few intimate friends, felt this was an intrusion. For her part, Lucy did not enjoy the company of Rossetti family favourites like Amelia Bernard Heimann, William Allingham, and various clergy members and church-goers. Christina's invalidism was another problem. Christina wrote a furious missive

to William, reporting that Lucy had complained when her dinner guests were disturbed by Christina's coughing.

Even the long-awaited birth of a Rossetti grandchild, Olivia, in September 1875 was not enough to keep the Rossetti family Round Table from dissolving. Normally more than willing to pitch in when bedside care was needed, Christina and Frances had been staying at Bloomsbury Square while Lucy was giving birth. Family reaction to the baby was decidedly muted, with Christina observing cattily that it was too soon to comment on the baby's looks, and Gabriel haughtily informing William that he ought to consider calling the baby 'Olive' rather than the more Italianate 'Olivia'. Frances agreed, though she did concede that 'Olivia' might be acceptable because Shakespeare had used it in *Twelfth Night*. Additionally, the Rossetti and Polidori women were disappointed that the child would not be brought up in the Christian faith. William's daughter also reminded his siblings that they had made no contribution to the next generation.

Prickly and over-sensitive, Christina and Gabriel gave up trying to needle their calmer siblings and turned on each other, disagreeing over a poem called 'The Lowest Room' which Christina wanted to include in a new edition of her collected poems. Gabriel hated the 'falsetto muscularity' of its 'modern vicious style.'[50] Christina countered that *Macmillan's Magazine* had no problem publishing the poem, and furthermore she especially liked it. Given its realism, Christian-based feminism and themes of sibling rivalry that cut close to the bone, Gabriel's reservations about the poem were predictable. Written in 1856, the year that William had gotten engaged to Henrietta Rintoul, Gabriel had started getting serious about marrying Lizzie, and All Saints Margaret Street had been established, it expressed the then twenty-six year-old Christina's anxieties about being left behind by her siblings. Originally titled 'An argument over the body of Homer', it is a poem whose theme is sibling rivalry. Maria's love for Homer's *Iliad* is a reference point here, as is the familiar Rossettian image of the sisters as birds 'of the selfsame nest'. It is a conversation between two sisters exploring one pessimistic sister's disappointment with modern life, and the other's realistic acceptance of the good and bad points of 'this degenerate age'. Although the discontented sister is the eldest, it is clear that in her gloomy, abstracted, guilt-ridden perspective she

is a stand-in for Christina. She complains that heroism and romance belong to days gone by, arguing that slaves were treated better in ancient Greece than wives are treated in modern life. Her younger sister points out the dangers of this kind of easy nostalgia, and affirms: 'I rather would be one of us / Than wife, or slave, or both.' Her strong sense of identity, she explains, is predicated on the modern advantage of knowing about Christ, who offers alternative identities to women that the ancient Gods withheld. In this argument we can see the Christian-based feminism of the Rossetti women, whose religion taught them that women should take more active roles in both church and community life outside the home. The elder sister is jealous and resentful of her sister's wisdom and faith, and guilty over her own feelings of inadequacy. Ironically, it is she who will end up neither slave nor wife, but spinster. She watches enviously as her sister gets married and has children, while she herself lives 'alone / In mine own world of interests / Much felt but little shown.' As the elder sister, she should be the first married. 'Not to be first: How hard to learn / That lifelong lesson of the past', she says, her only comfort the reversal that will take place in heaven, when 'many last' will be 'first'.

The anticipation of this power reversal contains more than a hint of aggression. That Christina would want to publish this twenty year-old poem in the same year that Maria left the Rossetti household reveals her (possibly unconscious) anger at her sister's desertion. Although they were all grown up, the Rossetti sisters were still playing at cards, and Maria's clubs were currently beating Christina's diamonds. In the closed circle of the Rossetti women's religious world, Maria's commitment to Christ trumped her sister's successful literary career. Maria was in a superior position as a bride of Christ on earth, but after death, it would be time for the lowly spinster Christina to assume a higher place in heaven.

Though Gabriel was polite about Maria's vocation, he had difficulty taking her beliefs seriously, announcing to a friend that 'Poor Maggie is parting with her grey hair…and annexing the Kingdom of Heaven for good.'[51] Shortly after Olivia's birth, in the autumn of 1875, Maria was formally professed in a veiling ceremony attended by Frances and Christina, and her transition out of the family was complete. This transformation was reinforced visually with the rather

striking uniform of the Sisterhood. A long white collar broke the monochrome of her shapeless dark dress with its long bell-shaped sleeves. The garment's only ornamentation was a rope girdle knotted at the side. Over her newly-shorn hair she wore a white hood whose elasticated sides provided an unflattering oval frame for her plump face. A photograph of Maria in her habit shows how much she had grown to resemble her father, as if Gabriele himself had decided to revisit the world in an unlikely disguise. Yet Maria's happiness is visible in the smile that reaches her eyes as she gazes confidently into the middle-distance, as if regarding her promising new future. She is the only Rossetti to smile in photographs, confirming her reputation as the cheerful sibling.

While the others tried to conceal their mixed feelings at spending the first family Christmas without her, Gabriel struggled to accept her absence. He had always hero-worshipped his eldest sister, who had transformed from his merry childhood partner-in-crime to someone far more remote. Maria wrote to her brother on Christmas Eve, trying to explain: 'Perhaps the ground of my declining it has never seemed intelligible, – considering the sacredness of family affection, it is very difficult to make it so.' She had discovered a life more sacred to her than family affection. She saw herself as a descendent of 'the Apostles and holy women' who followed Christ, and as such it was her duty to 'refrain' from the 'prolonged and impressive joys' of family life in order to keep her 'soul's eye fixed on Him.' For Maria, God would come first, and her family, second, though she conceded that there was a biblical precedent for retaining family ties, reminding Gabriel that 'out of the 12 Apostles, 6 at least were pairs of brothers'.[52] This was cold comfort indeed to the little brother who wanted to spend the holiday with his big sister. William too would remain in London that year, partially because Gabriel would not allow Lucy to bring an unknown nanny into his house. This flash of paranoia did not bode well, either for Gabriel's recovery or for his already precarious relationship with his brother.

The breakaway party of Christina, Frances, and the Polidori aunts made a grim assembly at Aldwick, Bognor Regis, where Gabriel had invited them to spend Christmas, along with Dr. Hake and his three sons. The soothing absence of 'the calms' from the festivities

was palpable. Christmas Day was a disaster, with the stern Rossetti and Polidori spinsters arranged straight-backed on one side of the festive table, facing down Gabriel's rather intimidated male guests on the other. Surveying this grim spectacle while the food went as cold as the atmosphere, Gabriel told Fanny he felt like he was about to preach a funeral sermon. The funereal atmosphere he detected would grow stronger over the coming year, culminating in the first Rossetti sibling death. Surprisingly, it was neither the suicidal and drug-addicted Gabriel nor the seriously ill Christina who would succumb, but the sister Gabriel deemed 'much the healthiest and cheeriest of us all.' The undiagnosed complaints from which Maria had been suffering turned out to be terminal ovarian cancer, and the following Christmas would find the Rossetti family mourning her loss. Maria's tenure as a bride of Christ would be cut as brutally short as her grey hair, and with her death, the Rossetti family would enter its decline.

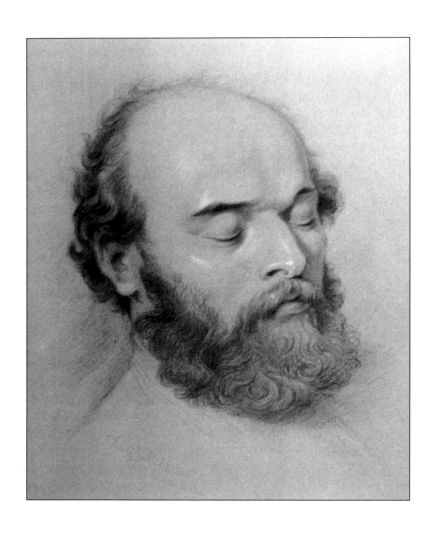

'A final drawing of Dante Gabriel Rossetti' by Frederick Shields, 1882

Even when he was rendered helpless by chloral addiction, Christina told
William she still considered Gabriel 'in so many ways the head of our family'.

11

'A HOLE IN THE WORLD'

The day of Maria's funeral was so bright that the sunshine made little rainbows in the tears that clung to Christina's eyelashes. But she was determined to keep her final promise to Maria to remain cheerful, a struggle for Christina even at the best of times. Through her tears, she tried hard to focus on the flowers heaped on her sister's coffin and to take comfort in the hymns sung at her grave. She and Maria had planned the ceremony together. 'Why make everything as hopeless looking as possible?'[1] Maria had argued. Like her aunt Eliza, Christina clung to out-dated fashions and customs in middle age, and had made a case for old-fashioned, ornate mourning wear. Fifteen years before, Queen Victoria's display of grief over Prince Albert's death had whetted the public appetite for black hatbands, heavy veils and jet jewellery. Bombazine or parmetta dresses were overlaid with expensive crape to ensure they reflected no light. But times had changed, and women were becoming increasingly reluctant to confine themselves with such costumes. Having spent the last few years in the simple uniforms of her Sisterhood, Maria was suspicious of the materialism and vanity reflected in elaborate mourning-wear, and was critical of its general ghoulishness. She was also aware of Christina's melancholy mindset, and even as she was dying, steered her younger sister away from morbid introspection.

Although Christina presented close friends with a sanitised version of her sister's peaceful death, in reality Maria's suffering had been long and drawn-out. Treatment included 'tapping', a gory surgical

procedure which involved the insertion of a cumbersome device called a trocar into Maria's swollen abdomen to drain the peritoneal fluid that had collected there, stimulated by a uterine tumour. She underwent this process twice to little avail, wasting away as she was unable to eat, and slipping in and out of consciousness while doctors tried to manage her pain with opium. One of her fellow Sisters at All Saints recalled Maria summoning her young nurse 'in her Italian ecstatic way, "Oh, Annie, my Annie, come to me!"'[2]

When opium use started to dehydrate her, Eliza and William sent pomegranates, lemons and oranges to moisten her parched mouth, along with flowers to brighten her room. Yet unlike the suffering sister of 'Goblin Market', Maria could not be cured by exotic fruit or sibling love. She summoned her brothers to her death-bed and gave them instructions. Just as she had advised Christina to be less melancholy in her outlook, she urgently counselled William to consider his spiritual life. Maria revealed that her main motivation for joining the Sisterhood had been to pray for both brothers to embrace Christianity. Ducking the issue, William told her he thought Gabriel was the more likely candidate for conversion. She warned William that her funeral would be handled by the Sisterhood, and therefore extremely religious. Would he still attend? 'Of course I will', he assured her.[3]

Although the return of Gabriel's paranoia meant he rarely ventured far from Tudor House, he managed to visit his mother frequently during this period. He sent Maria orange extract and religious photographs from a Book Of Hours, and pulled himself together for a two-hour visit with his dying sister. While Christina reported that he wasn't looking his best, she was encouraged when he came back with her to Torrington Square afterwards to comfort Frances, managing to stiffly compliment his mother on her new dining room. He was still avoiding William. The younger brother had kept his distance for a while now, protecting himself from Gabriel's mood swings and erratic behaviour, which only confirmed Gabriel's paranoid suspicions about him. The painter-poet was more interested in protecting his addiction than in overcoming it, and he became increasingly bullish toward William, his servants, and George Hake (Dr. Hake's son), who was threatening to leave. William knew the mysterious bruise that appeared on Gabriel's cheek was the result of

his brother's drunken nocturnal wanderings throughout the house, but he was forbidden to tell the family about the accident. Formerly inseparable, the Rossetti brothers were awkward now. Where once he'd enjoyed open access to Tudor House, William often found himself turned away when he tried to call. Christina tried to effect a truce, heavily hinting to Gabriel that William was depressed over Maria's decline and needed cheering up. Gabriel ignored his little sister's manoeuvrings. His own drug dependence he dismissed as simply a cure for insomnia, a self-diagnosis with which his primary physician, Dr. Marshall, seemed willing to play along, allowing him more chloral than his other physician, Dr. Jenner.

His downward spiral was not helped by Maria's decline. As shocked as Gabriel was by her appearance, he was even more unsettled by her changed demeanour. Although she was calm and lucid during his final visit on 19 November 1876, she was no longer her bright, playful self. While it is not recorded, it is very likely that she treated Gabriel to the same lecture on spiritual welfare that she had delivered to William. Had she seen the painting Gabriel was working on during her illness, she might have saved her breath. Jane Morris was the model for one of Gabriel's more erotic paintings yet: *Astarte Syriaca*, a Syrian Venus whose considerable curves are barely contained by sea-green, clinging drapery as she boldly stares down the viewer. His accompanying sonnet praised her 'Love-freighted lips and absolute eyes', and noted how 'Her twofold girdle clasps the infinite boon / Of bliss…' Critic and friend Watts-Dunton identified this work as an 'experiment in flesh painting' in which Gabriel worked out his idea that 'the corporeal part of man seemed more and more to be but the symbol of the spiritual'.[4] The daily deterioration of Maria's body challenged the idea that the body symbolised the soul, but this was an irony lost on Gabriel.

Maria died talking to angels. They appeared to comfort her, sometimes singing the praises of God. Just before her death, on the morning of 24 November, she told one of the Sisters that Christ was there, and he was 'so beautiful.' Christina felt that Maria's last words, 'come along', were directed at her brothers and meant to inspire their conversion, but it was not to be.[5] 'If Maria's beliefs were correct, she is certainly at this moment a Saint in heaven', William hedged. 'If other

beliefs are correct, she has lived worthily…and she rests forever.'[6] Christina's religious didacticism only increased on the death of her sister. She told Amelia Heimann that she was praying for her to resign her Jewish faith and embrace Christianity.

No one in the family expected Gabriel to be able to cope with his sister's funeral. Anticipating his excuses, Frances recommended that he attend the chapel service only and skip the burial at Brompton Cemetery. He surprised everyone by coming to both, and behaving himself throughout. Pregnant with her second child, Lucy Rossetti tactfully chose not to attend.

The November morning was crisp and clear as the fly carriages ferried mourners across London from the nuns' private chapel at Margaret Street to Brompton Cemetery. Located in the suburb of Kensington and Chelsea, it was closer to Gabriel's house than to the other Rossetti homes in Bloomsbury. A 39 acre garden cemetery founded in 1840, it occupied a stretch of land between Old Brompton and Fulham Road. Like Highgate, it was one of seven large suburban cemeteries created to relieve pressure on overcrowded church burial grounds. Its design was meant to suggest an outdoor cathedral, with a long Central Avenue acting as a 'nave' leading to the domed Anglican chapel. Built colonnades with catacombs beneath reached out like arms from each side of the chapel to create a 'Great Circle', reminiscent of St. Peter's in Rome.

The family had initially worried that the Sisters' habits would attract undue attention during the burial, but in the end they all agreed that the nuns' calm simplicity and pretty hymn-singing brought dignity to the proceedings. Maria's membership of the Sisterhood also, to some extent, kept the family on the outside. At her request, the inscription on her oak coffin identified her as 'Maria Francesca, a Sister of the Poor'. She had not elected for the name 'Rossetti' to appear. When Frances and Christina tried to view Maria's body in the mortuary, the Sisters forbade them. The Sisters also withheld a photo of Maria from the family, although they would relent and send it to Frances two years later. All her possessions now became Sisterhood property, though Frances did manage to spirit away a locket with a curl of Maria's hair to one of Maria's close friends, on the grounds that this was her daughter's wish before she joined the Sisterhood. A curl of

hair was also given to Gabriel and William. Burying Maria with the Sisterhood rather than in the Rossetti family tomb must have added to their sense of loss, for which a curl of hair may not have felt much compensation.

Although William and Gabriel assured themselves that Frances and Christina were adjusting well to Maria's death, they mistook the women's stoicism for recovery. For the seventy six year-old Frances (nicknamed Anne Tique by Gabriel), the Polidori longevity had started to feel like a curse instead of a blessing. In the last month of Maria's life, she had discovered a set of musical accompaniments to her husband's improvisations, a heart-breaking reminder of Gabriele's loss. She had lived to witness the death of her parents, her sister Margaret, her husband and now her daughter. Italian-style living arrangements with extended family had not worked out in the end, and she felt isolated in her Torrington Square house with only the sharp Eliza and gloomy Christina for company. She was keenly aware that Maria had never got the chance to set foot in the house. The lively Charlotte, still employed by Lady Bath, was not permanently resident. Frances had held such high hopes for her children, but her child-rearing theories had not so far produced particularly happy or functional adults. Gabriel's breakdown, Maria's death and William's preoccupation with his own family reinforced her sense of loneliness, which comes across in a poem she did not even have the heart to complete.

No longer hear the welcome sound
Of father's foot upon the ground:
No longer see the loving face
Of mother beam with kindly grace:
No longer hear 'how I rejoice'
At sight of me, from sister's voice:
No longer now from husband hear,
'*Cara Francesca, moglie mia*':
And sorely from loved daughter miss,
'My Dearest Dodo,' and her kiss.[7]

Genuine grief comes through Frances's somewhat halting style. What is striking about this fragment is the way in which it

concentrates on grief as a silent pain, conveying the impression of an echoing, empty house which no longer rings with the sounds of family footsteps and greetings. Though she was doing her best to obey Maria's instructions to avoid melancholy, Christina was also thinking about loss and the passage of time. 'How many years and how many joys and sorrows have overtaken you and me since we first knew each other,' she wrote to Amelia Heimann, 'and how many dear persons have passed out of sight.'[8]

Christmas that year was a sober affair, conducted rather than cel-ebrated at William and Lucy's house. Gabriel and Christina accepted Lucy's long-standing invitation after some graceless fussing over their arrival time, and with the stern proviso that no one outside the family would be allowed to intrude. Lucy respected their wishes. If William's wife remembered, or was aware of, Gabriel and Christina's insensitivity at the loss of her cousin Elizabeth the year before, she gave no sign.

Gabriel's efforts to collect himself for his sister's death and funeral had taken their toll, and the next year saw the beginning of the end. In the first month of the New Year he finally managed to drive away George Hake, much to his brother's chagrin. William wrote an embarrassed letter thanking Hake for his loyal service, as did Christina on behalf of her mother and Eliza Polidori. Gabriel self-righteously composed a list of things he wanted Hake to return, including letters, prescriptions, books and the house keys to Cheyne Walk. With Hake's departure, competition intensified among bidders for the addled Gabriel's affections. While Dunn and Fanny Cornforth squabbled, writer and critic Theodore Watts-Dunton entered the fray. Soon the aspiring writer Hall Caine would stake his claim. Even Christina and Frances got in on the act, though for them the fight was for Gabriel's soul. They nearly succeeded in converting a frail and panicked Gabriel to Christianity, much to Brown's annoyance.

Clearly unwanted, William withdrew. The brothers had not made up in the wake of Maria's death, as had been hoped, though he paid his older brother a tribute in naming his February-born son after him. As if in acknowledgement of the brotherly rift, everyone would refer to the boy by his second name, Arthur, rather than Gabriel. Having enabled his brother's behaviour for years, William came up hard

against the truth of addiction: that an addict will prioritise his vice more above anything, including his family and himself. No matter how many times his family begged him to stop, or Hake was summoned in the middle of the night to squeeze lemon into a soothing glass of claret, Gabriel was not about to give up his chloral. It is an indication of how little was understood about addiction in those years that William cheerfully recommend chloral to Lucy as an insomnia remedy around this time.

Even in his dissipated, irrational state, Gabriel retained his personal magnetism, which was only strengthened by his withdrawal from public life. His neurotic refusal to exhibit and his unwillingness to leave Tudor House were interpreted by a hungry public as further proofs, if any were needed, of genius. Those who listened to him rave about whispering enemies in the street, and who watched him order the construction of sawdust-filled double walls to prevent his neighbours from spying on him in his studio, knew better. He had gained so much weight that he wheezed and panted when he walked. A recurrence of hydrocele, and an operation to drain it, contributed to his sedentary lifestyle, but his reluctance to exercise was also symptomatic of his depression and drug addiction.

It was something of a relief to William when Gabriel went off to Hunter's Forestall, Herne Bay in August, 1877, first attended by Brown and later by Christina and Frances. Summer retreats at Kelmscott were now out of the question, not only because of emotional exposure to Jane Morris, but also because he had worn out his welcome in the neighbourhood; he had not returned since the summer of 1874, when he had accused a harmless group of anglers of insulting him during a riverside stroll. Such antics might be tolerated in the big city, but they created awkwardness in a small, countryside community. William Morris had been relieved to take possession of Kelmscott once again. His friend, the publisher Frederick Startridge Ellis, became Morris's new co-tenant.

Neither the sea air nor the constant ministrations of those who cared for him were enough to restore his health. Jane, fully occupied with caring for her epileptic daughter Jenny, could no longer shoulder the responsibility of looking after an addict. She would later tell a friend that, broken-hearted, she had washed her hands of Gabriel

in late 1875 or early 1876: 'When I found that he was ruining himself with Chloral and that I could do nothing to prevent it, I left off going to him.' She and Gabriel remained close friends, though their love affair was at an end. 'He was unlike all other men', she said.[9] They corresponded for many years afterwards, and she continued to visit on occasion and sometimes even to sit for him. Towards the end of his life, he would assure her that his 'deep-seated basis of feeling' was 'as fresh and unchanged in me towards you as ever, though all else is withered and gone.'[10]

At Herne Bay, Brown blustered that 'I bully Gabriel and that does him more good than medicine'. He shifted the blame for his continued deterioration onto Christina and Frances, complaining that Gabriel was 'more difficult to manage' around them.[11] The painful truth was that Gabriel wanted chloral more than he wanted to be saved, and no amount of bullying or coddling could persuade him now. Although Christina could occasionally rouse him from his depressed stupor to play a game of whist, much of the time he sat in semi-darkened rooms with his head down, shaking so hard he was unable to hold a paintbrush. Though his secretive behaviour made it difficult to estimate, Gabriel's daily dose of chloral was at least 90 grains, three times the recommended amount. Marshall told Frances that it was unlikely Gabriel would survive for very long.

Cayley had alerted William to a lunar eclipse in August, which he watched from his window in Euston Square. It was a rare moment of peaceful reflection in an otherwise hectic life. The eclipse was an apt figure for the Rossetti brothers' role-reversal that summer and early autumn, as William attempted something of a social take-over in Gabriel's absence. He and Lucy hosted 'at-homes' to rival the old days of parties at Brown's and Tudor House, and he did the social rounds on his own. Observers like William Bell Scott found the results mockable, with Lucy 'doing the amiable hostess thing...with everlasting fan in hand.' Although the couple attracted an interesting crowd, they did not have the draw that Gabriel did, amusing Scott one evening with 'a rum lot' of guests who were like 'a collection of incurables' including the blind poet Philip Marston and Charles Cayley, 'who is more shabby and more unintelligible than ever.'[12] Christina still appreciated Cayley's less-than-obvious charms. At the

turn of the year, he had sent her a gift of a 'sea-mouse', a hairy, irides-cent marine worm preserved in spirits. While this doesn't seem like much of a Valentine to modern eyes, in the Victorian era, the creature was considered very beautiful. *The English Cyclopaedia* noted, 'they do not yield in beauty either to the plumage of the hummingbirds or to the most brilliant precious stones.'[13]

Christina, always a fan of riddles, enjoyed decoding Cayley's message. That the sea creature was named *Aphrodita aculeata* after Aphrodite, Greek goddess of love, was significant. The sea-mouse was also timid and well-known for burying its head in the sand, much like a shy poetess they both knew. It was also sometimes called a 'needly Venus' because of its sharp-looking bristles. Prickly Christina was delighted, and composed a poem to commemorate the gift, picking up the themes of her earlier poetic response to Cayley, 'Venus's Looking Glass'. She recognised that the sea creature was a token of love, though she named hers after Aphrodite's Roman equivalent: 'A Venus seems my Mouse'. Like their love, the creature was 'Part hope not likely to take wing, / Part memory, part anything…' Even so, Christina treasured it: 'From shifting tides set safe apart / In no mere bottle, in my heart / Keep house.'

Gabriel's absence that summer gave others a chance to notice William's contributions. Lasenby Liberty, for instance, stopped him on the shop floor to pay him tribute as 'the first pioneer of Japanese art in London.'[14] He was fast-becoming a recognised expert in Romantic poetry, particularly that of Shelley. Along with the Shelley lectures he had delivered at the Birmingham Institute that spring, he was preparing a three volume *Poetical Works of Percy Bysshe Shelley* for publication. He was regularly contributing articles to *The Athenaeum* on Shelley and Italian literature in general. Having written *Poetical Works* of Longfellow, Byron, Walter Scott, Robert Burns, Wordsworth, Keats, Coleridge and Cowper, among others for the Moxon series, he was also working on a companion volume called *Lives of Famous Poets*, and his work was making an impact.

When a young Oxford undergraduate named Oscar Wilde sent him an article he had written on Keats for *The Irish Monthly*, he was disappointed with William's polite but noncommittal reply that he was more interested in Shelley than Keats. Wilde, who assiduously

attended Ruskin's lectures and was trying out remarks such as, 'I find it harder every day to live up to my blue china,' had appealed to the wrong Rossetti brother.[15] Where Gabriel might have encouraged this potential new acolyte, William was uninterested in recruiting knights for his Round Table. Having lost his leader, William was permanently disillusioned with searching for Holy Grails.

Yet his academic quests retained a romantic element. William's research on the Shelley lead him to befriend Edward Trelawny, the biographer, novelist and adventurer who had been Byron and Shelley's friend. Trelawny had famously snatched Shelley's heart from the drowned poet's funeral pyre. Now in his eighties, he gave William what he claimed was a charred fragment of Shelley's skull. Always susceptible to this kind of romanticising, William was enchanted. He wrote to Lucy in raptures from Trelawny's house in Sompting, where he had listened to the old rogue spin yarns as they sat smoking the afternoon away in his kitchen-garden.

He had also visited Mary Shelley's half-sister and Byron's lover Claire Clairmont in Florence. When she asked him to suppress details of her affair with Byron in his upcoming Shelley volume, he agreed. Like much of his writing, it was a restrained and modest contribution. In the end, it was William's politeness that was fatal to his writing, not his lack of talent or originality. This deference was a maternal legacy, a fatal attachment to a kind of upstanding Tory Englishness passed down from the Pierce relatives. It was in evidence when Charlotte destroyed parts of John Polidori's diary that she found inappropriate or scandalous. Her act of censorship was part of a larger project that year to clean up the Polidori family image, an agenda which also saw Charlotte contacting Old St. Pancras to restore John's damaged tombstone.

William was horrified when he discovered his aunt's excisions, but as a biographer, he showed a similar editorial discretion, if not her appetite for destruction. His writing is cautious and unremittingly fair, freighted with qualifications and carefully-weighed hesitations that put one in mind of J. Alfred Prufrock hesitating on the stair. Gabriel had once imitated his brother's voice for a poem he recited to amused friends on William's engagement. 'Monody' sent up his brother's notorious love of understatement, even in high romance:

I can no more defer it,
Conclusions I must tell, –
She's not devoid of merit,
And I love her pretty well.'[16]

The Rossetti siblings tended either to embrace or challenge the tradition of English reserve. Gabriel himself had rejected self-suppression from the start, taking after his father in expressing himself volubly and without compromise, in both art and life. Christina had remoulded this family reserve into a metaphysical philosophy which made her poetic lines practically hum with a suppressed passion. Maria had been deferential to God only, donning her nun's habit as a symbol of her rejection of the materialism of her age and its pressures on women to conform. William, despite his revolutionary politics and democratic sympathies, could not bring himself to rebel openly in his own work, much less in his personal life. If Claire Clairmont wanted discretion and Trelawny craved hero-worship, they had found their man in William Rossetti. Despite his cultivated air of impartiality, his personal connections to people did make him biased, probably all the more because he denied this possibility. Scott recalls William 'shrinking into a mere shrimp' when he discovered that an anonymous binding design he had denigrated in print as 'tastelessly showy and meagrely symbolic' was in fact taken from one of Gabriel's old designs. Scott relished this exposure of William's bias: 'Is not this truly characteristic of Billy's criticism, especially of his own relatives and surroundings?'[17]

William's tireless work on Romantic literature was a displacement of his love for Gabriel. The Shelley biography was the sort of work the brothers would have discussed in the good old days, as when they had helped the Gilchrists with their biography of William Blake in the early sixties. At the time, it was unimaginable that Blake's 'Jerusalem' would become a patriotic, standard hymn in Church of England services. Before the publication of Blake's biography, the inspired artist who gave us the phrase 'England's green and pleasant land', had been widely regarded as an obscure crackpot.

Initially, Blake's illustrations from Dante's *Divine Comedy* had alerted Gabriel to this little-known poet and engraver, but he soon

developed a passion for all his works. Having bought one of Blake's notebooks in 1847, Gabriel was fascinated by the engraver's ability to marry word and image, art and poetry. Whereas Gabriel felt he had to choose between the two arts, Blake had chosen both. Arguably, it had driven him mad, but oh what an inspired madness it was! The Rossetti brothers had collaborated with Alex Gilchrist on his Blake biography, and then helped his wife Anne complete it after her husband's death. It had been a palpable hit for supporters of the Romantics, inaugurating a rediscovery of Blake which would see him become one of England's most celebrated poets. It was memories of these good times, when the Rossetti brothers were a force to be reckoned with, that kept William's affection afloat in the sea of his brothers troubles. Though William had tired of playing his brother's rescuer, his loyalty to their past was unshakeable. Even as Gabriel was turning away his calls, he remained active behind the scenes, organising his care and arranging visits from Gabriel's friends to keep him occupied.

Gabriel's removal to Herne Bay had partially been to keep him away from Fanny, whom family and friends perceived as a drain on his resources, overlooking the ways in which she supported him emotionally. Gabriel soon wrote to advise her that he was withdrawing financial support. At first, this inspired a furious response, but shortly after, the indomitable Fanny opened The Rose Tavern in Jermyn Street with her lodger John Schott. This dramatic bid for independence had its desired effect, and Gabriel was soon backtracking in a panic: 'If you had told me that you meant to take such a step as leaving your house at once, I would much rather have sent you money'. He reassured her that Frances and Christina's plans to move in with him 'would not do' because 'my ways are not theirs.'[18] The Rossettis would not get rid of Fanny that easily. Even when Fanny married Schott in 1879, her visits to Gabriel did not diminish, though she made herself scarce whenever William was due to come over.

Although Brown grumbled about their negative influence on Gabriel, in fact Gabriel's time with his mother and sister revived his creativity. It was the coloured chalk portrait of Frances that did the trick. He declared it 'quite up to my mark', adding that 'I have no longer any doubts as to my being able to work much as heretofore.'[19]

Maternal expectations of success were still a strong motivator, keen enough to pierce the clouds of Gabriel's chloral and whisky stupor. In the portrait, the still-handsome Frances faces the viewer directly, her greying hair framed by her omnipresent peaked white widow's cap. Her unadorned blue-grey dress is buttoned right up to her plain white collar, and the long white lappets of her omnipresent widow's cap trail over her shoulders. Her head and shoulders dominate the space, her sharp blue eyes out-staring any curious viewer's gaze. Gabriel captured something of his mother's troubled state of mind at the time in her steely, unsmiling expression. The smudged chalks and the muted blues and grays lend a maternal softness to this portrait, conveyed also in Frances's wrinkled brow and worried eyes. Gabriel's portrait illustrates his sister's opinion that their mother remained, despite her grief, 'the down-pillow of the group.'[20] The undefined, light blue background has a suggestive, ethereal quality, which is echoed in the gauzy, semi-transparent cap framing her face, making Frances appear simultaneously Puritanical and angelic. While clearly idealised, as Gabriel's work always was, there is something here of the old Pre-Raphaelite truth to nature in this portrait's emotional honesty.

Gabriel also completed a portrait of mother and daughter together, as well as two separate chalk studies of Christina which reveal not only her grief for Maria, but also the toll taken by her recent ill-health. She had aged so dramatically that she and Frances look more like sisters than mother and daughter, and her eyes protrude noticeably. Their faces are drawn side-by-side in three-quarter profile, which draws attention to their familial resemblance, which is echoed in their sober expressions and forbidding air. In her individual portraits, Christina's black dress and elaborate black lace mourning cap seem a violation of Maria's instructions to avoid gloominess. Unlike Frances, Christina does not face front, but is in ¾ profile. Her averted gaze adds to the picture's melancholy mood. She had the image reproduced for her *carte-de-visite*. Cayley certainly thought the portrait was successful, composing a sonnet about it which Scott thought revealed 'the secret throbbings of Cayley's heart.'[21]

Though she was trying to make the best of being in Herne Bay, it had not been a happy holiday. Watching folk remedies such as

rose water and buttermilk fail to bring Gabriel back to his lively old self was hardly relaxing, and the lack of the cheerful Maria only added to the general gloom. In an effort to cheer themselves up, she and Frances had joined the local library and took walks and drives, but each diverting path only led back to an improved, but sleepless Gabriel, and the constant debate about whether to permit or restrict his chloral intake. More grim news arrived in October, with the suicide of Amelia Heimann's daughter Henriette from a chloral overdose, another reminder (if any were needed) of the hazards of drugs and a depressed mind. When they returned to London, she and Frances visited Maria's grave where they found cut flowers and plants left by William and Lucy. They added a winter cherry in full fruit to these tributes.

As Gabriel had feared, the New Year found Christina 'nowhere' without Maria's calming influence. Feminist poet Augusta Webster was the first unfortunate casualty of her tetchy mood at the beginning of 1878. When Webster tried to solicit Christina's support for women's suffrage, she was the recipient of a confused, angry letter which seemed simultaneously to argue for and against votes for women. Webster would have had better luck with William, the only Rossetti who was a feminist. He fully supported votes for women, joining the London Committee for Female Suffrage in the early 1870s, and donating to Barbara Bodichon's campaign to found the first university for women, Girton College, Cambridge. He thought women should have equal rights in education, marriage, earnings and property. For William, feminism was a family affair; he and Lucy attended women's meetings and demonstrations together.

Christina, by contrast, had her doubts about female equality. She reminded Webster that the Bible distinguished between the sexes, and so should society. 'I do not think the present social movements tend on the whole to uphold Xtianity,' she worried. Besides, as women did not fight in wars, it was only fair that they did not have equal representation in legislature. In the middle of the letter, she did an abrupt about-face, suggesting that perhaps Webster had not gone far enough. 'I feel disposed to shoot ahead of my instructress, and to assert that female *M.P.'s* are only right and reasonable.' She further objected to Webster's politics on the grounds that it only extended

the vote to single women. That this was merely a tactical concession to ultra-conservative male law-makers was not apparent to Christina, who was outraged because 'who so apt as Mothers…to protect the interests of themselves and of their offspring?' She went on to praise 'mighty maternal love which makes little birds and little beasts as well as little women matches for very big adversaries.'[22]

Christina was not usually a fan of such domestic Victorian platitudes, nor of confusion in her prose. Webster's request had clearly hit a nerve. Described as Maria's acolyte by Gabriel, Christina was clearly at a loss without someone to follow. She seems to have transferred her intense love and hero-worship of her sister entirely onto her mother, and even an imagined slight on motherhood was enough to trigger an intense emotional response. Her own childless state may also have a been a factor here. She felt guilty for failing to provide a Rossetti grandchild that Frances could raise according to her Church. As much as her mother loved her grandchildren, she worried for their souls: 'The prospect of a rising generation without religious restraint is most painful to me,' Frances wrote.[23] With Maria gone, Gabriel on death's door, and Christina nearing fifty, it was plain that while the Rossetti siblings paid lip-service to 'mighty maternal love', most had avoided becoming parents themselves.

Like Gabriel, Christina did not feel a natural affinity with babies. Nor did she endorse the Victorian view that childbearing was a woman's ultimate destiny. Her support of spinsterhood led to one of her few open arguments with the Bible. She wrote of her impatience with the barren Rachel's complaints in Genesis 31:10: '"Give me children or else I die," was a foolish speech: the children who make themselves nursing mothers of Christ's little ones are the true mothers in Israel.'[24] That said, Christina wasn't always adept as a surrogate mother either. 'I know myself to be deficient in the nice motherly ways which win and ought to win a child's heart,' she wrote to Lucy that summer. She was in trouble for reprimanding a boisterous Olivia during a visit to her aunty and grandmother at Torrington Square. The little girl's nurse reported that Christina's niece had been, as William delicately put it: 'making herself rather more than sufficiently "at home"'.[25] After the incident, it seems Lucy threatened to reduce the visits, and Christina backtracked, pleading

with her sister-in-law not to deprive Frances of Olivia's company. Yet her apology still carried a sting in its tail, as she persisted in calling the child the Anglicised 'Olive' rather than the preferred Italianate 'Olivia', and hoped pointedly that 'some day she comes to love me as well as to be familiar with me'.[26] Christina's severity with Olivia may well have been the relic of a previous generation, which was stricter where child-rearing was concerned, particularly when it came to girls. While being allowed Rossetti intellectual freedom, Christina and Maria had been ruled with a firm Polidori hand in matters of female behaviour and decorum. William's parenting philosophy was self-consciously based on his own father's 'love of freedom', and absolutely rejected his mother's Christianity. He adamantly refused 'to dose' his children with the 'goody-goody' books, and he and Lucy allowed them freedom to pursue religion or agnosticism as they chose.[27]

Although they were sustained by a tight female family circle, Christina and Frances displayed a marked preference for Gabriel Arthur, the first Rossetti grandson, over his older sister Olivia. That such chauvinism was questionable did not occur to them, even though little Gabriel Arthur's namesake was now slowly dying in Cheyne Walk, partially because no one had ever been able to deny this over-indulged first Rossetti son anything he wanted. The double-standard persisted in aunt and unclehood; where Christina was checked for her behaviour towards William's children, Gabriel's lack of interest in his nieces and nephew remained uncritiqued.

Though Christina was ambivalent about her era's sentimental attitude towards children, the self-critical poet worked hard to cultivate sympathy for them. Where she felt indulgence was merited, she gave it unstintingly. For instance, William Stillman remembers that of all the Rossetti family, she was the kindest to his invalid son Russie (named after John Ruskin), accompanying father and son on a trip to the Zoological Gardens. Christina knew what it was to suffer chronic pain, and she also knew that the secrets of its alleviation, however fleeting, lay in stimulating the imagination. She understood that a magical glimpse of a giraffe elegantly making its way through the urban park could be better medicine than the invasive proddings and pokings of the capital's finest surgeons.

She received a dose of such medicine herself, this time administered

by Lewis Carroll. His much-needed letter brought a smile to her face during an otherwise dreary year. He asked her to sign two copies of *Sing-Song*, which he intended to give as birthday presents. Christina confessed herself so thrilled by his admiration of her nursery rhymes that she felt like throwing her books in the air for joy. She was not normally given to such giddy displays, but Carroll's endorsement of her children's poems had countered the insecurity she had been feeling as both a children's writer and a childless woman. Hearing from him had returned her to her own past, when the Rossetti family had been at the height of its powers. She updated him on Maria's death, her own illness and William's marriage, confessing to Carroll that the Rossetti family was 'many ways changed since a certain summer day in the Cheyne Walk garden.' Discretion or distress kept her from mentioning Gabriel at all.[28]

William was trying to remain circumspect about his brother, whose continued absence from the London scene meant William was thrust reluctantly into the limelight. He was asked to testify in an influential art-world case, Whistler v. Ruskin. Whistler had brought libel charges against Ruskin for his review of *Nocturne in Black and Gold: The Falling Rocket*, a challenging painting of fireworks at the notorious Cremorne Gardens, Gabriel and Whistler's old stomping grounds. The painting, in which the fireworks were represented as tiny gold flecks in a smoky sky so dark it was practically indistinguishable from the murky river, pushed the boundaries of Victorian taste in both subject matter and treatment. An almost abstract portrayal of an industrial, Thames-side scene, it had neither a message nor a narrative, but was more a study in the effects of colour, light and atmosphere. Ruskin dismissed the painting, and Whistler, entirely: 'I have seen, and heard, much of cockney impudence before now; but never expected a coxcomb to ask two hundred guineas for flinging a pot of paint in the public's face.'[29] Whistler was pushing an Aesthetic agenda, completely apart from mid-century notions of 'truth to nature' propounded by Ruskin and the Pre-Raphaelites. 'To say to the painter that Nature is to be taken as she is, is to say to the player, that he may sit on the piano,' Whistler would later remark.[30] The painter won the case in the end, but was only awarded a farthing in damages. Yet he had succeeded in starting a much-needed debate about the purpose of art in a rapidly changing world.

Gabriel's opinion on the matter was that the paintings in question were not Whistler's best, but that Ruskin had gone too far in his critique. It was William, not Gabriel, who was called as an expert witness on behalf of the prosecution, confirming his value as one of London's most important art critics. Earlier that year, he had been very much in the running for a post as Secretary to the National Gallery, though he ultimately lost out to designer Charles Eastlake, whose uncle had been the Gallery's first Keeper. Unfortunately, the trial played into the diplomatic William's greatest nightmare: he had to come down firmly on one side. He did not want to cause trouble for former Rossetti family-friend Ruskin, but at the same time felt he had to defend Whistler's painting, and so was evasive in his testimony. Sir John Holker's exasperated cross-examination finally forced him to proclaim definitively that Whistler's painting was indeed a legitimate work of art worth the asking price of £200. That it took an English court of law to force William Rossetti to take sides reveals the depths of his need to please. After the trial, he wrote to Ruskin to apologise, explaining that he had not volunteered as a witness, but had been compelled. A week later, he and Lucy went to breakfast at Whistler's house.

William's public performance could not hope to compete with Gabriel's private one. The more reclusive Gabriel became, the more he stimulated curiosity. Where other painters such as Burne-Jones, Whistler and G.F. Watts garnered publicity from exhibiting at the newly-opened Grosvenor Gallery, Gabriel got just as much attention from declining to exhibit, particularly as even the Pre-Raphaelite old guard, Hunt and Millais, were showing work there. Opened by Sir Coutts Lindsay on New Bond Street in 1877 as an alternative to the Royal Academy Exhibition, the Grosvenor quickly became known as the premier showcase for Pre-Raphaelite and Aesthetic work. The interiors were done in green and gold, a colour scheme immortalised in Gilbert and Sullivan's *Patience* which pokes fun at the 'greenery-yallery, Grosvenor Gallery'. Aestheticism was originally a derogatory term deriving from the conservative critique of 'fleshly' art and poetry. Aesthetes' interest in surface beauty, eroticism and artistic melancholy was viewed by their critics as unhealthy and morbid. That women were often the consumers of this new art reinforced this reputation.

Taking a leaf out of Lasenby Liberty's book, the Grosvenor's

exhibition rooms were set up to mimic intimate domestic spaces, complete with oriental rugs and sumptuous draperies. There was even a refreshment room. The Grosvenor also exhibited women's painting, including works by Stillman's wife and Brown's pupil, Marie Spartali, who was also modeling for Gabriel. Located square in the middle of the Bond Street shopping district, this feminised environment was designed to attract the wealthy, 'artistic' female customer who bought her silks and china from Liberty, and regarded her house as a work of art. The Grosvenor created a brand identity that helped consolidate the disparate aspects of first and second generation Pre-Raphaelitism and Aestheticism. Henry James recognised that 'In so far as these beautiful rooms in Bond Street are a commercial speculation, this side of their character has been gilded over and dissimulated in the most graceful manner,' proclaiming the gallery 'an artistic enterprise of an unusually brilliant sort'.[31]

Gabriel's old Pre-Raphaelite brothers Hunt and Millais were making more money, but even in his drug-addled state, Gabriel was still exercising his influence, making himself conspicuous by his absence. *Macmillan's Magazine* spoke for everyone when it declared: 'it is much to be regretted…that one remarkable painter whose praise is loud on the lips of those who are admitted to familiarity with his works, should not have availed himself of the same opportunity'.[32] *Macmillan's* captures the essence of Gabriel's new popularity: his exclusiveness and sense of mystery. 'Those who are admitted to familiarity' with Gabriel's works were encouraged to think of themselves as a select, discerning group within an already exclusive circle of art connoisseurs. In an age when everything was becoming more available, Gabriel's inaccessibility made him special. He confessed to Jane that he avoided exhibiting because of insecurity, fearing unfavourable comparison with his peers, but his fans were happy to imagine more romantic explanations.

Gabriel's mysterious ways intrigued Aesthetes like Oscar Wilde, who eagerly sent him a copy of his first *Poems*, 1881, hoping for an invitation to Cheyne Walk. Bound in white vellum decorated with a gold floral design, the binding self-consciously referenced the cover of Gabriel's 1870 *Poems*. One poem, 'The Garden of Eros', paid more obvious tribute:

For One at least there is,– He bears his name
From Dante and the seraph Gabriel,–
Whose double laurels burn with deathless flame

Gabriel, who was nervous enough with his designation as the leader of the 'fleshly school', rebuffed Wilde. He told Jane that Wilde's 'wretched' poems were 'trash', and that Burne-Jones must have 'gone drivelling' for admiring them.[33] Gabriel did not regard himself as an Aesthete, with all its connotations of radical unmanliness, and was quick to disassociate himself from the Aesthetic movement he helped to inspire. Years after his brother's death, William was still insisting on 'the masculine traits of his character', and denying that he was 'a pallid and anaemic "aesthete"'.[34]

Yet there was no escaping this association. In the same year that Wilde sent Gabriel his poems, Gilbert and Sullivan's *Patience, or, Bunthorne's Bride*, an operetta parodying the Aesthetes, premiered to a rapturous reception at the Opera Comique. Before the year was out, it would transfer to D'Oyly Carte's new Savoy Theatre, taking its place as the first production in the world to be lit entirely by electricity. This 'original Aesthetic opera' featured a pretentious 'fleshly poet' named Bunthorne and an 'idyllic poet' named Grosvenor, both competing for the love of the same woman. Bunthorne is a self-confessed 'aesthetic sham' who recommends walking 'down Piccadilly with a poppy or a lily in your medieval hand,' while Grosvenor is prone to overblown declarations such as 'I have loved you with a Florentine fourteenth-century frenzy...'

In 1882, D'Oyly Carte would send Oscar Wilde on a lecture tour of America to help promote the show, forever linking these characters with Wilde in the public mind, and launching him as Aestheticism's ambassador. The mockery of fleshly poetry, medievalism and Italy make it clear that the creators originally had the much more famous Gabriel Rossetti in mind. Bunthorne and Grosvenor are also an obvious amalgam of prominent figures associated with Aestheticism at the time *Patience* was written, including Swinburne and Whistler.

The glum, depressed and paranoid Gabriel interpreted the production as a personal attack. William thoroughly enjoyed *Patience*, and argued that its satire was not aimed at any artist in particular. While

that may be true, there were certainly uncomfortable parallels with Gabriel, or at least the version of him presented by his severest critics. Worshipped by pretty 'damozels', Bunthorne describes his poetry as 'a wild, weird, fleshy thing; yet very tender, very yearning, very precious.' Yet he confesses that 'my medievalism's affectation, / Born of a morbid love of admiration!'[35]

In light of the Rossetti brothers' stand-off, it is no wonder that William admired *Patience*. Laughing along with the Opera Comique audience at the foibles of the self-regarding poet Bunthorne was cathartic. There was also some satisfaction to be found in the triumph of Archibald Grosvenor, who gets the girl when he rejects his artistic inclinations and transforms himself into someone rather more like William Rossetti:

> A Chancery lane young man,
> A Somerset House young man,
> A very delectable, highly respectable
> Threepenny-bus young man![36]

The opera's happy ending, where the 'fleshly poet' apologises for his moody, selfish disposition and promises to reform, would have touched the Somerset House man in the audience, hoping against all odds for such a change of heart in Gabriel.

William was working on a collection of political sonnets at the time, and *Patience*'s parody of fashionable Aestheticism spoke to his own newfound impatience with the doctrine of 'art for art's sake'. Like his father, William felt that it was poetry's job to intervene in current affairs and attempt to change the political climate. Gabriel rejected this paternal inheritance, and said it was inappropriate and ill-advised for a civil servant to challenge the status quo. He argued that there was a conflict of interest between William's government job and his liberal sympathies, warning that radical poetry was 'most objectionable when coming from one who depends on the government for his bread.'[37] This accusation of hypocrisy stung.

Christina and Frances, who were staying at Cheyne Walk at the time, had held many anxious conferences on the subject with Gabriel. They agreed with Gabriel that William should not publish,

though William dismissed their anxieties because of 'Mamma's great age' and 'Christina's isolated devoteeism'.[38] Their anxiety had a more rational cause than he allowed: the memory of the ruin brought upon the Rossetti family by Gabriele's political extremism. The Rossetti patriarch's career had been wrecked by his obsession with revolutionary politics, and they had no desire to see history repeat itself in his youngest son. Though he disagreed with Gabriel, William deferred to his brother as always, shelving the publication of *Democratic Sonnets*. Perhaps the birth of his twins that spring, Michael Ford Madox and Mary Elizabeth Madox, made him wary of courting controversy. Yet he fumed silently, resenting his brother's interference.

Gabriel was spoiling for a fight, snarkily pointing out that William's successful lecture series *Wives of the Poets* should emphasise the fact that happily-married poets were conventional and unpoetic. This was self-serving criticism; Gabriel was reassuring himself that his own bad marriage and hopeless love for another man's wife at least had artistic merit. As if to prove it, he was putting together a new volume of poems, *Ballads and Sonnets* which contained poems inspired both by Lizzie and Jane Morris. Gabriel further annoyed William by asking his younger brother to correct the proofs, then ignoring most of his suggestions. William dutifully continued to visit Gabriel once a week, a habit he had forced himself to adopt in 1879, after a long interval of mutual avoidance. His heart was no longer in it, and he was at his wits' end with Gabriel's chloral addiction and drinking.

Gabriel's belief in the artistic merit of unhappy marriages was shored up by his identification with Dante Alighieri, whose marriage to Gemma Donati had been unable to compete with his unconsummated passion for his muse, Beatrice. Along with writing poems, Gabriel was making changes to *Dante's Dream*, his largest painting at 6 by 10 feet, originally commissioned by the wealthy wine merchant and port shipper William Graham. A Scottish MP for Glasgow, Graham was one of Gabriel's most enthusiastic patrons, but even he could not accept a picture which was too big to display in his house. This white elephant had been taking up studio space at Cheyne Walk ever since 1871. While there had been some talk of showing *Dante's Dream* at the RA, in the end the new money from the Industrial

north carried the day when the painting was purchased by the city of Liverpool. Gabriel was as agitated about the exhibition of this painting as he was about the publication of his *Poems and Ballads*. It was an old-school Pre-Raphaelite production, in the sense that the models were mostly family friends. It showed Beatrice (Jane Morris) reclining in death, while the figure of Love bends to kiss her, holding hands with Dante (Stilllman / Howell) while two colourfully draped attendants (Alexa Wilding and Maria Spartali Stillman) look on. Compared to the 1856 watercolour version done for Ellen Heaton, the painting is also a radical update. Its proportions weren't the only thing that had gone giant. The attendants, now swathed in subdued shades of 'greenery-yallery', rather than emerald green and purple, boasted the square jaws and wavy hair so beloved by the middle-aged Gabriel. Jane Morris had modelled for the swan-necked Beatrice, whose blissful expression recalls Lizzie's erotic swoon in *Beata Beatrix* rather than Mrs. Hannay's serene visage in the 1856 *Dante's Dream*. The figures are no longer hard-edged and flattened after early Pre-Raphaelite iconography, but are fleshed out with curves to which Robert Buchanan would no doubt have strongly objected. The symbolism too had been magnified in this chamber of death and dreams; there was a greater abundance of fleshy red poppies strewn across the floor, an apple blossom to signify consummation in death, two birds glowing red with love, a ring of red angels hovering over the Florentine cityscape glimpsed through the chamber's roof. The network of imagery was so dense that Gabriel wrote a note for the Liverpool exhibition catalogue to help viewers untangle it. The picture's poppies and birds had been imported from his tribute to Lizzie, *Beata Beatrix*, but this time these messengers of death had come for Gabriel.

Gabriel's renewed productivity had given the family hope that he was recovering his health, but by 1881 things took a turn for the worse. He was hearing voices again, and his paranoia was on the increase. The loyal Dunn, who was owed back-pay, was sent packing that spring. Repeating his pattern with George Hake, Gabriel demanded the return of his keys, and requested that the man he once described as his 'guardian angel' never contact him again. While Christina conceded that Gabriel was best-placed to criticise Hake and Dunn, she gently reminded her brother of their good qualities, going so

far as to invoke Maria in their defense: 'I recollect our good Maria once remarking that one never understood a person unless one liked him…'[39]

That summer, Hall Caine moved into Cheyne Walk and took over Dunn's old duties, which included competing with Fanny for Gabriel's favour. Fanny's husband did not seem to mind all the time she spent at Cheyne Walk, probably because at this stage Gabriel was more a source of cash than romantic competition. The Rose Tavern was failing, and Gabriel's friends were convinced that Fanny was after his money. In any case, Gabriel was far too unwell for sex, and, if Caine is to be believed, his recurrent hydrocele had rendered him impotent for years. Fanny offered him the consolations of nostalgia, if not sexual solace. Shadows of their younger selves trailed the middle-aged Fanny and Gabriel around the garden at Cheyne Walk, reminding them of the golden-haired beauty who had once laughingly spat nutshells at the dashing young painter beneath the gaslights of the Cremorne Gardens. If Fanny presumed on their shared history, she was encouraged by Gabriel himself, who had once declared, 'you are the only person whom it is my duty to provide for, and you may be sure I should do my utmost as long as there was breath in my body or a penny in my purse.'[40]

According to Caine, she took this very literally, attempting in Gabriel's last days to manipulate him into willing his entire estate to her. Fanny's brand of mercenary materialism had always amused rather than offended Gabriel. As Scott pointed out, 'he is generous of what he does not value – money'.[41] But the last straw came when Fanny slandered Watts, and Gabriel barred her from further visits, much to Caine's satisfaction.

Gabriel's final days were marred by an undignified jockeying for position among those caring for him. Within his family, this manifested itself in the battle for his soul. Overwhelmed by terrible, unappeasable guilt about his father, Gabriel asked to see a Roman Catholic priest. The Rossetti patriarch had been dead for nearly thirty years, but still loomed large in his eldest son's imagination, and, aided by chloral dreams, he started reliving and regretting their clashes during his youth. The parallels between Gabriel's decline and his father's death were striking. Paranoia, psychosomatic blindness and

deep depression plagued both father and son, and for the first time, Gabriel felt something like empathy for his father's struggles, and regret about his own rebellious behaviour.

Hoping against hope that the request for a priest betokened the death-bed conversion the Rossetti women had long been praying for, Christina urged her brother to unburden his soul. She told him that she had 'gone through the same ordeal', having 'borne myself till I became unbearable by myself, and then I have found help in confession and absolution and spiritual counsel, and relief inexpressible.'[42] Gabriel was far beyond being helped by a friendly chat with the local vicar. There were key differences between Gabriel and Christina's struggles with mental health. It was true that Christina showed the family tendency towards depression and self-hatred, but hers had been neither exacerbated by a severe substance abuse problem nor excused by favouritism. Though she still lived with her aging mother and Eliza Polidori, she was as much their primary carer as their dependent, and with that responsibility came a greater sense of self worth. This was augmented by her religion, which she was exploring seriously in middle age, producing authoritative devotional writings and considering deep metaphysical questions. Religion was a source of strength, and she believed its power could help Gabriel in the same way it had helped her.

Eagerly, she discussed with William the possibility of sending, not a Roman Catholic priest, but the trusty Anglican Burrows of Christ Church, Albany Street. Alarmed, William intervened, reminding Gabriel that if he wanted absolution for his sins, he would not be able to get out of doing proper penance. In order to be forgiven, he must be sure that he really believed, and be prepared to demonstrate his commitment via regular religious observance and the making of amends. William knew how to appeal to his brother. Gabriel's response to his sister does not survive, but no priest was summoned.

A few days later, Gabriel suffered a stroke which paralysed his left side. His doctors limited his whisky to one glass per day, took him off chloral and started injecting morphine directly into his wrist. Unsurprisingly, this method made the situation worse. He began hallucinating documents and conversations, sometimes speaking in an incoherent mix of English, Italian and French. His speech was slurred

and his left arm hung useless at his side, despite treatment with a galvanised arm-band believed to administer electrotherapy. He was in such a state that only William could visit at Christmas. Heartbroken, Frances refused Lucy's holiday invitation, and withdrew for muted festivities at Torrington Square. The message was clear; not even five grandchildren were enough to take Gabriel's place.

At a loss, Dr. Marshall fell back on a classic medical cure-all; a change of air. Accompanied by a nurse called Mrs. Abrey and Caine's thirteen year-old sister Lily, Gabriel and Caine moved into a rent-free bungalow at Birchington on Sea near Margate in Kent. Though he was dying, Gabriel's charm was still alive. During the train journey, he did his best to entertain Caine's little sister, pretending that their carriage had been designed just for them. He explained that the London, Chatham and Dover Railway insignia on the carpet ('LCDR'), stood for Lily Caine and Dante Rossetti.

The bungalow was a detached one-storey building with an airy verandah, and rooms located on each side of one long corridor, an easily navigable set-up was ideal for an invalid. Gabriel chose the back bedroom, using the dining room as a studio. A large garden and private beach access were also provided. Gabriel's bungalow was one of a number of marine villas designed by the Rossettis' old PRB friend John Seddon, an architect whose newest development capitalised on the late nineteenth century taste for private holiday homes by the sea. Loosely inspired by similar structures in India, these isolated bungalows provided middle-class holiday-makers and invalids with a stylish alternative to the overcrowded resort towns like Margate. Far from the crowds of 'German bands', 'distressing niggers on the shore' and 'revolting donkey-drivers' the bungalow-dweller could enjoy an 'uncontaminated playground' and a 'secluded sanitorium' in peace.[43] Gabriel stayed in the modestly-named Westcliff Bungalow, but others in Seddon's development were given artistic names to attract those who fancied themselves part of the metropolitan cultural elite: 'Shakespeare', 'Gainsborough', 'Spenser,' 'Constable'.[44] It was ironic that Gabriel, one of the promoters of the unique beauties of the Arts and Crafts household, would die in a purpose-built, bourgeois development. William noted wryly that it was comfortable, 'but not a sort of palace for bloated oligarchs.'[45]

The railway system facilitated a steady stream of friends to keep him amused. Howell was forgiven all his indiscretions when he pulled out all the stops during his spontaneous visit. He and Gabriel had previously fallen out over Gabriel's suspicions that Howell had been selling forgeries of his works, cunningly copied by Howell's mistress. With the 'face of a whipped cabhorse', Howell may have been looking the worse for wear, but he amused Gabriel with his gossip, outrageous exaggerations, and delusions of grandeur. When he claimed to be buying horses for the King of Portugal, Gabriel laughed so hard he nearly fell out of his chair. He also chuckled grimly at the black humour in Howell's joke about a clergyman coming to visit a man on his deathbed. "Dear friend, do you know who died to save you?" asks the clergyman. He is taken aback by the dying man's reply: 'is this a time for conundrums?'[46] Perhaps unsurprisingly, the local rector, Mr. Alcock, was politely but firmly discouraged when he came to call on Gabriel.

Gabriel had wanted Christina and Frances to come down with him, and spent January and February repeatedly exhorting them to visit, pointing out that Birchington was only a little more than 2 hours out of London by train and chaise, and importing a chair identical to Frances's favourite at home in anticipation of her arrival. These letters are an unconscious echo of his mother's pleas for him to visit more frequently in earlier, happier days. When they did make plans to come in February, Gabriel, worried by his own state, put them off. His mother and sister were delayed by bad weather and winter colds until March. The family was also suffering from compassion fatigue, of which Christina was guiltily aware. 'It is trying to have to do with him at times,' she admitted to William, 'but what must it be *to be* himself!'

Gabriel attempted to work, though illness had forced him to abandon his paintings of *Proserpine* and *Joan of Arc*. In his last days, Gabriel was still trying to work out his relationship with his father. His last drawings were sketches of his father for a proposed monument at Vasto. A surviving sketch shows Gabriele straight-backed and in his prime, wearing a dashing frock coat and smart cravat. Gone was the omnipresent visor and what Christina called the 'menacing look' of their father's old age, replaced with a look of

benevolent confidence.[47] Gabriel's attempt to reclaim the past was also evident in his return to 'Jan Van Hunks', his unfinished ballad begun in 1846. William saw some irony in his dying brother's desire to revisit a tale about a self-destructive man being dragged down to hell after losing a smoking duel with the devil. It was a mark of how much their relationship had deteriorated that William was not by his side during his last months. When he did visit in early April, he was clearly shocked by Gabriel's state, but worried at the same time that his hypochondriac brother might be crying wolf. 'I think he fancies himself…more incapable than he is,' William reported to Lucy.[48] A week later Gabriel was dead.

Attended by his mother, Christina and William, he had cried out and gone into convulsions before dying of kidney failure on 9 April, 1882. That his death was expected did not make it any easier to endure. Caine noticed that Frances took it particularly hard: 'It was impossible to attempt to console the sweet old lady without feeling that we were holding out our hands to her in the dark.'[49]

He was surprised that the family did not discuss burying Gabriel at Highgate, but seemed content to lay him to rest in Birchington churchyard, near a path where he and Gabriel had taken walks on first arriving. They were in fact respecting Gabriel's wishes, though it is difficult to determine whether this was intentional. He had left specific instructions about his death in a letter to Hake: 'Let me not on any account be buried at Highgate', further requesting that he be cremated and that no cast be taken of his head and hand (a customary tribute to artists).[50] While the family did not bury him at Highgate, they did authorise a cast of his head and hand and buried rather than burned his body. It is impossible to determine whether they were aware of his instructions to Hake, or whether indeed his wishes had changed in the five years since they were written. As Jan Marsh suggests, Gabriel's letter may have been temporarily misplaced during the chaos of Hake's departure. Furthermore the precedent for legal cremation was not set until two years after Gabriel's death, so it is unlikely that the upright, law-abiding Rossettis would have wished to turn Gabriel's funeral into a test case for cremation reform. In any case, Frances and Christina's beliefs about the body remaining intact for Resurrection would have mitigated against cremation.

Whether burial at Birchington was chosen for reasons of convenience, defiance, faith or simple emotional exhaustion, it is curious that a family so insistently self-defined by notions of family should agree to exclude two of its important members (Gabriel and Maria) from the family tomb. The reasons Gabriel was averse to the Rossetti family tomb are also unclear. Was he avoiding Lizzie, as is often popularly assumed? Or was the adamant refusal to be buried in the family tomb a final gesture of defiance toward his father? Perhaps, like Maria's decision to be buried with her Sisterhood, it was an assertion of extra-familial identity.

A light drizzle had fallen on the day of the funeral, but abated for the burial. The plot was close to the south porch, recalling the opening lines of Gabriel's 'The Church Porch' sonnets, written for his sisters so long ago:

> Sister, first shake we off the dust we have
> Upon our feet, lest it defile the stones
> Inscriptured, covering their sacred bones

Officiated by Mr. Alcock, the funeral ceremony was even more simple than Maria's, and smacks of Frances and Christina's influence. Frances left a floral tribute of woodspurge and forget-me-nots which Christina had collected in the grounds, and accepted the sympathies of other attendees, including Alexa Wilding and Liverpool ship-owner and loyal patron Frederick Leyland. Known for patronising and encouraging Pre-Raphaelites and their associates, this 'modern-day Medici' was also Gabriel's friend.[51]

Notable among those absent but invited were Burne-Jones, Scott, Swinburne, Hake and Dunn. His aunt Charlotte was there, but Eliza was not well enough to make the trip. The old guard from the early days of the PRB were represented by Frederic Stephens, John Seddon and George Boyce, while newer acolytes included Hall Caine, artist Frederic Shields and writer William Sharp. Not everyone thought this sparsely-attended ceremony was a fitting tribute. 'If my brother had his due he would be buried in Westminster Abbey,' William groused.[52] His grief would be delayed; for the moment the unbearable sadness was rechanneled into anger and self-protection. When

Fanny wrote to ask if she could pay her last respects, he denied her: 'The coffin had been closed last evening, and the funeral takes place early this afternoon – there is nothing further to be done' he wrote callously.[53]

It was the silence everyone noticed after Gabriel was gone. Returning to London, Frances added two lines to her unfinished sonnet commemorating the deaths in her family: 'I never more shall hear him speak / The dearly loved who called me Tique.' Returning to Cheyne Walk, Caine could hardly believe how his steps echoed around the empty house, and he half-expected to hear Gabriel call out for him from another room. The departure of a larger-than-life character like Gabriel had left a void. Even Morris, who had hardly been his biggest fan of Gabriel's in his later years, remarked on this sense of absence: 'he has left a hole in the world'.[54]

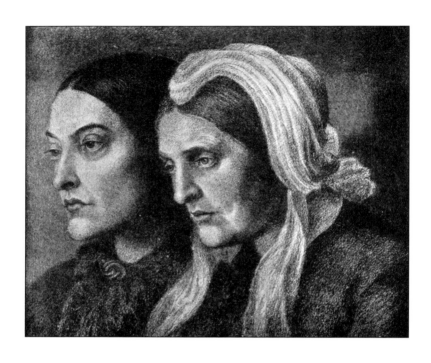

Dante Gabriel Rossetti, *Christina and Frances Rossetti*, 1877

Chronic health problems and the loss of Maria and Gabriel had aged Christina so dramatically that she and Frances began to look more like sisters than mother and daughter.

12

AFTERLIFE

If people were intrigued by Gabriel when he was merely a recluse, their curiosity multiplied exponentially once he became unreachable in death. The cemetery keeper at Birchington noticed increasing numbers of female pilgrims to the painter-poet's gravesite, one of whom swooned beside the unmarked turf. Competition to control his posthumous reputation intensified among those who had known Gabriel. Hall Caine and William Sharp were quickest off the mark with their respective biographies; *Recollections of Rossetti* and *Dante Gabriel Rossetti: A Record and A Study* appearing six months after the burial. Watts was next, comparing Gabriel's 'influence throughout the entire world of English taste' to 'the influence of Darwin throughout the entire world of English thought.'[1] Dunn too produced a memoir of his days at Cheyne Walk, though it was not published until after his death in 1903.

From January to March, Leyland volunteered his Rossetti pictures for an exhibition of 84 works at the Royal Academy, while the Burlington Club hosted a viewing of 153 of Gabriel's pictures. Even this caused some grousing. William remarked on the irony of the Royal Academy only recognising (and profiting from) his brother in death, and Brown's son-in-law Francis Hueffer wrote a *Times* article implying that the pictures had deliberately been hung badly. Many viewers enjoyed the opportunity to see works of a painter known for his refusal to exhibit. Lewis Carroll visited the Royal Academy twice and the Burlington once, armed with the free ticket Christina had given him. He was particularly moved by Gabriel's unfinished *Found*, 'one of the most marvellous things I have ever seen done in painting.'[2]

In May, Christina received an invitation from a Mr. Schott to attend a small exhibition of her brother's works at the newly-opened 'Rossetti Gallery' in Old Bond Street. From the way she innocently asked about Mr. Schott, it seems that Christina remained largely in the dark about Fanny's dealings with Gabriel. Though he went to see it for himself, it is safe to assume that William discouraged his sister from patronising Fanny's husband's latest money-making scheme. In August 1883, Ruskin delivered two lectures at Oxford discussing Gabriel's work. Though not all he had to say was laudatory, the lectures made it clear that Gabriel was a significant force in the art world, and helped consolidate his reputation as an important influence on the art of the next generation. Ruskin's lectures set the tone for future evaluations of Gabriel's work; while critics still disagree on whether he had the talent and genius his circle so often ascribed to him, few would deny that his life and work were influential.

The June auction of Gabriel's possessions at Tudor House turned out to be a flashpoint for power struggles among his friends. Scott was disgusted by reports of the unsettling spectacle of William sitting alongside Howell, Fanny and 'other members of that infernal circle' presiding over the sale.[3] Money had to be raised to pay off Gabriel's debts, which included unfinished commissions for various patrons. Scott felt that William's management of the affair was penny-pinching and petty, and when he was offered worthless keepsakes such as a shawl pin, a black pot and a plated buckle, Scott lost his temper so badly that he had to be placated with Gabriel's cast of Keats's head. Henry Tebbs, a patron who had been present at Lizzie's disinterment, reported that items were priced too high. Tebbs purchased a picture by Thomas Seddon, who had died tragically during an 1856 painting tour of the Middle East. William mentioned that if the painting had gone for less, he would have bought it himself to present to Seddon's surviving brother John. Tebbs thought the comment in bad taste, as it was John who had generously provided the dying Gabriel with a rent-free bungalow for the last three months of his life.

William's stoicism started to show hairline cracks when Fanny predictably surfaced with an IOU for £300 from his brother. Upon investigating, William was shocked to find that Gabriel had been deceiving him for years as to how regularly Fanny was at Tudor House.

This confirmed William's worst fears; he had not been immune to his brother's manipulations. This, more than the money, was at the heart of William's uncharacteristic vehemence when he discussed the matter with Watts. It was easier to blame Fanny than his brother. He suggested 'one might *terrorize*' Fanny with 'awkward questions' over her claim that Gabriel had given her his portrait, painted by George Frederic Watts. William fantasised about reclaiming it from Fanny and snarling, 'what becomes of your pretty little subscription for the engraving from that portrait'?[4] In the end, the Schotts hired a lawyer and William settled with them in exchange for their promise to pursue no further claims on the estate.

Among the remaining members of the Rossetti family, the fight for Gabriel's soul continued. Leaving Eliza at Torrington Square to oversee home renovations in July 1883, Frances and Christina spent a morbid summer holiday at Birchington where they were proud to discover that Westcliffe had been rechristened 'Rossetti Bungalow'. A frustrated correspondent wrote to *The Times* to complain that the Birchington grave had no tombstone, but it was not until July 1884 that a tall Celtic cross was erected to mark the spot. Designed by Brown, the white sandstone memorial dominated the cemetery, a fitting tribute to a man accustomed to holding centre stage. It was decorated with bas-reliefs representing St Luke, Dante and Beatrice, and the temptation in the Garden of Eden. William had argued that such blatant Christian iconography was 'not the most appropriate' for Gabriel, but Frances and Christina got their way in the end. Having lost Gabriel, the agnostic William was now outnumbered. There was also the rector Mr. Alcock to contend with, as he had final approval. Gabriel might have rejected Alcock's beliefs in life, but the rector was keen to gather this stray sheep in death. Through gritted teeth, William agreed to the cross, but registered his protest by refusing any further involvement in the plans for the monument, 'my only part in it being the payment of the cost.'[5]

William had also envisioned two stained glass windows to be designed by Frederic Shields and chosen and paid for by Gabriel's friends, but this project too was quietly taken over by Frances and Christina, again for religious reasons. Mr. Alcock primly rejected the first design. It was taken from Gabriel's *Mary Magdalene at the Door*

of Simon the Pharisee, which boasted a voluptuous Magdalene being admired by an adoring crowd, including Christ, whose halo shoots forth enthusiastic sparks that look suspiciously unholy. Mr. Alcock was not interested in its artistic merits: 'I do not think this picture is likely to inspire devotional thoughts and feelings, and fear that in some cases it might rather do the reverse.'[6]

Shields ultimately chose Gabriel's more family-friendly design for the two-light window, *The Passover of the Holy Family: Gathering the Bitter Herbs*, an ironically appropriate topic, given the bitterness the memorial project was causing between William and his mother and sister. The other light was from Shields's own design, depicting Christ healing the blind man of Bethsaida, though what this subject had to do with Gabriel was anybody's guess. Realizing that there was no getting around Mr. Alcock and the Rossetti women, William and Gabriel's friends abandoned the idea of a second window and instead started a subscription for a bronze memorial fountain in front of Tudor House, which would include a drinking-trough for the capital's thirsty dogs. It was clear that Gabriel was viewed very differently by his friends and William than by his mother and sister. The London and Birchington memorials both caught different aspects of Gabriel's personality: the reclusive, contemplative mystic and the warm urban socialite.

It was important to the family to banish the memory of the weakened, morose Gabriel, and to restore the image of the man in his prime. Christina had been upset by Caine's biography, which she felt presented her brother at his morbid, unglamorous worst. She set herself the task of chasing down another important memorial to Gabriel, the photographs taken by Lewis Carroll at Cheyne Walk. Having read about Gabriel's death in the paper in August, Carroll visited her in October, and promptly sent her print portraits and a negative, to which he signed over the copyright. By the following summer, she was able to proudly present Mr. Martin, a helpful and kindly Birchington hotel manager, with a photograph of the 35 year-old Gabriel, 'taken by the author of "Alice in Wonderland"'.[7] Sporting beautifully-draped trousers, a smart waistcoat, an unbuttoned over-coat, clean-shaven cheeks and a beard and moustache, Gabriel looked every inch the successful bohemian artist. Legs crossed, he lounged in

a chair, holding the brim of a hat in his left arm, his expression hovering somewhere between sleepy and amused. Seeing her brother at his charming best again, Christina felt mixed emotions: 'Photographs seem a sort of ghost...'[8] The photograph proved a valuable tool for rehabilitating her brother in the public mind. Reproduced in countless poetry collections and anthologies, it would become one of the best-known portraits of the artist.

Even after the memorials were settled on, divisions in the family persisted. Gabriel had worried about the repercussions of Maria's death, but he had underestimated his own role in holding the family together. Although his role as *paterfamilias* had been symbolic at best, with the real grunt-work being done by William, symbols were just as important in the Rossetti family as reality. Even when he was inarticulate, paranoid and half-paralysed with his kidneys shutting down from alcohol and chloral abuse, Christina told William she considered Gabriel 'in so many ways the head of our family'.[9] If William, who deserved this accolade, was provoked by her remark, he did not show it, except perhaps by largely remaining in London during his brother's last weeks. Frances and Christina found it difficult to shift their loyalties to William, though rationally they knew he was a trustworthy custodian of his brother's legacy. When William asked Frances to sort through Gabriel's letters, with a view to publication, Frances flatly refused. Saying she had already broken down once in the attempt, she made him wait until November.

Christina was, to some extent, liberated by the deaths of her two eldest siblings. Without the expert Maria looking over her shoulder, and in the absence of Gabriel's editorial interference, she became more confident in her religious writing. She stepped up her publications with the Society for the Promotion of Christian Knowledge (SPCK), which were religious prose works interspersed with poetry. This was done with an eye to the Christian market, which she knew well, but her increasing commitment to devotional work also reflects greater self-knowledge. Her heart and intellect were best engaged by religious writing and thinking, rather than by Gabriel's Pre-Raphaelitism or Maria's spiritual commitment. No matter her accomplishments, while her brother and sister were alive, she had been trapped in her role as the baby of the family, and seemingly content to remain so. Yet her

role as a religious writer gave her a sense of adult attainment, and she keenly felt 'how grave a responsibility' this duty was.[10]

With the centenary of her father's birth approaching, and his native Vasto preparing to celebrate in his honour, Christina addressed another responsibility; the promotion of Dante Alighieri in England. The Municipality of Vasto were turning the house where her father was born into a landmark building, helping to restore the pride of the Rossetti family in their formerly disgraced patriarch. When Gosse asked her to produce an article on the *Commedia* for *The Century* magazine, she was thrilled at the opportunity to further the paternal legacy: 'Family feeling stirs within me – the tradition of my race – !' In her article, she placed herself very much in a family tradition, listing her father and siblings' contributions to Dante studies: 'I, who cannot lay claim to their great learning, must approach my subject under cover of "*Mi valga...il grande amore*" ("May my great love avail me"), leaving to them the more confident plea, "*Mi valga il lungo studio*" ("May my long study avail me"). This statement is both a humble acknowledgement of her family's work and a declaration of independence. Being an inferior scholar might be an advantage; cultural memory and instinctive love would guide her pen. Love, something she associated with women and with faith, led her to re-evaluate Dante from a Christian female perspective. She took pains to credit Dante's education to his mother's influence, something few commentators thought worth mentioning. Where her father and Gabriel praised Dante to the skies, Christina was more circumspect. She critiqued Dante's callous neglect of his wife Gemma Donati, a 'mere flesh and blood' woman who couldn't hope to compete with the ideal, unattainable Beatrice: 'Gemma is truly to be pitied in her comparatively thankless and loveless lot.' She gave Gemma credit for saving Dante's manuscripts when his house was burned by the Florentine authorities, a curious action to praise, given that Christina's own mother had gladly committed her husband's *Amor Platonico* to the flames.

Instead of concentrating on Beatrice as an object of romantic worship, Christina focused on her much more human appearance in *Purgatory* 30. Here, Dante compares Beatrice to a scolding mother when she chastises him for 'Chasing fallacious images of weal' in his

faithlessness. Seeming to disagree with her father's notion of Bea-
trice as pure allegory, Christina gave Beatrice Portinari's biographical
history, provocatively referring to Dante as her 'boy-friend'. She
was wary about the 'hidden lore' which interpreted Beatrice as 'an
impersonation rather than a woman' and 'a meaning political rather
than dogmatic' in the *Commedia*. For Christina, heaven and hell were
literal realities. Although she would not openly contradict her father's
political interpretation of the poem, it was clear that she did not
approve. She was very conscious of her responsibility to her Christian
readers, and would not help in leading them astray: 'So obscure a field
of investigation is not for me or for my readers; at least, not for them
through any help of mine'.[11] Though she used Gabriel's translation
of the *Vita Nuova*, she chose Cayley's *Commedia* translation over
William's. By including Cayley in an article memorialising the Ros-
setti family's contributions to Dante studies, Christina came close to
admitting that she considered him part of the family.

Though she was creative and intellectually independent, like her
youngest brother, she was deferential and tended to downplay her
own accomplishments. She told Edmund Gosse, who was writing an
article on her for *The Century*, that she 'beheld far ahead of myself'
her 'clever sister and two clever brothers'. She felt she 'lagged out
of all proportion behind them, and have never overtaken them to
this day.'[12] This was modesty bordering on silliness. Christina was
an internationally recognised poet whose work had been repeatedly
painted, illustrated and set to music, which was why Gosse was
writing an article on her in the first place. Her poems were very
popular in the United States, while at home she was considered to be
Elizabeth Barrett Browning's worthy successor. Increasingly, critics
seemed to be positioning her as a challenger for Mrs. Browning's title
as the nation's first female poet. This media-fuelled rivalry may have
played a part in Browning refusal to approve Christina as his wife's
biographer. Christina had been enthusiastic when approached with
the project by John Ingram, editor of an 'Eminent Women' biography
series, but she quickly withdrew when she learned Browning refused
'any co-operation with its author, however illustrious or friendly'.[13]
He was concerned about privacy, but as a friend and mentor of Gabri-
el's, he must have known he had nothing to fear from the Rossettis,

particularly the famously discreet Christina. No biographer would have been less likely to publish or seek anything salacious in Mrs. Browning's papers.

Robert Browning's reluctance may also have had to do with Christina's 1881 preface to her sonnet sequence *Monna Innominata*, ['Unnamed Lady'] which had suggested that there was room for improvement in his wife's poetry. Christina argued that had Mrs. Browning 'been unhappy instead of happy, her circumstances would have invited her to bequeath to us, in lieu of the "Portuguese Sonnets" an inimitable "monna innominata" drawn not from fancy but from feeling, and worthy to occupy a niche beside Beatrice…' Not only did this curiously phrased preface position *Monna Innominata* as a challenger to Mrs Browning's *Sonnets from the Portuguese*, it also seemed to imply that her happy love life caused her poems to fall short of their potential. When Hall Caine singled out this statement in a review for *The Academy*, Christina back-pedalled and claimed that she had been misunderstood, but the damage was done. Browning may have had other reasons for distancing himself from the Rossetti family. William never confirmed the extend to which Browning was aware of Gabriel's paranoid animosity toward the end of his life, but it is safe to assume that the poet noticed that he was being unfairly rebuffed and felt justified in cooling relations with the family. He surprised William by turning down an offer to become President of William's pet project, the Shelley Society, claiming he no longer admired Shelley's character. Of course, his wish to maintain his wife's privacy should not be ignored, as this was common enough in the era. Eliza Polidori, for example, had recently refused access to a biographer of Florence Nightingale who was curious to find out more about her experience working at Scutari Hospital during the Crimean War. Displaying the exaggerated modesty so prevalent in the family, Eliza claimed that her role had been small and her contact with Nightingale too minimal to be of interest. Christina said as much when she politely turned the biographer away. In truth, Eliza had been decorated by the Turkish government for her work, and Nightingale had confessed that she felt 'almost overwhelmed' at losing her 'invaluable services' when Eliza returned to England.[14]

William found that his sister's humility and self-deprecation

bordered on the annoying, and were not that different in effect from Gabriel's entitlement and self-regard. Both extremes resulted in a distorted self-image which made it difficult for them to achieve true intimacy with others, or genuine confidence in their own abilities. Like William, Christina also harboured the anger of the deeply repressed. It had revealed itself in her breakdown and self-mutilation with scissors during her adolescence, but as she aged, this suppressed emotion found more healthy outlets. Christianity allowed her to rechannel anger into self-assertion. Theology and faith gave her the authority she lacked as a woman and a younger sibling. She would not go so far as to stand up for herself, but she could stand up for her beliefs. This strategy was not that dissimilar to William's habit of supporting the underdog in politics, whether it was women, the working class or European revolutionaries. Through the medium of politics and religion, younger brother and sister were able to enact and address their own feelings of disempowerment, inferiority and injustice at one remove.

When Shields showed her some nude fairy drawings by Elizabeth Gertrude Thompson, Christina was so vocal about her disapproval that she wrote him the next day to explain herself. While most Victorians (including Lewis Carroll) regarded these fairies as mainstream whimsical fantasy-figures, Christina found the representations of naked pre-pubescent children and young women disturbing. Despite her probable sexual innocence when it came to her own experience, as an anti-prostitution activist, she recognised exploitation when she saw it. She supported the Criminal Law Amendment Act, which raised the age of female sexual consent from 13 to 16, tightened legislation against prostitution, and promised longer prison terms for offenders. Certainly to the modern eye Thompson's coy, child-like nudes seem less than innocent, and it is unimaginable that they would feature on Christmas cards today. 'I do not think that to call a figure 'a fairy' settles the right and wrong of such figures', Christina argued. She felt she owed Shields an explanation, but not an apology: 'last night's blunder must not make me the slave of false shame this morning.'[15]

Middle age gave Christina an increasing confidence in herself. She was now the primary carer for the elderly Frances, Eliza and Charlotte, who had finally retired from Lady Bath's service at the

age of 82. This trusted role gave her faith in her own stewardship. She was now effectively head of the household. Though she poked fun at herself as one of the 'unmixed and unmitigated old ladies' of Torrington Square, she did not treat this family as a poor substitute for a husband and children.[16] She made it very clear that the welfare of the older relatives was no less important to her than that of the new generation. When William's daughter Mary caught scarlet fever and had to be quarantined, Christina did not immediately agree to allow the other children to move into Torrington Square. Her first response was to debate whether the children would disturb the elderly Aunts. She chastised William for neglecting to write to their uncle Henry after he suffered a bad fall, and nagged him to write to Charlotte.

This impulse to cater to others wasn't always healthy. In some sense, it was a displacement of affection and care for herself. Responsible for her ailing, depressive father at an early age, she had developed a tendency towards extreme self-abnegation which worried her surviving brother. While Frances too had sacrificed to take care of her family, she was made of sterner stuff than Christina. Unlike her daughter, she did not possess a literary talent which sat uneasily alongside feminine humility and self-effacement. Her Evangelical training, which cautioned against the vanity of martyred behaviour, had kept her own priorities and sense of self in sight, even in the darkest days of her husband's illness and depression. Christina, by contrast, was all too eager to lose herself in others. 'My dear Mother *absorbs* me,' she explained with pre-Freudian naiveté.[17] Describing her mother as her closest friend, she never strayed far from her side, though she was in her fifties and Frances in her eighties. Now that Frances had lost a son as well as a daughter, husband and sister, Christina tried to fill all of these roles. She strove manfully to emulate Maria's stoicism, Gabriel's charm, and Margaret's reliability. Playing the surrogate husband, she even composed special Valentine poems for her mother every 14th of February.

At the same time, she was also beginning to face the painful reality of her mother and aunts' mortality, and tried once more to bond with her sister-in-law and extended family. She made a real attempt to clear the air. 'I am sorry to recollect how much you and I have undergone from my irritability, and how much there is for you

to bury in kind oblivion,' she told Lucy. She joked that in fact she had mellowed with age: 'Ask William, who knew me in my early stormy days: he could a tale unfold…'[18] William felt that his over-scrupulous sister was exaggerating her flaws; her conflicts with Lucy were not a question of temperament, but of religious difference. The kind of woman who was wary of stepping on stray scraps of paper in case they contained the word 'God' was never going to be an easy fit in an agnostic household.

Religion remained a stumbling block in relations, and Christina's dogmatic Anglo-Catholicism recognised few boundaries. In the beginning of the year, while William and Lucy's son Michael was dying of meningitis, Christina insisted on baptising him in his last hours, surprisingly unopposed by his agnostic parents. The boldness of this gesture was only increased by the fact that, as a woman and a lay person, she was not authorised by her Church to perform this act. This was a role reserved for male clergy, a prohibition which might have stopped Christina in her teens and twenties but did not give her pause in middle age. While the parents allowed this ad-hoc baptism, Christina's timing was insensitive, to say the least, although she would not have seen it that way.

Modelling herself on the Polidori aunts, Christina made more of an effort to take an interest in her nieces and nephews, including the children of Lucy's half-sister Cathy Hueffer. The baby of the family herself, she felt a special bond with her youngest niece, Helen. Self-consciously echoing her grandfather Polidori's praise of herself in childhood, she predicted that Helen "*avrà piu spiritu di tutti*" ("She will be the cleverest of the set")', allowing, she added unconvincingly, for the superiority of 'man over woman.'[19] She wasn't an indulgent or doting aunt, liable to let personal bias lead her to over-praise childish productions. Her attitude echoed Frances's early injunction against witless drawing-room poetry. She complained to Lucy about the many strangers who sent her bad amateur poems, and only half-jokingly warned her against allowing her children to do the same: 'Don't you ever publish a volume unless you are quite sure you can excel (say) Shakespeare; or if not, at least don't bestow it on poor disconcerted me!'[20] Christina had finally figured out that the best way to appeal to children (who could always sniff out the inauthentic)

was to be herself. This approach was validated when George Hake asked her to be godmother to his daughter Ursula, a duty she gladly accepted.

Although Christina claimed to have outgrown the morbidity of her youth, a distinctly gothic atmosphere lingered around her. Living in relative seclusion with elderly aunties added to this impression. Her friend, Irish writer Kathryn Tynan, remembers the 'gloomy' square, with its 'solid Georgian houses and the sooty London sparrows chattering on the smoke-stained trees inside the enclosure.'[21] Ever ready to defend her beloved urban environs, Christina resisted this reductive assessment of her neighbourhood. 'The other day,' she wrote, 'I saw myself described as residing in a *dreary London Square*; but really I find my contemned London trees cheerful'.[22]

Visitors often noted the preternatural quiet inside the house, which complemented its dim interior. Torrington Square was like a dark double of Tudor House, reflecting its inhabitants' introversion just as Cheyne Walk had reflected Gabriel's welcoming, expansive nature. Like Tudor House, it became something of a shrine, attracting curious pilgrims and acolytes wanting to partake of the Rossetti legend. She had many American visitors, as her poems were particularly popular in that country, thanks to her publishers Roberts Brothers, who had also agreed to bring out a copy of *Time Flies* in the United States. Though patriotic, she was not xenophobic, and welcomed their admiration, having once said, 'I am glad if warm English blood throbs in many American hearts.'[23] She was not, however, as enthusiastic an admirer of American poetry as William. For instance, while Emily Dickinson's best work reminded her of Blake, she found her writing style alienating.

At home Christina wore dark, plain dresses, sturdy boots and a white lace cap, which she exchanged for a long black veil when attending church services at Christ Church Woburn Square. Designed by Lewis Vulliamy, the architect of St. Barnabas, Pimlico, the neo-gothic church was made of white brick and bath stone. It was famous for its east window, which was 28 by 13 feet and boasted mullions and elaborate tracery. The interior seated 1500, which makes Christina's late-life habit of taking the front pew and being the last parishioner to leave after the service a more daunting feat that it might at first

appear. Fortunately, the church was only a four minute walk from her house, so this custom wasn't as time-consuming as it might have been otherwise. Nor would clergy or fellow parishioners have thought her particularly fanatical, as Woburn Square had Puseyite leanings, and had been the subject of anti-ritualist suspicion earlier in the century. Like many High Anglican churches, it put an emphasis on devotional music and had such good acoustics that it would be chosen in the 1940s as a regular venue for BBC broadcasts by the Renaissance Singers. While her mother and aunts were often too unwell to go to church, sometimes receiving the sacrament from a home-visiting vicar, Christina seldom missed a service.

Her clothes struck others as old-fashioned and deliberately middle-aged, 'garments fit for a ten-mile walk over ploughed fields' which contrasted with her 'spiritual face, with the heavily-lidded eyes.'[24] Youth and beauty were gone, but so were their pressures. People had stopped wondering if she would ever get married or have children, and she was allowed to relax into middle-aged spinsterhood. 'I wrote such melancholy things when I was young,' she joked with Tynan, 'that I am obliged to be unusually cheerful, not to say robust, in my old age.'[25]

Juliet Hueffer, Brown's grand-daughter, recalls often arriving to find her aunty Christina sitting lost in thought with her hands folded, waiting for the kettle to boil. In a room which boasted a goldfish bowl, a sweet cupboard and a strip of carpet dividing Charlotte and Eliza's beds, she 'made us sit round the table and have tea, and eat as much as we wanted'. Christina always greeted her nieces with the fairy-tale phrase, 'Welcome, merry little maidens'. She gave Juliet the eccentric gift of a miniature dining room table and chairs made out of chestnuts, pins and red string. Christina's nieces lived in fear of Eliza and Charlotte, who were 'old and dried and wrinkled', and wore flowered bed-jackets and frilled nightcaps which put the girls in mind of the wolf in Little Red Riding Hood.[26]

With the exception of attending church services, Christina and her mother both received calls and ventured out less and less. Charles Cayley, however, was always welcome. He had taken lodgings in Bedford Square, a five-minute walk from Christina's house, and they continued to see each other frequently. His admiration of Christina

had not flagged with age. He also visited William and was kind to Christina's nephews and nieces. The two year-old Mary was fond of Cayley, proudly lisping the Greek alphabet for him on one occasion, evidence that Lucy and William were imitating Frances and Gabriele's ambitious parenting techniques.

When Cayley revealed to Christina that he was dying of heart disease in the winter of 1883, she was devastated. The pair conducted a heartbreakingly reserved correspondence, making gentle plans for each other's deaths as if they had been husband and wife. Christina agreed to be his literary executrix and hinted that she would bequeath him any money left over after any debts had been paid out of her estate. She promised to 'nurse your name and fame', and cringed at the memory of rejecting his marriage proposal, recalling the time when 'those who loved you best thought very severely of me.' She came close to an apology when she wrote 'I deserved severity at my own hands, – I never seemed to get much at yours.'[27] Had she truly loved Cayley but been too bound up with her family to strike out on her own? Did she use her religion, as she sometimes used Frances, as a barrier against a frightening intimacy? Here again is a surprising similarity between Gabriel and Christina. Though the siblings' methods of avoiding intimacy were at the opposite ends of the spectrum, Gabriel's sexual self-indulgence and Christina's self-denial yielded similar results.

In early December 1883, William's work was interrupted by the unannounced arrival of his sister at Somerset House. She didn't cry and her tone was calm, but he could tell something was terribly wrong. She had just heard that Cayley had died in his sleep, on the night of her fifty-third birthday. Had she been his wife, she would have been with him. 'I shall not easily forget the look of her face,' her brother wrote, 'and the strain of self-command in her voice.' Years of suppression and self-control triumphed: 'she did not break down.'[28] William had always believed that his sister truly loved Cayley, and that she was foolish to have allowed her religious beliefs to come between them, but whether her emotions were that of a lover or a simply a close friend, they evidently ran deep.

Christina's grief was profound and private. On reading the generous obituary William wrote for the *Athenaeum*, she found herself unable

to write to him about it. Although invited, she did not attend Cayley's burial at Hastings, but visited the grave privately in January. Along with the copyright to his works, Cayley had left her a ring and his writing-desk, which she treasured. While the ring is certainly suggestive, the desk may be the more romantic bequest. It was a fitting gift, as their romance (such as it was) had been a shared creative endeavour, carried on in coded poems cautiously transmitted from the safety of their writing desks. 'Thus only in a dream we are at one, / Thus only in a dream we give and take,' she had written in *Monna Innominata*, the sonnet sequence William associated with Cayley. After her death, William discovered a bundle of his sister's unpublished Italian poems, *Il Rosseggiar dell'Oriente*, written in response to Cayley's *The Purple of the West*. They were hidden away in her writing desk, perhaps the one Cayley had given her. The Cayley family recognised the importance of their relationship; his brother Arthur personally delivered the desk to Torrington Square and carried out Christina's request to destroy her letters to Charles. That February's 'Valentine' poem to Frances was bleak: 'A world of change and loss, a world of death / Of heart and eyes that fail, of labouring breath, / Of pains to bear and painful deeds to do…'

Christina's attempts to be philosophical about change and loss are recorded in *Time Flies: A Reading Diary*, which provided readers with an anecdote or meditation for each day of the Christian calendar, sometimes including a poem. The anecdotes were taken from real life, such as her grisly parable of the funnel spider web, which Shields had spotted at Birchington:

That funnel web seems to me an apt figure of the world.

It exhibits beauty, ingenuity, intricacy. Imagine it in the early morning jewelled with dewdrops, and each of these at sunny moments a spark of light or a section of rainbow. Woven, too, as no man could weave it, fine and flexible, frail and tenacious.

Yet are its beauties of brilliancy and colour no real part of it. The dew evaporates, the tints and sparkle vanish, the tenacity remains, and at the bottom of it all is a spider.

Other meditations were inspired by conversations with her aunts,

childhood memories of Holmer Green, and Maria's funeral. She quoted Cayley's translation of Dante's *Paradiso* in a self-soothing entry which anticipates the joy of Resurrection 'for the renewal's sake of beloved ties'.[29]

While her religious readers enjoyed her Christian meditations, others campaigned for her to return to poetry. Somewhat underwhelmed with Christina's gift to him of her devotional work, *Called to be Saints*, Swinburne published a 'Ballad of Appeal, to Christina Rossetti', begging her to write more poems. Christina explained that writer's block, rather than reluctance, was the problem. 'Pray believe that dumbness is not my *choice*', she wrote, adding that 'no one is more pleased than I am when by fits and starts I become vocal.'[30] She did not explain the cause of this block, but it seems that the deaths of so many loved ones must have contributed. A month after Christina wrote to Swinburne, Henry Polydore suffered a stroke, and he died early in the New Year, 1885. With his unspectacular career, his endless demands for second-hand periodicals, and crass attempts to convert the Rossettis to Roman Catholicism, Henry had sometimes been considered the family bore in life, but death proved him an honourable family man. He left the bulk of his £3,000 estate to Frances, Charlotte and Eliza, and even willed £1000 to his wife who had deserted him for America so long ago. William and Christina each received £250.[31] It was hardly surprising that Christina's creative fires were burning low. In a three year period, she had endured the deaths of three close relatives and her best friend. Eliza had also suffered a stroke and was declining.

On the face of it, Swinburne was the least likely candidate for friendship with Christina. A dissipated aristocrat with an alcohol problem, a taste for flagellation, an attraction to homosexuality, and an aversion to organised religion, he had made *épater la bourgeoisie* a way of life. And yet he admired Christina's poems and particularly enjoyed Frances's company. For all his faults, he was warm, loyal and demonstrative. He had a good reading voice and especially liked cats, which endeared him to the Rossetti women. They also must have noticed that he didn't treat William as a second-class citizen, like some of Gabriel's friends. He was also a passionate supporter of Italian unification, producing an entire volume of political poems,

Songs Before Sunrise (1871), which he dedicated to his hero Mazzini.

William fondly remembered walking into Gabriel's studio and finding an unlikely tableau; his mother sitting in a chair with a respectful Swinburne perched on a stool close to her feet. Swinburne continued to make overtures to the Rossetti women, even after Gabriel's death, encouraging the London-centric Christina to venture out into the English countryside, though to no avail. Watts, apparently needing a Gabriel substitute, had invited him to move into his home in Putney in 1879, where he looked after him and tamed his alcoholism to some extent. Though they were busy caring for the dying Gabriel at the time, the Rossetti women had monitored this move with concern, and were relieved when it became apparent that Swinburne was improving. While their differences kept them from becoming close, he and Christina liked each other, and each respected the other's work. When Christina spotted two atheistic lines in his gift copy of his play, *Atalanta in Calydon*, she merely pasted strips of paper over them and carried on reading what she came to regard as a masterpiece. This private act of censorship has often been presented as evidence of a closed mind and wilfully limited intellect, but in fact it proves that she was not totally impervious to the doctrine of art for art's sake.

While Swinburne's play fell far short of her beliefs about God, it reaffirmed her faith and interest in women. Atalanta is a virgin warrior who helps the hero Meleager rid the kingdom of Calydon of a dangerous wild boar. When Meleager awards Atalanta the boar's skin, his jealous uncles try to reclaim the trophy. He slays them, and is in turn killed by the uncles' grieving sister, his mother Althea. Swinburne's treatment of the themes of heroic virginity and ambivalent maternity clearly appealed to Christina, as they did to many women of the time, including Florence Nightingale, who wrote that Atalanta had 'more reality, more character, more individuality...than all the *jeunes premiéres* in all the men novelists I have ever read.'[32] With Christina's permission, Swinburne dedicated his poems *A Century of Roundels* (1883) to her. After her death, William returned the favour, dedicating her *New Poems* to Swinburne in 1896.

William had remained close to the red-headed poet long after Gabriel, in his paranoia, had exiled Swinburne under suspicion of

conspiring against him. Swinburne also enjoyed spending time with William's children; when Michael died, he impressed both parents with the commemorative poem, 'A Baby's Death'. Though they had different views, William enjoyed talking politics and religion with Swinburne, who was open-minded enough to listen. At the age of 53, William marvelled how much he still had in common with his 18 year-old self. He still held the same liberal and democratic political views, and was sceptical about religion. A supporter of the 1871 Paris Commune, he longed to attend Victor Hugo's 1885 funeral in France, which he hoped would inspire the people to revolt once again. While his female relatives were comforted by the notion of resurrection, even the death of his brother could not move William to re-think his stance against 'personal immortality'. He could not accept that 'Gabriel Rossetti and William Rossetti are to continue to all eternity to be Gabriel and William Rossetti, and to be conscious of so being'. His choice of examples was no coincidence; after his own unsentimental fashion, William was wondering just who he was without his brother.[33]

Even though Gabriel was dead, William still found himself working for his brother *gratis*. With time-management, business and accounting skills honed by years of work at Somerset House, William kept grief at bay by hyperfunctioning as his brother's executor. Along with arranging the depressing sale of Tudor House and its contents, he dispersed willed items to Gabriel's friends and acquaintances and helped organise the sale of his works at Christie's, which took place on Gabriel's birthday in 1883. His grieving was practical, unsentimental and to some extent delayed by the work of handling Gabriel's complicated estate, in addition to fatherhood and full-time work. His lack of sentiment, which sometimes struck others as cold, is evident in his attempts to find storage space for the bulky moulds of his brother's head and hand. His letter to Lucy on the matter is a study in Victorian ghoulishness and unintentional black humour. Finding that 'the head is too large even for the largest drawer in the wardrobe in the spare room', he decided to place it in 'the wardrobe in *our* bedroom'. Gabriel's hand went in a drawer in the spare-room, while casts of his head and hand were stored in a back-parlour cabinet. Scott, by contrast, felt nauseated when his cast of Gabriel's 'whole cranium…rolled over on the carpet'. The hand, reduced to skin and

bone by illness, was 'more painful to look at than the face'.[34]

William's grief was displaced into anxiety over his brother's posthumous reputation. On reading a salacious, unsympathetic life of Byron, he realised that his brother was vulnerable to a similar biographical treatment. A lifelong enabler, William wasn't about to let death expose his brother's weaknesses. So far, only family friends had written publicly about him, but that situation couldn't last forever. His brother would replace Shelley as his pet project and idol. Restyling himself as the guardian of his brother's afterlife was a neat way of avoiding the awkward questions Gabriel's death had raised. William rechanneled his conflicted feelings towards his brother into a series of biographical and literary memorials. Promoting the less seamy side of Gabriel, he began to prepare a volume of *Family Letters*, a *Collected Works* and a serious consideration of his life and art, *Dante Gabriel Rossetti: Designer and Writer*, which would be published in 1889 with Carroll's portrait photograph as its frontispiece. He gave aspiring biographer and friend Joseph Knight limited access to material, but would not allow him to publish from the letters. Knight's was very much an authorised biography, and William maintained an amount of control, advising Knight on various passages and referring him to approved sources. He and Lucy were amused when the biographer came across a letter where Gabriel called Knight an old gossip.

Having learned from the Birchington Cross debacle, he politely but firmly declined his mother's donation toward his brother's memorial fountain. William spent Christmas 1885 at Torrington Square, treating his mother and sister to a reading from his draft preface to his brother's *Collected Works*. Christina affectingly noticed how easily William 'dropped back into your old place in your old family.'[35]

Other activities kept William's mind off his grief, such as his campaign to raise funds by subscription for Walt Whitman, whose poetry he had long admired and promoted in Britain. He even wrote to Grover Cleveland, President of the United States, urging him to support one of his nation's finest poets. He also helped start the Shelley Society, along with Frederick James Furnivall, one of the founders of the Working Men's College in the 1850s. Later he would threaten his resignation when the Society tried to deny membership to the common-law husband of Karl Marx's daughter on the grounds

that the couple were unmarried. William brought it to the Society's attention that, under such restrictions, Shelley himself would have been denied membership.

With a lifetime's worth of training in repression, William was congratulating himself on being a master of self-control when the one event capable of spinning the family off its axis occurred: the death of Frances Rossetti. The trouble started in late February 1886, when Frances had a fall in her bedroom, badly bruising her back. Dr. William Edward Stewart, whose father had attended Gabriele Rossetti during the old man's dying days, diagnosed a spinal injury. By the middle of March she was still bed-ridden and an All Saints nurse named Annie Jackson was engaged, possibly the same nurse who had taken care of Maria in her final days. William stepped up his visits from once a week to daily, and his agitation is obvious in his diary and letters. He had more than one reason to worry; Lucy, who had been suffering on and off with bronchial complaints, was starting to cough blood.

While she and the children were taking the healing sea air at Ventnor, Frances slipped into unconsciousness. Christina coped by keeping up her mother's diary, while William's anxiety for his mother was augmented by the absence of his wife. As Frances lay dying, the National Gallery purchased her eldest son's *Ecce Ancilla Domini* for £840 in Christie's William Graham sale. It was the ultimate validation of Gabriel's genius, although it came too late for both mother and son. William and Christina hovered anxiously around her bed, pale aging shadows of their lithe, youthful selves when they had modelled for their brother's 'Blessed Daub'.

Around noon on April 8, William was shrugging on his great-coat, intending to go out and post some letters, when Annie Jackson stopped him. The nurse had seen many people die, and she assured him that his mother's death was imminent. Dr. Stewart arrived, and two minutes later, attended by her surviving children, Frances died without regaining consciousness. In a daze, William walked the familiar London streets of his childhood that afternoon, buying flowers and mourning wear, and engaging a Marylebone undertaker. Christina did her best to match her brother's calm, and William was proud that his little sister was 'only giving way at moments'.[36] The

siblings worried that Charlotte and Eliza's health would suffer, but the Polidori aunts put a brave face on things, and gave their sister's children no further cause for anxiety. As he had with his brother's death, William used planning, order and arrangement as talismans to keep grief at bay, a secular ritual akin to the prayers Christina and her aunts used to comfort each other. 'I "arm myself with stoicism"', he had told Brown during Frances's last days, 'and as yet it protects me to the full.' Even so, a note of doubt crept in: 'I know myself pretty well in these matters: one of these days I shall break down…'[37]

William Michael Rossetti, photographed by Julia Margaret Cameron, 1865
A Somerset House young man.

13

JUST WILLIAM

On the morning of 12 April 1886, William Rossetti made his way to Torrington Square to say a final goodbye to his mother. He noticed London's trees were finally coming into bud, but the fine spring weather could not lighten his heavy heart. By ten past eleven, he had joined Christina and Eliza, who filed numbly into a pew at Christ Church, Woburn Square for Frances's funeral service. Like all Rossetti funerals thus far, it was a small and private affair; William's sister-in-law Cathy and her husband Franz were among the handful of mourners. A hired carriage then took William, Christina and the Reverend John Glendinning Nash north to Highgate Cemetery while Eliza returned home to look after Charlotte, now too ill to leave the house. Christina made sure that her mother was buried in her widow's cap, which she had rarely appeared without for thirty years. Like Queen Victoria, Frances had clung stubbornly to a mourning custom which had long gone out of fashion, hinting at the Romantic nature that had so long done battle with her pragmatism. Italian flowers were strewn in her coffin before it was finally closed.

A fresh look at the family tombstone confirmed that alterations would have to be made. After the fiasco with Gabriel's Birchington memorials, William was prudent enough to delegate this task to his sister. Frances's name was chiseled into the white Portland stone beneath her husband's. For her mother's inscription, Christina chose biblical quotations which anticipated reunion in heaven: 'Our Saviour Jesus Christ...hath abolished death' (2 Timothy 1.10); 'Friend, go up higher' (Luke 14:10). The latter was a common refrain in Christina's

poems, serving as a reminder of daughterly achievement as well as shared faith.

The second order of business was to alter the tombstone's inscriptions to make Lizzie Siddal's relationship to the family crystal clear; Christina did not want future generations mistaking 'E.E.R' for a true Rossetti daughter. She augmented her inscription to identify Lizzie as 'Wife Of Their Eldest Son, Dante Gabriel Rossetti'. Proving that sibling rivalry never dies, Christina's alteration quietly out-manoeuvred Gabriel's last wishes to avoid being buried at Highgate. A casual visitor would be forgiven for assuming that Gabriel was buried along with his family. Grief for their brother had softened the remaining siblings' attitudes toward Lizzie. Her self-portrait hung in William's smoking room, while Christina's drawing room boasted two of her watercolours, *The Eve of St. Agnes* and *The Haunted Tree*. Tynan remembers Christina becoming very emotional while showing her Gabriel's drawing of Lizzie in an armchair: 'Poor little Lizzie… Poor little wife and mother!'[1] By the last year of her life, Christina was regularly referring to her as 'our poor Lizzie', and making active efforts to promote her sister-in-law's 'name and fame'.[2]

More so than Gabriel's passing, the Rossetti matriarch's death marked the end of an era for her children. Looking back on the event, William wrote, 'In the death of a mother there is something which, more than aught else, severs one from one's past: it is the breaking of a tie…'[3] That tie, which had been so strong, was both lifeline and restraint to Frances's children. Without it, William and Christina felt unmoored.

Their mother's passionate pedagogy, with all its Romantic and Victorian contradictions, had shaped their love for art and culture, and instilled an insatiable appetite for achievement. But in trying to match their mother's high expectations, the Rossetti children trod a fine line between high achievement and dangerous perfectionism. This had been especially true for Gabriel and Christina, whose depressive temperaments meant that periods of fierce aspiration alternated with episodes of paralysing inactivity. Both possessed a fundamental insecurity which no amount of success could ever ease. Christina's worship of Frances ensured that she had trouble seeing her mother as a real person, complete with flaws and foibles. Hero-worship threw

her own defects into exaggerated relief, but it was a price worth paying to avoid the complications of ambivalent feelings. Everyone was aware that Christina was struggling with her mother's death. Finding himself in London two months after Frances's funeral, Lewis Carroll made a special afternoon visit to Torrington Square to offer his condolences. Without her mother, Christina was lost. 'I have been grieved before but never so desolate as now', she wrote.[4] William corroborates this view, noting that from this point onward, his sister abandoned herself to 'religious resignation', only 'looking forward to the end.'[5]

While there is some truth in this assessment, fraternal vanity may have skewed his perception; William was mystified by Christina's stubborn refusal to move in with him. Since early childhood, the two siblings had considered themselves special friends. It seemed logical to William that they should consolidate that bond by sharing a home, now that everyone else had gone. Suffering from consumption, Lucy was abroad with the children, trying to recover her failing health. In two slightly scrappy conversations, brother and sister made plans for the future. These revealed the differences in their lives, and cracks in their relationship, that had been obscured by the need to care for Gabriel and the desire to please Frances.

On the day of their mother's funeral, William suggested that Christina come and live with him for an undefined amount of time. Although he was alone at Endsleigh Gardens, he did not frame this invitation as a desire for his little sister's company, but as a favour to her. Her immediate refusal took him aback. William clearly believed he was rescuing her from the drudgery of caring for two invalid aunts in her gloomy Torrington Square quarters. Neither Gabriel nor William fully appreciated the devotion and love among the Rossetti and Polidori women, who co-habited much longer than either man with his wife. In William's memoirs, the Polidori aunts come across as caricatures of spinsters. He mentions their unfashionable clothes and stern piety, recalls Margaret's cackling laugh with a shudder, and dismisses Eliza's work as a Nightingale nurse as the sole adventure in an otherwise dreary life. He saw nothing extraordinary in Charlotte's accomplishments, which included parlaying a temporary situation as a governess into a lucrative lifelong position with an aristocratic family.

His interpretation was accurate, insofar as it reflected his relationship with them. But the Polidori sisters had long given Christina unqualified support and love, and had been role models of single, independent womanhood in a time when unmarried and childless women were considered social and sexual failures. They were her last link to Frances, and Christina had no desire to abandon them. William thought this smacked of martyrdom, and utterly failed to notice that his sister's decision also maintained her own independence.

In her brother's household, Christina would be answerable to William, and in the absence of his wife would be expected to care for him and potentially for his family. Victorian spinsters were expected to pull their weight in married couples' households, and unpaid, round-the-clock child-minding was one way they could contribute. Given Lucy's increasingly fragile state of health and William's full-time work at Somerset House, it was likely that Christina would get roped into looking after three children under the age of twelve. Christina weighed up her options, and decided that caring for two very grateful aunties would be less of a strain than running William's household.

Frances had given Christina the means to make such a decision. She left the bulk of her estate, totalling £4,000, to her daughter. Eager to secure her freedom, Christina wanted to give William £2,000, in order to repay past debts she had incurred as his dependent. He replied that there was no immediate hurry, and she agreed to wait. Christina added that she planned to leave her estate to him or his children. Following the deaths of the Polidori aunts, she planned to take a house in Rochester, some thirty miles outside London. Her home would be large enough so that William and his family could regularly spend holiday time with her. This was all news to William, who had heard her mention moving to Birchington before, but wondered about the sudden appeal of Rochester. The answer was simple enough. Burrows had relocated from Christ Church, Albany Street to become canon of Rochester Cathedral. Following her mother's death, Christina had travelled to Rochester alone to see Burrows for comfort and spiritual counsel, and had clearly been impressed. The mere mention of Canon Burrows put William on his guard. Putting it bluntly, William told her prolonged family holidays would be problematic because of Christina's need to 'prosletyze the kids.'[6] Bridling,

she replied that in her home she needed to be free to practice her religion. The best she could promise was not to pressure his children to join her. Reluctantly, William approved the plan. The tetchy sibling discussion may have concluded; the same could not be said for the feelings which inspired it.

Perhaps to prove that there was no lingering ill will on her part, Christina took a more lively interest in William's children, taking Olivia on a month-long summer holiday in Brighton and encouraging the others by correspondence to keep up with their Italian. It was a mark of how far the Rossettis had come that William's children had their own Italian tutor in San Remo, where Lucy was wintering in 1887 for the sake of her health.

Christina was equally determined to strengthen her relationship with her sister-in-law, paying regular calls at Endsleigh Gardens when Lucy was in London. In June she dined with William's family for the first time in four years. Nevertheless, relations remained awkward. On one occasion, when William and Lucy's front door slammed shut on Christina unexpectedly, she dithered on the front steps, eventually leaving rather than ringing the bell for re-admittance. Her nieces and nephew could not compensate for the loss of Christina's mother. While she found them 'affectionate and intelligent', they lacked what she saw as that special Rossetti spark of genius: 'they are not prodigies.'[7]

Despite her promise not to proselytize, by the following summer Christina was urging Lucy to have the children baptised. 'We were talking about your "happy" children', she wrote. But did Lucy really think they were happy? After all, 'Baptism…is the sole door I know of whereby entrance is promised into the happiness which eye has not seen nor ear heard neither hath heart of man conceived.'[8] William argued that he simply disagreed with his sister on matters of religion, but in reality, Christina's dogmatism rankled.

Even William would have been hard-pressed to deny that it was God who helped Christina get around her writer's block. Religion by itself wasn't helping Christina assuage her grief, and so she turned to writing. Inspired by Revelation, the final book of the bible, Christina proclaimed that her creative drought was over. In autumn, she began an ambitious work of biblical exegesis, which closely analysed

each chapter and verse of Revelation, offering commentary and the occasional poem. 'I work at prose and help myself forward with little bits of verse', she explained.[9] Her poetic creativity had been numbed by grief, and needed prose to be coaxed into life. She returned to her Tractarian roots, and to a metaphysics which sought not to explain itself, but rather to inspire contemplation. Poignantly dedicated 'for the first time' to her mother's 'cherished memory', Christina's final book, *The Face of the Deep* (1892) was a commercial success which ran to seven editions.

Her devotional books argue that creating beautiful poetry is as important as the Christian message; in fact, the medium and the message were inseperable. In *Time Flies*, Christina returns to an old Rossetti sibling argument to make this point. Looking back at Gabriel's introduction to his *Early Italian Poets*, she remembers her brother's remark that 'a good translation' cannot turn 'a good poem into a bad one'. Christina takes Gabriel's idea in a religious direction, suggesting that dogmatic, unbending Christians are bad transla-tors of God's message. In being overscrupulous, rigid and literal in their interpretation of religious faith, they alienate others. Although aiming to be 'truthful', 'conscientious' and 'right', they end up acting 'offensively', 'unkindly' and 'ridiculously'. Sounding very like her mother, Christina asks: 'and what gift or grace can quite supply the lack of common sense?' 'Scrupulous Christians,' she continues, are like bad poems: they 'resemble translations of the letter in defiance of the spirit', meaning that 'their good poem has become unpoetical.' Instead, Christian translators of God's message should act 'like stars, luminous, steadfast, majestic, attractive.' Good poetry and good faith were, for Christina, one and the same.[10]

The riddles, contradictions and ambiguities that shaped her verse were also evident in her religious prose. While the bleaker impulses of her youth had been modified, she remained fascinated by the 'dark continent of spiritual geography.' A sonnet on the Whore of Babylon is violent and disturbing, featuring the 'foul' figure whose 'heart lusts' for 'blood'. 'Gaze not upon her, lest thou be as she,' Christina warns: she will meet a grisly end when her evil catches up to her, and 'she amid her pomp are set on fire.'[11] The apparent misogyny of the poem is offset by the prose, which argues (unconvincingly perhaps) that the

whore of Babylon is not meant to represent an actual woman, but is a metaphor for the enchanting sins of the world.

Christina was uncomfortable with the way in which the bible portrayed women as harbingers of evil and temptation, but her religious conservatism prevented her from mounting a direct ideological assault upon its dogmas. She repeatedly affirmed St. Paul's view of man's right to rule over woman, and took care not to challenge masculine interpretation of the bible openly. At the same time, she uses Christian theology to gently suggest alternative views. About the Whore of Babylon, she writes, 'Some have opined that a woman's wickedness even exceeds that of a man…But this point must stand over for decision to the Judgment of that Only Judge to whom each and all of us will one day stand or fall.' Juxtapositions of prose and poetry suggest surprising new approaches. Her meditation on 'Babylon the Great, The Mother of Harlots and Abominations of the Earth' (Rev. 17:5) shifts the focus from sexual sin to female redemption. In the middle of a passage about 'women's wickedness', she celebrates women's goodness, and reminds readers to think of all women, even fallen ones, as mothers and sisters. Taking a leaf from the preachers she so admired, Christina transformed her personal grief over the deaths of Maria and Frances into a devotional lesson:

> Our Mothers, lovely women pitiful;
> Our Sisters, gracious in their life and death;
> To us each unforgotten memory saith:
> "Learn as we learned in life's sufficient school,
> Work as we worked in patience of our rule,
> Walk as we walked, much less by sight than faith,
> Hope as we hoped, despite our slips and scathe…[12]

Here, women are not evil temptresses, but mothers, sisters and role models. They are encouraged, not to fear one another, but to be inspired by each other to 'learn', 'work' and 'hope'. The influence of Christina's work with prostitutes at Highgate Penitentiary and her push for legislation to protect vulnerable women is apparent in this redemptive philosophy.

Feminism was another faultline in Christina's relationship with

William. Like his sister, he supported legislation against prostitution, but he felt that a liberalisation of sexual attitudes was key to effecting permanent change. He advocated a 'less monkish view on all questions of sex, especially as affecting the position of women in society.'[13] While Christina happily signed Mary Ward's anti-suffrage petition, William enthusiastically campaigned for women's right to vote. '...*Justice to Women* will be the great cry and fulcrum of advance. So be it!' he wrote to his wife.[14] Proving that he meant what he said, William had encouraged Lucy to open her own bank account when the Married Woman's Property Act of 1882 finally allowed married women control of their own finances. Ironically, this caused trouble for him later on when Lucy willed the house to her children rather than to him after their marriage turned sour.

Christina's brand of conservative feminism may have alienated William, but there was no denying that it was making her popular with a whole new generation of readers on both sides of the Atlantic. Her collection of religious poems, *Verses* (1893), would become her best-selling work. During the Christmas season, London's bookshops could not keep it in stock and had long waiting lists for the new edition. But, like her overachieving brother Gabriel, Christina regarded herself as having fallen short of her goals. No amount of praise could dampen her enthusiasm for self-reproach and regret: 'How awful "might have done", "might have been", "might have achieved", "might have become", grow as life…shortens before one'.[15] This gloomy self-assessment was far from accurate, however. Along with new American selections of her poetry in 1882 and 1888, other successes included a new and enlarged edition of collected *Poems* (1891) and a new edition of *Goblin Market* (1893), with illustrations by Laurence Housman. Those with fond memories of Christina's nursery rhymes bought Macmillan's new edition of *Sing-Song* (1893) to share with their own children. Her poems also appeared in popular commercial anthologies such as *The Poet's Bible* (1888). F.T. Palgrave, the revered poetry editor and Oxford Professor of Poetry, had personally paid her a visit to discuss her inclusion in his anthology, *Palgrave's Treasury of Sacred Song* (1889). She was now widely recognised as one of England's best woman poets. On Tennyson's death in 1892. she was rumored to be a contender for the vacant office of Poet Laureate, a

suggestion that was wholeheartedly endorsed by Lewis Carroll: 'If only the Queen would consult *me* as to whom to make Poet-Laureate! I would say, 'for once, Madam, take a *lady*!'[16]

Torrington Square was becoming a shrine for literary pilgrims; Christina was bemused and flattered when two lady tourists left flowers on her doorstep. Raised in an era when female literary success was regarded with suspicion, she remained circumspect about her accomplishments, having little patience for collectors and hero-worshippers. When a curator representing a collection in Iowa requested a lock of her hair, she icily refused: 'such a proceeding is repugnant to me.'[17] The nearest Christina came to acknowledging her success was when ascribing it to her family's influence; she had inherited her 'literary bias' from her 'clever and well read parents.' While Maria had been a good listener, and Gabriel her best critic, William was distinguished only as the sibling who 'now remains to me', faint praise that hints at their discord during the period following their mother's death.[18]

By the turn of the decade, however, brother and sister softened towards each other as the shock of their mother's death receded. Christina's efforts to court Lucy and the children were acknowledged by William, while Christina came to appreciate anew her brother's dependability and loyalty, letting him know that he was her '*oasis in the desert*'.[19] His dedication of Gabriel's *Collected Works* 'To the Mother's sacred memory' by 'the surviving son and brother' moved her to tell him that 'the brotherly inscription excels the book in my heart.'[20] A shared interest in their brother's literary and artistic legacy united them once again, and they made a habit of keeping each other informed of mentions of his work in the press. They were both overjoyed when Lady Mount Temple donated Gabriel's *Beata Beatrix* to the National Gallery in November.

In January 1890, Charlotte Polidori died, leaving Christina £3,000. William was bequeathed the lease on Endsleigh Gardens, and the house was now fully his own. After the funeral at Christ Church, Woburn Square, Charlotte was reunited with her sister Margaret in the Polidori family tomb at Highgate. Looking after two elderly, invalid aunts had taken a toll on Christina, now sixty years old herself. The financial burden of finding and paying nurses, cooks and servants

had been worryingly heavy. Days before Charlotte's death, Christina fired her nurse for drunkenness. Fortunately, Gabriel's nurse Mrs. Abery was available, but that didn't make the episode any less stressful. Lewis Carroll's timely gift in March of *The Nursery Alice* (1889), an abridged version of *Alice's Adventures in Wonderland*, was a welcome diversion during a difficult period.

The atmosphere of sickness and anxiety was not conducive to either Christina's mental or physical health. Her 'natural tendency to despondency' was aggravated by the depressing and time-consuming task of sorting out her aunt's estate.[21] Christina sent Charlotte's clothes to Lucy, though whether the family could make real use of old-fashioned items like white woolen sleeves and a velvet and fur hood remained in doubt. Charlotte had also left Christina in charge of maintaining support payments to Polidori relatives in Florence.

There was soon another, more serious burden; Christina discovered a double lump in her left breast. A consultation with Dr. Stewart confirmed the worst: breast cancer. She kept her condition from William until just before her mastectomy in May 1892, administered under chloroform and performed by George Lawson, surgeon to Queen Victoria. Conscious that William was already coping with Lucy's ill-health, Christina did not want to add to his troubles. She underestimated her brother's family loyalty. William stayed with her during her surgery, writing in his diary that she had 'borne herself like a heroine', despite mood swings brought on by opium medications.[22] Olivia accompanied her convalescing aunt Christina to Brighton in June, where William joined them at the end of the month. Putting aside his ordinary objections to Christianity, he read out loud to her from the *Autobiography of Isaac Williams*. Although she recovered well from the surgery, by March 1893, the cancer was back. When her aunt Eliza died in early June at the age of 83, Christina was too ill to attend either the funeral or Highgate burial. Having comforted all of her female relatives in their dying hours, it looked like Christina would die in the care of strangers. She sorely missed Eliza, whose down-to-earth vitality and good humour were antidotes to her own melancholy. Now that Eliza was gone, who would comfort Christina on bad days with the reminder that 'no day lasts longer than twenty-four hours'?[23] It seemed impossible that the last of the English Polidoris, who had

run the hospital stores for Florence Nightingale at Scutari and once took 'a Buffalo by the horn to get by him in a narrow street in Pera', now lay silent in Highgate cemetery.[24]

Having already witnessed Maria's painful death from ovarian cancer, William was devastated and afraid for Christina. It was a mark of his distress that he suspended his diary from March to June. Even so, he held firm to his agnostic principles, refusing to allow Christina to dedicate to him her forthcoming (and final) volume of devotional poems, *Verses*.

Christina's heroic demeanour contrasted with Lucy's, whose consumption had altered her personality for the worse. Olivia and Helen ascribed her irritability to chronic pain and anxiety. Friends noticed she was shockingly thin, hollow-eyed, and prone to picking fights. She tried to involve William in an argument with her half-sister Cathy, but he remained aloof from the fray, advising that 'it would seem well to make the best of her good qualities, and not lay special stress upon the bad ones.'[25] Lucy was not the first to find William's neutrality maddening, but even she could not induce him to take sides. The couple had not shared a bed since November 1892. William confessed to his diary: 'This change in my relations of affections and home-life is about the most painful thing that could have occurred to me: deeply do I feel it, but bear it as I may.' As much as they worried about their mother, his children were bewildered by Lucy's hostility toward their 'Fofus' (his family nickname, a combination of fussy, funny and fogey). A liberal, benevolent father in the habit of energetically performing his silly piano composition called 'Fastasia Fofetica' was not an obvious candidate for exclusion. Lucy may have had another motive. As Angela Thirlwell has revealed, passionate sex was very much a part of their marriage. Tuberculosis was a wasting disease, distressing to witness, and perhaps exiling her husband from her bedroom was meant not to punish him, but to preserve Lucy's dignity and the memory of better times. Even if this were the case, William experienced this change as an exile. Like his own father, William was an affectionate parent and devoted husband, but his 'brightness and elasticity of feeling and demeanour' which had 'developed itself in family life' was 'almost entirely lost' in the face of Christina's illness and the loss of Lucy's affections.[26] William defined

himself by family, and now it looked at if he was losing both the family he had made as well as the one into which he was born.

His depression filtered through to his working life, causing William to yield to the nagging sense of personal failure that had so afflicted Gabriel and Christina. Part of him could not believe he was still slaving away at Somerset House. When he did not win a promotion to Secretary of the Inland Revenue, his spirits plummeted. He regarded a greatly exaggerated newspaper report of his own death as an ironic reflection of his obsolescence.

In October 1893, Lucy and her daughters travelled to northwest Italy, with the hope that a prolonged stay at Pallanza, Lake Maggiore might bring some relief. Three days after she left London, Lucy's father and William's old friend Ford Madox Brown died of a stroke. With Brown's death, another tie to the past had been severed. Alone and grieving for his beloved father-in-law while also fearfully anticipating his wife's death, William asked Christina to move into Brown's old house, two doors down from his own. He was now reluctantly living in St. Edmund's Terrace near Primrose Hill, Lucy having insisted they leave Endsleigh Gardens. There was also some discussion of Christina moving in with William for the winter. But not even impending death could induce Christina to forfeit her hard-won independence, and she gently refused, citing too many stairs and the absence of her favourite niece Helen, now in Pallanza with her mother. A procrastinator by nature like her brother Gabriel, she would consider taking a cottage nearer William after Michaelmas. So the siblings spent Christmas apart, but in various degrees of physical discomfort: Christina suffered from heart trouble, William from gout, though at least now he had his son Arthur to keep him company.

William wrote asking if he could join Lucy in Italy, but was discouraged. Unassertive and unassuming as always, William did not press the point. On the 19th of March, 1894, William received a telegram saying Lucy was near death, and the next day he and Arthur set off for the Hotel Victoria, San Remo, where she had been wintering. When they arrived, they were shocked by her emaciated frame and persistent cough. Only Olivia and William were present when she died during the night of 12th April. Hers had been a long

drawn-out and painful death, and the family were physically and emotionally exhausted. But there was more distress to come. Lucy left all her property, including the family home, to her children rather than William. Adding insult to injury, she had chosen a lawyer as Trustee rather than the children's father. In theory, William could legally be evicted from his own house, either by the Trustee or his children when they came of age. Thirlwell suggests a kinder interpretation of Lucy's actions. Guarding against the possibility of William's re-marriage, she may have intended to ring-fence her property for her Olivia, Helen and Arthur.

William felt the will was an insult to him as a loving father, devoted family man and committed feminist. His distress is palpable in a letter to Christina, though couched as always in measured tones: 'My position thus becomes a matter of some embarrassment and speculation to myself, as I seem to have no personal right in the house – not even to live there…'[27] Furthermore, he was retiring soon, which meant his income would be drastically reduced from £900 to £600 per year.

There was some talk of shipping Lucy's body back to England, but when it was discovered that the cost would be £200, William decided to bury her in San Remo. In light of their deteriorating marriage, it is possible that William thought Lucy would not wish to be included in the Rossetti family tomb. Or raw from her death and hurt by his exclusion from her will, perhaps he simply did not want her there. 'I will not venture to say that I regret anything in Lucy's will', Christina wrote diplomatically, assuring William that if there should be any trouble 'about the house', brother and sister could surely work out a co-habitating 'arrangement'.[28] Christina assured her brother that, given the expense of bringing Lucy's body back to London, he had made the right decision, though she did acknowledge that it must have cost him a 'pang…to leave so beloved a person behind.' She also hinted that her cancer was progressing toward its inevitable end, a reminder that his precarious family finances could expect a boost following her death.

Word had spread that Christina was sinking fast. In early April, she was moved by a visit from Charles Cayley's niece Mary, who brought her daffodils and filled her in on family news. At the end

of Mary's visit, Christina was delighted when Henry Cayley, an architecture student, came by to collect his sister. This visit was a tacit acknowledgement that the Cayley family still honoured the relationship Christina and Charles had shared. In June, William received the last letter written to him in his sister's hand. From then on, she had to dictate her correspondence to her nurse, Harriet Read. By August she was bedridden; by September, she was unable to read, write or receive visitors. Dr. Stewart diagnosed heart problems and hysteria; William saw no evidence of the latter, though he would change his mind when another doctor noticed she 'was subject to some fanciful and varying impressions…'[29]

In their final days together, brother and sister took refuge in sharing childhood memories, which were recorded by the pragmatic task-oriented William for his biography of Gabriel. After one visit with Christina, William found himself wandering by the first Rossetti home on 38 Charlotte Street. They laughed remembering 12 year-old Christina's determination when composing 'A Chinaman' in an effort to compete with her brothers. They reminisced about the excitement of the early PRB and producing *The Germ*. In a more serious mood, they discussed whether or not their mother had been happy. William thought so, but received the impression that Christina disagreed, probably because she was more aware of Frances's distress over her sons' agnosticism. Before the argument heated up, brother and sister tactfully guided the topic to safer ground such as current biographies about Napoleon and his circle. Between the palliative drugs and her pain, Christina was not always lucid, once apologising incoherently to William for never giving him paints she'd promised him when they were children, and for lunching with Charles Cayley when she'd promised him she wouldn't. She was worried for her brother, and tried to comfort him with the gift of a yellow tabby kitten from the litter of her favourite housecat, Muff. Remembering how Gabriel had always referred to yellow tabbies as 'carroty cats', they christened it 'Carrots'.

Both Ellen Proctor and William recorded Christina's uncomplaining tendency to downplay her pain. This self-suppression had a price; in November, her next-door neighbour was so unsettled by the 'long-continued fits of hysterical screaming' coming through the

walls at night that she wrote to alert William.[30] His reply does not survive, but a further letter from the neighbour suggests that he tried to affect a solution: perhaps, as Jan Marsh suggests, by asking the doctors to increase Christina's morphine. William recorded that the opiates were causing hallucinations in his sister, which might have brought on these terrors at night. Later critics have hypothesised that the real cause was a believer's fear of hell.

Tennyson was reported to have died as befits a Poet Laureate, with his hand on a copy of Shakespeare while the moon bathed his death-bed in golden light. Christina Rossetti's death borrowed from the agonised gothic aesthetics of her own work. At times disoriented and confused, she had to be convinced that the strange animal crawling on her sheets was simply the product of her imagination, and that her furniture had not been secretly rearranged. Whereas Maria approached death with 'rapt trustfulness', Christina's focused on the 'torments' of the afterlife. William was alarmed when she exclaimed, 'How dreadful to be eternally wicked! for in hell you must be so eternally …'[31] This was the sort of fear-mongering didacticism that made William an enemy of organised religion, and he had to restrain himself from interfering with visitors like the Reverend Gutch, a direct disciple of Pusey and former curate of All Saints Margaret Street whose 'austere' conversations with the dying Christina were 'foolish' and 'unfeeling.'[32] Gutch was exactly the kind of preacher designed to test William's patience. His sermons blamed sinful workplace behaviour for a Leeds mill accident; he had also credited the 1857 Divorce Act with causing excessive rainfall.[33] Nash, who had performed Frances's memorial service at Christ Church, Woburn Square, was a more compassionate spiritual adviser, reminding her of the comforts and blessings of her religion.

Following a horrific final night during which 'she was obliged to be fastened down', Christina died on the morning of 29th December, 1894 attended by her nurse. Long, drawn-out, painful and full of fear, hers had been the opposite of a Victorian 'good death'. 'Indeed it is a blank for me, but I could not wish her back,' the nurse wrote.[34]

It has been a commonplace of Christina Rossetti biographies to seize on the grisly and more dramatic aspects of Christina's final days as evidence that her religion was detrimental to her. William's many

writings about his sister's illness tend to emphasise his scepticism about her beliefs. Certainly, his influential 'Memoir', written as a preface to his 1904 *Poetical Works of Christina Rossetti*, tries to settle old family scores regarding faith and doubt. His oft-quoted portrayal of Christina's death has enshrined her as a victim of her faith: 'the terrors of her religion compassed her about, to the overclouding of its radiances'. What is cited less frequently is William's qualification that 'physical minor reasons' were equally responsible for Christina's state of mind. His diary speculates that religion may have been the cause of her distress, but William admits that Christina herself never said as much.[35]

Published ten years after his younger sister's death, William's 'Memoir' continues an argument between agnosticism and faith that Christina was unwilling to entertain when alive. Her refusal to speculate on the existence of God frustrated William, who felt that 'the field for debate, had she been minded to it, would have been a very large one.' He dismisses the religious currents of his sister's life, declining to discuss 'slighter matters' like her church-going, confession, communion, prayers and fasts, and spiritual guidance by the clergy. These may have seemed slight to an agnostic like William, but they were daily practices at the heart of Christina's creativity and philosophy. William even goes so far as to claim that religious belief restricted her 'poetic performance'. Her work suffered from 'over-scrupulosity' which was 'more befitting for a nunnery than for London streets'. Christina's art was 'too restricted' by its subject matter, and was not sufficiently involved with 'rising currents of thought.'[36] The same could easily be said of Gabriel's poetry and painting, but William does not say it.

It is surprising that a committed feminist like William failed to perceive the ways in which Christina's faith liberated her from the cultural imperatives of marriage and maternity. Being an artist allowed her to evade many restrictive categories of Victorian womanhood. Tractarianism provided an alternative model of successful spinsterhood, encouraging female spirituality and artistic creativity, and providing a serious platform for what Lynda Palazzo calls her 'feminist theology'. Christina's ascetic impulses were better-suited to a career in poetry than life in a convent. She confessed to a friend that

'like many young people' she 'went thro' a sort of romantic impression' about becoming a nun, but ultimately she felt 'no drawing in that direction.' Contrary to what her brother believed, she was unable to give up her beloved London streets for the confinement of a nunnery: 'It was my dear sister who had the pious, devotional, absorbed temperament: not I,' she declared.[37]

Her faith had allowed Christina to trespass on what many considered male territory. She had been inspired by Christianity, like many great English poets before her. Rather than clinging uncritically to her faith, as William suggests, she created a complex metaphysics in her own writing to help explore its contradictions and complications. For Christina, religion was neither an escape hatch nor a comfort blanket, though her gender has misled some critics on this point. Male religious poets writing in a similar vein are seldom if ever criticised for possessing restricted intellects or being better-suited to monastic life. Christina was utterly aware of the limiting effects 'overscrupulosity' might have on art, and was careful to avoid its pitfalls. If William had actually read her devotional work (which he scrupulously avoided) he might have been surprised to find how often she confronted this very issue.

William was pleasantly surprised at the number of uninvited mourners who attended Christina's funeral on the 2nd January, 1895. Snow had fallen during the night, but the winter's day dawned bright and clear. Despite her fierce love for her siblings, there was no question of the baby of the Rossetti family being buried with anyone other than her parents, or in any other place but London. The black mourning carriage rattled to Highgate cemetery once again, this time bearing William's children along with Christina's good friend Lisa Wilson and the trusted Nash. Christina was buried in a coffin decorated with a cross, identical to her mother's. Her brother chose the second stanza of her poem, 'The Lowest Place', as her epitaph. The white-haired-and-bearded William buried the last of his siblings in the full knowledge that he would be the final occupant of the Rossetti family tomb. Four days later, a well-attended memorial service was held at Christ Church, Woburn Square. Nash's memorial sermon, which quoted heavily from Christina's poetry, was popular enough to warrant publication. Burne-Jones designed a set of memorial

panels, showing Christ and the four Evangelists, which were painted by Thomas Rooke. Originally displayed in Christ Church Woburn Square, they would go on permanent loan to All Saints Margaret Street when Christ Church was demolished in the 1970s.

After the death of his parents, his siblings and his wife, William was alone, save for his children. He found an unlikely companion in the shape of Christina's favourite cat Muff (the ginger kitten 'Carrots' had vanished some time before). William was generally unsentimental about animals, so was surprised at his affection for the Persian mongrel. Purring, she would follow him up stairs, dangerously winding herself about his ankles. If he tried to pour milk in his tea or cocoa, she would either knock over the jug or greedily poke her nose inside it. When he was at work, Muff would either sit on his writing desk or try to perch distractingly on his shoulder. She would regularly slink off to give birth to a litter of kittens in any convenient cupboard or drawer. 'The amount of pleasure which I got out of this cat and her quaint ways was extreme', he recorded. She brought chaos into his well-ordered life, and her daily incursions symbolised the inconveniences, trials and rewards of love. In short, she reminded him of his sister. His reserve nearly cracked when he admitted that 'some' of his affection for the cat 'was clearly due to her association with Christina's memory...'[38]

Despite his scepticism about his sister's Christian beliefs, William was certain of her talent; even death failed to halt his efforts to promote her. On the day she died, he approached Watts about writing an article about her for *The Athenaeum*. Before January was out, he was reminding Alexander Macmillan to take advantage of the increased publicity to readvertise his sister's poems. In February, he offered some of her manuscript poems to the British Museum. Christina's true value as an English poet only became clear after her death, when papers on both sides of the Atlantic tripped over themselves to publish memorials, memoirs and tributes. As had been the case with Gabriel, death began the process of her canonisation. William offered her portrait to the National Portrait Gallery, pointing to the 'scores or hundreds' of current articles proving that she was now considered 'second (or perhaps not second) to Mrs. Browning.' He even managed to sneak his mother into the National Portrait Gallery,

which accepted Gabriel's chalk portrait of Christina and Frances in September 1895. Normally, the Trustees only admitted portraits of subjects who had been dead at least ten years, but they waived this rule for Christina 'on account of her high eminence as a poetess in the literary history of this country.'[39] In 1906, Christina's ambition to contribute to the tradition of English hymnody would be achieved when Gustav Holst set 'A Christmas Carol' ['In the bleak midwinter'] to music for the influential *English Hymnal*.

William was disappointed when the Gallery declined James Collinson's portrait of Maria Rossetti. Apparently she was not 'up to the mark of celebrity', despite the continuing success of *Shadow of Dante*, which had recently been included in Longman's Silver Library series.[40] William's contact at the Portrait Gallery tactfully assured him that the rejection had as much to do with Collinson's mediocre style as the subject's lack of fame. Christina's fame may not have shone brightly enough to reflect glory on Maria, but it did help restore her disgraced uncle, John Polidori. The National Portrait Gallery accepted John's portrait, the same one that had hung in pride of place in Frances's house. Painted by F.G. Gainsford in 1816, the three-quarter profile portrait showed the twenty one year-old John adapting the self-conscious pose of a Romantic poet, gazing meditatively into the middle distance, his brown eyes thoughtful, his dark hair carelessly tousled. William wrote how proud Gaetano Polidori would have been to have seen his son's portrait become a part of the National collection. That same year, G F Watts donated his 1871 portrait of Gabriel, who was already represented in the Gallery in the 1847 self-portrait purchased by the Trustees two years before.

Because William found no comfort in the Church, he sought it instead in continued acts of devotion to his family. Visiting his grandfather's former home in Buckinghamshire with Christina's first biographer Mackenzie Bell, he was flooded with memories of the past, a sensation he decided he enjoyed. He became the Rossettis' self-appointed archivist, sifting through papers, possessions and letters, monitoring the copyright of his siblings' works, advising biographers and corresponding with publishers. William himself produced so many articles and books about the family that he threatened to flood the market. There was something compulsive and self-soothing in

this activity, which he realised, but which did not unduly alarm him. On Swinburne's death, he recommended biography-writing as balm to a devastated Watts: 'It may do something towards revising your energies; as the writing of Gabriel's Memoir did for me after I had lost my wife, and was compelled to look out almost daily for the death of Christina.'[41]

Others, however, felt that his Rossetti publications were a morbid, dull and exploitative form of ancestor worship. In later years, Edmund Gosse would accuse him in *The Times* of doing 'serious harm' to his family:

> The deaths of his mother and of his illustrious sister Christina had left one brother the sole guardian of [Gabriel's] reputation…Then publications, revelations, sales of objects followed in terrible succession…At length, not a shilling more could be drained out of the body of the unhappy man, and public curiosity was definitely sated.[42]

Others simply felt that William overestimated his family's importance. As early as 1889, a reviewer had sounded a note of caution about 'the exaggerated vogue' for Gabriel's work, wondering if his 'achievements can bear this weight of narrative and commentary', pointing out that 'in execution his work was impressive rather than masterly'.[43]

Later twentieth century critics would find William's Rossetti publications uninformative, monotonous and too discreet. Recent work by William Fredeman, Roger Peattie and Angela Thirwell has regarded William more sympathetically. He is beginning to be portrayed as the unsung hero of the Rossetti family, sacrificing himself to a dull job in order to support his more talented siblings, content to remain proudly in the background as they collected their plaudits.

William's compulsive archival and biographical projects were not only money-spinners, but efforts to preserve his connection to the past, and to guard the family heritage. He had seen the great poets of his generation, like Swinburne, dying without much fanfare, and he felt that his family's posthumous reputation needed a strong advocate. Whatever his motivations, William's published work on the Rossettis is a valuable source of information. Though his methods of

arrangement and selection are chaotic, they belong to a Victorian biographical tradition which tries, not always successfully but often touchingly, to balance inclusion and discretion.

There were comforts besides memorializing his family, most of them offered by the city he loved. With no siblings to rescue anymore, William turned his attentions to strangers. In old age, he became more like his father, attracting 'beggars and bores' for company. He became 'a sort of consul-general for all Italians in London', informally helping out newly-arrived emigrés with food, clothes, donations and introductions. William maintained his connection to his father in other ways; in 1896, he published an English translation of his father's *Versified Autobiography*, including a long-winded commentary and earnest notes. He still regularly visited the Zoological Gardens, which had changed so much and so little since his childhood. Donning his poet's cloak and slouch hat he looked like 'a figure out of the past' as he took solitary walks up Primrose Hill, just north of Regent's Park.[44] Only 206 feet at its summit, the Hill was modest by most standards, but its close proximity to the city meant that it offered an unparalleled panoramic view of London. His obituarist, J L Patton, often encountered William 'looking out over the great black space on the south to the great mass of lights beyond, and listening to the "low sullen roar" of London's life, the still, sad music of London's humanity.'[45] The area was also a portal to the past; as children, the Rossettis had enjoyed family walks to Primrose Hill.

Christina had teased her brother that he was 'the most of a Polidori and the least of Rossetti', and this was certainly true in terms of his health and longevity.[46] Along with Gaetano Polidori's stoicism, William had inherited his grandfather's unassailable good health, although he was not immune to Rossetti gout. Polidori longevity was a curse as well as a blessing. Not only did he outlive Christina by twenty years, he would go on to bury almost all of his old friends. Swinburne's death in 1909 hit him particularly hard. Unable to attend the funeral on the Isle of Wight, he sent his daughter Helen to represent the Rossettis. She proved an excellent stand-in; when the vicar read a few lines of the funeral service against the atheist Swinburne's dying wishes, Helen walked away in protest. William was incensed that the establishment did not see fit to honor the poet's passing. Just

as he had complained that Gabriel ought to have been buried at Westminster Abbey, he argued that Swinburne deserved a more impressive send-off. The English ought to have followed the lead of the Italians, who were 'much better' at displaying 'the *emotion* of appreciation.'[47] His admiration was rewarded in September 1909, when the Italian ambassador to the Court of St. James recommended him for 'the insignia of some order' from the Kingdom of Italy. Uncelebrated in his own country, William was appreciated in his father's native land. He modestly refused, but added that he regarded Italy 'as being my native country almost in equal degree with England.'[48] Italy returned the compliment; representatives from the Italian Embassy would be present at William's burial.

The next generation of Rossettis inherited their father's passion for the old country, along with his taste for radical politics. Olivia and Helen both married Italians and emigrated to Italy, though in 1904 Helen would return to London with her daughter, Imogen Lucy Maria, to live with William after her husband's premature death. Olivia would later become a supporter of Italian fascism, and a correspondent and friend of Ezra Pound, who mentioned her in his *Cantos*. In 1903, the sisters co-authored *A Girl Among the Anarchists*, a novel based on their experiences as teenage editors of the anarchist journal, *The Torch*, which originated from the private printing press in the family basement. Joseph Conrad's biographer, Norman Sherry, claims that the young anarchists in 'The Informer' and *The Secret Agent* were partially based on the Rossetti sisters; Conrad met Helen some time between 1903 and 1904, when he called on William to discuss *Nostromo*.

William had his doubts about Anarchism, but the revolutionary in him was tickled that Anarchist propaganda was being produced in the home of a 'Somerset House young man'. When he at last retired from the Inland Revenue, his children cheekily hung out a red flag to mark the occasion. It was a female-dominated household, too much for Gabriel Arthur, who showed little flair for art and literature, and seems to have seized his first chance for escape. He had once amused his aunt Christina by requesting a barometer as a birthday gift. He became an electrical engineer, married at twenty-four and moved to Bolton, where he and his wife Dora raised a son, Geoffrey.

In 1901 a Rossetti family photograph taken in a Camden Town studio hints at how much times were changing. Queen Victoria's death in January ushered in the modern age. In that same year, the first trans-atlantic radio signal was sent from Galway to Newfoundland, Britain's first cinema opened in London, and Winston Churchill delivered his maiden speech in the House of Commons. Over forty years had passed since the previous Rossetti family portrait was taken in the garden at Cheyne Walk. William was the only subject left alive to experience the turn of the century.

William, his four children and Arthur's future wife Dora pose artificially before a backdrop. A relaxed, confident patriarch, William lounges on a chair with Helen seated at his knee, Mary at his left elbow, and Olivia standing behind him on his left. Tall and slim like his father, Arthur stands next to Olivia and behind Dora, who is seated stiffly on William's right. Free from the crushing weight of parental ambitions, and from Dante Alighieri's ghost, William's children look clear-eyed, confident and secure in this new world, just as he and Lucy had intended. This posed studio photograph of William's upstanding, modern family shows what the new century had lost; there was no garden, no natural light, no symbolic chessboard uncannily forecasting the epic match of *Through the Looking-Glass, and What Alice Found There*. Just as gentlemanly innovators in photography like Lewis Carroll had made way for commercial portrait studios, that sense of a Romantic, Pre-Raphaelite pursuit of 'truth to nature' was making way for a more pragmatic age. William was a modern man who welcomed new developments, but he worried that the Arts would be the loser in the march toward progress. 'The English are hideously apathetic in matters where only intellect is concerned', he had raged on Swinburne's death. 'The funeral of a conspicuous Railway-director or a fifth-rate MP...would excite more perceptible attention than that of the one great poet of the present generation.'[49]

Once, he had mocked Christina and his aunts for retreating from the world and clinging to old-fashioned customs. Now, in his old age, William was much the same. His house, crammed with a lifetime's worth of Pre-Raphaelite drawings, Japanese prints and china cabinets, struck visitors as a mid-Victorian time capsule. To step over its threshold was to feel 'transported not merely in atmosphere but

in time itself; it was 'as if one had escaped into another world.'[50] A lifetime honing his time-management skills had taught William to appreciate the comforts of routine, and visitors could set their clocks by his habits. He would appear at the same hour every morning to begin work in his study. Here he would enjoy his first pipe by the open window which overlooked a garden where Muff and her off-spring frolicked. In the afternoons he would take a walk on Primrose Hill before retiring for the night. It was the calm, ordered life he had always wanted, and yet something was missing. 'I should regard it as a disaster if I should live to be ninety', William said with a shudder.[51]

He felt that the social whirl of the modern arts scene was super-ficial. His disapproval of the changing social landscape reflects an older man's awareness, and sadness, at no longer being one of its key players. It was disconcerting to receive visits from Holman Hunt, frail, white-bearded and half-blind, whom he remembered as a strap-ping, bullish 'Maniac' youth. He would live to witness the death of his son-in-law, and the progression of his unmarried daughter Mary's chronic rheumatoid arthritis. He would experience the death throes of the Victorian era along with the rest of a shell-shocked Britain during the First World War.

Longevity did have its benefits. Without his siblings to over-shadow him, or to eat away at his free time, William could devote his full attention to his own pursuits. He remained passionately committed to the Arts throughout his seventies and into his eighties, taking a retirement job as a tax assessor of valuable estate paintings as well as writing and travelling. As keeper of the Rossetti flame, he had his admirers as well as his detractors, and he welcomed the company of new friends such as the museum curator and collector Sydney Cockerell, American writer Richard Curle and the artist William Rothenstein, who painted his portrait in 1909. He tried hard to inspire a love of Pre-Raphaelitism in the next generation. 'William Rossetti was the only one of the Pre-Raphaelites who was sympathetic towards the work of the younger writers and painters,' Rothenstein noted.[52]

Max Beerbohm speculated that future generations would compare William with his more celebrated siblings and conclude that he was 'one sane man among lunatics.'[53] But in the immediate aftermath

of their death, his sanity was publicly perceived as a drawback. His pedestrian publications of 'Rossetiana' were seen either to make a mockery of his family's genius or to exaggerate it beyond reason. Gabriel's 1895 *Family Letters* were 'dreadful; obviously forgeries by his brother', Oscar Wilde sniped from his cell at Reading Gaol. The unimaginative William ought to have taken Gabriel's conspiracy theories more seriously, he added darkly.[54] Wilde misunderstood William's personality. Passive, measured and acute, it was William's nature to bear witness rather than to participate or intervene. This impulse was self-protective, a kind of willed disassociation. It seems entirely characteristic that William's first memory was of silently enduring the pain of teething: 'I used to sit on a stool or little chair with its back to the wall, and with my hands drooping in front of me like a Kangaroo's – suffering in silence.'[55]

Richard Curle presents us with a late-life instance of this defensive passivity. Having missed by seconds the ferry from Sark to Guernsey, Curle gestured frantically to William, already on board with his daughter Helen, to get someone to come to his aid. Though he was only feet away, William 'continued to gaze at me with despairing commiseration, audibly announcing in tones of deepest gloom, "Poor, unfortunate fellow!" Curle did catch the boat, no thanks to William, who 'felt convinced that all efforts would be useless' and 'just stood there without doing anything'.[56]

As an agnostic, William accepted that his family were dead and gone for good; but as a son and brother, he found it difficult to let them go. He sought them in the only places he was sure to encouter them: old diaries and correspondence, and the recesses of his own encyclopaedic memory. His almost frantic biographical activities reveal an emotional intensity that William otherwise worked hard to suppress. Keeping the memory of his siblings alive was not only a form of fraternal pride, but of self-preservation. He had always defined himself in relation to Gabriel, Christina and Maria; without them he never seemed entirely sure who he was.

In June 1896, William visited the National Portrait Gallery, which had recently re-located to St. Martin's Place from Bethnal Green. It was now adjacent to the National Gallery, which the Rossetti children had once eagerly explored with their mother. Admiring their

portraits as he strode proudly through the Gallery was as close as the agnostic William was going to get to a heavenly family reunion. There was Christina and Frances, sweetly rendered in the mournful blues and greys Gabriel had chosen, looking tenderly down at him. And there was Gabriel's pencil and chalk self-portrait, done when his older brother was a dashing, ambitious nineteen year-old art student. Also present was Gabriel as he had been in the early 1870s, thin, balding and haggard from chloral abuse, yet dignified and stately nonetheless. Gabriel had hated G.F. Watts's realist portrait, but years after his death, even the memory of brother's dissatisfaction filled William with nostalgia. He would have been pleased to learn that, next door at the National Gallery, Holman Hunt had recently come upon two modern ladies diligently copying Gabriel's *Ecce Ancilla Domini*. Hunt himself heard the painting speaking to him 'in long-forgotten words.'[57]

After this understandably emotional experience, William suppressed his feelings by rushing home to dash off a fogeyish letter to the Director, in which he complained that the portrait of Christina and Frances was badly hung. It also niggled that Maria's portrait was not on the Gallery walls, or at least not yet. He would have to do something about that. For all his Polidori good sense, William was prone to Rossetti obsessiveness when it came shaping his siblings' afterlives. Perhaps, as he sat down to write, he glanced at the preserved sea-mouse he had inherited from Christina. Bobbing morosely it its jar, far from the coastal sunlight needed to bring out its reds, blues and greens, it might have impressed the casual observer as simply a shriveled, greying relic from days gone by and best ignored. For William, the creature would never lose its lustre. When he admired the sea-mouse's 'brilliant, iridescent hues', he vowed that it would 'remain with me to the end'.[58]

Gabriel had once said, 'Art must be its own comforter, or else comfortless.'[59] In the absence of his siblings, William decided to comfort himself by turning the act of remembrance into an art. He cast his mind back to his boyhood, and recalled how his father enjoyed laughing at the motto of the ducal Bedford family, which had been proudly emblazoned over Covent Garden Market: '*Che sará sará*' ['what will be, will be']. The Italian inscription contained an error;

sarà was missing the required accent, and so the word translated as 'Sarah'. This proved to Gabriele that the English ruling classes weren't as clever or powerful as they thought, or, at the very least that their children were in need of some good Italian tuition. William gleaned a different truth from the Covent Garden motto. A less literal translator in childhood than he was as an adult, William was able to overlook the letter of its grammatical inaccuracy and embrace its stoic spirit: 'it has been present to my mind, as a far-reaching and regulative truth, all my life.'[60]

In his old age, the motto would take on a different meaning, something nearer to passive resistance than stoic acceptance. The family memoribilia with which William surrounded himself ultimately served the same function as his father's Dantean *libri mistici*. They were fortifications against the passage of time, declarations of his faith. With his sister's trusty cat purring at his elbow, William would settle at his desk and began a day's work, deaf to the cries of exploitation, cynicism, and commercialism that greeted his ceaseless publications about his parents and siblings. '*Che sarà sarà*' would be his unspoken response to anyone who thought he might be damaging the family reputation: 'What will be will be.' The 'one sane man' among the Rossettis would spend the rest of his days memorialising the 'lunatics' who had made life worth living.

NOTES

Preface

1. Entry for 1 Oct 1863, *Lewis Carroll's Diaries: The Private Journals of Charles Lutwidge Dodgson (Lewis Carroll)*, with notes and annotations by Edward Wakeling. Vol. 4 (Luton: The Lewis Carroll Society, 1997), 247.

2. Lewis Carroll to E. Gertrude Thompson, Aug 10, 1897, *The Letters of Lewis Carroll*, ed. Morton N. Cohen Vol. 2 (NY: Oxford University Press, 1979), 986.

3. Entry for 6 Oct 1863, *Lewis Carroll's Diaries*, Vol. 4: 252.

4. Jerry White, *London in the Nineteenth Century: 'A Human Awful Wonder of God'* (London: Jonathan Cape), 2007.

5. William Sharp, *Selected Writings of William Sharp, Uniform Edition Arranged by Mrs. William Sharp* Vol. 3 (New York: Duffield and Company, 1912), 353–56

6. DGR to WA 6 Aug 1863, *Fredeman* 3:71.

7. *FLM* 2:187.

8. *FLM* 1:422.

9. *SR* 2:328.

10. CGR, 'The House of Dante Gabriel Rossetti', *Literary Opinion* 2 (1892): 129.

11. CGR to Lewis Carroll, ? November 1863, *Harrison* 1:185.

12. Sharp, 3:77.

13. MFR to Amelia Barnard Heimann, 2 Nov 1846 *Harrison* 1:6, note 3.

14. 'Reflections', *Hodge-Podge* 27 May 1843, Ms.facs.C95 in *RFP*.

15. Sharp, 3:77.

16. *Letters of DGR to WA 1854–1870*, ed. George Birkbeck Hill (London: T. Fisher Unwin, 1897), 89–90.

17. Alexander Gilchrist, *Life of William Blake* Vol. 1 (London: Macmillan, 1880), 364. First published 1863.

18. DGR to Lewis Carroll 3 Dec 1863, *Fredeman* 3.92.

19. CGR to DGR 4 May 1874 *Harrison* 2:12.

20. CGR, 'The House of Dante Gabriel Rossetti', *Literary Opinion* 2 (1892): 129.

Chapter 1

1. Thomas Carlyle to Alexander Carlyle, 14 Dec 1824, *Early Letters of Thomas Carlyle*, ed. C.E. Norton (London: 1886), 316–17.
2. Waller, 29.
3. Henry Luttrell, *Advice to Julia: A Letter in Rhyme* (London: John Murray, 1820), 60.
4. Waller, 27.
5. *VA* 82.
6. Charles Dickens, *Oliver Twist* (London: Dent, 1907), 181.
7. *VA* 75.
8. Ibid.
9. GR to G.H. Frere, 2 May 1824, quoted in Gabrielle Festing, *John Hookham Frere and His Friends* (London: J. Nisbet and Co', 1899), 302
10. GR to G.H. Frere, 4 Dec 1827, Ibid., 304.
11. *VA* 15.
12. Gabriele had also written over sixty Carbonari manifestos and brochures which urged the nation to prepare for war against Austria.
13. ST Coleridge to H.F. Cary, 14 Dec 1824, *Letters of Samuel Taylor Coleridge* ed. Hartley Coleridge, Vol. 2 (London: Heinemann, 1895), 731, 733.
14. *VA* 57–58.
15. Ibid. 59.
16. Waller, 20.
17. *AV* 75.
18. 'The Italians of Hatton Garden', *Holborn and Bloomsbury Journal* 24 March 1866, quoted in Lucio Sponza, *Italian Immigrants in Nineteenth Century Britain* (Leicester: Leicester University Press, 1988), 239.
19. Waller, 23.
20. *The Letters of ST Coleridge*, 2:732.
21. *The Times*, Monday, Mar 06, 1820; pg. 3.
22. GR to G.H. Frere, 2 May 1824, *John Hookham Frere and His* Friends, 302.
23. *VA* 73.
24. WMR's notes, *VA*, 32.

25. Jane Welsh Carlyle to Jeannie Welsh, 16 November 1842 *The Collected Letters of Thomas and Jane Welsh Carlyle*, ed. Claude Ryals and Kenneth J. Fielding Vol. 15 (Durham: Duke University Press, 1987), 187–188.

26. To Thomas Carlyle, 17 July 1837. *The Collected Letters of Thomas and Jane Welsh Carlyle*, ed. Claude Ryals and Kenneth J. Fielding Vol. 9 (Durham: Duke University Press, 1981), 250.

27. Jerry White, *London in the Nineteenth Century* (London: Jonathan Cape, 2007), 26.

28. Ibid. 14.

29. John Fisher Murray, *The World Of London* 1 (London: Blackwood, 1843) 46.

30. *FLM* 1:33.

31. *VA* 86.

32. *VA* 8.

33. Waller, 37.

Chapter 2

1. William James Stillman, *The Autobiography of A Journalist* Vol. 1 (Boston: Houghton Mifflin, 1907), 302.

2. Harriet Martineau, *Autobiography* 1 (London: Smith Elder, 1877), 82.

3. *FLM* 1:28

4. *SR* 1:6.

5. Letter from JP to FR, 2 May 1816, *The Diary of Dr. John William Polidori*, ed. WMR (London: Elkin Mathews, 1911), 212.

6. Letter from Byron to John Murray, 21 Aug 1817, *Life, Letters and Journals of Lord Byron in One Volume* (London: John Murray, 1844), 364. Originally published 1830.

7. Letter from JP to FR, 2 May 1816. *The Diary of Dr. John William Polidori*, ed. WMR (London: Elkin Mathews, 1911), 210.

8. William Wordsworth, preface to *Lyrical Ballads* Vol. 1 (London: Longman, 1802), xxviii

9. *SR* 1:117, 127

10. William Sherlock, *A Practical Discourse Concerning Death* (Albany: Pratt and Doubleday, 1814), 222.

11. *FLM* 1:32, 23

12. *FLM* 1:21

13. Byron, ll. 16–18, 'Remind Me Not, Remind Me Not', quoted in ADC 12.

14. FLM 1:29

15. FLM 1:22
16. Mackenzie Bell, *Christina Rossetti: A Biographical and Critical Study* (London: Thomas Burleigh, 1898), 8. (original in Italian. tr. WMR).
17. *FLM* 1:10.
18. Waller, 44.
19. 'Notices', *The Monthly Review* No. 1 Vol 3 (Sept 1832): 151.
20. *William Allingham: A Diary*, ed H. Allingham and D. Radford (London: Macmillan, 1907), 165.
21. Pusey, *Sermons during the season from Advent to Whitsuntide* (London: John Henry Parker, 1848), 299.
22. FLM 1:12,10
23. See Ruth Brandon, *Other People's Daughters: The Life and times of the Governess* (London: Phoenix, 2008), Chapter 1.
24. *SR* 1:10
25. CGR, *Speaking Likenesses* (London: Macmillan, 1874), 31, 43.
26. *SR* 1:21
27. Quoted in E.R. Vincent, *Gabriele Rossetti in England* (Oxford: Clarendon, 1936), 31.
28. *FLM* 1:68
29. *SR* 1:18.
30. quoted in Waller, 130.
31. *SR* 1:19.
32. William Sharp, *Selected Writings of William Sharp: Papers Critical and Reminiscent*, 3 (London: Heinemann, 1912), 77.
33. *SR* I, 121.
34. Sharp, Vol. III, 70.
35. *FLM* 1:31
36. *FLM* 1:63, 61.
37. ADC 6.18
38. DGR to FMLR 21 Jan 1876 *Fredeman* 7:202.
39. *FLM* 1:22

Chapter 3

1. *FLM* 1:63.
2. J.H. Frere to G.R., 6 April 1836, cited in P.R. Horne, 'Autocensorship in the Age of Victoria: The case of Gabriele Rossetti and Charles Darwin', *The Modern Language Review* Vol. 89 No. 2 (April 1994): 347.
3. Ibid. 11 June 1840, 349.
4. Ibid. 23 Feb 1841, 349.

5. Waller, 111.
6. *FLM* 1:63–4.
7. Quoted in Waller, 140.
8. GR to Lyell, 20 May 1843. Quoted in Waller, 150.
9. Charles Kingsley, *Alton Locke* (London: Chapman and Hall, 1852), 16.
10. *FLM* 1:66.
11. William Sharp, *Some Reminiscences* in *Papers Critical and* Reminiscent, Vol. 3, ed. Mrs. William Sharp (London: Heinemann, 1912), 73.
12. *A Picturesque Guide to the Regent's Park* (London: John Limberd, 1829), 20–21.
13. See *The Collegiate Chapter of the Royal Hospital of Free Chapel of St Katherine Near the Tower in its Relation to the Church in the East of London*. Privately Printed (London: Clay, Son & Taylor, 1865), 186.
14. *FLM* 1:81.
15. William Sharp *Some Reminiscences* in *Papers Critical and Reminiscent.* Vol 3, ed. Mrs. William Sharp. (London: Heinemann, 1912), 73.
16. *FLM* 1:76.
17. William Powell Frith, *My Autobiography and Reminincences* Vol I (NY: Harper, 1888), 31.
18. DGR to FMLR 14/15 Aug 1843, *Fredeman* 1:26.
19. *RFP* Ms facs C.95, 'Reflections', *Hodge-Podge* 3 (3 June 1843),
20. Ibid.
21. Ibid. *Hodge-Podge* (15 Aug 1843).
22. *Edinburgh Review* (Jan 1874), 63.
23. For a detailed comparison, see Raymond Chapman, *Faith and Revolt* (London: Weidenfeld and Nicolson, 1970).
24. Newman, *Tracts for the Times* Vol. 3 No 71. 'On the Controversy with the Romanists', (London: Rivington, 1836), 3.
25. *FLM* 1:103
26. *SR* 1:122, 41.
27. Waller, 158
28. *SR*I: 39.
29. *FLM* 1:103
30. *Notes and Queries* (Nov 1968): 423
31. Edmund Pusey, *Sermons during the season from Advent to Whitsuntide* (Oxford: John Henry Parker, 1848), 105.
32. Helen Rossetti Angeli, 'Aunt Christina', *The Times* (5 Dec 1930): 15.
33. *PWCGR* lxviii
34. Waller, 173.

35. *VA* 90.
36. Tr. Waller, 153. Tellingly, William omits these lines from his own published translation.
37. *SR* 1:77–78.

Chapter 4

1. See chapter 7 of Alison Millbank's *Dante and the Victorians* (Manchester: Manchester University Press, 1998).
2. FGS *Dante Gabriel Rossetti* (London: Seeley, 1904), 7.
3. DGR to Leigh Hunt, Jan 1848; Leigh Hunt to DGR 13 March 1848; *Fredeman* 1:49, 52.
4. FGS, *Dante Gabriel Rossetti*, 10.
5. *AN* 1:247.
6. *The Life and Letters of Sir John Everett Millais*, ed. John Guille Millais Vol. 1 (London: Methuen, 1899), 52.
7. John Keats to George and Thomas Keats, 22 December 1817; to John Taylor, February 27, 1818, in *Life, Letters and Literary Remains of John Keats*, ed. Richard Monkton Milnes (London: Edward Moxon, 1848), 92, 108.
8. *FR*1:109
9. *FLM* 1:135.
10. WMR, *The PRB Journal*, ed. William E. Fredeman (Oxford: Clarendon Press, 1975), 241.
11. FGS, *William Holman Hunt and His Works* (London: John Nisbet & Co., 1860), 12.
12. DGR to WHH, 12 July 1848, *Fredeman*, Vol. 1: 64.
13. Pusey, *Sermons during the season from Advent to Whitsuntide* (Oxford: John Henry Parker, 1848), 299.
14. Waller, 183
15. DGR to WMR, 30 Aug 1848, *Fredeman* 1:71.
16. WMR, 'In the Hill Shadow', *Athenaeum* 23 September (1848): 961.
17. *Pre-Raphaelitism* 161; FLM 1:131; AN 1:281.
18. DGR to Charles Lyell, 14 Nov 1848. *Fredeman* 1:75.
19. DGR to Lyell, 14 Nov 1848, *Fredeman*, Vol. 1: 47–48.
20. *Pre-Raphaelitism* 114
21. *FLM* 1:132.
22. DGR to FGS, 21 Aug 1849, *Fredeman* 1:88.
23. WMR to WBS, 5 Feb. 1850, *Peattie* 12.
24. *FLM* 1:133.

25. Waller, 157.

Chapter 5

1. CGR to WMR 25 Aug 1849, *Harrison* 1:19.
2. CGR to WMR 24 Sept 1849, *Harrison* 1:26.
3. Bell, 22.
4. William Sharp, 'Some Reminiscences of Christina Rossetti' in *Papers Critical and Reminiscent* William Sharp', (London: William Heinemann, 1912), 76.
5. Bell, 20.
6. CGR to WMR 19 Sept 1849, *Harrison* 1:25.
7. DGR to WMR 8 Oct 1849, *Fredeman* 1:114–115.
8. WHH, *Pre-Raphaelitism*, 1:188.
9. DGR to WMR 8 October 1849, *Fredeman* 1:110; 18 Oct 1849, 117.
10. WMR to FGS 27 Sept 1849, *Peattie* 6.
11. *Pre-Raphaelitism*, 1:188.
12. CGR to WMR, 14 Jan 1850, *Harrison* 1:31.
13. CGR to ABH 19 Jan 1850, *Harrison* 1:33.
14. *AN* 1:324–5.
15. *Athenaeum* review (20 April 1850): 424.
16. *The Times* (15 April 1850): 5.
17. Angus Reach, 'Town Talk and Table Talk', *Illustrated London News* (4 May 1850): 306.
18. 'The Pictures of the Season,' *Blackwood's Edinburgh Magazine* 68 (July 1850): 82.
19. *The Times* (9 May 1850): 5.
20. Charles Dickens, 'Old Lamps for New Ones' *Household Words* 1 (15 June 1850): 265.
21. 'Royal Academy' *Athenaeum* no 1179 (1 June 1850): 590
22. Charles Dickens to Daniel Maclise, 30 May 1850, *Letters of Charles Dickens* 6, ed. Storey Tillotson and Burgis (Oxford: OUP, 1988), 107.
23. Ralph Wornum, 'Modern Moves in Art', *The Art Journal* 12 (1850): 271.
24. 'The Pictures of the Season,' *Blackwood's Edinburgh Magazine* 68 (July 1850): 82.
25. *Pre-Raphaelitism* 1:219, 221.
26. *PRDL* 276.
27. *PWCGR* lii.
28. John Galt, *The Ayrshire Legatees* (Edinburgh: Blackwood, 1821), 288.

29. *The New Monthly Magazine*, ed. Theodore Hook (London: Colburn, 1841), 171.

30. Edwin Lee, *Brighton and its Sanative Resources* (London: J. Churchill, 1850), 24.

31. DGR to FGS, Sat 19 Oct 1850, *Fredeman* 1:154.

32. JEM to Thomas Combe, 16 Dec 1850, *Life and Letters* 1:93.

33. Elizabeth Wordsworth, *Henry William Burrows: Memorials* (London: Kegan Paul, 1894), 138, 234.

34. Bernard Rainbow, *The Choral Revival in the Anglican Church* (1839–1872) (Oxford: OUP, 1970), 175–6.

35. DGR to Charlotte Polidori, Thu. Feb 1851, *Fredeman* 1:167.

36. DGR to John Tupper, Thu. April 1851, *Fredeman* 1:170

37. Ford Madox Hueffer, *Ford Madox Brown: A Record of His Life and Work* (London: Longmans, 1896), 77.

38. John Ruskin, 'Pre-Raffaelites', *The Times* (13 May 1851): 8–9.

39. DGR to Walter Howell Deverell, 30 Aug 1851, *Fredeman Letters* 1:181.

40. DGR to WMR Nov 1851, *Fredeman* 1:188.

41. Jerry White, *London in the Nineteenth Century* (London: Cape, 2007), 14.

42. FLM 1:171.

43. *From* letter 4:29, in *Pre-Raphaelite Friendship*, letters of WHH and JLT, quoted in *Fredeman* 1:151.

44. FLM 1:76, 177.

45. RRP 33.

46. John Ruskin, *Praeterita* Vol. 3 (London:George Allen, 1907), 22.

Chapter 6
1. *SR* 1:117.

2. CGR, *Maude: A Story for Girls*, introduction by WMR (London: J Bowden, 1897), 117–118.

3. FMLR to DGR 5 July 1855, ADC 3.17.

4. Waller, 163.

5. From *Miss Eden's Letters*. Vol 2, ed. Violet Dickinson (London: Macmillan, 1919), 184, 181.

6. *SR* 1:109.

7. WMR to FR 10 Apr 1853, *Peattie* 43.

8. CP to FMLR 19 Apr 1853, ADC 27D.

9. MFR to FMLR 25 April 1853, ADC 13.

10. WMR to FMLR 10 Apr 1853, *Peattie* 42.

11. CGR to FMLR 28 Apr 1853, *Harrison* 1:64.
12. FMLR to DGR 23 July 1853, ADC 3.17
13. *Pre-Raphaelitism*, 1:267.
14. *SR* 1:92.
15. CGR to WMR 4 July 1853, *Harrison* 1:70.
16. *FLM* 1:160.
17. *PRDL* 309.
18. FMLR to DGR 8 June 1853, ADC 3.17.
19. DGR to FMLR 30 Sept 1853, *Fredeman* 1:285.
20. FMLR to DGR 3 Oct 1853 ADC 3.17.
21. *FLM* 2:114
22. WMR to FMLR 20 July 1853, *Peattie* 45, note 1.
23. Peattie 248.
24. DGR to WBS 19 Dec 1853, *Fredeman* 1:298.
25. DGR to CGR 4 Aug 1852, *Fredeman*, 1:197.
26. DGR to CGR 8 Nov 1853, *Fredeman* 1:294.
27. *AN* 1:314–15.
28. Arthur Hughes to William Allingham, 24 Nov 1856, *Letters to William Allingham*, ed. H. Allingham (London: Longmans,1911), 64.
29. DGR to FMB, 23 May 1854, *Fredeman* 1:354.
30. *FLM* 1:177, 175, 174.
31. WMR to Anne Gilchrist, 24 Aug 1876, *Peattie* note 4, 316.
32. *SR* 1:115.
33. DGR to FMLR 7 May 1854, *Fredeman* 1:343.
34. *SR* 1:116.
35. DGR to William Allingham 26 April 1854, *Fredeman* 1:340.
36. DGR to CGR 8 Nov 1853, *Fredeman* 1:294.

Chapter 7
1. Waller, 137.
2. DGR to WHH, 30 Jan 1855, *Fredeman* 2:14.
3. J.P. Emslie, 'Art Teaching in Early Days', in *The Working Men's College 1854–1904*, ed. Rev. J Llewellyn Davies (London: Macmillan, 1904), 45.
4. *Letters of DGR to WA 1854–1870*. ed. George Birkbeck Hill (London: T. Fisher Unwin, 1897), 90.
5. DGR to George Price Boyce 27 April 1855, *Fredeman* 2:34.
6. DGR to Charlotte Polidori 3 May 1855, *Fredeman* 2:35.
7. *FLM* 1:427.

8. Quoted in Sir William James, *John Ruskin and Effie Gray* (NY: Scribner's, 1947), 220.
9. John Ruskin to Mrs. Acland 10 July 1855, *The Works of John Ruskin* 36, eds. Cook and Wedderburn (London: George Allen, 1909), 217.
10. *FLM* 1:210
11. John Ruskin to Mrs. Acland, 10 July 1855, *The Works of John Ruskin* 36, eds. Cook and Wedderburn (London: George Allen, 1909), 217.
12. *FMBD* 155.
13. *FMBD* 1:126.
14. *FLM* 1:174.
15. FR to DGR 5 July 1855, ADC 3:17.
16. John Ruskin to EES, May 1855, *The Works of John Ruskin* 36, eds. Cook and Wedderburn (London: George Allen, 1909), 204.
17. *TF* 77.
18. FMB to MFR c. Feb 1856, ADC 9.11.
19. CGR to WMR 13 Nov 1855, *Harrison* 1:102.
20. *SR* 1:261.
21. DGR to WMR 2 Aug 1856 *Fredeman* 2:131.
22. *FMBD* 181, 183.
23. EP to FMLR 7 Dec, 1854 ADC 27D.
24. Ibid.
25. *SR* 1:6.
26. EP to FMLR, 21 December 1854 ADC 27D.
27. Sue M. Goldie, *Florence Nightingale in the Crimean War 1854–56*, ed. Sue M. Goldie (Manchester: Manchester University Press, 1987), 132.
28. EP to FMLR 15 Feb 1855, ADC 27D.
29. CGR to ABH 22 Nov 1855, *Harrison* 1:104; CGR to WMR 13 Nov 1855, 102.
30. WMR to WBS 15 Nov 1854, *Peattie* 53.
31. WMR to ACS 28 January 1877, *Peattie* 350–51.
32. DGR to WBS, 7 Dec 1854, *Fredeman* 1:398.
33. *FLM* 1:250.
34. Elizabeth Barrett Browning to Arabel Barrett, spring 1859, quoted in *Sublime and Instructive: Letters from John Ruskin to Louisa, Marchioness of Waterford, Anna Blunden and Ellen Heaton*, ed. Virginia Surtees (London: Michael Joseph, 1972), 261.
35. DGR to WA 6 March 1856 *Fredeman* 2:101.
36. DGR to WA 25 Nov 1855, *Fredeman* 2:80–81.
37. *SR* 1:249, 248.

38. Mary Howitt, *An Autobiography*, ed. Margaret Howitt, Vol. 2 (London: WM Isbister, 1889), 348–9.
39. Jan Marsh, *Pre-Raphaelite Sisterhood*, (London, Quartet, 1985).
40. 'America', *The Times* (20 Sept 1858): 6.
41. *FMBD* 101.
42. *RRP* 258.
43. Edmund Gosse, *The Life of Algernon Charles Swinburne* (London: Macmillan, 1917), 137.
44. *PWCGR* 459.
45. *PWCGR* 459.

Chapter 8
1. CGR to WMR 30 Nov 1860, *Harrison* 1:139.
2. John Tosh, *A Man's Place: Masculinity and the Middle-Class Home in Victorian England* (New Haven: Yale University Press, 1999), 109.
3. 'Queen Bees or Working Bees', *Saturday Review* 12 November 1859.
4. Diane D'Amico notes that while a letter from WMR to CGR's biographer Mackenzie Bell suggests she may have been a formal Associate or Outer Sister of All Saints, her name does not appear in the Sisterhood's records in this capacity. (*Faith, Gender and Time*, 44). WBS's wife wrote a letter to her husband which suggests that CGR was an Associate sister. (*AN*2:59).
5. 'Miss Hughes,' quoted in Thomas Jay Williams and Allan Walter Campbell, *The Park Village Sisterhood* (London: SPCK, 1965), 30.
6. Susan Mumm, *Stolen Daughters, Virgin Mothers* (London: Leicester University Press, 1999), 140.
7. *All Saints Margaret Street: A Pitkin Guide* (London: Pitkin Pictorials, 1990), 16.
8. Eastlake, *History of the Gothic Revival* (London: Longmans Green and Co', 1872), 254.
9. John Ruskin, *The Stones of Venice* Vol. 3 (London: Smith, Elder and Co., 1853), 196.
10. A.H. Bennett, *Through an Anglican Sisterhood to Rome* (London: Longmans, Green and Co., 1914), 7.
11. Tosh, *A Man's Place*, 28.
12. MFR, *Letters to my Bible Class on Thirty-Nine Sundays* (London: SPCK, 1872), 49, 3. Maria explains in her preface that when illness forced her to suspend her weekly bible class in December 1860, 'writing was substituted for verbal teaching, till at last the class

passed…into other hands, and my little papers were no longer needed', 2. She was suffering from erysipelas, a painful rash also known at 'St. Anthony's Fire'. It is often an indication of a suppressed immune system.

13. Ibid., 15–16.
14. Ibid., 10.
15. Ibid., 13–14; 38.
16. Ibid., 22; 51.
17. CGR to Barbara Bodichon, 15 Aug 1860, *Harrison* 1:134.
18. James Collinson to WMR 14 April 1858, RFP, WMR Series Ms.facs. d. 277, p 106.
19. CGR to ABH 17 Jan 1860, *Harrison*, 129.
20. *SR* 2:311.
21. *FMBD*, 143, 164.
22. DGR to Alexander Macmillan 220 Aug 1861, *Fredeman* 2:399.
23. CGR to David Masson, 19 Jan 1861, *Harrison* 1:141
24. CGR to ABH 5 Dec 1857, *Harrison* 1:112.
25. *FLCGR* 54.
26. Marsh, *Christina Rossetti: A Literary Biography*, 207.
27. CGR to ABH 8 June 1860; CGR to Pauline Trevelyan 27 Aug 1860, *Harrison* 131; 136.
28. Terry M. Pernissen, *Secret Passions, Secret Remedies: Narcotic Drugs In British Society, 1820–1930* (Manchester: Manchester University Press, 1983), 11–15. See Chapter 2 of Pernissen's book for more on the international opium trade during this period.
29. *FLM* 1:212.
30. DGR to FMLR 13 Apr 1860, *Fredeman* 1:292.
31. *FLM* 1:221.
32. Georgina Burne-Jones, *Memorials of EBJ*, Vol. 1 (London: Macmillan, 1904), 218.
33. W. Stokes to William Allingham, 2 March 1861 *Letters to William Allingham*, ed. H. Allingham (London: Longmans,1911), 272.
34. Ibid. 208–09.
35. *FLM* 1:219.
36. J.W. Mackail *The Life of William Morris* Vol. 1 (London: Longmans, 1899), 186.
37. Arthur Hughes to WA, Sunday Feb 1860, *Letters to William Allingham*, ed. H. Allingham (London: Longmans, 1911), 67.
38. DGR to FMLR 2 May 1861, *Fredeman* 2:353.

39. Charlotte Polidori to Margaret Polidori 15 May 1861, ADC 27D.
40. Georgina Burne-Jones, *Memorials of EBJ*, Vol. 1 (London: Macmillan, 1904), 222, 229.
41. *FLM* 1:222.
42. CGR to ABH 14 Feb 1862, *Harrison* 1:155.
43. Samantha Matthews, *Poetical remains: Poets' Graves, Bodies, and Books in the Nineteenth Century* (Oxford: OUP: 2004), note 12, p. 20.
44. *FLM* 1:227.

Chapter 9

1. Georgina Burne-Jones, Vol. 1, *Memorials of GBJ* (London: Macmillan, 1904), 292.
2. DGR to George Rae 2 Jan 1865, *Fredeman* 3:238.
3. DGR to FMB 7 Dec 1864, *Fredeman* 3:224.
4. SR 1:273.
5. *FLM* 1:264.
6. Thomas Keightley to WMR, 1 March 1865, *RP*, 79.
7. MFR, preface to *Exercises in Idiomatic Italian* (London: Williams and Norgate, 1867), v-vi.
8. CGR to DGR 16 Jan 1865, *Harrison* 1:220.
9. *William Allingham: A Diary*, ed H Allingham and D. Radford (London: Macmillan, 1907), 164.
10. *The Diaries of George Price Boyce*, ed. Virginia Surtees (Norwich: Real World, 1980), 36, 46.
11. *SR* 1:288.
12. CGR to DGR, 6 Feb 1865 & 10 Feb 1865, *Harrison* 1:225, 226.
13. CGR to Dora Greenwell, ?October 1863, *Harrison* 1:184.
14. Bell, 38.
15. CGR to DGR, 6 Mar 1865, *Harrison* 1:231.
16. *SR* 1:18.
17. *Pre-Raphaelitism* 149.
18. DGR to WA 23 Sept 1863, *Fredeman* 3:76.
19. *FLM* 1:158.
20. Arthur Benson, *Essays* (New York: Macmillan, 1896), 271.
21. DGR, preface to *Early Italian Poets* (London: Smith, Elder & Co.,, 1861), x.
22. *William Allingham: A Diary*, ed H Allingham and D. Radford (London: Macmillan, 1907), 163.
23. JR, *Praeterita* 3 (George Allen, 1907), 22.

24. *RP* 105–110, *passim.*
25. *William Allingham: A Diary*, ed H Allingham and D. Radford (London: Macmillan, 1907), 165.
26. CGR to Anne Burrows Gilchrist, Autumn 1865, *Harrison* 254.
27. *RP* 104.
28. CGR to Elihu Burritt [after June 1867], *Harrison* 1:295.
29. *SR* 313.
30. CGR to ABH 13 Aug 1866, 279.
31. CGR to WMR 11 Sept 1866, 283.
32. CGR to ABH 13 Aug 1866, 279.
33. *FLM* 1:255.
34. CGR to DGR 23 Dec 1864, *Fredeman* 1:209
35. *AN* 2:66.
36. *RP* 348.
37. FMLR to DGR 8 June 1868, ADC 3.17.
38. *Recollections of Dante Gabriel Rossetti and His Circle* (Westerham: Dalrymple Press, 1984), 25–6.
39. FMLR to DGR 21 Aug 1867, ADC 3.17.
40. *William Allingham: A Diary*, ed H Allingham and D. Radford (London: Macmillan, 1907), 166.
41. *RP* 384.
42. DGR to FMLR 1 Mar 1869, 156–7.
43. *Swinburne's Poems and Ballads: A Criticism* (London: John Camden Hotten, 1866), 42; 50–51.
44. DGR to WA 23 Sept 1863, *Fredeman* 76.
45. *William Allingham: A Diary*, ed H. Allingham and D. Radford (London: Macmillan, 1907), 100.
46. WBS to Alice Boyd 26 Nov 1868, quoted in William E. Fredeman, 'Dante Gabriel Rossetti, *Bulletin of the John Rylands Library* Vol 53, No 1 (1970): 102.
47. FLM 1:243.
48. *The Works of John Ruskin*, ed. Cook and Wedderburn Vol. 35 (London: George Allen, 1909), 346–7.
49. DGR to Jane Morris 3 Sept 1880, *Fredeman* 9:268.
50. *The Precariously Privileged: A Professional Family in Victorian London*, ed. Zuzana Shonfield (Oxford: OUP, 1987), 113.
51. FLM 1:265.
52. FMLR to DGR 17 Oct 1868, ADC 3.17.
53. WMR to WBS 1 Dec 1868, *Peattie* 199.

54. DGR to WMR 21 Sept 1869, 284.
55. DGR to WMR 13 Oct 1869, 302.
56. WMR to DGR 14 Oct 1869, *Peattie* 234.
57. DGR to WMR 15 Oct 1869, 304.
58. FLM 274.

Chapter 10

1. Susan Mumm notes that adopting new names was one of the Sisterhoods' most controversial practices because it 'upset the applecart of the transmission of names through the father'. While most sisters kept their Christian names, 'they abandoned the use of their surname, except for legal purposes.' (*Stolen Daughters, Virgin Mothers*, 184).
2. For detailed information on Anglican Sisterhoods, see Susan Mumm, *Stolen Daughters, Virgin Mothers* (London: Leicester University Press, 1999).
3. Barbara Bodichon, 'Women and Work', *Friend's Intelligencer*, Vol. 16, 1860, p. 239.
4. William Sharp, 'Some Reminiscences' in Vol. 3 *Papers Critical and Reminiscent*, ed. Mrs. William Sharp (London: Heinemann, 1912), 4.
5. William James Stillman, *the Autobiography of a Journalist* Vol. 1 (NY: Houghton Mifflen, 1901), p. 302.
6. WMR preface to *The Poetical Works of Longfellow* (London: Moxon, 1870), xiv.
7. Robert L. Gale, *A Henry Wadsworth Longfellow Companion* (Connecticut, Greenwood Press, 2003) 278
8. Longfellow to Ethan Allen Hitchcock, 30 June 1846, *The Letters of Henry Wadsworth Longfellow*, ed. Andrew Hilen, Vol. 3 (Harvard: Harvard University Press, 1972), 96
9. MFR, *A Shadow of Dante* (London: Rivington, 1871), 6.
10. MFR to Longfellow, 21 May 1871, Houghton Library (MS Am 1340.2–1340.7)
11. CGR *The Churchman's Shilling Magazine* 2 (October 1867): 200.
12. MFR to Longfellow, 21 May 1871, Houghton Library (MS Am 1340.2–1340.7).
13. MFR, *A Shadow of Dante*, 5.
14. John Ruskin to Constance Hillyard 31 October 1877, John Rylands mss 1254 in John Rylands University Library, Manchester, quoted in Alison Milbank, *Dante and the Victorians* (Manchester, Manchester University Press, 1998), 259.

15. *FLM* 1:262.
16. *AN* 2:128.
17. DGR to CGR 23 March 1870, *Fredeman* 4:412.
18. CGR to Ellis, *Fredeman* 4:358; CGR to DGR ?April 1870, 4:348.
19. FMLR to DGR 23 Dec. 1870, ADC 3:17.
20. *FLM* 1:239.
21. DGR to Mrs. William Cowper Temple 26 March 1871, *Fredeman* 5:41.
22. DGR to FMLR 17 July 1871 *Fredeman* 5:79.
23. FMLR to DGR 19 July 1871 ADC 3.17.
24. FMLR to DGR 28 Aug 1871, ADC 3:17.
25. CGR to ABH 17 Aug 1871, *Harrison* 1:377.
26. CGR to Frances Catherine Howell 31 July 1871, *Harrison* 1:375.
27. DGR to Frances Catherine Howell, May-June 1871, *Fredeman* 5:57.
28. Robert Buchanan (As Thomas Maitland) 'The Fleshly School of Poetry: Mr. D.G. Rossetti', *Contemporary Review* 18 (Oct 1871), *passim*; Robert Buchanan (writing as Walter Hutcheson) 'Tennyson's Charm', St. Paul's Magazine March 1872. Cited in Marsh, *Dante Gabriel Rossetti, Painter and Poet*, 555.
29. *FLM* 1:316.
30. CGR to WMR 5 Sept 1872, *Harrison* 1:404.
31. 'Mr. Cayley sent to my sister a short MS. Poems named *The Birth of Venus*, and soon afterwards…another shorter poem on the same argument. Upon the latter poem she wrote the following note: 'The longer of these two poems was sent me first. Then I wrote one which the second rebuts. At last I would up by my sonnet *Venus's Looking Glass*.' In a copy of her collected *Poems*, 1875, there is also the following note: 'Perhaps "Live-In-Idleness" would be a better title, with an eye to the next one ' – *i.e.* to *Love Lies Bleeding*. (*PWCGR* , 487).
32. Bornand, 222.
33. Thomas Wright, *The Life of John Payne* (London: Fisher Unwin, 1919), 51.
34. CGR to WMR 10 July 1873, *Harrison* 1:433; to Lucy Madox Brown, 434.
35. CGR to DGR 18 July 1876, *Harrison* 2:87.
36. Henry William Burrows, *The Half-Century of Christ Church, St. Pancras*, (London: Skeffington and Son, 1887), 13.
37. Justin McCarthy. *The Galaxy* Vol 21, No 6. June 1873, p. 725.
38. Iain Nairn, *Nairn's London* (Harmondsworth: Penguin, 1966).
39. CGR to DGR 4 May 1974, *Harrison* 2:12.

40. DGR to FMLR 13 Sept 1873, *Fredeman* 6:269.
41. FMLR to DGR 31 July 1873, ADC 3.17.
42. WMR to MFR 11 Sept 1873, *Peattie* 309.
43. WM to Louisa Baldwin 26 March 1874, *Collected Letters of William Morris* Vol. 1 (Princeton: Princeton University Press, 1984).
44. *SR* 1:128.
45. Helen Rossetti Angeli, *Dante Gabriel Rossetti: His Friends and Enemies*, 194.
46. MFR to DGR, 20 June 1874, quoted in 'Maria Francesca to Dante Gabriel Rossetti: Some Unpublished Letters', *PMLA* Vol. 79, No. 5. (Dec., 1964), p. 616.
47. MFR to LMB ?Autumn 1874, ADC 13.9.
48. CGR to WMR 16 Nov 1875, *Harrison* ": 2:65
49. *SR* 1:128.
50. DGR to CGR, 3 Dec 1875 *Fredeman* 7:152.
51. DGR to Alice Boyd 3 Nov 1875, *Fredeman* 7:128.
52. MFR to DGR 24 Dec 1875, quoted in 'Maria Francesca to Dante Gabriel Rossetti: Some Unpublished Letters', *PMLA* Vol. 79, No. 5. (Dec., 1964), p. 619.

Chapter 11

1. *TF* 213.
2. 'Memories of Sister Caroline Mary', from Church of England Record Society 9: *All Saints Sisters of the Poor: An Anglican Sisterhood in the 19th Century*, ed. Susan Mumm p. 32.
3. WMR Diary, 16 Nov 1876, ADC 15.2
4. *The Nineteenth Century*, March 1883, pages 412–413.
5. WMR Diary, 24 Nov 1876, ADC 15.2.
6. WMR to ACS 5 Dec 1876, 347.
7. FLM 1:24.
8. CGR to ABH 4 Dec 1876, *Harrison* 2:120.
9. Blunt's diary entry for May 1892, *The Letters of Jane Morris to Wilfred Scawen Blunt*, ed. Peter Faulkner (Exeter: University of Exeter, 1986), 66.
10. DGR to Jane Morris 26 Nov 1880, *Fredeman* 9:317.
11. Ford M. Hueffer, *FMB: A Record of his Life and Work*, (London: Longmans, 1896), 319
12. WBS to Alice Boyd, June 1877, *LPI* 322–3.

13. Charles Knight, *The English Cyclopaedia: Natural History* Vol. 1 (London: Bradbury Evans and Co., 1866), 207.

14. *SR* 1:278.

15. Richard Ellmann, *Oscar Wilde* (NY: Vintage, 1988) p. 45

16. Note 2, *LPI*: 308.

17. WBS to Alice Boyd, 23 Oct 1877 *LPI*: 325.

18. DGR to FC 22 Sept 1877, *Fredeman* 7:399.

19. DGR to WMR 28 Sept 1877, *Fredeman* 7:406.

20. CGR to WMR 30 Aug 1877, *Fredeman* 2:140.

21. WBS to Alice Boyd, 13 June 1880, *LPI*: 331.

22. CGR to Augusta Webster ?1878, *Harrison* 2:158–59.

23. FMLR to DGR, 28 April 1877, ADC 3.17.

24. *FD* 312.

25. *FLCGR* 74.

26. CGR to LMR, ?12 June 1878, *Harrison* 2:166.

27. *SR* 2:450.

28. CGR to Charles Lutwidge Dodgson, ?1878, *Harrison* 2:159.

29. Quoted in Prologue to Whistler's *The Gentle Art of Making Enemies* (NY: Putnams, 1904).

30. James McNeill Whistler, 'Ten O'Clock Lecture' delivered 20 Feb 1885, taken from *Modern Essays*, ed. John Milton Burden (NY: Macmillan, 1916), 17.

31. Henry James, 'The Picture Season in London', *The Galaxy* 24 (NY, Sheldon and Company, 1877), 154.

32. *Macmillan's Magazine* 36, 'The Grosvenor Gallery', (London: Macmillan and Co., 1877), p. 118

33. DGR to JM 1 Oct 1881, *Fredeman* 9:630.

34. introduction to *PRDL*, 4.

35. *Patience*, W.S. Gilbert and Arthur Sullivan Act 1 (London: Chappell and Co., 1881).

36. Ibid., Act 2.

37. DGR to LMR 12 April 1881, *Fredeman* 9:465.

38. WMR to DGR 13 April 1881, *Peattie* 396.

39. CGR to DGR ?17 Oct 1881, *Harrison* 2:305.

40. DGR to FC 11 Sept 1872, *Fredeman* 5:264.

41. WBS to Alice Boyd, 30 Oct 1880, *LPI*: 333.

42. CGR to DGR 2 Dec 1881, *Harrison* 2:311.

43. Athol Mayhew, *Birchington-on-Sea and its Bungalows* (Canterbury: 1881), 7.

44. Anthony D. King, *The Bungalow: the Production of a Global Culture* (London: Routledge, 1984), 87.
45. WMR to LMR, 2 April 1882, *Peattie* 405.
46. Hall Caine, *My Story* (London: Heinemann, 1908), 233–34.
47. CGR to WMR 19 Feb 1882, *Harrison* 3:13.
48. WMR to LMR 2 April 1882, *Peattie* 404.
49. Hall Caine, *My Story* (London: Heinemann, 1908), 244.
50. DGR to George Gordon Hake, 30 April 1876, *Fredeman* 7:271.
51. Linda Merrill, 'Leyland, Frederick Richards (1831–1892)', *Oxford Dictionary of National Biography*, ed. Lawrence Goldman. Vol. 133 (Oxford: OUP, 2004), 705.
52. Hall Caine, *My Story* (London: Heinemann, 1908), 245.
53. WMR to FC 14 April 1882, *Peattie* 416.
54. WM to WBS 29 April 1882, *LPI*: 344.

Chapter 12
1. Theodore Watts-Dunton, 'The Truth About DGR', *Nineteenth Century* 13 (March 1883): 408.
2. Collingwood, Stuart Dodgson, *The Life and Letters of Lewis Carroll* (London: Unwin, 1898), 224–225.
3. *LPI* 342.
4. WMR to Theodore Watts-Dunton 18 June 1883, *Peattie* 450.
5. WMR to CGR 10 Aug 1883, quoted in *Harrison* 3:147, note 1.
6. *The Life and Letters of Frederic Shields*, ed. Ernestine Mills (London: Longmans, Green and Co., 1912), 281.
7. CGR to Mr. Martin, ?9July 1883, *Harrison* 3:128.
8. CGR to Charles Lutwidge Dodgson, 17 Nov 1882 *Harrison* 3:73.
9. CGR to WMR 19 Feb 1882, *Harrison* 3:13.
10. CGR to Miss Henderson, 16 April 1883, *Harrison* 3:112.
11. 'Dante: The Poet Illustrated Out of the Poem', *The Century Magazine* 27 (Feb 1884): 566–73.
12. CGR to Edmund Gosse, 26 March 1884, *Harrison* 3:183.
13. Robert Browning to Ingram, 5 May 1882, quoted in *Harrison* 3:44, note 1.
14. Florence Nightingale to Eliza Polidori, 16 Sept 1855, *The Collected Works of Florence Nightingale*, ed. Lynn McDonald, Vol. 14 (Ontario: Wilfrid Laurier University Press, 2010), 231.
15. CGR to Frederic Shields, ?Dec 1883, *Harrison* 3:164.
16. CGR to George Gordon Hake, 4 Jan 1884, *Harrison* 3:174.

17. CGR to Anne Burrows Gilchrist, ?June 1885, *Harrison* 3:265.

18. CGR to LMR 14 Aug 1883, *Harrison* 3:155.

19. CGR to WMR 23 Sept 1884, *Harrison* 3:214.

20. CGR to LMR 11 Jan 1886, *Harrison* 3:294.

21. KT, 'Some Memories of Christina Rossetti', *The Outlook* (9 February 1895), quoted in *Beauty and the Beats: Christina Rossetti, Walter Pater, RL Stevenson and Their Contemporaries*, ed. Peter Liebregts and Wim Tigges, (Amsterdam: Rodopi, 1996), 88.

22. CGR to Miss Newsham ? Sept 1889, *Harrison* 4:157.

23. CGR to Sophia May Eckley, 2 Aug 1869, *Harrison* 1:328

24. KT, 'Santa Christina', *The Bookman* (January 1912), quoted in *Beauty and the Beast: Christina Rossetti, Walter Pater, RL Stevenson and Their Contemporaries*, ed. Peter Liebregts and Wim Tigges, (Amsterdam: Rodopi, 1996), 92.

25. Katharine Tynan, *Twenty-five Years: Reminiscences* (NY: Devin Adair, 1913), 181.

26. Juliet M. Soskice, *Chapters From Childhood: Reminiscences of an Artist's Granddaughter* (London: Selwyn and Blount, Ltd, 1921), 7–9.

27. CGR to Charles Cayley, 26 Feb 1883, *Harrison* 3:98.

28. *SR* 2:315.

29. *TF* 88.

30. CGR to ACS, 19 Nov 1884, *Harrison* 3:231.

31. ADC 15:4, quoted in *A Rossetti Family Chronology*, eds. Chapman and Meacock (Basingstoke: Macmillan, 2007), 360.

32. Quoted in Sir Edward Cook, *The Life of Florence Nightingale* (London: Macmillan, 1913) 2:95.

33. WMR to ACS 13 Feb 1883, *Peattie* 443.

34. *LPI* 341.

35. CGR to WMR 20 Dec 1886, *Harrison* 3:350.

36. WMR to LMR, 9 April 1886, *Peattie* 485.

37. WMR to FMB 2 April 1886, *Peattie* 485.

Chapter 13

1. Tynan, *Twenty-five Years*, 160.

2. CGR to WMR 10 Nov 1893, *Harrison* 4:355.

3. *SR* 2:525–6.

4. CGR to Lady Georgiana Mount Temple 9 April 1886, *Harrison* 3:309.

5. SR 2:525.

6. WMR to LMR 5 May 1886, *Peattie* 490.

7. CGR to Caroline Maria Gemmer, 18 Feb 1890 *Harrison* 4:187.
8. CGR to LMR Summer 1887, *Harrison* 4:51.
9. CGR to Theodore Watts-Dunton 22 Nov 1886, *Harrison* 346.
10. *TF* 2.
11. 'Foul is she, ill-favoured, set askew,' *FD* 406.
12. *FD* 400–401.
13. WMR MS Diary, Quoted in Note 1, *Peattie* 473.
14. WMR to LMR 23 Aug 1885
15. CGR to Caroline Gemmer 18 Feb 1890, *Harrison* 4:187.
16. *The Letters of Lewis Carroll*, ed. M.C. Cohen with the assistance of Roger Lancelyn Green, vol. 2 (London: Macmillan, 1979), 986.
17. CGR to Charles Alrich, 18 Dec 1893, 360.
18. CGR to Unknown, 23 Jan 1888, *Harrison* 4:65.
19. CGR to WMR 7 Dec 1889, *Harrison* 4:166.
20. CGR to WMR 8 Oct 1889, *Harrison* 4:160.
21. CGR to Miss Newsham, 11 Oct 1889, *Harrison* 4:161.
22. ADC 15:5, quoted in *A Rossetti Family Chronology*, p. 390.
23. *TF* 197.
24. EP to FMLR 20 May 1855, ADC 27D.
25. WMR to LMR 28 Apr 1892, *Peattie 552*.
26. Diary entries for 25 July and 23 Aug, 1893, ADC 15.6, quoted in *Peattie* xxviii.
27. WMR to CGR 18 April 1894, *Peattie* 573.
28. CGR to WMR 18 April 1894, *Harrison* 4:382.
29. *FLCGR* 222.
30. Charlotte Stopes to WMR 31 Oct 1894, quoted in Lona Mosk Packer, *Christina Rossetti* (University of California Press, 1963), 399.
31. *SR* 2:533.
32. *SR 2* 532, 533, 534.
33. See Jamie L. Bronstein, *Caught in the Machinery* (Stanford: Stanford University Press, 2008), 66; Frank Miller Turner, *Contesting Cultural Authority* (Cambridge: CUP, 1993), 156.
34. Harriet Read to Rose Donne Hake 4 Jan 1895, *Harrison* 4:391.
35. *PWCGR* lix.
36. *PWCGR* lix, liv', lv', lxviii.
37. CGR to Caroline Maria Gemmer 27 June 1884 *Harrison* 3:196.
38. *SR* 2:537.
39. Quoted in *Peattie* note 1, 591.
40. WMR to Lionel Henry Cust, 10 Aug 1895, *Peattie* 588; 589, note 4.

41. WMR to Theodore Watts-Dunton 22 May 1909, *Peattie* 668.
42. Edmund Gosse, *Sunday Times* (6 May 1928): 8.
43. Review of WMR's preface to *The Collected Works of DGR* from the *St. James's Gazette*, quoted in *Harrison* 4:161n.
44. Richard Curle *Caravansary and Conversation: Memories of Places and Persons* (London: Jonathan Cape, 1937), 77.
45. JL Paton, 'William Michael Rossetti', *Manchester Guardian*, 7 February 1919, quoted in Thirlwell, p. 323.
46. CGR to WMR 25 Jan 1894, *Harrison* 4:367.
47. WMR to Theodore Watts-Dunton 30 Apr 1909, *Peattie* 667.
48. WMR to Marchese Antonio Di San Giuliano, 12 Sept 1909 *Peattie* 669.
49. WMR to Theodore Watts-Dunton 30 Apr 1909, *Peattie* 667.
50. Curle, 79
51. Curle, 82.
52. William Rothenstein, *Men and Memories* (London: Faber, 1931), 230
53. *The Best of Friends: Further Letters to Sydney Carlyle Cockerell*, ed. Violet Meynell, (London: R. Hart-Davis, 1956), 30.
54. Oscar Wilde to Robert Ross, 6 Jan 1896, *Four Letters by Oscar Wilde* (Privately Printed, 1906), 8.
55. Bornand, 189.
56. Curle, 80.
57. *Pre-Raphaelitism and the Pre-Raphaelite Brotherhood* 2:358.
58. Notes to CGR *New Poems*, ed WMR (London: Macmillan, 1896), 387.
59. *FLM* 1:422.
60. *SR* 1:125.

SELECTED
BIBLIOGRAPHY

All Saints Margaret Street: A Pitkin Guide. Foreword by Sir Roy
Strong. London: Jarrold Publishing, 2005.

Angeli, Helen Rossetti. *Dante Gabriel Rossetti: His Friends and
Enemies.* London, Hamish Hamilton, 1949.

Armytage, AJ Green. *Maids of Honour,* London: Blackwood, 1906.

Arseneau, Mary. *Recovering Christina Rossetti.* London: Palgrave,
2004.

*Autobiographical Notes of the Life of William Bell Scott and Notices of
His Artistic and Poetic Circle of* Friends. Edited by William Minto.
2 vols. London: Osgood, 1892

Bell, Mackenzie. *Christina Rossetti: A Biographical and Critical Study.*
Boston: Roberts Brothers, 1898.

Bennett, A.H. *Through an Anglican Sisterhood to Rome.* London:
Longmans, Green, 1914.

Benson, Arthur Christopher. *Essays.* NY: Macmillan, 1896.

Bentley, DMR, 'The Pre-Raphaelites and the Oxford Movement',
The Dalhousie Review 57 (1977: 525–539).

Boime, Albert. *Art in the Age of Civil Struggle.* Chicago: University
of Chicago Press, 2007.

Bostridge, Mark. *Florence Nightingale: The Woman and Her Legend.*
London: Viking, 2008.

Brandon, Ruth. *Other People's Daughters: The Life and Times of the
Governess.* London: Phoenix, 2008.

Brown, Ford Madox. *Diary of Ford Madox Brown.* Edited by
Virgina Surtees. New Haven: Yale University Press, 1981

Burne-Jones, Georgina. *Memorials of Edward Burne-Jones* Vol. 1. London: Macmillan, 1904.

Burrows, Henry William. *The Half-Century of Christ Church, St. Pancras, Albany Street*. London: Skeffington and Son, 1887. (General Books Reprint, 2009).

Caine, Hall. *Recollections of Dante Gabriel Rossetti*. Elliot Stock, 1882.

Carlyle, Thomas, *Early Letters of Thomas Carlyle*, Edited by C.E. Norton. London: 1886.

Chapman, Raymond. *Faith and Revolt*. London: Weidenfeld and Nicolson, 1970

Cherry, Deborah, *Painting Women: Victorian Women Artists*. London: Routledge, 1993.

Christina Rossetti: The Complete Poems, Edited by Betty S. Flowers. Text by R.W. Crump. London: Penguin, 2001.

Church of England Record Society 9: All Saints Sisters of the Poor: An Anglican Sisterhood in the 19th Century. Edited by Susan Mumm. Suffolk: The Boydell Press, Church of England Record Society, 2001.

Church, R.W. *The Oxford Movement: 1833–45*. London: Macmillan, 1891.

The Collected Letters of Thomas and Jane Welsh Carlyle, Edited by Claude Ryals and Kenneth J. Fielding Vols. 9 and 15. Durham: Duke University Press, 1981, 1987.

Cunningham, Patricia A. *Reforming Women's Fashion, 1850–1920: Politics, Health, and Art*. Ohio: Kent State University Press, 2003.

Curle, Richard. *Caravansary and Conversation: Memories of Places and Persons* London: Jonathan Cape, 1937.

D'Amico, Diane. *Christina Rossetti: Faith, Gender and Time*. Baton Rouge: Louisiana State University Press, 1999.

Denney, Colleen. *At the Temple of Art: the Grosvenor Gallery, 1877–1890*. London: Associated University Presses, 2000.

The Diaries of George Price Boyce. Edited by Virginia Surtees. Norwich: Real World, 1980.

The Diary of Dr. John William Polidori. Edited by William Michael Rossetti. London: Elkin Mathews, 1911.

Doughty, Oswald. *A Victorian Romantic: Dante Gabriel Rossetti.* London : Oxford University Press, 1963.

Dunn, Henry Treffry. *Recollections of Dante Gabriel Rossetti and His Circle*, Edited by Rosalie Mander. Westerham: Dalrymple Press, 1984.

Early Victorian England 1830–1865, Edited by G.M. Young. London: OUP, Humphrey Milford: 1934.

Eastlake, Charles Locke. *History of the Gothic Revival.* London: Longmans Green and Co', 1872.

Ellmann, Richard. *Oscar Wilde.* NY: Vintage, 1988.

Festing, Gabrielle. *John Hookham Frere and His Friends.* London: J. Nisbet, 1899.

Faxton, Alicia Craig. *Dante Gabriel Rossetti.* Oxford: Phaidon, 1989.

Gale, Robert L. *A Henry Wadsworth Longfellow Companion.* Connecticut, Greenwood Press, 2003.

The Germ: Thoughts towards Nature in Poetry (Facsimile Reprint). Portland: Thomas B. Mosher, 1898. Originally published in 1850 in London by Aylott and Jones.

Gilchrist, Alexander. *Life of William Blake* Vol. 1 (London: Macmillan, 1863).

Goldie, Susan M. *Florence Nightingale in the Crimean War 1854 – 56.* Manchester: Manchester University Press, 1987.

Gosse, Edmund. *The Life of Algernon Charles Swinburne.* London: Macmillan, 1917

Gray, Fred. Edited by *Designing the Seaside: Architecture, Society and Nature.* London: Reaktion, 2006.

Haunted Texts: Studies in Pre-Raphaelitism. Edited by David Latham. Toronto: University of Toronto Press, 2003.

Hueffer, Ford M. *Ford Madox Brown: A Record of his Life and Work.* London: Longmans, 1896.

Hill, Michael. *The Religious Order.* London: Heinemann, 1973.

Hunt, Holman. *Pre-Raphaelitism and the Pre-Raphaelite Brotherhood.* London: Macmillan, 1905.

Janzen Kooistra, Lorraine. *Christina Rossetti and Illustration.* Athens: Ohio University Press, 2002.

King, Anthony D. *The Bungalow: the Production of a Global Culture*. London: Routledge, 1984.

The Language of Flowers: An Alphabet of Floral Emblems. Edinburgh: T. Nelson and Sons, 1857.

Lee, Edwin. *Brighton and Its Sanative Resources*. London: J. Churchill, 1850.

Letters of DGR to William Allingham 1854 – 1870. Edited by George Birkbeck Hill. London: T. Fisher Unwin, 1897.

The Letters of Lewis Carroll. Edited by M.C. Cohen with the assistance of Roger Lancelyn Green, Vol. 2. NY: OUP, 1979.

Letters from Robert Browning to Various Correspondents. Edited by Thomas J. Wise. Volume I. London: Privately Printed, 1895.

The Letters of Jane Morris to Wilfred Scawen Blunt. Edited by Peter Faulkner. Exeter: University of Exeter, 1986.

Letters of Samuel Taylor Coleridge Edited by Hartley Coleridge, Vol. 2. London: Heinemann, 1895.

Letters of William Allingham. Edited by H[elen] Allingham and E. Baumer Williams. London: Longmans, Green and Co, 1911.

Lewis Carroll's Diaries: The Private Journals of Charles Lutwidge Dodgson (Lewis Carroll), with notes and annotations by Edward Wakeling. Vol 4. Luton: The Lewis Carroll Society, 1997.

Linton, W.J. *Threescore and Ten Years 1820 – 1890: Recollections*. New York: Charles Scribner's Sons, 1894.

The London Encyclopaedia. Third Edition. Eds. Ben Weinreb, Christopher Hibbert, Julia Keay and John Keay. London: Macmillan, 2010.

Mackail, J.W. *The Life of William Morris* Vol. 1. London: Longmans, 1899.

'Maria Francesca to Dante Gabriel Rossetti: Some Unpublished Letters', *PMLA* Vol. 79, No. 5. Dec., 1964: 613–619.

Marillier, HC. *Dante Gabriel Rossetti: An Illustrated Memorial of His Art and Life*. London: George Bell, 1899.

Marsh, Jan. *Christina Rossetti: A Literary Biography*.

Marsh, Jan. *Dante Gabriel Rossetti: Painter and Poet*. London: Weidenfeld and Nicholson, 1999.

Marsh, Jan. *The Legend of Elizabeth Siddal*. London: Quartet, 1989.

Marsh, Jan. *Pre-Raphaelite Sisterhood*. London: Quartet, 1985.

Mary Howitt, An Autobiography. 2 Vols. Edited by Margaret Howitt. London: WM Isbister, 1889.

Matthews, Sam. *Poetical Remains: Poets' Graves, Bodies, and Books in the Nineteenth Century*. Oxford: OUP, 2004.

Millbank, Alison. *Dante and the Victorians*. Manchester: Manchester University Press, 1998.

Mumm, Susan. *Stolen Daughters, Virgin Mothers*. London: Leicester University Press, 1999.

Murray, John Fisher. *The World Of London* 1. London: Blackwood, 1843.

Nurse Sarah Anne : with Florence Nightingale at Scutari. Edited by Robert G. Richardson ; with a foreword by Charles Hugh Terrot. London: John Murray, 1977.

Outsiders Looking In: The Rossettis Then and Now. Edited by David Clifford and Laurence Rousillon. London: Anthem, 2004.

The Owl and The Rossettis Letters of Charles A. Howell and Dante Gabriel, Christina, and William Michael Rossetti, Edited by C.L. Cline. University Park: Pennsylvania State University Press, 1978.

The Oxford Companion to Western Art. Edited by Hugh Brigstocke. Oxford: Oxford University Press, 2001.

Packer, Lona Mosk. *Christina Rossetti* Berkeley: University of California Press, 1963.

The Paintings and Drawings of Dante Gabriel Rossetti (1828–1882): *A Catalogue Raisonné*, Edited by Virginia Surtees. Oxford: Oxford University Press, 1971.

Pandaemonium: 1660 – 1886. Eds. Mary-Lou Jennings and Charles Madge. London: Andre Deutsch, 1985.

Pater, Walter. *Appreciations*: MacMillan, 1889.

Pedrick, Gale. *Life With Rossetti, or, No Peacocks AllowEdited by* London: Macdonald, 1964.

Pernissen, Terry M. *Secret Passions, Secret Remedies: Narcotic Drugs in British Society, 1820–1930*. Manchester: Manchester University Press, 1983.

Pusey, Edward Bouverie. *Sermons during the season from Advent to Whitsuntide* London: John Henry Parker, 1848.

Rappaport, Helen. *No Place For Ladies: The Untold Story of Women in the Crimean War.* London : Aurum Press, 2007.

Rainbow, Bernard. *The Choral Revival in the Anglican Church (1839–1872).*Oxford: OUP, 1970.

Reed, John Shelton. *Glorious Battle.* Nashville: Vanderbilt University Press, 1996.

The Rossetti Archive: The Complete Writings and Pictures of Dante Gabriel Rossetti. Edited by Jerome McGann. 1993 – 2008. http://www.rossettiarchive.org/index.html

Rossetti Christina, *Commonplace.* London: Ellis, 1870.

Rossetti, Christina. *The Complete Poems.* Text by R.W. Crump. Notes and Introduction by Betty S. Flowers. London: Penguin, 2001.

Rossetti, Christina. *The Face of the Deep: A Devotional Commentary on the Apocalypse.* London: SPCK, 1892.

Rossetti, Christina. *The Letters of Christina Rossetti.* Edited by Antony H Harrison. 4 Vols. Charlottesville: The University Press of Virginia, 1997 – 2004.

Rossetti, Christina. *Maude: A Story for Girls*, introduction by William Michael Rossetti. London: J Bowden, 1897.

Rossetti, Christina. *New Poems.* Edited by William Michael Rossetti. London: Macmillan, 1896.

Rossetti, Christina. *The Poetical Works of Christina Georgina Rossetti.* Edited by William Michael Rossetti. London: Macmillan, 1904.

Rossetti, Christina. *Selected Prose of Christina Rossetti.* Edited by David A. Kent and P.G. Stanwood. Basingstoke : Macmillan, 1998.

Rossetti, Christina. *Sing-Song: A Nursery Rhyme Book.* With illustrations by Arthur Hughes. London: Routledge, 1872.

Rossetti, Christina. *Speaking Likenesses.* London: Macmillan, 1874.

Rossetti, Christina. *Time Flies: A Reading Diary.* London: SPCK, 1886

Rossetti, Dante Gabriel. *The Correspondence of Dante Gabriel Rossetti.* Edited by William E. Fredeman. 9 Vols. Cambridge: D.S. Brewer, 2004 – 2010.

Rossetti, Dante Gabriel. *The Early Italian Poets.* London: Smith and Elder, 1861.

Rossetti, Dante Gabriel. *Poems*, 1870. London: Ellis and White, 1870

Rossetti, Dante Gabriel. *Ballads and Sonnets* 1881. London: Ellis and White, 1881.

Rossetti, Dante Gabriel. *Poems: A New Edition*. London: Ellis and White, 1881.

Rossetti, Dante Gabriel. *Collected Poetry and Prose*, Edited by Jerome McGann. New Haven: Yale University Press, 2003.

Rossetti, Gabriele. *Gabriele Rossetti: A Versified Autobiography*, translated and supplemented by William Michael Rossetti. London: Sands, 1901.

Rossetti, Maria. *Aneddoti Italiani. Italian Anecdotes Selected from "Il Compagno del Passeggio Campestre." A Key to Exercises in Idiomatic Italian*. London: Williams and Norgate, 1867.

Rossetti, Maria. *Letters To My Bible Class on Thirty-Nine Sundays*. London: SPCK: 1872. (General Books Reprint, 2009).

Rossetti, Maria. *A Shadow of Dante*. London: Rivingtons, 1871.

Rossetti, William Michael. *Dante Gabriel Rossetti As Designer and Writer*, London: Cassell and Company, 1889.

Rossetti, William Michael. *Dante Gabriel Rossetti: His Family Letters, With a Memoir by William Michael Rossetti*. 2 Vols. London: Ellis and Elvey, 1895.

Rossetti, William Michael. *Democratic Sonnets*. 2 vols. London: Alston Rivers, 1907.

Rossetti, William Michael. *The Diary of William Michael Rossetti 1870–1873*. Edited by Odette Bornand. Oxford: Clarendon, 1977.

Rossetti, William Michael. *Family Letters of Christina Rossetti*. London: Brown, Langham, 1908.

Rossetti, William Michael. *Praeraphaelite Diaries and Letters*. London: Hurst And Blackett Limited, 1900.

Rossetti, William Michael. *The P.R.B. Journal*. Edited by Fredeman, William E. Oxford: Clarendon, 1975.

Rossetti, William Michael. *Rossetti Papers 1861 – 1870*. London: Sands, 1903.

Rossetti, William Michael. *Ruskin: Rossetti: Pre-Raphaelitism*. London: George Allen, 1899.

Rossetti, William Michael. *Selected Letters of William Michael Rossetti.* Edited by Roger W. Peattie. University Park: The Pennsylvania State University Press, 1990.

Rossetti, William Michael. *Some Reminiscences.* 2 Vols. London: Brown, Langham 1906.

Rossetti, William Michael. *Swinburne's Poems and Ballads: A Criticism.* John Camden Hotten, 1866.

Rothenstein, William. *Men and Memories.* London: Faber, 1931.

Rudman, Harry W. *Italian Nationalism and English Letters: Figures of the Risorgimento and Victorian Men of Letters.* NY: AMS Press, 1966.

Ruskin, John. *Praeterita* 3. George Allen, 1907.

Scott, William Bell. *Autobiographical Notes of the Life of William Bell Scott.* 2 Vols. London: Osgood, McIlvaine, 1892.

Scott, William Bell. 'The Letters of Pictor Ignotus,' by William E. Fredeman, *Bulletin of the John Rylands Library* 58 (1976), 306 – 352.

Sharp, William. *Papers Critical and Reminiscent,* Vol. 3. Edited by Mrs. William Sharp. London: Heinemann, 1912.

Soskice, Juliet M. *Chapters From Childhood: Reminiscences of an Artist's Granddaughter.* With a forward by A.G. Gardiner. London: Selwyn and Blount, Ltd, 1921.

Sponza, Lucio. *Italian Immigrants in Nineteenth Century Britain.* Leicester: Leicester University Press, 1988.

Stephens, F.G. *Dante Gabriel Rossetti.* London: 1894.

Stephens, F.G. *William Holman Hunt and His Works.* London: John Nisbet & Co., 1860.

Stillman, William James. *The Autobiography of A Journalist* Vol. 1. Boston: Houghton Mifflin, 1907.

Straub, Julia. *A Victorian Muse : the Afterlife of Dante's Beatrice in Nineteenth-Century Literature.* London: Continuum, 2009.

Sublime and Instructive: Letters from John Ruskin to Louisa, Marchioness of Waterford, Anna Blunden and Ellen Heaton. Edited by Virginia Surtees. London: Michael Joseph, 1972.

Taylor, Fanny. *Eastern Hospitals and English Nurses: A Narrative of Twelve Months' Experience of the Hospitals of Koulali and Scutari by a Lady Volunteer.* London: Hurst and Blackett, 1857.

Tennyson, G.B. *Victorian Devotional Poetry*. Cambridge: Harvard University Press, 1981.

Thirlwell, Angela. *William and Lucy: The Other Rossettis*. New Haven: Yale University Press, 2003.

Thomson, FML. *The Rise of Respectable Society: A Social History of Victorian Britain, 1830 – 1900*. London: Fontana Press, 1988.

Tosh, John. *A Man's Place: Masculinity and the Middle-Class Home in Victorian England*. New Haven: Yale University Press, 1999.

Tynan, Katharine. *Twenty-five Years: Reminiscences*. NY: Devin Adair, 1913.

Waller, R.D. *The Rossetti Family 1824 – 1854*. Manchester: Manchester University Press, 1932.

William Allingham: A Diary. Eds. H. Allingham and D. Radford. London: Macmillan, 1907.

Weintraub, Stanley. *Four Rossettis*. London: WH Allen, 1978.

White, Jerry. *London in the Nineteenth Century*. London: Jonathan Cape, 2007.

Wood, Esther. *Dante Rossetti and the Praeraphaelite Movement* London: Sampson, Lowe, Marston and Company, 1894.

Wordsworth, Elizabeth. *Henry William Burrows: Memorials* London: Kegan Paul, 1894.

The Working Men's College 1854 – 1904. Edited by Rev. J, Llewellyn Davies. London: Macmillan, 1904.

The Works of John Ruskin. Vol. 36. Eds. Cook and Wedderburn. London: George Allen, 1909.

Vincent, E.R. *Gabriele Rossetti In England*. Oxford: Clarendon Press, 1936.

Yates, Nigel. *Anglican Ritualism in Victorian Britain, 1830–1910*. Oxford: OUP, 1999.

ACKNOWLEDGEMENTS

A ll writing about the Rossettis is dependent on the valuable contributions of others, and mine is no exception. The most enjoyable part of my research has been the contact I have had with various institutions and authors, who could not have been more helpful, supportive and inspiring.

I am very grateful to the community of Rossetti scholars whose research has been integral to this project. In particular, I worked extensively from the following editions: Antony Harrison's *Letters of Christina Rossetti* (1997–2004), Jerome McGann's online *Rossetti Archive*, William E. Fredeman's *Correspondence of Dante Gabriel Rossetti* (2004–2010), Roger Peattie's *Selected Letters of William Michael Rossetti* (1990), R.W. Crump and Betty S. Flowers's *The Complete Poems of Christina Rossetti* (2001), and *The Rossetti Family Chronology*, by Alison Chapman and Joanna Meacock (2007). For information about Gabriele Rossetti I have relied on the scholarship of Robert Waller and E.R. Vincent. Every effort has been made to ensure that all necessary permissions have been obtained, but if any copyright holders have been overlooked, the publisher will be pleased to make the necessary arrangements at the first opportunity.

Many Rossetti biographers were generous with their time and advice. I am very grateful to Diane D'Amico and Mary Arseneau, both of whom have supported this project from its beginnings. Arseneau's excellent research on Christina Rossetti's maternal heritage has been invaluable, while D'Amico's *Christina Rossetti's Faith, Gender, and Time*, has long been an inspiration. Angela Thirlwell, who has recovered so much important information about William Michael

Rossetti, generously took time out of her busy schedule to advise me when this project was in the proposal stage. Jan Marsh, who has written authoritatively about all the Rossettis, was kind enough to meet with me and offer her advice about the pleasures and pitfalls of writing a biography, and on the Rossetti family in general. I am very grateful for her generosity with her time and specialist knowledge. I am indebted to Susan Mumm's research and advice on Anglo-Catholic Sisterhoods. I would also like to thank, as always, Danny Karlin, for over a decade of wise counsel.

My research was made possible through the professionalism and care of the staff at many libraries in the United Kingdom, Canada and the United States, including: the London Library; the British Library; the Houghton Library; and the Harry Ransom Center. The Trustees of the London Library were very generous in granting me a reduced membership fee which helped support the writing of this book. I am indebted to Colin Harris at the Bodleian Library for his help in finding and interpreting various indices to the large facsimile archive of the Rossetti Family Papers in the Bodleian Special Collections. Sarah Romkey's advice and guidance were invaluable in navigating the vast Angeli – Dennis collection of Rossetti Papers at the University of British Columbia Library; Annelle Harmer and Ken Hildebrand were also tremendously helpful. Thanks also to the Friends of Brompton Cemetery, in particular Robert Stephenson, who provided me with information about Maria Rossetti's grave.

The project would not have been possible without a writer's grant from the Arts Council, England and an Authors' Foundation grant from the Society of Authors. Their support has been more than just financial, and the courtesy and eagerness with which they have responded to queries and offered assistance is a testament to the excellence of these Arts organisations. David Cross of Arts Council England deserves recognition in this respect. I am also grateful to Owen Davies at the University of Hertfordshire, and to Jennifer Young for her unflagging support, both personal and intellectual.

I would like to thank everyone at Haus Publishing, in particular Barbara Schwepke for her patience and support, Robert Pritchard for his professionalism and guidance throughout this complex process and Edward Gosling for his attention to detail. Thanks are also due to

my agent, Andrew Lownie, whose efficiency, knowledge and acumen have been invaluable.

Special thanks must go to my readers of draft chapters, including: David Cross, Katherine Davey, Rose Dawson, Alex Goddard, David Shelley, and Alyse, Kathleen, Ralph and Oliver Roe. Their fresh eyes and unique perspectives were vital in the final stages of this project. In particular, I would like to thank James Kidd, who was cheerfully willing to read more chapters than he'd bargained for, and whose suggestions were insightful and inspired. In the past year, he has been more than generous with emotional and financial support, and I am more grateful to him than I can say. I would also like to thank Darren Cohen and Fran Varian for believing in me from the start. Thanks also to Hamish, Dors and Nick Kidd, as well as Lali Smith, Annere Creighton and Owain Martin, for making me feel part of the family. As always, my deepest love and gratitude are for family: the Morgans, Kidds, Rileys and especially the Roes, to whom this book is dedicated.

Picture sources

The author and publishers wish to express their thanks to the following sources of illustrative material and/or permission to reproduce it. Acknowledgements will be made in future editions in the event that any omissions have been made.

akg-images London, The National Portrait Gallery, Topham Picturepoint.

INDEX

Reach, Angus 112
Read, Harriet 358
Red House, the 213–16, 248
Richards, Upton 198
Rintoul, Henrietta 140, 169, 170–1, 173, 191, 192–3, 227, 270, 286
Rintoul, Robert Stephen 169–71
Rolandi, Pietro 28, 48
Rose, William Stewart 9, 24
Rossetti, Christina Georgina
 Anglican Sisterhood, and 195–6, 203–4
 birth 23
 Charles Cayley, and 9, 154, 204–6, 220, 226, 240–2, 259, 260, 270, 275, 276, 298–9, 303, 329, 335–8, 357–8
 childhood 24, 26–32, 35–40, 281–2, 331
 children, and 306–7, 333–4
 clothes 31, 76–7, 334–5
 Crimean War, and the 179–80
 death 357–9
 education 29–32
 health 65–7, 84–5, 116, 269–71, 354–9
 Italy, visit to 235–9
 James Collinson, and 89–92, 101, 102, 107–10, 116–19, 204, 231, 240, 241
 John Brett, and 208
 Pre-Raphaelite Brotherhood, and the 82–3, 102, 104–5, 164, 188, 206–7
 religion, and 54, 60–3, 65–7, 83, 90–1, 116, 117–18, 165, 194–9, 203–4, 240, 281, 319, 327, 334–5, 348–51, 359–61
 Ruskin's criticism of her poems 187, 207, 263
 self-harming 67, 83
 women's suffrage, and 304–5, 351–2
 WRITINGS:
 Called To Be Saints 338
 Commonplace 264
 'Dante: The Poet Illustrated Out of the Poem' 328–9
 Goblin Market and Other Poems 187–8, 227, 244, 352
 Il Rosseggiar dell'Oriente 240, 337
 Maude: A Story for Girls 131
 Monna Innominata 330, 337
 New Poems 339
 'Pros and Cons' 280
 Sing-Song 264, 270, 277, 397, 352
 Speaking Likenesses 30–1
 The Face of the Deep: A Devotional Commentary on the Apocalypse 350
 The Poetical Works of Christina Georgina Rossetti 299, 360
 The Prince's Progress 227

 Time Flies: A Reading Diary 3, 134, 168–9, 334, 337, 350
 Verses (1847) 69, 75, 77, 86, 91
 Verses (1893) 352, 353
 INDIVIDUAL POEMS:
 'A Birthday' 207
 'A Chinaman' 358
 'A Christmas Carol' ['In the bleak midwinter'] 363
 'A Hopeless Case' 84
 'A Portrait' 65, 249
 'Autumn' 204
 'Babylon the Great' ['Foul is she, ill-favoured set askew'] 350–1
 'Corydon's Lament' 62
 'Death' 84
 'Death's Chill Between' 88
 'Eden Bower' 252
 'Enrica' 238
 'Goblin Market' 24, 188, 192, 206, 252, 263, 292
 'Heart's Chill Between' 88
 'In An Artist's Studio' 163, 230
 'Is and Was' 103
 'Lady Isabella' 65–6, 86
 'Later Life' 236
 'Life Out of Death' 86
 'Lines given with a Penwiper' 69–70
 'Lines to my Grandfather' 68–9
 'Love Lies Bleeding' 275–6
 'Maiden Song' 246
 'My Mouse' 299
 'No Thank You John' 208
 'Our Mothers, lovely women pitiful' 351
 'Portraits' 138
 'Rosalind' 62
 'Song' ['When I am dead my dearest'] 98–9
 'Songs in a Cornfield' 246
 'The Convent Threshold' 203
 'The Dead Bride' 86
 'The Lowest Room' 210, 286
 'The Martyr' 86
 'The Prince's Progress' 230–1
 'The Ruined Cross' 86
 'The Water Spirit's Song' 77
 'The World' 186
 'Three Moments' 119
 'To Lalla, reading my verses topsy-turvy' 153
 'Up-Hill' 187, 207
 'Venus's Looking Glass' 275–6, 299
 'Winter: My Secret' 209, 241
 'Ye have forgotten the exhortation' 156